Diners

American Retro

SOURCEBOOKS, INC.
NAPERVILLE, ILLINOIS

Diners

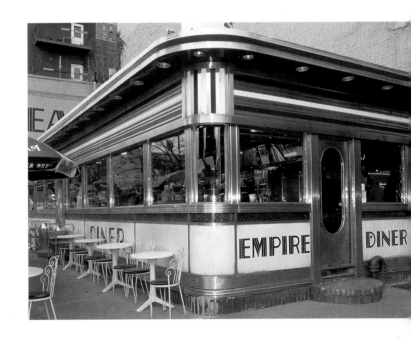

American Retro

Take outs are fine,

but please leave

the tables and chairs.

'50s diner logo

Contents

Introduction

"On that road the nation is steadily traveling beyond the troubles of this century, constantly heading toward finer tomorrows. The American Road is paved with hope."

1951 Ford ad

The great highways of America were its very heart and soul. They spanned the limits of this vast country from top to bottom and east to west. They carried the new breed of motorists from good to bad, from boom to bust, through towns with such names as Mammoth Cave, Kentucky; Pleasantville, New York; and Broken Bow, Nebraska; many of them with nothing more than a Main Street and a drugstore.

Along the way these arteries offered succor in the form of welcoming diners, serving plates of wholesome freshly prepared dishes—food that spawned a universal language in the shape of hot dogs, hamburgers, fries, and malts. Comfortable motels with warm rooms offered the latest in modern conveniences, from power showers to the combination television and radio set, and provided a safe haven for the night. They were clean and affordable family businesses, which allowed the nuclear family, for the first time, to explore the wonders of their own land.

Parked outside were the trappings of prosperity—Cadillacs, T-Birds, Chevrolets, and Corvettes—cars that any sane person has always wanted to drive. These were elongated giants, explosions of chrome grilles and wire wheels, creating fantasies of speed and escapism with features taken from aircraft designs and space travel. These were the only beasts capable of taming this extraordinary country, and are as representative of the United States of America as the Statue of Liberty or the Stars and Stripes.

The names of those great roads—Highway 61, Route 66, Pacific 1—have since passed into popular mythology. For those with a passion for adventure, the names evoke images of *Easy Rider*, and the

lyrics of Bob Dylan and the Rolling Stones. At the same time, they are able to convey that air of safety and innocence, when mom and pop ushered the kids into the back of the family automobile and headed off on vacation.

Now this golden age is all but gone, although remnants do remain. The highways have fallen into disrepair, superseded by freeways with no recognizable character. Many diners have served their last "special," and a large number of "ma and pa" motels have been swallowed up into chains with such alluring names as Comfort Inn and Motel 6 (we are never told what happened to Motels 1 through 5). Small towns, with the whole of life encapsulated on Main Street, are a far cry from the soulless shopping malls of today. And the cars—oh those glorious, gas-guzzling monsters—have been replaced by sensible, compact, economical models with dull names.

As a tribute to the post-war period when people had money in their pockets and a hankering to spend it, the four titles in the *American Retro* series draw on images, both retro and modern, that resonate with the spirit of '50s America. These pictures are paired with advertising slogans, popular sayings, puns, and quotations from personalities that bring to life an age when being economical with the truth came naturally to the advertisers and salesmen of the day, who were desperate to paint a dazzling and futuristic world in which everyone could share. Motels shamelessly claimed to offer comfort fit for the "Queen of Sheba"; car manufacturers used such buzz words as "Rocket Ride" and "Glamorous new Futuramics"; and diners bedecked themselves in chrome detailing and neon lights.

The *American Retro* series recaptures a little of what made those times so special, with images that will fill those who lived through that age with nostalgia and gently amuse and inform those who did not. Read, remember, and enjoy.

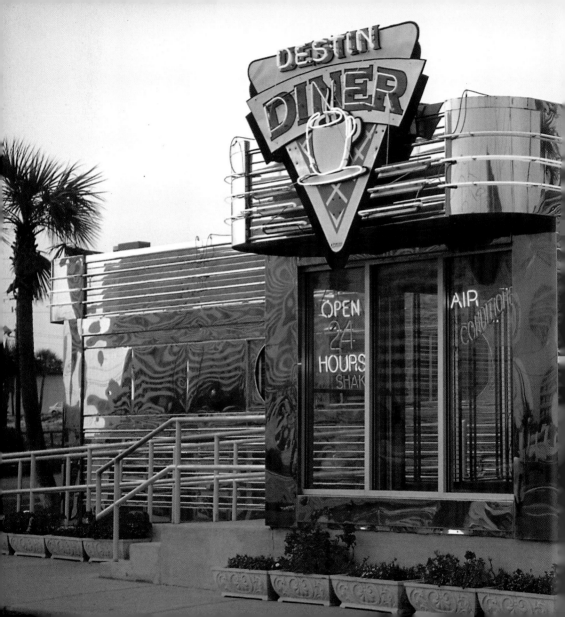

I don't know what your destiny will be, but one thing I do know: the only ones among you who will be really happy are those who have sought and found how to serve.

Albert Schweitzer

Clean as a whistle.

'50s diner logo

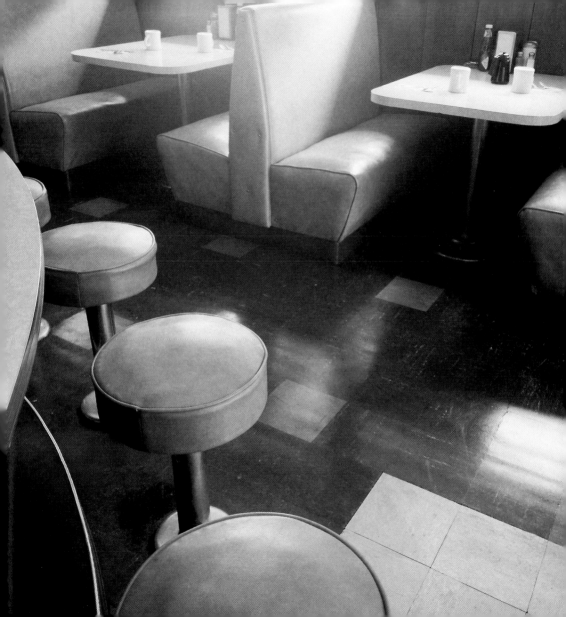

How do you like your eggs?

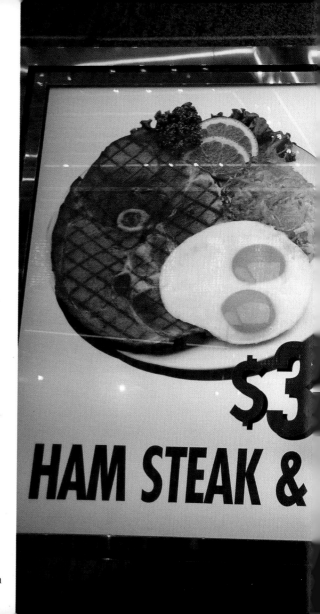

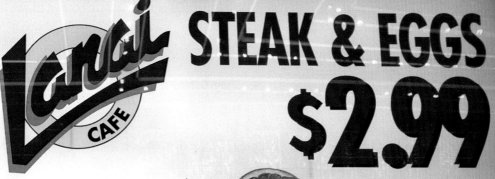

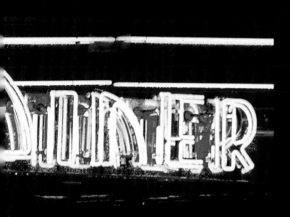

San Francisco, California 15

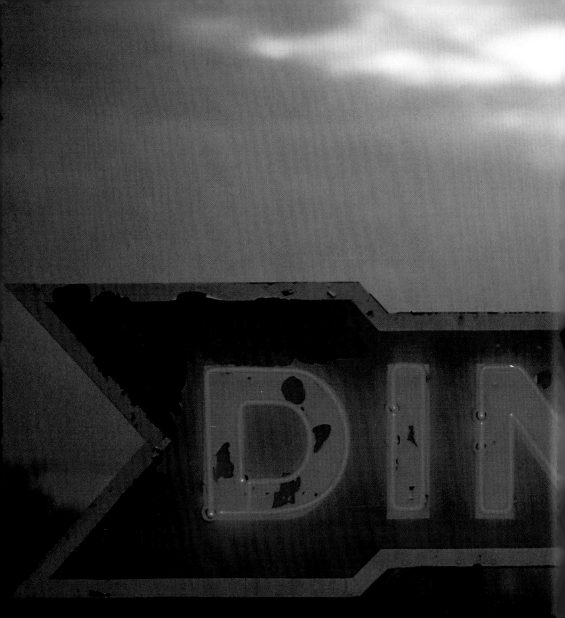

Marion, Virginia 17

Never eat more than you can lift.

Miss Piggy

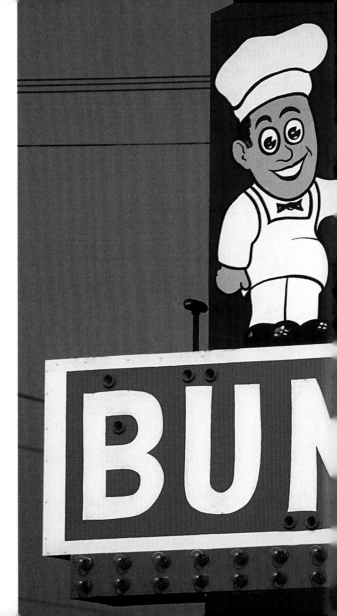

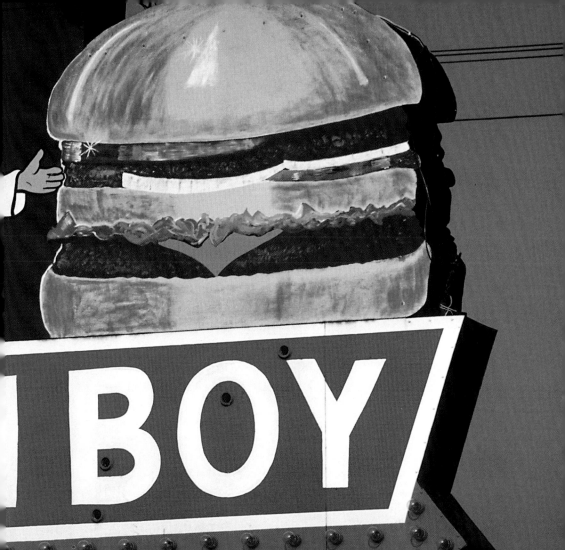

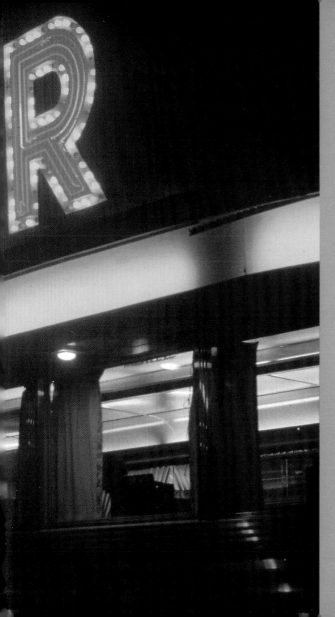

Without an architecture of
our own we have no soul of
our own civilization.

Frank Lloyd Wright

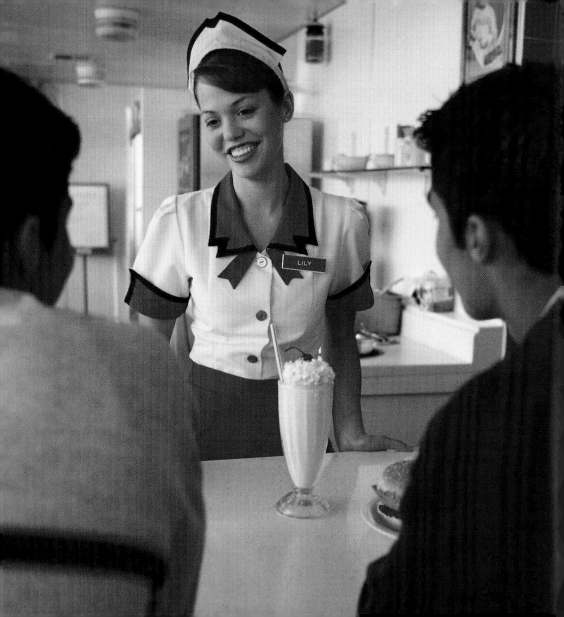

Good and wholesome always.

'50s diner logo

Ever notice that

"What the hell"

is always the right decision?

Marilyn Monroe

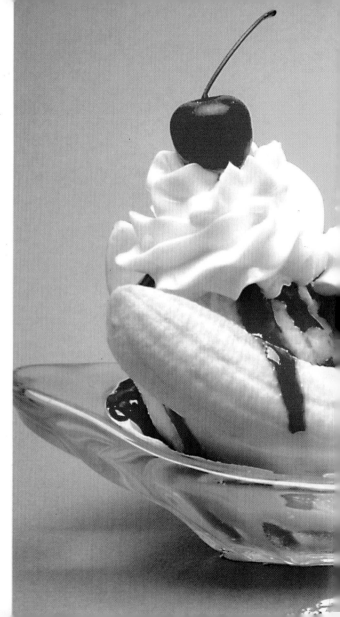

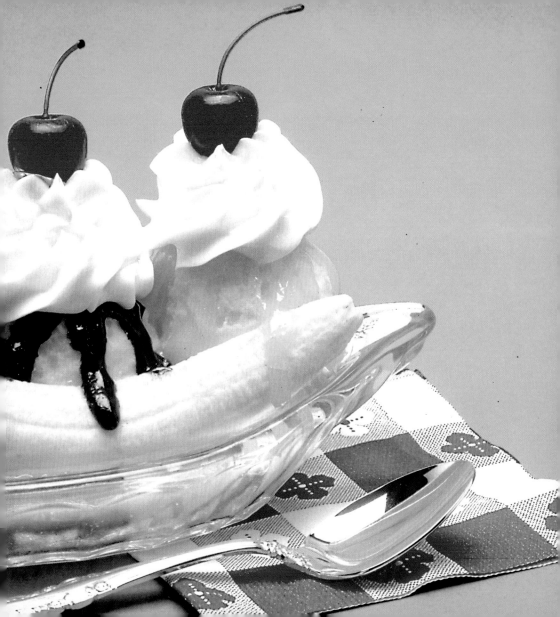

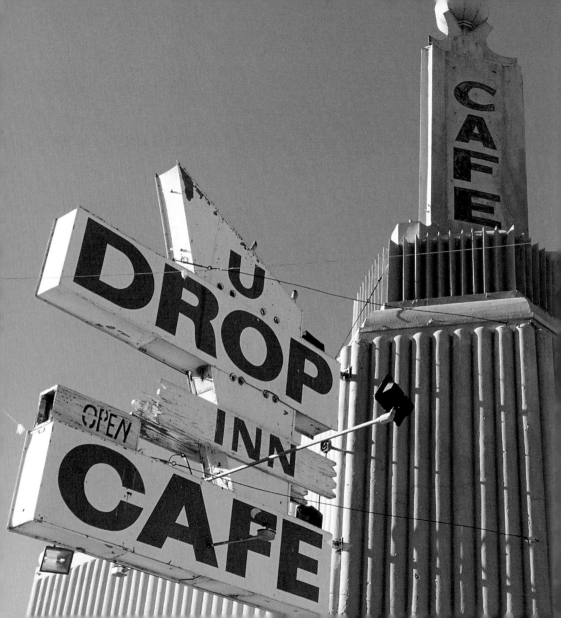

Can't spell; can cook.

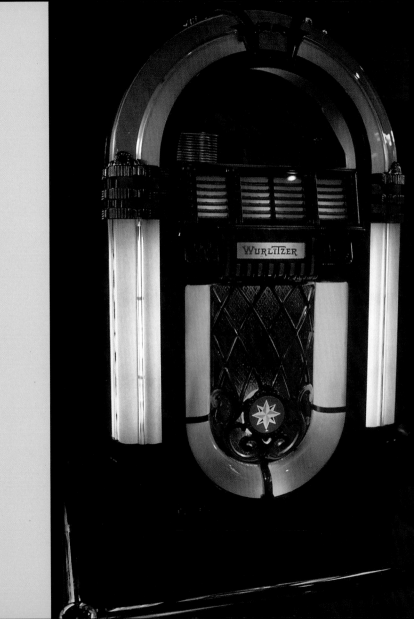

Stay tuned for more rock and roll.

Cup of Joe to go.

'50s diner logo

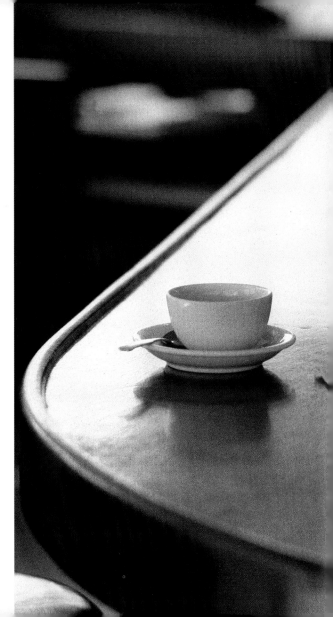

　　　　New York City

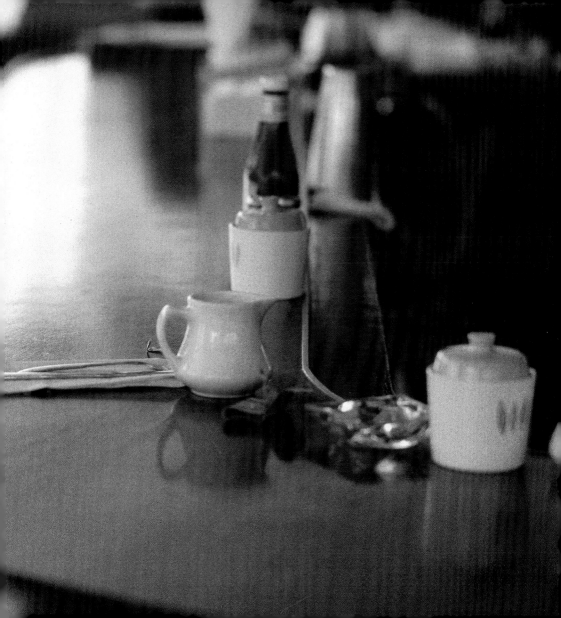

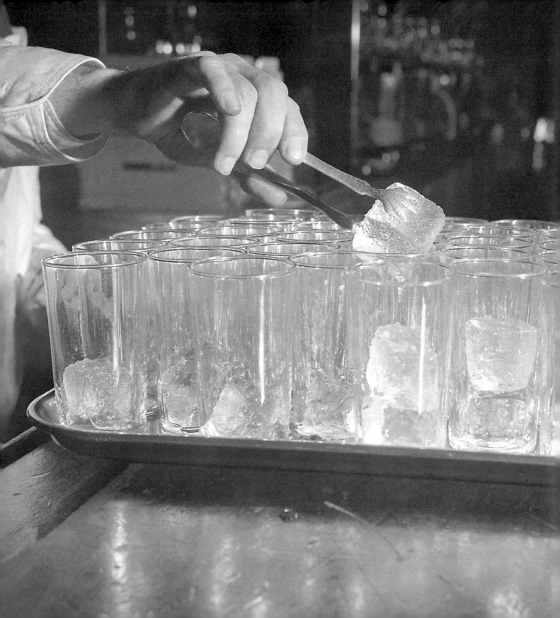

Lexington Hiball.

'50s diner glassware logo

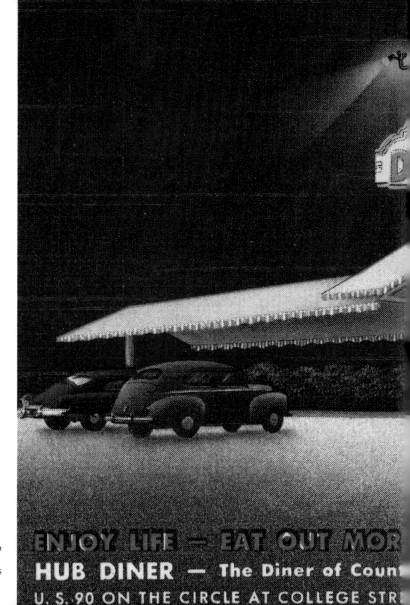

Postcard from the Hub
Diner, Beaumont, Texas

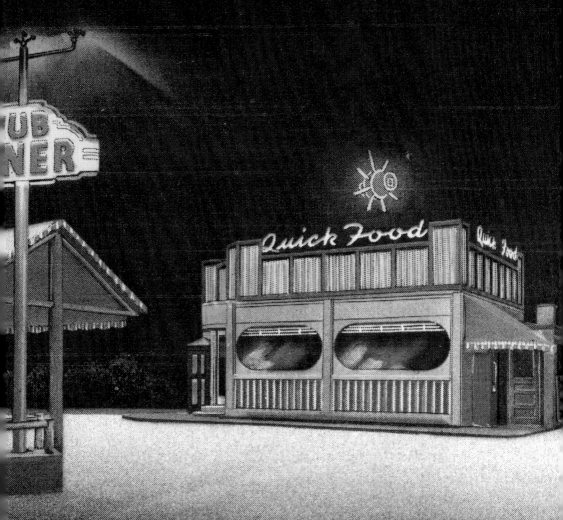

BEAUMONT, TEXAS

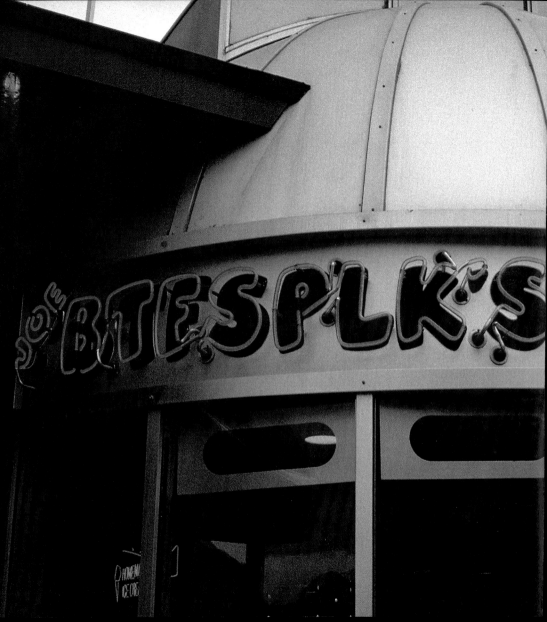

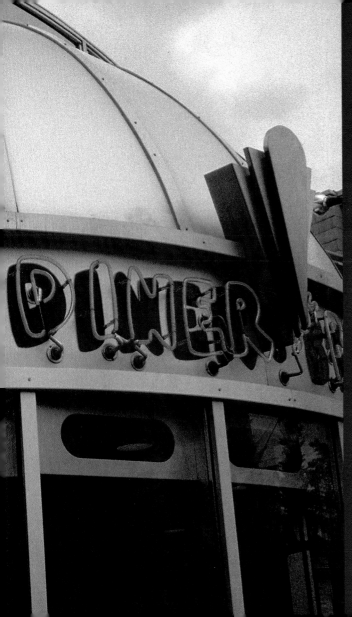

For food that's

out of this world.

Banff, Arizona 37

Take outs are fine, but please leave the tables and chairs.

'50s diner logo

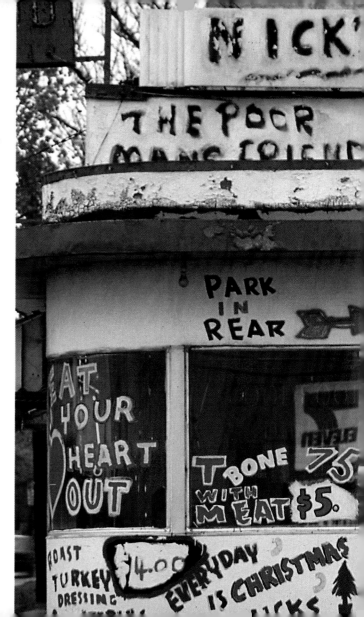

Front Royal, Virginia

GOOD FOOD DINER GOOD COFFEE

BREAKFAST $1.25 PLATE LUNCH $

WELCOME W

GOOD FOOD
QUICK SERVICE

IT'S
COOL

WE'RE
FIGHTING
INFLATION

INSIDE

DON'T
STARVE

HILL BILL
CHICKEN
DANGER SO GOOD

PARK
IN REAR
$2.85

IN RE

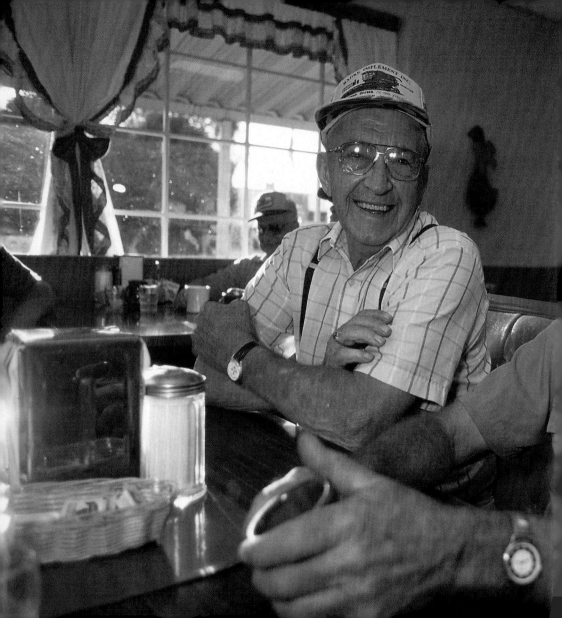

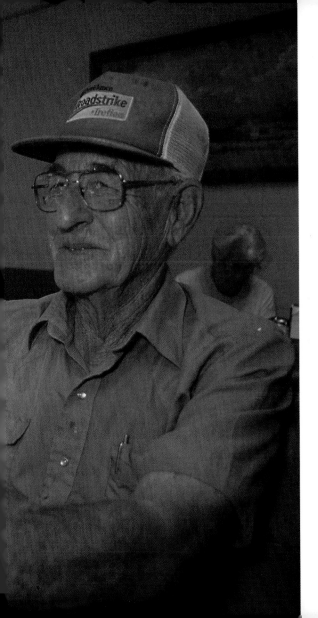

We'll take our regular booth.

Like grandma's, only more so.

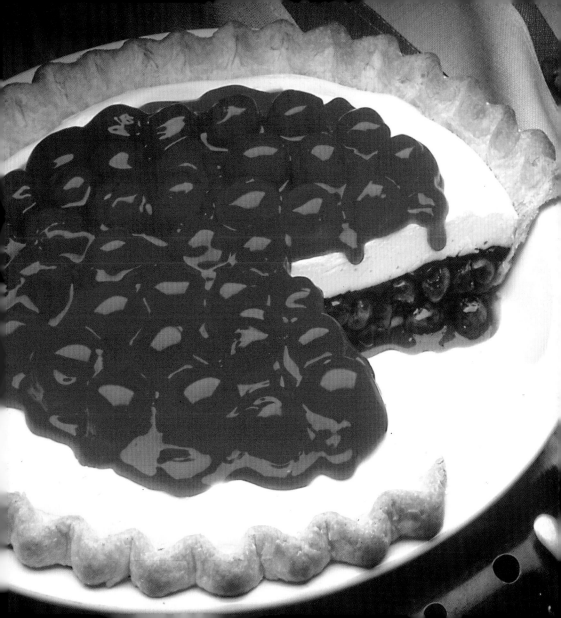

Every great architect is—necessarily—a great poet. He must be a great original interpreter of his time, his day, his age.

Frank Lloyd Wright

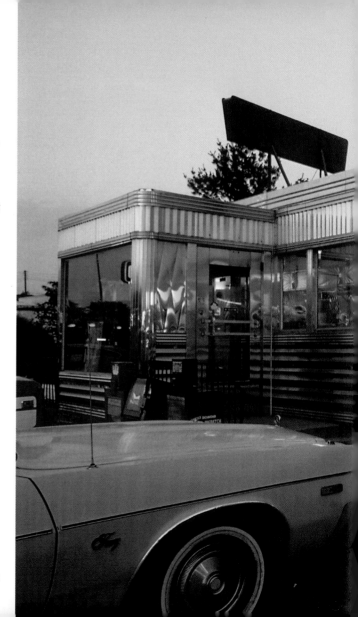

Warrenton, Virginia

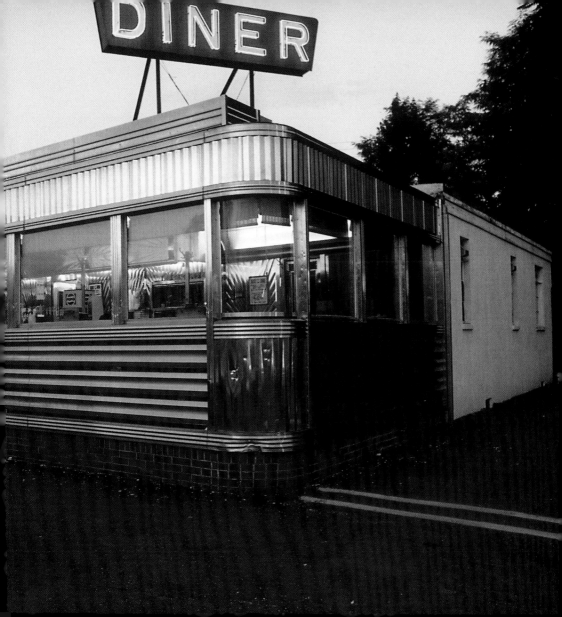

Form never follows function.

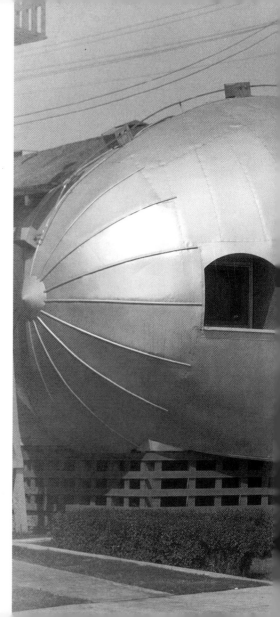

Diner shaped like a
dirigible airship in Los Angeles

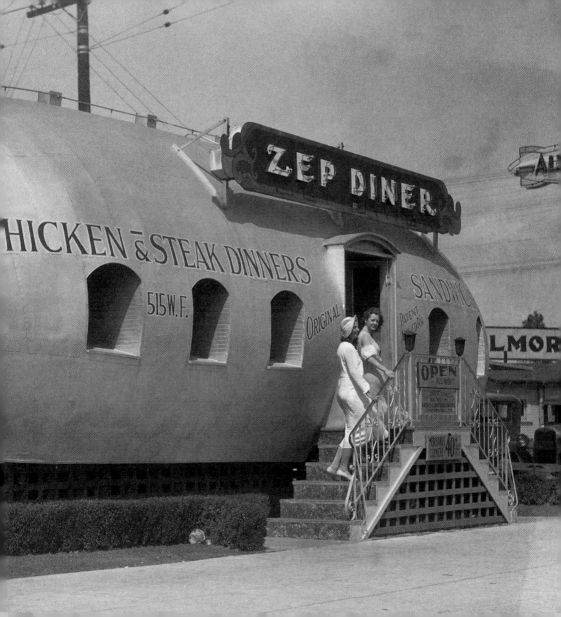

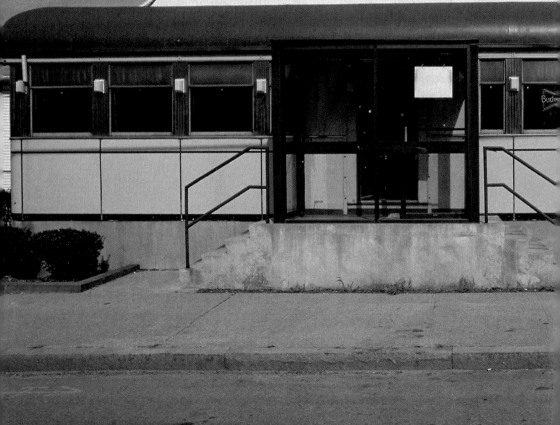

A warm welcome.

The whole of society

can be found in a small town diner.

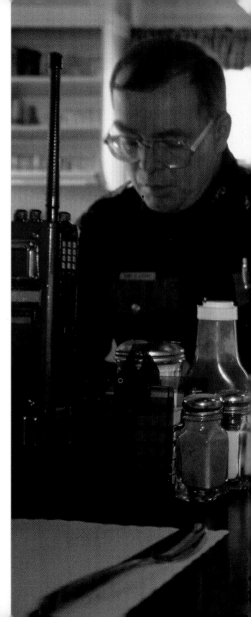

Pittsburgh, New Hampshire

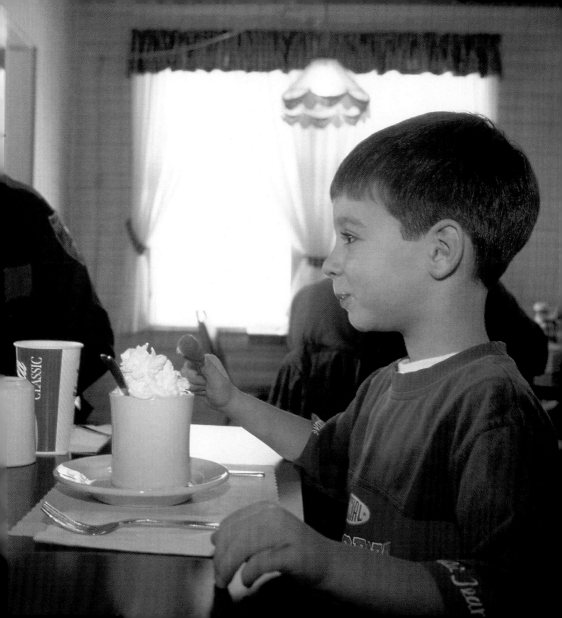

All architecture is great

architecture after sunset;

perhaps architecture is really

a nocturnal art,

like the art of fireworks.

G. K. Chesterton

You can tell the ideals

of a nation by its advertising.

New York City

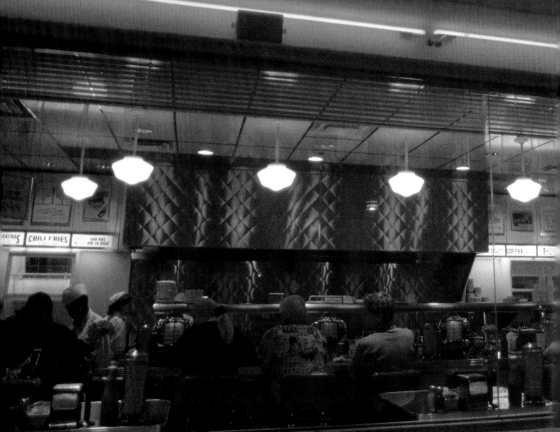

I am not a glutton—

I am an explorer of food.

Erma Louise Bombeck

Atlanta, Georgia

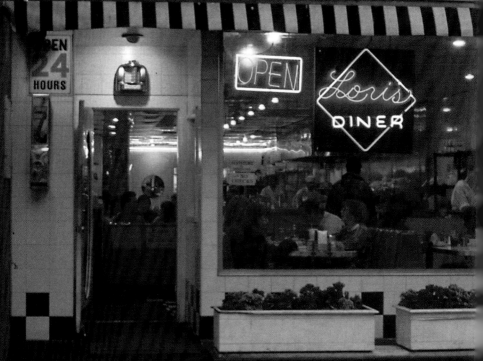

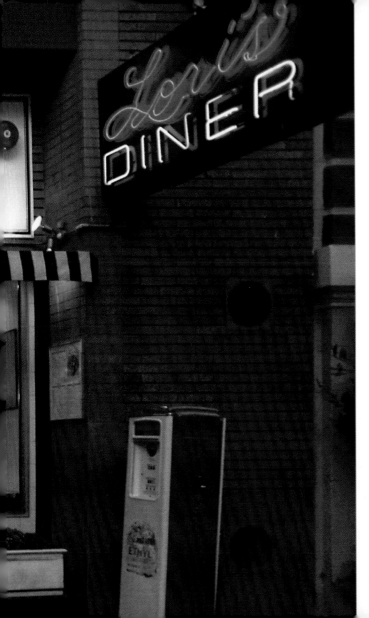

San Francisco, California 59

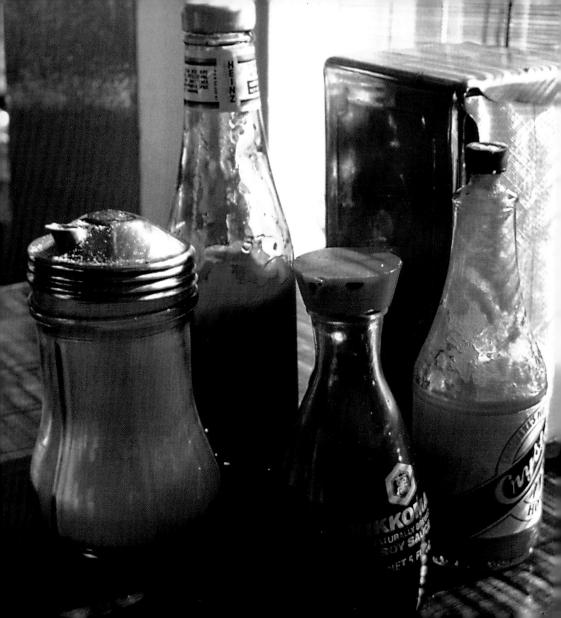

Pass the ketchup.

Johnny Rockets hits the spot.

'50s diner logo

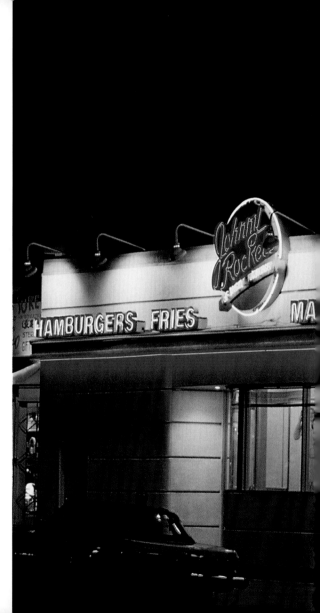

Los Angeles, California

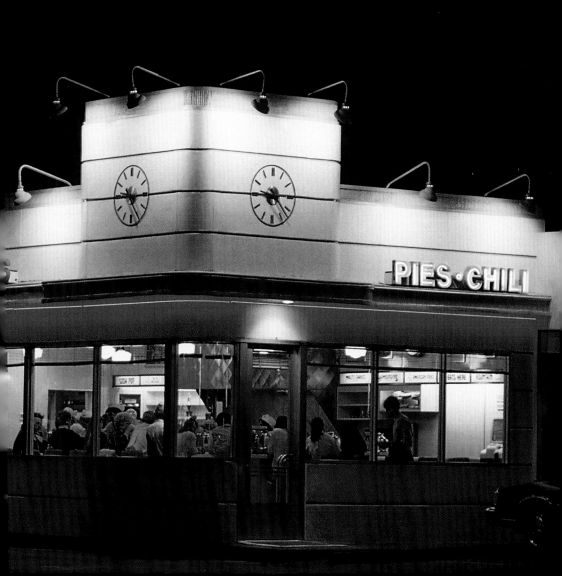

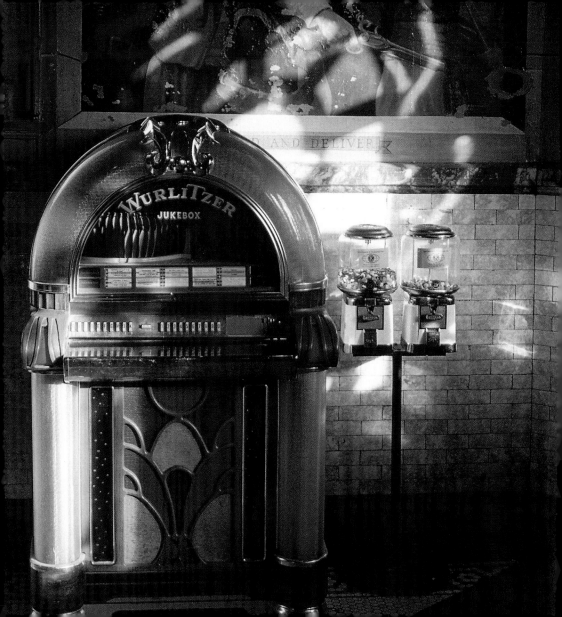

No dancin' in the aisles.

'50s diner logo

Ich bin ein Frankfurter.

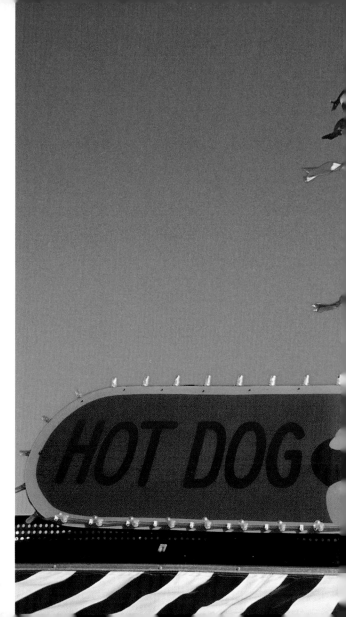

San Francisco, California

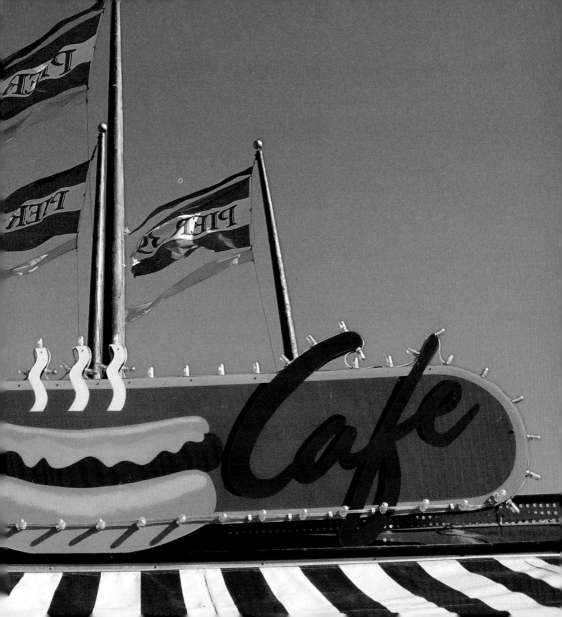

The national dish of America is menus.

Robert Robinson

Los Angeles, California

SPECIALS

COFFEE CAKES	2¢	PURE ORANGE JUICE	5¢
DOUGHNUTS	1¢	VARIETY of SALADS	5¢
HOT BISCUITS	1¢	FRESH VEGETABLES	5¢
MUFFINS or CORN BREAD	2¢	STEWED FRUITS	5¢
BUTTERED TOAST	1¢	LARGE PIE or CAKE	5¢
CHICKEN or VEG. SOUP	3¢	CHOICE of PUDDINGS	5¢
COFFEE with PURE CREAM	3¢	ROAST BEEF HASH	5¢
HOT CHOCOLATE or TEA	3¢	FISH CAKES	5¢

ALL CEREALS WITH MILK 5¢

FEWSTER'S SPECIAL DINNER

10:30 A.M. —— *to* —— 10 P.M.

Soup, Meat Order, Potato
and Gravy, Vegetable, Salad,
Desert, Bread & Butter
Coffee, Tea or Buttermilk

all for **20¢**

Wishes won't wash dishes.

Fort Madison, Iowa

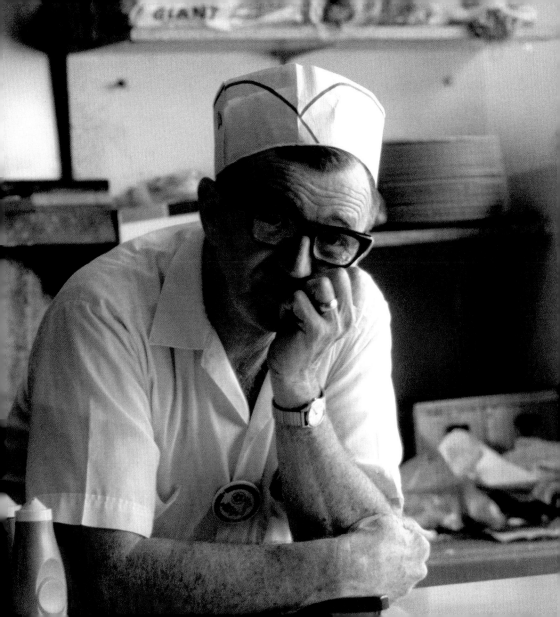

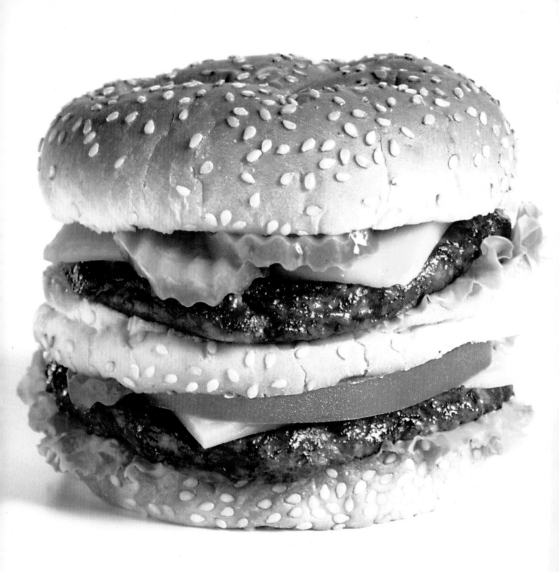

It requires a certain kind of mind to see beauty in a hamburger bun.

Ray Kroc

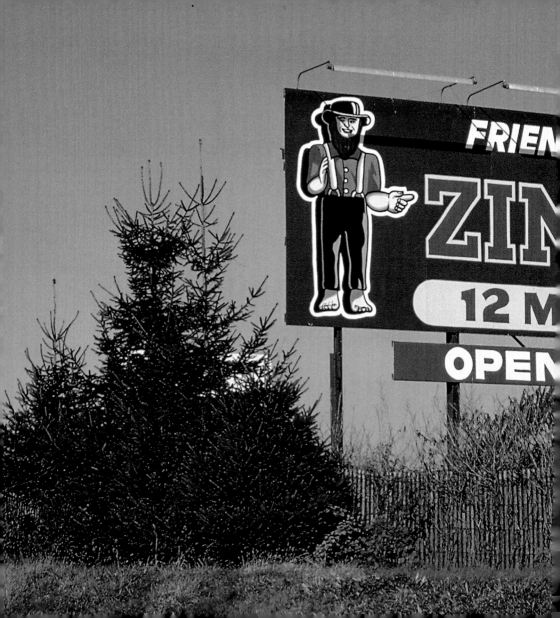

Open for business.

Watertown, New York

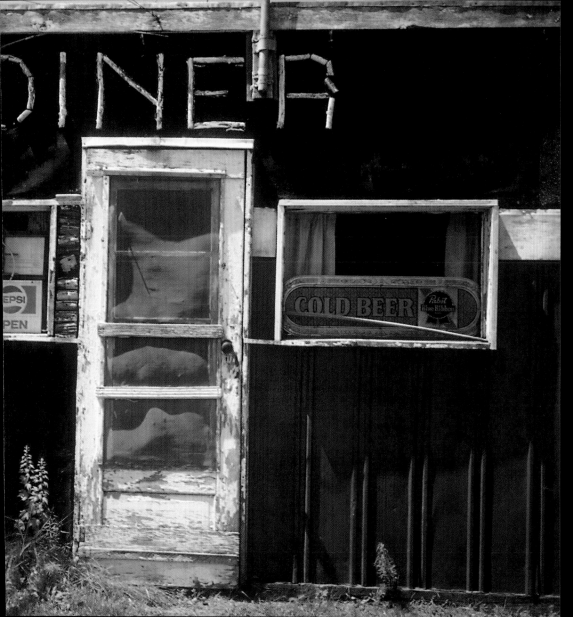

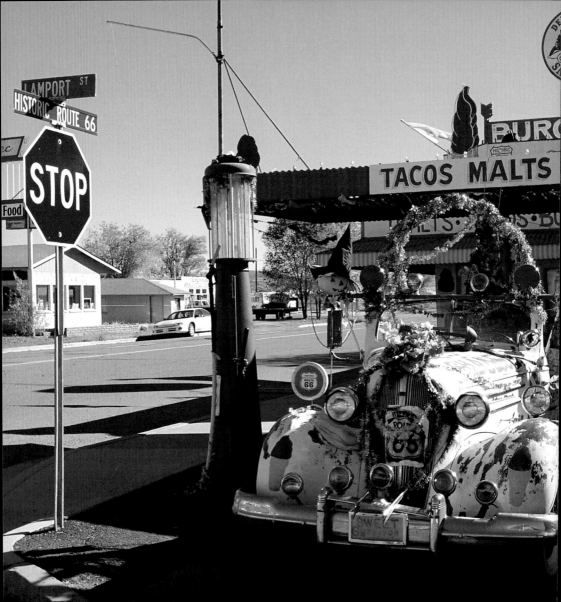

Adventure is worthwhile

in itself.

Roadside diner along Route 66

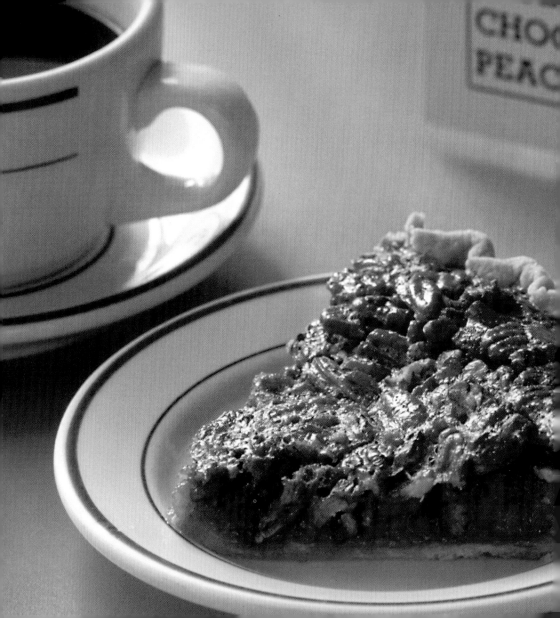

As American as pecan pie.

The morning cup of coffee has an exhilaration about it

which the cheering influence of the afternoon or evening cup of tea

cannot be expected to reproduce.

Oliver Wendell Holmes, Sr.

Las Vegas, Nevada

$1.95

Breakfast

11 PM to 7 AM

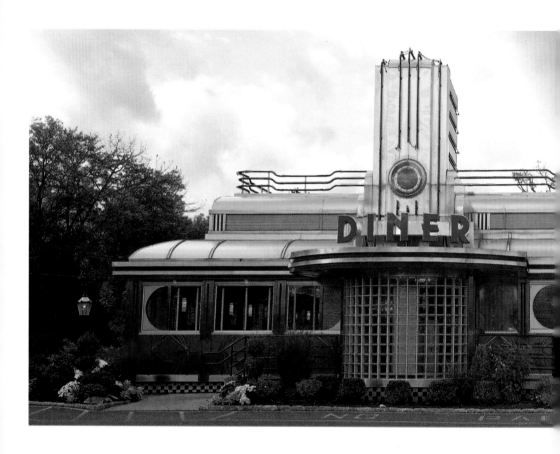

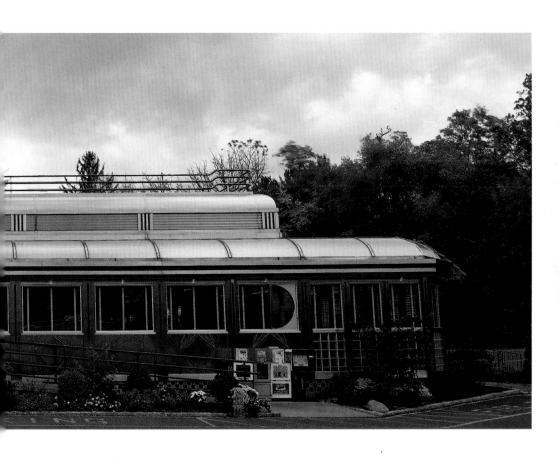

Hyde Park, New York

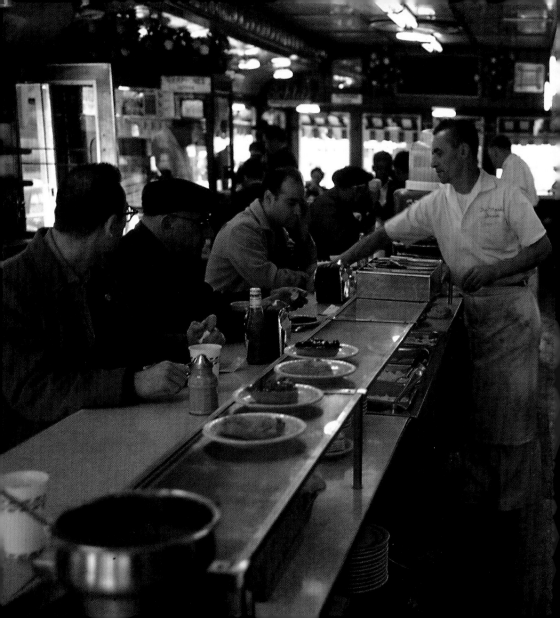

We must stop talking about

the American dream

and start listening to

the dreams of the Americans.

Reubin Askew

Strong minded,

resolutely willed,

you can create out of

nothing a great business,

a huge empire,

a new world.

Claude M. Bristol

New York City

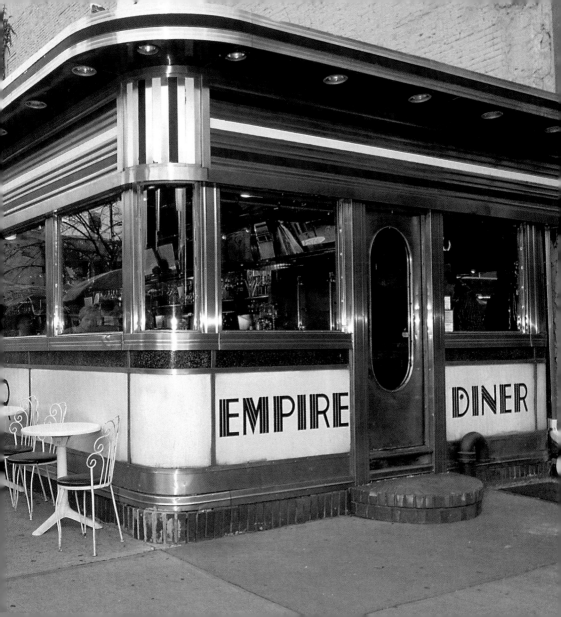

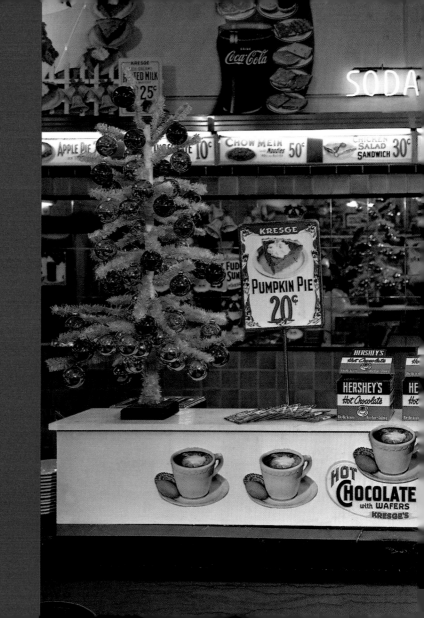

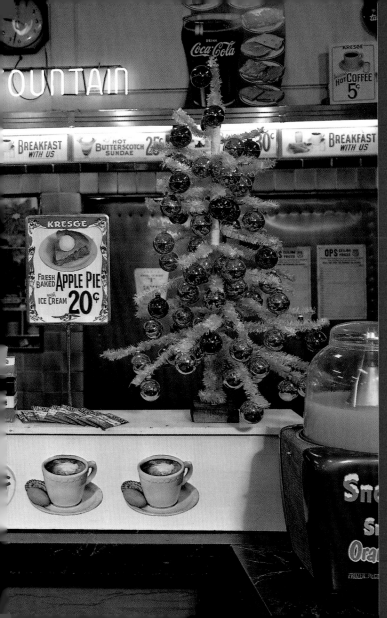

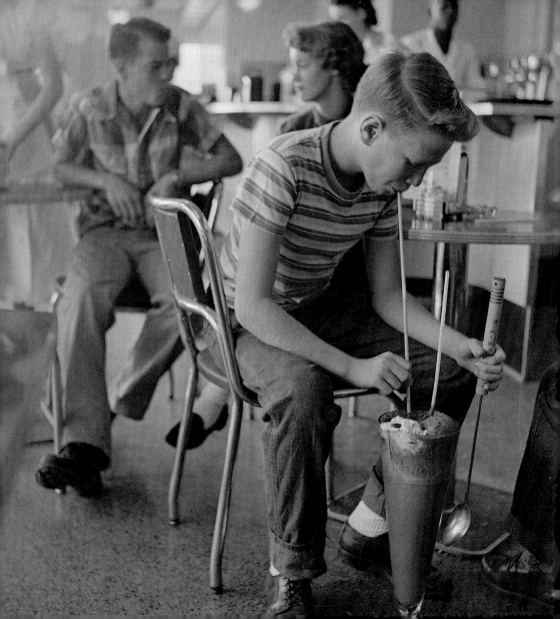

Drink Cheer Up.

'50s diner glassware logo

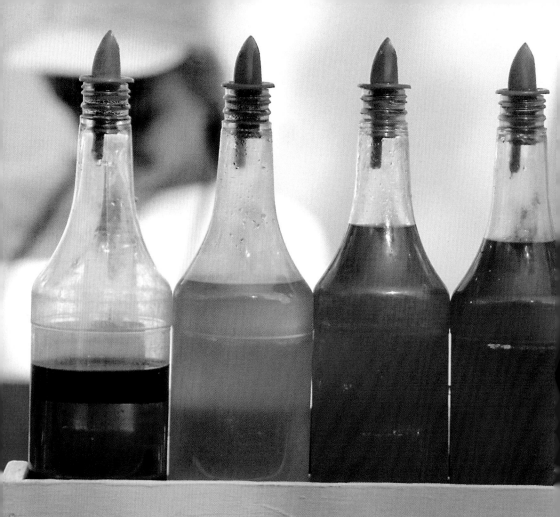

SHAVE

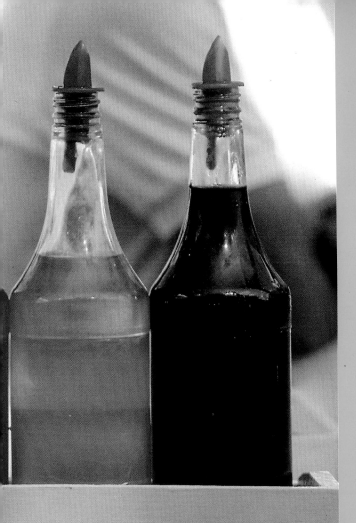

...enjoy your ice cream

while it's on your plate—

that's my philosophy...

Thornton Wilder

herokee Translation

ᏫᏣ ˢ	150	CONES, ᎤᏬᏓᎢᎢ-ᎤᎬᎾ ᏚᏗᎬᎢ ~~25~~	35 45 55
ᏫᎤᎢ	1.75	CHOCOLATE DIP CONES, ᎠᎤᏚᎢ ᎤᏬᎯᎵ ᏚᏗᎬᎢ	50 60
	1.00	FLOATS ᎤᎩᏱᏟ ᎠᎢᏗᎤᎢ	55 75
	1.20	FREEZES ᎤᏟᎤᎢᏔᎷᎢ	.75
	1.20	BANANA SPLITS, ᎢᎦᎾ ᎠᎤᎧ Ꭹ BT	1.60
	1.40	MALTS and SHAKES, ᎤᎤᎢ ᎠᏚ ᎤᏟᎯᎵ	.75
	1.40	SUNDAES, ᎠᏛᎤᎾ ᎠᏛBᏔᎢ	.60 75
Ꮯ	1.60	Chocolate, Cherry, Butterscotch, Strawberry and Pineapple	
	1.60	SUNDAES, Hot Fudge, Butter Pecan	70 85
	1.60	DRINKS, ᎤᏴᏟ ᏍᎢᎢᎤᎢ	
	1.40	COKE, ROOT BEER, DrPEPPER, SPRITE 2?	40 ?? 75
	85	ORANGE or GRAPE SLUSH, ᏚᏟ~ᎬᎤᎶᏔ	40 ?? 75
	70	LIMEADE or LEMONADE, ᎢᏟᎯᏫ ᏚᏟ~ᎬᎤᎶᏔ	55 75
	85	ICE TEA, ᎤᎢᏟᎩ ᎠᏚᎤᎢ	40 ?? 75
	1.00	COFFEE, ᏫᎾ	??
	70		
	70	We Use "BUNNY" Bread and Buns	
	85		

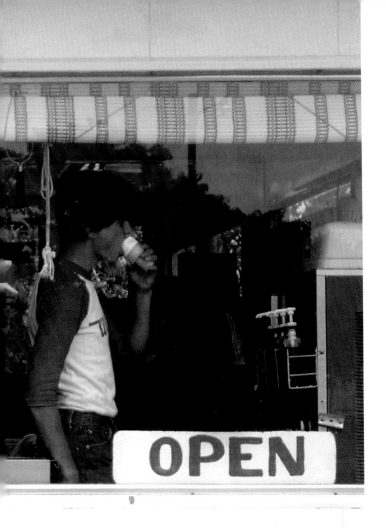

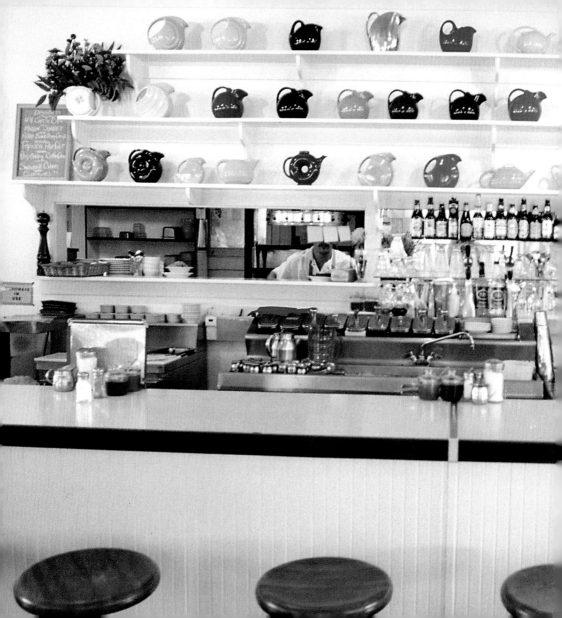

We live in a rainbow of chaos.

Paul Cezanne

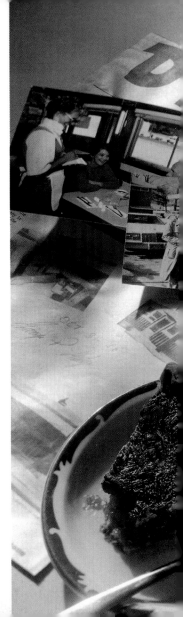

Home is where the stomach is.

South Burlington, Vermont

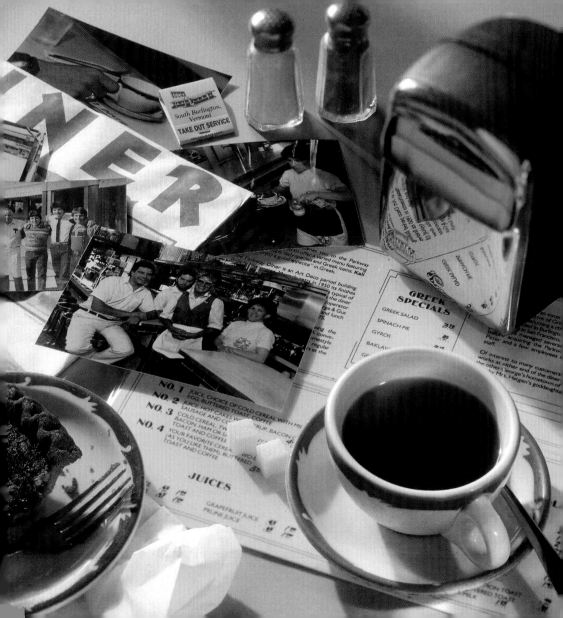

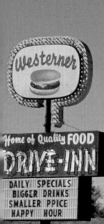

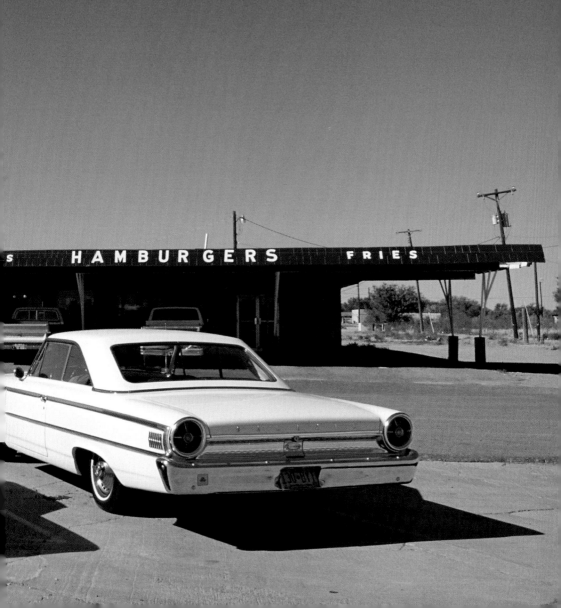

The morning pick-me-up...

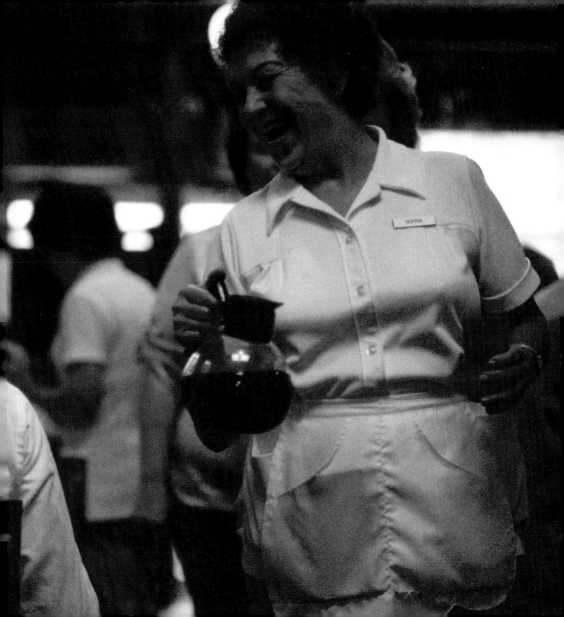

Picture credits

All images reproduced by permission of Corbis Images unless otherwise stated.

Page 8/9: Destin Diner in Destin, Florida; credit Dave G. Houser.

Page 10/11: Booths and stools in a diner; credit Eric Poppleton.

Page 12/13: Sign in Las Vegas, Nevada; reproduced by permission of Travel Ink/Simon Reddy.

Page 14/15: Fog City Diner in San Francisco, California; credit Morton Beebe.

Page 16/17: Neon sign points the way to a Diner in Marion, Virginia; credit Scott T. Smith.

Page 18/19: Sign for the Bun Boy restaurant in southern Indiana; credit Philip Gould.

Page 20/21: Olympia Diner near Hartford, Connecticut; credit Joseph Sohm.

Page 22/23: Waitress; credit RNT Productions.

Page 24/25: Banana split.

Page 26/27: U Drop Inn Café in Shamrock, Texas; reproduced by permission of Travel Ink/Walter Wolfe.

Page 28/29: Original jukebox in the Country Music Hall of Fame, Nashville, Tennessee; credit Philip Gould.

Page 30/31: Edge of the counter; credit David Katzenstein.

Page 32/33: Longchamps, on the corner of 42nd Street and Lexington Avenue in New York City; credit Bettmann.

Page 34/35: Postcard from the Hub Diner, Beaumont, Texas; credit Lake County Museum.

Page 36/37: Joe Btfsplk's Diner in Banff, Arizona; credit The Purcell Team.

Page 38/39: Nick's Diner in Front Royal, Virginia; credit Scott T. Smith.

Page 40/41: Two elderly farmers in a diner in Kansas; credit Philip Gould.

Page 42/43: Cherry pie; credit Carl Corey.

Page 44/45: Frost Diner in Warenton, Virginia; credit William A. Bake.

Page 46/47: Women entering the Zep Diner, shaped like a dirigible in Los Angeles, California; credit Bettmann.

Page 48/49: The Modern Diner, a historic landmark, in Pawtucket, Rhode Island, the first diner to be listed on the National Register of Historic Places; credit Bob Rowan.

Page 50/51: A policeman and a boy at Muriah's restaurant in Pittsburg, New Hampshire; credit Phil Schermeister.

Page 52/53: Destin Diner in Destin, Florida; credit Robert Holmes.

Page 54/55: Painted window in New York City; reproduced by permission of Travel Ink/Andrew Cowin.

Page 56/57: Diner at Underground Atlanta in Atlanta, Georgia; credit Nik Wheeler.

Page 58/59: Lori's Diner in San Francisco, California; credit Robert Holmes.

Page 60/61: Condiments; credit Carl Corey.

Page 62/63: Johnny Rockets in Los Angeles, California; credit Nik Wheeler.

Page 64/65: Wurlitzer jukebox at Fernandina Beach, Florida; credit Raymond Gehman.

Page 66/67: Hot Dog Café in San Francisco, California; reproduced by permission of Travel Ink/Geraint Tellem.

Page 68/69: Menu in window, Los Angeles, California; credit Bettmann.

Page 70/71: The short order cook in the Pantry Café in Fort Madison, Iowa; credit Nathan Benn.

Page 72/73: The classic American cheeseburger; credit Ron Stenzak.

Page 74/75: Billboard for Zinn's Diner near Wakarusa, Indiana; credit Bob Rowan & Progressive Images.

Page 76/77: Diner in Watertown, New York; credit John Bartholomew.

Page 78/79: Roadside diner along Route 66; reproduced by permission of Travel Ink/Walter Wolfe.

Page 80/81: Lea's Restaurant in LeCompte, Louisiana; credit Philip Gould.

Page 82/83: Landmark Diner in Atlanta, Georgia; credit Bob Krist.

Page 84/85: Sign advertising breakfast in Las Vegas, Nevada; reproduced by permission of Travel Ink/

Page 86/87: Eveready Diner in Hyde Park, New York; credit Joseph Sohm.

Page 88/89: New York City diner; credit Roger Wood.

Page 90/91: Empire Diner in New York City; credit Kevin Fleming.

Page 92/93: Diner in St Paul, Minnesota; credit Minnesota Historical Society.

Page 94/95: Teenager drinking a large milkshake in Lincoln, Nebraska; credit Genevieve Naylor.

Page 96/97: Shaved ice syrups in Minneapolis, Minnesota; credit Owen Franken.

Page 98/99: Menu in English and Cherokee in Tulsa, Oklahoma; credit Annie Griffiths Belt.

Page 100/101: Counter seating in a diner in Yountville, California; credit Robert Holmes.

Page 102/103: Pecan Pie in a diner in South Burlington, Vermont; credit Becky Luigart-Stayner.

Page 104/105: Drive-Inn in Tumcari, New Mexico; reproduced by permission Travel Ink/Walter Wolfe.

Page 106/107: Waitress serving coffee; credit Annie Griffiths Belt.

Attributions

Page 8/9: Albert Schweitzer.

Page 10/11: '50s diner logo.

Page 12/13: Anon.

Page 18/19: Miss Piggy.

Page 20/21: Frank Lloyd Wright.

Page 22/23: '50s diner logo.

Page 24/25: Marilyn Monroe.

Page 26/27: Anon.

Page 28/29: Anon.

Page 30/31: '50s diner logo.

Page 32/33: '50s diner glassware logo.

Page 36/37: Anon.

Page 38/39: '50s diner logo.

Page 40/41: Anon.

Page 42/43: Slogan of the General Food Corporation.

Page 44/45: Frank Lloyd Wright.

Page 46/47: Anon.

Page 48/49: Anon.

Page 50/51: Anon.

Page 52/53: G. K. Chesterton.

Page 56/57: Erma Louise Bombeck.

Page 60/61: Anon.

Page 62/63: '50s diner logo.

Page 64/65: '50s diner logo.

Page 66/67: Anon.

Page 68/69: Robert Robinson.

Page 70/71: American proverb.

Page 72/73: Ray kroc, Chairman of McDonald's.

Page 76/77: Anon.

Page 78/79: Anon.

Page 80/81: Anon.

Page 84/85: Oliver Wendel Holmes, Sr.

Page 88/89: Reubin Askew.

Page 90/91: Claude M. Bristol.

Page 94/95: '50s diner glassware logo.

Page 96/97: Thornton Wilder.

Page 100/101: Paul Cezanne.

Page 102/103: Anon.

Page 106/107: Anon.

Designer: WDA
Editor: Alison Moss
Researcher: Suzie Green

Sourcebooks, Inc.
P.O. Box 4410, Naperville, Illinois 60567-4410
(630) 961-3900
FAX: (630) 961-2168

·Printed and bound in Spain by Bookprint, S.L, Barcelona

MQ 10 9 8 7 6 5 4 3 2 1

ISBN: 1-57071-593-9

WITHDRAWAL

About the Author

S hanna Mahin is a high school dropout who rallied late despite her ninth-grade English teacher's prediction of a lifetime of wasted potential. Her writing fellowships include the MacDowell Colony, the Norman Mailer Writers Colony, and PEN Center USA Emerging Voices, among others that she will tell you all about over a glass of wine. Just like her character, Shanna is third-generation Hollywood, but any other similarities are strongly renounced, at least until the statute of limitations expires.

much she made me cry the first time she talked to me about it and then cry even harder when she acquired it.

Rachelle Mandik, for copyediting all my bad habits and tics into oblivion.

Plus a cadre of people at Dutton I haven't met yet because these things happen with such a long lead. But I love you anyway, you beautiful book people.

And, finally, and most important, my husband, Chris, who didn't even blink when I came home in 2006 and said I was finally ready to try. "Fly, little chicken," he said.

And I did.

My indefatigable and quite glamorous agent, Wendy Sherman, who plucked this manuscript from the slush pile and worked with me tirelessly as it morphed into the book you're holding in your hands. Wendy, I love you more than pie.

Joel Ross, who read every word of this book a thousand times and made me get up and run when I was sure I couldn't. For giving me a place to stay when I was in a face-plant after setting my first book aside and for buying me the world's best breakfast sandwiches while I cried and made lists of alternate careers that included sign twirler and world's oldest waitress.

My writer tribe, the people I've sidled up to in all those places I mentioned (and others) and begged/wheedled/forced to be my friends, whom I've stayed in touch with across miles and years and who have read endless drafts of all my work before this book and then this book, plus a bunch of scrawled illustrations on cocktail napkins about what our writer commune will look like someday. These people talk me down from the rafters when I'm ready to throw it in and gossip madly with me when schadenfreude seems like the only reason I have to go on: Jennifer Pashley, Eileen Cook, The Hydra (Teri Carter, Suzy Vitello, Averil Dean, Amy Gesenheus), Allison Burnett, Polly Dugan, Libby Flores, Betsy Lerner, Jim Ruland, Haven Kimmel, and some other very important people I'm blanking on right now, which means you'll probably be getting flowers or chocolates or something from me in the near future.

Scott Hoffman, for believing in me when I was just a baby writer with thirty pages ripped from my journal. Your years of encouragement and cocktails and dinners were invaluable. Plus you can sing the hell out of "Black Dog" at karaoke, and who doesn't need that person in their corner?

Denise Roy, my brilliant editor at Dutton, who loved my book so

They don't necessarily mean it the way I usually hear it, which is, "How did a girl like *you* figure out how to write a book?" At least I don't think they do. Whatever. Haters to the left. Anyway, here's how: I read and read and read, and then I wrote and wrote and wrote, and then a lot of amazing people and venerable institutions rose up to meet me and shepherd me along the way. Herewith, my undying gratitude and thanks to:

Patti Carmalt, for showing me, again and again (and again) until I finally got it, that I could grow beyond my dark and twisty upbringing. Yep, I'm the girl who just thanked her therapist. I would be facedown in a ditch somewhere with bugs in my eye sockets without her.

Samantha Dunn, my first mentor and friend for life, for putting the machete in my hand and telling me to start hacking out my own path, because sure as shit no one else was going to do it for me.

The amazing fellowships and residencies who extended their hospitality despite my brash and often inappropriate applications: the MacDowell Colony, the Norman Mailer Writers Colony, the Prague Summer Program for Writers, the Atlantic Center for the Arts, and Writers @ Work, among others, and, last but certainly not least, the PEN Center USA Emerging Voices program. An important part of my education happened in those cabins and dorm rooms and living rooms and barrooms, around dinner tables and Ping Pong tables and on walks in the woods and on van rides into town to get whiskey. Thank you, Andrew Solomon, Nam Le, and William Finnegan, for making me feel as though I already had a place at the table. George Singleton, for so much beer and even more laughter. William Giraldi, you delicate flower, for being kind to me when the discussion of Baudelaire went completely over my head. Abigail Thomas, for just being so fabulous.

Acknowledgments

I'm a late bloomer. If late blooming was a booth at a carnival, I would totally win one of those giant stuffed pandas they keep all the way at the top. I don't have an MFA; I didn't study writing in college. In fact, I didn't go to college at all. Or high school, for that matter, at least not past the first half of the tenth grade. But books, *books*! Books have been a constant—often the only constant—in my life from the moment I learned to read, some (mumble) forty years ago. Books saved my life and gave me a soft place to fall in a childhood with some really hard edges.

When I was a kid, I read everything on my mother's bookshelf, from Thomas Wolfe, Mark Twain, and Charles Dickens to Harold Robbins, Sidney Sheldon, and the *I Ching*. Also *Dianetics*, which was seriously confusing, and the Reader's Digest Condensed Books series, for which I still blame my incomprehension of Pearl S. Buck books. But by the time my teen peers were writing papers on *To Kill a Mockingbird* and *Catcher in the Rye*, I was busy selling Quaaludes to Nikki Sixx in the parking lot of the Starwood and reading books by Jackie Collins. Don't judge.

I guess my long-winded and convoluted point is that my journey to publication has been unconventional, and there certainly wasn't a clear path from there to here. People often ask me how I did it.

Seventy-four

There's a picture on hollywoodhookups.com of Eva and JJ sitting on the hospital bench on that first day, their denim-covered legs barely touching. JJ is smiling at someone out of frame while Eva taps on her phone, chestnut hair falling across her face like a theater curtain. The picture must have been taken from behind the reception desk, either by the nurse in the vegetable scrubs or the one who looked like Thor on *Nurse Jackie*. One of them got paid the equivalent of a couple long shifts changing IV bags and reassuring relatives.

There's a close-up inset in the corner of the photo, one of those rectangles the tabloids overlay to show the grainy detail of a starlet's engagement ring or cellulite ripple. But this close-up shows Eva's sleek Prada-clad foot twined behind JJ's ankle in the sea of blue linoleum.

My big toe, with its chipped blue-black nail polish, hovers just inside the frame, marring the perfect symmetry of the shot.

"Sure," I say, and walk to the edge of the bed.

Donna looks like she's sleeping. I've watched enough hospital deathbed scenes to know I should say something, but I meant it when I said that I'd already said my good-byes. I've been saying them for years.

I sign a half dozen documents and field condolences from an equal number of hospital staff, then stumble with Megan into the halogen-lit parking lot, blinking and disoriented.

"Wow," I say. "I'm having a *Groundhog Day* moment."

"Huh?"

"Here I am, again, square zero. Jobless, clueless, and now Mom-less."

Megan glances at me. "Jobless?"

"I'm done with Eva," I say, suddenly certain.

"Yeah?"

"Yeah. I'm done with all that. But what am I doing now?"

"What are *we* doing now, you mean?" Megan says. "We're going home."

"You mean *home* home?" I ask. "We don't technically live there anymore. Also? The walls are sandalwood."

Megan opens the car door. "We'll repaint."

Seventy-three

We're still kind of floaty and giggling when we walk into Donna's room. We immediately stop short and Megan grabs my hand. Two nurses are standing at Donna's bedside, making awkward eye contact with each other over Donna's lifeless body. It's like they're mentally playing rock-paper-scissors to see who has to tell me the news that is completely evident.

"Holy shit, Boof, she died during intermission," Megan whispers.

Megan is the only person on the planet who could say that to me—in the room where my mother's body isn't even cold yet—and get a laugh.

"She would have hated dying offstage," I say, and the nurses side-eye each other awkwardly. One murmurs that they'll give us a few minutes as they shuffle out of the room.

Dr. Mark Ruffalo comes skidding in like Kramer on *Seinfeld*. "I tried to have someone find you in the cafeteria. I'm so sorry you weren't here."

"It's fine," I say. "I already said my good-byes."

He frowns and I realize that I sound flip, but I don't have the energy or the inclination to explain.

"Well, take all the time you need," he says. "Then there are forms to sign and a couple of people you need to talk to."

ness. "Do you want me to bring you food or clothes or something after my appointments?"

"We're good," I say, willing myself not to cry at his kindness. "But I really appreciate it."

"Well, if there is anything you need—"

"If you keep being nice, I'll lose my shit. You need to hug me and go."

I hold out my arms and he hugs me. It's not a kiss, it's not a promise. It's nothing at all, but he feels solid and warm, and for a moment I hang on tight.

"Okay, get out," I finally say. "I have to find Megan before she texts all my suitors and has them lining up."

He shoots me a look like he wants to say something, then he changes his mind and starts backing away, miming that I should call him with an imaginary phone to his ear.

I find Megan perched on the counter in the women's bathroom, playing Minecraft on her phone. "You are incorrigible, Boof, and I'm pretty much in love with you right now."

She hops down. "This is the moment where I get to say 'I told you so,' right?"

"If you were that kind of person, then yes, this would be that time."

We get into the elevator, which is filled with a couple doctors in lab coats and a handful of fruit-scrubbed nurses. We ride two floors in silence and then Megan blurts, not softly, "I TOLD YOU SO," and we stifle our hysterical giggles while the elevator slowly empties.

Then he's upon us and I'm profoundly aware of my ratty, unwashed hair and my questionable level of general hygiene.

"Hey," he says, setting the tray on the counter and pulling me into a hug. "Are you okay?"

I'm glad that my face is hidden in his shoulder, because my eyes immediately start to leak. "Yeah," I say, my voice muffled. "It's complicated, but yeah."

I extricate myself as he and Megan introduce themselves.

"You brought real coffee," I say.

"And you're starting to wonder if that's my answer to everything," he says.

He hands each of us a white paper cup. I peel off the plastic top of mine and bury my nose in the sharp, fragrant tang of dark Italian roast.

"I . . . um, thanks for the coffee," Megan says. "I'll be in the ladies' room."

"Oh, no you don't," I say, as if Kirk isn't standing beside me. "You're staying right here."

"Okay," she says, and scampers off toward the restrooms.

"Bitch," I hiss at her retreating form.

Kirk smiles at me. "She's very subtle."

"I'm not good with subtle."

"I've noticed that."

He smooths a stray clump of hair away from my face. Which is extremely tender, until he rubs his fingers together like they're slicked in motor oil and raises an eyebrow into a Jack Nicholson smirk.

"Don't you dare say anything about my hair," I say. "We've been here for a year and the shower facilities are decidedly lacking."

"Wouldn't dream of it," he says, his face softening into earnest-

Seventy-two

In a Hollywood ending, this would be the part where a lilting voiceover reveals my newfound appreciation for the precious gift of life, enumerating the lessons I learned by making peace with Donna for the traumas and transgressions that pocked our lives like so many shotgun blasts.

Yeah, that's not how it went. That was the last thing she said to me before she died.

Megan and I are in the cafeteria getting coffee when it happens. I'm standing in the checkout line holding a giant cup of coffee so weak I can see through to the bottom. Megan is behind me, slumping her entire upper body against my back. We are seriously sleep deprived at this point.

I hallucinate that Kirk is walking toward us from across the room, wearing his white Fleur et Diables T-shirt and holding a tray of Peet's coffee and a white paper sack that is transparent at the edge from a slick of butter.

I jostle Megan. "Holy fuck, Boof. Kirk is here."

She gives me a sleepy, self-satisfied smile. "I texted him from your phone."

"You can tell me," I say.

"I need a better room," she says. "They've got me in fucking steerage."

I squeeze her hand. "I'll see what I can do."

I mean, really, what else is there to say?

Megan doesn't ask if I'm okay or if I need anything. She just handles it. Water, cigarettes, a phone charger, her proximity. It's all just there.

Despite what everyone expects, Donna doesn't die right away, and sometime in the still-dark hours of the morning, they move her into a private room. Megan and I smell like old French fries and burnt coffee from sitting in the fluorescent cafeteria waiting for visiting hours. When they finally let us in, we drag the fold-out futon chair to her bedside and curl together on it like puppies. We take turns reading Donna page after page of unsubstantiated gossip from crazydaysandnights.com, which is her absolute favorite. She just lies there doing her Madame Tussauds impression.

"It doesn't matter," Megan says, after a while. "The point is, you showed up."

"Yeah," I say. "I guess I did."

The day after that, we don't read so much. Eva sends an arrangement of calla lilies that look like a funeral and probably cost five hundred bucks. I give them to the nurse to take to the children's floor.

We mostly sit and wait, shuffling between the parking lot, the cafeteria, and the tiny, sterile bathroom, where we wipe our armpits with paper towels and antibacterial soap.

In the afternoon, Donna suddenly snaps into lucidity.

"Jess?" she says, eyes still closed, her voice a raspy whisper.

She gropes blindly for my hand, and I touch her fingertips with mine. Here it is. Here is our big, emotional come-to-Jesus moment.

"I'm right here," I say.

"I need something." Her voice fades. "I need . . ."

Seventy-one

Donna turns her head toward us when we step into her curtained cubicle. Her eyes blink open for an instant, vague and cloudy, then flutter closed, her thin eyelid skin quivering lilac. I'm expecting blood-spattered gauze and betadine-stained skin, but she looks like she's ready for her deathbed close-up, all pale skin and just a thick swath of flesh-colored compression bandage wrapped around her hair like a turban. She has an IV snaking out of the back of her left hand, and a few white circles with wires sticking out of them glued to her chest, but other than that, she looks like she's taking a nap.

"Hi," I say, stepping to her bedside and putting my hand over hers, which is limp on the coarse, white cotton sheet.

The monitor beeps more rapidly for a second, then steadies out again. Megan is standing so close behind me that I can feel her breath on the back of my neck, warm and smoky.

I wait for Donna to open her eyes, ask for a cigarette, tell me that my shirt makes my boobs look flat, something. But we all stay exactly where we are, motionless except for breath and beeping.

Eventually, a nurse sidles in beside us to check a digital readout, and we go out the side door to Megan's car, where we blast old Nine Inch Nails until a potbellied security guard tells us, not unkindly, that we need to turn it down.

bottle of water, checks in with the nurses, and finally leads Dr. Ruffalo over.

"Miss Dunne?" He focuses only on me, which is either excellent bedside manner or an impressive un-stare. "I think now is a good time to say your good-byes."

When I stand up, I feel ungainly and disjointed. I don't know what to do with the water bottle in my hand.

"Yeah." I look to Megan and Eva and JJ. "Will you come?"

"Of course," Eva says, while Megan and JJ just nod.

"Wait a second." Dr. Ruffalo raises his iPad like a crossing guard stopping traffic. "One person. Not a whole crowd."

"It's not a crowd," I say.

"Hospital regulations," he says. "You and one other person."

I look at Eva. Her beautiful face is an attentive mask, but I know her too well, now, to not see what's beneath it. She's eager to come, and she'll say all the right things. She'll lean in close and squeeze my mother's dying hand. She's so spoiled and selfish and luminescent. And she'll offer exactly what my mother wants: a performance.

I'm so tired of performances.

"Can't you make a tiny exception this once?" Eva asks, looking up at Dr. Ruffalo pleadingly.

He shifts his weight almost imperceptibly toward her. "Well . . ." he says, wavering.

"We're good," I tell him. "Come on, Boof," and Megan takes my hand as we walk down the swimmy blue hallway without looking back.

beautiful, glittery woman who pulls me in close and then pushes me away.

An angry fuse ignites in my chest, but then I hear the sound of an iPhone camera shutter nearby, and it just as quickly sputters out. Because Eva *did* come as soon as she got my call, when there's nothing in this for her except uncomfortable exposure. Because, and it pains me to admit it, she's just as damaged as I am, just as needy and just as brittle.

I look around to get a bead on who might be Instagramming my anguish, but, although there are a dozen people in armchairs, fondling one kind of electronic communication device or another, nobody stands out as a prime suspect.

"Hey, Jess," JJ says. "I'm sorry about your mom." He ducks his head. "Hi, Megan."

Ugh, even his abashed-cheater face is compelling. It should be illegal.

Megan keeps her shit utterly together, like this is all about me, not about her and Eva and JJ. "Hey, guys. Let's go over there, where it's a little more private."

She herds us toward a bench in the corner and tells them what I gleaned from Dr. Ruffalo. Eva seethes at the story of the worn apartment steps, magnanimously threatening to sic her lawyers on the landlords.

"I don't think that's where we want to focus our energy right now," Megan tells her.

"Of course, you're right," Eva says, crossing her legs and resting her hand on JJ's thigh without breaking eye contact.

JJ remains quiet, eyes on his phone, and a surge of protective anger for Megan floods me, but Megan grabs my hand and squeezes it like *You don't need to go there right now.* She buys me a

Seventy

Eva is always particularly well received wherever people work the night shift. Even with the advent of the DVR, that's the soap opera demographic: nurses, flight attendants, strippers, stay-at-home moms. And celebrity isn't additive, it's exponential. Two celebrities are four times as thrilling as one, so Eva and JJ together make the whole room hold its breath.

Eva throws her arms around me. "Ohmygod! I came as soon as I got your call."

She's wearing a little nothing of a James Perse T-shirt dress and a pair of Prada flats, effortless yet chic, like a stylist had a "rush to the hospital" outfit waiting in a garment bag for just this occasion. Her face is a perfect portrait of anguished concern, but she's still playing a role. The selfless star, here to comfort an underling.

Fuck her. Fuck her for her manipulation, fuck her for fucking JJ, and fuck her for blowing me off about Trent in New York. Go ahead, use me all you want. Send me on humiliating errands, treat me like a friend one day and a staff member the next, scapegoat me to your string of boyfriends, whatever. Pretending you forgot a painful secret I told you to manipulate me? Even *betraying* a confidence isn't as bad as blowing one off like that. I want to *matter* to her, that's the problem. It's my fucking Donna legacy to be drawn to every

I look at my cigarette, red ember glowing to a half inch of gray ash, which I flick into my open palm and dump out the window. *"She wants Eva. I want you."*

"She's the one dying."

"One thing about my mother," I say. "She'll do whatever it takes."

"Would Eva even come?"

"I don't know," I say. "Whatever. I'll think about it."

Then, five minutes after we return to the waiting room, Eva and JJ walk in.

"I'm so glad you're here," I say.

"Should we go inside?"

I shake my head. "I've been watching the shopping channel so long, I'm running out of reasons to not order one of those fake ponytails."

"Oh, man, that's dire." She pushes me into the driver's seat of her car, then walks around and slides in beside me. "Roll the windows down and let's smoke about it."

I start to cry. I don't even know what I'm crying about. My mother? Megan? Me? I don't know. But Megan makes comforting noises while I sniffle, until I finally catch my breath.

"I'm going to call Kirk," I tell her, which, frankly, is news to me.

"What? Now? The plant guy?"

"He came to my house and kissed me." I tell her the story. "And when all this is done, fuck it. I'm cooking him a meal he'll never forget."

"Well, good," she says. "That's a good thing for you to do."

"Maybe I'll start a ravioli truck."

Megan nods somberly. "Sure, that follows."

Her delivery makes me smile. Then she gives me a cigarette and I say, "My mom's in and out of consciousness, but she keeps asking for *her*."

"For you?"

"For *her*," I say.

Her face hardens. "Oh."

"Yeah."

"That bitch," she says.

I hope she means my mother, but I guess it works either way. "Yeah," I say again.

"Are you going to call her?"

ment she ever made will finally pay off if she dies with a celebrity by her bedside.

"I'm afraid her periods of lucidity will not continue," Dr. Ruffalo continues. "We're going to get another picture of what's going on in her brain, then someone will bring you to see her."

"Why do doctors always call everything *pictures*? X-rays, CAT scans, MRIs. Pictures are what you take of your friends doing tequila shots in fucking Ensenada. They're mug shots of the guy who stole your bike."

He looks at me like I'm the one who needs a radiologic exam.

I take a shaky breath. "Sorry."

"Are you okay?"

"I don't know," I say.

"There's no wrong way to feel," he says.

"You might be surprised," I tell him.

Dr. Ruffalo makes a sympathetic face, and clicks the button on his iPad so the screen goes black. "I'll have someone come out to update you shortly."

"Okay," I say, and he walks away.

Time passes, I don't even know how much, but I'm sitting with an unopened copy of *Martha Stewart Living* in my lap, staring at QVC, when Megan texts.

Boof, I'm parking.

I'm through the automatic doors and halfway to her car before she's even turned off the engine.

"Oh, honey," she says, folding me into her arms.

"I haven't— I haven't even seen her yet."

Megan squeezes me tighter.

blindly leaf through old copies of *People* and *AARP* and stare at QVC on mute.

I mark time by going to the Nancy Reagan Garden Pavilion to sneak cigarettes. Despite the No Smoking signs, a handful of ICU relatives lurk among the manicured hedges, avoiding eye contact as we surreptitiously puff away.

After my third or fourth trip, Dr. Mark Ruffalo reemerges. His mouth and his words are still out of sync, like a bad print of an old movie. His fingers swipe his iPad and he tells me that the already compromised glial cells are being suffocated by her internal bleeding.

"Can't you—I don't know—drain it or something?" I say.

"We're going to honor her DNR."

There's a stiff little pause. "So she's dying?"

"Yes," he says, somberly, "but we're not exactly sure of the time-line."

"What does that mean?" I don't know what to say. What do people say? "You mean you can't tell me how long? Five minutes? Five days? Five fucking months?"

"There's no way to tell. I expect she'll drift in and out of consciousness for some time, until . . ." His expression lightens in the glow of his touchscreen. "She did ask for you, though. She was quite insistent."

Gut punch. "What did she say?"

He furrows his brow. "She was a little confused, but she said 'please bring her' several times."

Oh. That makes much more sense. She's not asking for me, she's asking for Eva. I am so not my mother's *her.* This is her dying wish, this is the trump card she wants to play: having Eva Carlton at her deathbed will give my mother a winning hand. Late in the game, but what does that matter? Everything she's done, every twitchy invest-

"Emily" moans about not speaking to her "son" . . . wow. If Donna managed to convince herself that she wanted to connect with me, after she'd spent my entire life disconnecting, this is the triumph of her acting career. She's utterly inhabiting her character.

"Can you tell me what that means?" I say, and I'm not at all sure which thing I'm talking about.

His matter-of-fact expression doesn't waver. "In layman's terms, a brain tumor. The medical term is a high-grade glioma, which refers to the star-shaped glial cells surrounding the brain's neurons."

My mother's *star-shaped* brain cells are killing her? No words.

"She sustained a blow to her head," he continues. "She fell down a flight of stairs. Maybe the glioma caused a dizzy spell or . . . In any case, we're seeing a lot of intracranial hemorrhage."

"Can I see her?" I ask.

"As soon as we get her stabilized."

"That's a tall order," I mutter, but he's already shuffling away, and I'm grateful he didn't hear me.

I return to the parking lot and curl my back against the warm Santa Anas blowing in from the ocean. I leave messages as the hot air rushes over me like a blanket.

"Boof," I tell Megan's voice mail, "the doctor looks like Mark Ruffalo and they won't let me see her yet. The whole 'imaginary Emily' thing was really her. Jesus, she's been dropping hints like a motherfucker and I missed them all. I'm losing it. Where are you?"

Then I call Eva: "I can't deal with the car. I'm at St. John's with my mom. She had an accident and I honestly don't even know what else."

After my second cigarette, I find my way to the ICU waiting room. I Google "anaplastic astrocytoma," but it's like looking at hieroglyphics in a Wikipedia format so I set it aside, opting instead to

the acronym with my mother, who is more of a KUWS type person: kill using wooden stake.

"Are you sure?" I ask.

"The EMTs found her MedicAlert necklace. It says, and I quote, 'DNR in my wallet. Yes, you, motherfucker.'"

He clearly finds this amusing. Who wouldn't? My mother can steal the scene even from a hospital bed.

"Why does she have a . . ." I trail off. "She never even gets a runny nose."

He flips through a couple screens on his tablet. "She gave the DNR order in, uh, Reno. After her diagnosis."

I have an out-of-body moment where I'm watching myself have this conversation. I see my lips move, but the sound that comes out is vague and distorted. "Her what?"

"It looks like she checked herself out against medical advice from St. Mary's in Reno . . ." He flips through another screen or two. "Five months ago."

"That doesn't make sense," I say. "She never told me anything."

"You'd be surprised at the secrets people keep, even in close-knit families."

"Yeah," I say. "I probably would."

He waits there, watching me like I missed a cue.

"So what's wrong with her?" I finally croak out.

"She has a stage IV anaplastic astrocytoma," he says.

A row of dormant synapses fire across my brain. Holy shit. She *was* Emily, or, rather, the imaginary Emily was literally her. I'd pegged Emily as a work of fiction, but I completely missed that she was "based on a true story." That explains Donna's sudden reappearance, all the needy hints on the telephone. Oh, Jesus, and the Oxy-Contin in the Mickey Fine bag. So the weepy scene in Act II where

Sixty-nine

The hospital is such a typical hospital it feels like a soap opera set, all swimmy blue linoleum and bustling nurses wearing scrubs covered with brightly colored vegetables and fruits. What happens, exactly, when you become a nurse and suddenly want bell peppers and pears all over your clothing? Of course, I'm wearing men's pajama pants and a Pabst Blue Ribbon T-shirt, so it's not like I have a lot of sartorial leeway.

The doctor looks like Mark Ruffalo, with chest hair curling from the top of his V-necked scrubs, five-o'clock shadow, and a beleaguered expression.

He paws his iPad. "Dunne?"

"I'm Jess Dunne," I say.

"Your relationship to the patient?"

"I'm her daughter."

He gives me a faded smile. "I see the resemblance."

"Estranged," I say.

He looks even more beleaguered. "Then you might not be aware of her DNR."

"Her what?"

"Her do-not-resuscitate order."

I shake my head. I know what a DNR is, I just never associated

"My mother?"

"She's in the hospital. She fell down the stairs."

"Wait, what?"

"It's your mom," she says with a sorrowful patience in her voice that I've never heard before. "She fell down those janky-ass stairs at our old apartment. They got my number from—what the fuck is that guy's name?—Frankenstein hair and sweatpants."

"Her boyfriend," I say. "Rick."

"Yeah, Rick. You need to call the hospital, honey."

For the first time, the seriousness hits me. "Did you just call me *honey*?"

"She's in the ICU; she broke some ribs and she's got a . . ." Paper rustles. "Basal skull fracture?"

"She broke her head?"

"Listen," Megan says. "I'm leaving in fifteen minutes. I'll get to the hospital as fast as I can. I'll hit traffic, but I'll be there, okay?"

"Are you sure it was even a hospital that called you? We're talking about my mother, let's not forget."

"Oh, Boof," Megan says, and there's a catch in her voice that makes me realize this isn't just another of Donna's ploys for attention. "Call the hospital, then call me back. I'm throwing my shit in the car right now."

"Okay, but, Megan?"

"Yeah?"

"I need you to know that I didn't lie about JJ," I say. "I really didn't know."

"It doesn't matter, honey."

"Did you just honey me again?"

"Sorry, Boof," she says, and we laugh for a second and everything seems almost okay.

"Hey," she says. "I was just about to call you."

It's 6:45 A.M. I'm not supposed to be at her house until eleven, because her call time is at two. It's a night shoot at the dilapidated convention center downtown, and shoot days are a pain in the ass. There's always a moment where a cadre of drunk men are catcalling me as I'm lugging food or clothes into the trailer alley that is a mile from where I have to park my car.

"I just got your messages," I say, then lean into the silence. I'm not really interested in making things easy for Eva right now.

But she's never cared about nuance. I hear her tapping on a keyboard, then she says, "Can you also get me a kale salad?"

I take a drag off my cigarette. "I assume we're still talking about Gjelina."

She laughs, a hearty laugh that tells me everything I need to know.

I end the call and try to summon the energy necessary to put myself in motion, but my eyes are still closed when the phone rings.

It's Megan.

"Boof!" I fumble to plug in my headset and knock over a half-empty glass of water. "You called!"

I miss the first thing Megan says; there's just her tinny voice coming through the headset speakers. I jam in an earbud and catch the tail end of what she's saying. ". . . my number from that guy across the hall, so they left me a message yesterday, but I just got it."

"What are you talking about?" I say. "What guy? Where are you?"

"I'm home," she says.

"JJ's?" I say, my stomach coiling.

"My mother's."

"I'm so sorry. I fucked up, bad. I—" After weeks of practicing this apology, I'm at a loss. "You . . . You should have come here."

"Did you hear me? About your mother?"

who fronts a multiplatinum band, which suddenly rendered him interesting to Eva, after years of ennui. Plus, he's known for playing the portly, balding sidekick but he recently spent serious coin on a ground-up renovation: hair plugs, laser hair removal, sculpting his doughy body into a ripped leading-man physique, the works. Goody for him.

I light my cigarette and consider the message about JJ, which is like an SAT logic question. If A and B have dinner at Gjelina and A has too much wine, where do A and B go in A's car? To A's house? To B's house? To the Four Seasons? And how does C get from Gjelina to B's house to A on set without cloning herself?

There are two big problems.

One: if I drive to Gjelina, I'll have to leave my car there when I take JJ's to Malibu, where I guess he's now staying. There is no public transportation in Malibu. There's not even a cab company, except for one old surfer dude who only works when there are no waves. I can get a round-trip cab from Santa Monica, but it will cost two hundred dollars. Which isn't a big deal, but Eva will forget why I needed a cab by the time I turn in my expense report, which will turn into another lash of humiliation.

Two: how am I still working for Eva? I don't care if someone abuses me, but she fucked with my best friend. That matters. I've rehearsed my "I quit" speech a dozen times, yet here I am, cleaning up her messes. I can't walk away from her. I can't close the door on Eva Carlton. They're called "stars" for a reason. Once your eyes adjust to the light, how do you go back to the gloom?

I waste a few minutes on a *Parent Trap* daydream, where I get Pax and Eva together, so JJ will return to Megan. Then I roll over and park my cigarette in the ashtray. I'm exhausted and haven't even gotten out of bed yet. I hit Send on Eva's number and before I can settle in against my pillow, she answers.

Sixty-eight

First thing in the morning, I listen to a voice mail Eva left at 2:30 A.M. "I need you to go pick up J's car first thing." Her voice is muffled, like she's calling from inside a closet stuffed with fur coats. "We left it at Gjelina because I had too much wine. The manager knows you're coming."

She clicks off without saying good-bye and I roll over and reach for a cigarette, wondering if she's still with him. Wondering why I'm still with her.

The next message is from her too. "When you get J's car, I need a favor," she says, and now it sounds like she's left the fur closet and is eating an everlasting gobstopper.

I hate that she calls him J. I hate that she stole him from my best friend and it's my fault. I hate that whatever is coming next is *a favor*, whatever the fuck that means. And I hate her habit of leaving me messages while she's eating. Considering she weighs ninety-two pounds, I'm pretty sure she does the bulk of her calorie ingesting while on my personal voice mail.

"Can you grab me an order of the roasted eggplant and olives? I ate it last night and it was legendary. Drop it by set when you're done. In fact, get two. Pax needs to try it."

Pax is Eva's costar. He just got engaged to a one-named pop star

I pause, like I'm expecting her to answer me from the vapor.

"You have to believe that I didn't know. And you should be staying here and not under an on-ramp to the 405. Call me. Please. I love you."

I fall asleep watching a rerun of *The Real Housewives of New Jersey* season recap. Two women in bandage dresses and flat-ironed hair are screaming abuse at each other. Watching this is about the worst thing you can do to your psyche that doesn't involve an illegal act.

Sixty-seven

S cout is staying at Eva's, like they're having an extended slumber party and I'm not invited. Whenever I show up, toting Eva's dry cleaning and giant squishy rectangles of toilet paper and paper towels from Costco, they're holed up in Eva's room with the door deadbolted and the music blasting.

I stand in the hallway and send Eva short, informational texts:

I brought you guys chai blendeds. Leaving in fridge.

CAA messenger brought your script. Leaving by bed door.

It's both a relief and a disappointment when they go unanswered. I drift through the house like a poltergeist, but instead of upending plants and making the TV go staticky, I clean up dog shit and unpack groceries and salads from Mozza and clear the stacks of plates that Eva and Scout shove into the hallway outside the door.

At night, I sit in my airless apartment and wait for things to change. I call Megan yet again, and after one ring it clicks to a new outgoing message: a long whoosh of traffic noise, then the beep.

"It's Jess," I say. "I hope your new message doesn't mean you're living in your car."

smog-colored Jell-O. In my gray desperation, I even call my mother, but her phone just rings and goes to voice mail.

You there? I text.

Nothing.

Sixty-six

When Eva gets back from New York, she leaves a chirpy message on my voice mail. "Are you ready to work tomorrow? I'm not in this week's episode, but I have a lot of bullshit I need done. We missed you. Well, Scout didn't, but I did."

I hear Scout in the background, laughing and calling Eva a bitch.

Now we're all acting like she was just fucking with me when she sent me home early? We're glossing over the fact that she pretended she'd forgotten about Trent—or, worse, that she actually *did*? This is the worst thing you can do to a neurotic-brained girl like me, pretending that everything's fine. I'd rather have a fistfight in the street than Megan's freeze-out or Eva and Scout's fakey *Pleasantville* situation. Also, when there's no one for me to brawl with, I beat myself up worse than anyone else could. I'm such a dirty fighter when my only opponent is me.

Since I've been back I've been holed up in my apartment, eating potato chips and watching *The Real Housewives of Everywhere* until I feel greasy and nauseated. I call Megan twice a day. She never answers. If I were a cutter, I'd have crop circles on my thighs, but instead I'm just bloated and fuzzy.

I wake up every morning feeling like I'm swimming through

Sixty-five

S ince I moved to Hollywood, I've gotten in the habit of hiking
Runyon Canyon first thing in the morning. At first I did it be-
cause it was the only time of day I could turn my cell phone off
without worrying about Eva's imminent need for wheatgrass or an-
other copy of Eckhart Tolle's *The Power of Now*.

But today I can't sleep. Everything's gone so completely off the
rails. So I trudge up the hill and sit on the first bench and watch the
early sun brush the buildings downtown, so far away. I feel like I'm
trapped in someone else's life, yet I know this is all mine.

My myopic self-centeredness hurt my best friend, and a coil of
red shame writhes in my torso. And the only way out of it is through
the middle.

I call Megan again when I get back in the car, but it goes straight
to voice mail after one ring, like she sees it's me calling and hits
Ignore.

"I know that! I know—it didn't click until I was on the plane today."

She narrows her eyes at me, a suspicious look she's never leveled in my direction until this moment.

"I didn't know when it was happening, I swear."

"How do you not know?" She wipes her eyes on the back of her sleeve. "How do *you* not know?"

I don't have a good answer. Because I didn't want to know? Because they're Eva Carlton and JJ Kelly, and I didn't want to know?

"I just—" My voice gets even smaller than hers. "I didn't."

"When you've got to make a call between what you know and what you suspect, you cover the home team, Jess. You cover the fucking home team."

"I'm sorry," I say. "I'm so sorry."

She runs upstairs and shuts the door to the master bedroom with a sharp snick. I wait and wait for her to come back down, but she doesn't. I text her: I'm sorry. I'm so fucking sorry. Please come out. But my phone is mockingly silent no matter how many times I repeat it, so finally I call a cab and go home.

"This is better," I say, sinking into a teak chair with a burgundy-and-cream-striped cushion.

"His sister did this part," Megan says. "She brings people through on a tour at noon on Mondays and Thursdays."

"Sounds like fun for you."

"Doesn't make a difference at this point."

"Oh, Boof."

"He asked me to marry him." She extends her left hand into the circle of light from the rustic chandelier above us. A yellow diamond the size of a Lemonhead glitters in a wide platinum band. "Last week, at the Griffith Observatory."

I don't say anything; I just watch her and listen to the blood rushing in my ears.

"I wanted to tell you in person," she says.

"What happened?"

She tells me she hacked his voice mail, and realized he was sneaking around. She said she knew before the PA left that message. She just knew. "But maybe I'm wrong," she says tentatively. "Maybe . . . I don't know. Maybe it's something else."

"It's not," I say.

"It could be," she says, and the hope in her voice breaks my heart.

I don't know how to tell her, so I just tell her. "It's Eva."

"What is?"

"The girl. It's Eva. I walked in on them last month."

"You *what*?" she says, in that small, controlled voice that brought me here in the first place. "You knew about this and you didn't tell me?"

"No! No, no— I didn't even know what I was seeing, I didn't know it was him until—"

"Until *what*?" Megan stands. "Boof, how could you not tell me this? You're my best fucking friend."

325

Sixty-four

JJ's house is a sprawling two-story faux-adobe structure with a terra-cotta-tiled roof, perched at the top of a steep hillside driveway lined by a row of backlit hedges.

Megan buzzes me into the compound and is waiting in the open doorway as I trudge up the stairs leading to the wide, rough-beamed porch. Her eyes are swollen and she looks like she hasn't slept for a week, which, for the record, still leaves her 82 percent hotter than anyone you'd run into on a regular day in any other town.

"Oh, Boof," I say, wrapping my arms around her.

"You have no idea," she says. "I'm just— I'm gutted."

JJ's been working as an actor and supporting his family since he was nine, and his entryway confirms that he hasn't made a lot of strides in the grown-up decorating department. The two-story wall flanking the staircase looks like a prop castle from a *Game of Thrones* set. There's an old-timey soda fountain in what should be the living room, complete with red leather barstools. Instead of a normal seating arrangement, a row of high-end Barcaloungers faces a wall-size HDTV screen.

"Let's smoke," Megan says, leading me through a set of French doors onto a patio where a two-story waterfall splashes into a pond filled with fat koi and lily pads.

I can't believe I've been so stupid about the clues. My stomach is looping in lazy, greasy circles; I'm nauseated to the point that I think I may have to roll down the window and puke. Megan has been my rock since I set foot back in L.A. She's always had my back; never—not once—has she not been there for me when something big went down. And I've done the same. Until now. This.

I'm such an asshole.

"Where were you?" she says, and her voice flattens like a dog's ears sensing an intruder.

"Work. Long story. I'll tell you when I see you."

"Which needs to be immediately."

I hear her pull the cork from a wine bottle and ask, "Are you starting without me?"

"I'm pre-gaming. That's not the Petrus."

A guy in blue Dickies work pants and a reflective vest taps me on the shoulder. "You wanna move up?" he says, gesturing to the hole I've left in the stream of people jostling their bags as they wait for the taxis to swing into place.

"Are you even listening to me?" Megan says.

"Shit, I'm sorry," I say. "I'm getting in a cab. Can I call you back?"

"Seriously? I've been waiting to talk to you for *three days*."

"Boof, it's been *six hours*."

"I need you," she says, her voice small and contained.

"I'll be there in an hour," I tell her, hating the hurt in her voice. "I'm sorry I wasn't here."

"JJ is sleeping with someone else," she blurts.

"I'm on my way, Boof," I say. "Fast as I can."

Ninety minutes later, the meter rounds seventy dollars and we're still inching our way past Third Street and the Beverly Center. The driver finally stopped laying on the horn and yelling unintelligible epithets out the window, and settled into cycling through the radio dial, pausing for a few seconds on each blaring station. That kind of chaotic, cacophonous noise usually makes me crazy, but it's perfectly mirroring what's going on in my own head right now and I'm kind of grateful for it.

Sixty-three

I have four messages from Megan when I get off the plane in L.A.

Boof, call me.

Where are you? I have a bottle of Chateau Petrus. Don't
make me beg.

Where ARE you? I'm having a moment. JJ said he was
going to do press, but I just heard a voice mail—okay, I
hacked his inbox, sue me—and some PA left a message
about his "days off." WTF?

JESS, IT'S MEGAN. NEED YOU.

I call her back while I'm in the taxi line on the arrivals level,
sweating in the humid L.A. evening.

She answers as soon as I hit Send. "I've been calling you all day,"
she says indignantly.

"I'm standing in the cab line at LAX. I just got off a long-ass
flight."

ing in my stomach, the way I've been half-assedly avoiding Megan. My growing resentment of Eva. And it's probably why Eva and Scout were having gigglefests in New York. There's been a constant whisper that I've shoved down into some dark place to fester because I haven't wanted to deal with it. It's official: I'm not just the worst assistant on the planet, I'm also the worst friend.

It's my own fucking fault. If there's a beautiful, neurotic woman within a ten-mile radius, I will be drawn to her like a pile of metal shavings to a magnet.

The seatbelt indicator dings about three seconds before I commit myself to another crying jag. A packed airplane is about the last place I want to unpack my psyche, so I take a breath and flick through the movie choices on the touchscreen in front of me. Tyler Perry. *Nope.* Screwball cop buddy movie. *Pass.* A-list musical period piece. *Seen it.*

I stop at *Viva Lost Vegas!* It's just what I need: something familiar and comforting. Megan and I saw it in the theater before she even met JJ. It's cute and mindless, with JJ in the lead role as a down-on-his-luck James Dean impersonator at a seedy casino. There are worse ways to spend ninety minutes.

I slip in my earbuds and press Play. It's the perfect distraction, watching JJ and a girl blackjack dealer running from some stock Mafioso bad guys through a series of Vegas landmarks. Then they're alone in a motel, neon blinking in through the curtains. She pulls JJ onto the bed, tugging his grimy T-shirt from his back as the music swells, and he spreads himself across her body, his muscles expanding like the hood of a cobra before it strikes.

Wait, a hooded cobra.

My stomach twists, and I suddenly *know.* That morning I walked in on Eva fucking some guy: that was *JJ's* back. At the rooftop party at my house, Eva and JJ hadn't been looking for a lime. They'd been looking for some time alone.

How could I have not known that? Or maybe—and this hits me like a cartoon anvil on the top of my cartoon head—I've known for weeks, without ever admitting it to myself. It explains the sick feel-

and a refrigerated wall with fresh sushi to rival Whole Foods. There's a hot soup bar, for fuck's sake.

Fifty-two dollars later, I'm headed for my dreaded middle seat, toting a bag filled with marcona almonds, Parmesan crisps, a container of mixed olives, and a bar of salted-caramel dark chocolate. I breeze through the newsstand and grab all the tabloids that are too humiliating to read anywhere but in a middle coach seat on an airplane: *OK!, InTouch, Star, Life & Style.* The flight attendants are always happy to have them after I finish; I once even traded my castoffs for free drinks.

On board, my seatmates are a pair of elderly sisters who speak in voices so whispery I have to strain to hear them. One immediately offers me her window seat.

"We were hoping we wouldn't get someone between us," she says. "I don't want to be leaning over you every five minutes."

"Well, if you insist," I say.

I give them my eleven-dollar artisanal Brooklyn chocolate bar, which isn't nearly enough to express my gratitude. I feel like I just got a row of sevens on a Vegas slot machine. *Jackpot.*

Two hours later I've exhausted my supply of trash mags and almonds, and I've had two glasses of mediocre Chardonnay. I want to have a third, but I know it's the last thing I need right now, with the crying and the flying and the what-have-you.

I close my eyes and see Trent Whitford's blank smile. Gross. I wonder if from now on, instead of remembering him in the pool house, in the upstairs bedroom, I'll picture his polite disinterest instead. Ugh, it's like caring enough to hurt me is better than not caring about me at all. Which is maybe why Eva's reaction is an even bigger blow. Did she really not remember?

Sixty-two

There are five nonstop flights to L.A. on Virgin America and every single one is sold out, a possibility I wish I'd thought of before I flung myself into the smelliest taxi in New York. If I had to hazard a guess, I'd say someone stuffed a half-eaten lobster roll under the backseat two days ago and the car has been parked in a sauna ever since. The balmy morning in the park has morphed into a humid eighty-five degrees, and I have both of the windows in the backseat rolled down as far as they will go.

We're in bumper-to-bumper traffic on the Van Wyck heading toward JFK as I frantically try to wring a reasonable ticket out of Expedia.com. My Internet connection is shitty, and my phone goes dark over and over.

I finally find a ticket on a JetBlue flight for eight hundred dollars. The on-time record is a dismal 42 percent, and I wince about the charge to Eva's credit card—I try not to care, but I can't help myself.

By the time I get through security, my phone battery is perilously low. I look around for an available outlet, then I just think, *Fuck it. I'm hungry and miserable and I don't give a shit if anyone needs me right now.* I power my phone off and wander into the fanciest airport snack shop I've ever seen. There's a whole table of fancy chocolates

It's 11:00 A.M. when I get back to the hotel, and I'm feeling almost normal. Fuck Trent Whitford. And fuck Eva and Scout—especially Eva, because I know I told her about him, but I'm not sure I ever told Scout. The room is deserted when I enter, but there's a note on a hotel stationery envelope in Scout's writing.

Hope you're okay. Eva says you can head back to L.A. on an earlier flight if you want. XOXO Scout

"I told you," I say. "I fucking told you. We were sitting in your bedroom and I told you everything."

"Take a breath, Jess," Scout snaps. "Today isn't about you."

She's such a fucking parrot.

"I'm sorry," Eva says, sounding anything but, "if I don't have perfect recall of every little thing you ever told me."

"It's not every little fucking thing. It's . . ." I take a shuddering breath. "You know what? It doesn't matter. It's a million years old."

"And Eva's two minutes from going live," Scout says.

I wipe my face again. "Sure. Of course. Let me get your food."

"Yeah, maybe not," Eva says. "Why don't you go back to the hotel and make sure everything's okay there?"

"Already handled." I toss the damp napkins into the trash. "You're welcome to stay as long as you like, and they'll even put you in a bigger room if you want."

"No need," Eva says, the blankness of her face shading into hardness. "I mean, it's just going to be me and Scout. I mean, unless you want to pony up ten grand for an hour of my time."

From the doorway, the page says, "They're ready for you for a photo op."

"Coming," Eva says brightly, and she and Scout file out without another word.

"Talent is walking," the page says as the door shuts behind them. When I get outside, I head down Fifty-Seventh across Central Park West and into the park. It's one of those beautiful New York days that happen in May and September—seventy degrees, crisp and bright—and I sit down on a bench in the morning sun and sob. Fortunately, this being New York, no one gives me a second glance. When I'm done, I just stay there, watching thin, manicured women walking their purebred dogs while joggers expertly dodge them on the footpath.

He slips back into his room and I stand there for a moment, feeling his fingers on my arm like a bruise.

Once he's out of sight, I stumble back to Eva's beige cubbyhole. Thankfully, a page has collected Minka and Todd for their tour, so it's just Eva and Scout, sitting on the half-size loveseat with their heads together, giggling about something. They fall silent when I enter.

"I brought you some food," I say, then realize I don't have the plate anymore.

"Are you okay?" Scout asks.

I open my mouth to answer and a sob boils up in my throat. I hesitate for a second, then let it rip: the full-on ugly cry. It's easier to give in. Trying to stifle the ugly cry only makes it fester, like slapping a Band-Aid on a third-degree burn.

"What happened?" Eva says, pitching her voice into sudden warmth.

"In th-the hallway—" I'm all stuttery and hiccuppy, like a little kid who got scared at a haunted house. "I ran into Trent Whitford. I fucking physically ran right into him."

Eva cocks her head, the picture of pretty bafflement. "Who? Is that the director who didn't make the call sheet?"

"Trent Whitford," I repeat, because right now I can't think of another way to explain.

"Right," Eva says. "So what's the deal with him?"

I scrub my face with a fistful of napkins. "He's the guy."

Eva frowns. "I'm drawing a blank, Jess."

"The guy I told you about from when I was a kid." I falter at the emptiness in her face. "At the beach house in Malibu?"

She looks honestly confused, and I can't tell if she really doesn't remember or if she's pretending and is punishing me—and I suddenly don't care.

at the end of the hall, a final door swings open and I catch a glimpse of the handwritten name.

I'm in a different hallway, in a different state, three thousand miles and fifteen years away, and then I'm back, my face flushed, my body cold and numb. I look down at the floor as a cluster of stilettos flanking a single pair of scuffed men's wingtips come to a halt in front of me.

"Let's give makeup a pass," the man says, and his voice sparks a chill of recognition up my arms and into my neck.

I raise my gaze and there's Trent Whitford, close enough to touch. He's barely aged at all, and his face is as smooth and shallow as a wading pool. He's puffing on an e-cigarette and smiling at one of the women flanking him, a friendly, avuncular, untroubled smile.

"Whatever you want, Trent," the woman says, her voice a silky purr.

He notices I'm staring. There's no hint of darkness in his eyes as his gaze flicks across my face without a glimmer of recognition.

"Is everything all right?" he asks.

I shake my head and take a step backward.

He steps forward, his eyes creasing in concern. "It's okay," he says, and his voice is gentle and kind.

Everything goes blurry at the perimeter of my vision. I'm not a fainter, but I seriously feel like I might pass out or throw up if I don't lie down.

"You want an autograph?" Trent asks, and his unknowing polite-ness is more unsettling than if he'd leered and lunged.

I nod, almost imperceptibly.

"Wait here," he says, and touches my arm. "I'll be right back."

Eva flops onto the sofa and props her feet up on the table next to the bulging basket from Zabar's. "Jess, it's a little close in here. Can you go see what the green room's all about and get me something for after?"

Most green rooms have a few sofas and chairs, a couple televisions, and a spread of food that's nothing as elaborate as a normal day at craft services, even on a weekly cable sitcom. But this green room is pretty swank. Fresh melon and berries arrayed on thick, white porcelain platters, baskets of bagels and croissants and pastries, crocks of butter and jams. There's a cheese board, a charcuterie plate with glistening rosettes of prosciutto and rows of thinly sliced salami, and a wire basket filled with hard-boiled eggs.

There are clusters of people huddled in two distinct groups in the room, but no one looks up when I enter.

"Will this be okay for you guys?" the blond page asks rhetorically.

"It's perfect," I say. "What do you need from me?"

"Well," she says, holding her hand to her earpiece like she's a Secret Service agent at a presidential press conference. "Kelly is on her way down and I need to get back to Ms. Carlton's room to facilitate that. Is there anything I can get you?"

"Not a thing."

"Great," she chirps, and beelines off down the hall. "On my way back to talent," she says to the vapor.

I peel a plate of boiled eggs and head back to Eva's dressing room. The hallway is momentarily deserted, and I slow my pace and breathe for a moment. There are closed doors at evenly spaced intervals on both sides of the corridor. The guests have whiteboard nameplates in the shape of stars, with their names written in Sharpie, I'm guessing by the intern with the best handwriting.

I pass the doors for the basketball player and pet psychic. Then,

and a director who didn't even get name-checked on the call sheet. It literally just says 'director.'"

Eva rolls her eyes and puts her head into Scout's lap. Scout is wearing a tie-dyed vintage silk nightgown over a pair of black leggings and she crosses her legs and pets Eva's head like she's soothing a crying child.

I'm grateful for the distraction. It's only about a mile from the hotel to ABC Studios, but it's a dog leg past the edge of Central Park and down Broadway, and it's taking forever, especially at the unreasonable hour of 8:00 A.M. Also, Eva has not said one word to me this morning, except a curt request that I stop at the desk on the way out and extend her stay for two days. No details, just "I need to stay a couple of extra days. Can you make sure that's handled on our way out?"

If Minka and Todd hadn't been in the room, I would have asked her what was going on, even though I know better. I mean, I would have just gotten an innocent shrug anyway. Pointless.

When we arrive, a page whisks us into Eva's dressing room, which is half the size of our hotel room and is populated with the requisite loveseat and coffee table adorned with an amenity basket. There's a square vase of white peonies, and everything else is a tasteful, muted beige. The tiny sofa, the coffee table, the walls. It's like standing inside a three-dimensional graham cracker. The page stands awkwardly in the doorway, her hand pressed to her ear as she listens to a producer.

"They're ready for you in makeup," she tells Eva, doing a New York version of the un-stare.

"I'm good," Eva says. "I'll do a touch-up on my way to set."

Normally, this is the part where I intervene so Eva doesn't have to make her needs known directly to a stranger, but everything is off-kilter with so many bodies in the small room.

Sixty-one

The ride to the *Live! with Kelly and Michael* show is mercifully short. Five of us are crammed into a blacked-out Lincoln Navigator, so I'm sitting up front with the driver. We usually don't travel so deep, but Kelly and Eva are friends from their soap opera days and Eva is comfortable enough with her that she's asked Minka and Todd to come along, as a treat for them. Although if you ask me, there's nothing rewarding about spending the morning in a green room watching the show on an oversize HDTV when it's happening live just forty feet away.

It's clearly just me, though, because Minka and Todd are effusive about the potential other guests.

"I hope it's Justin Timberlake," Minka says. "Did you see him on *SNL*? He's dreamy."

"Hopefully it's those girls from Scores," Todd says.

"Right," I say from my banished position up front. "Because strippers are such a mainstay on morning television."

"Why don't you know this, Jess?" Scout says, frowning. "Didn't Janine tell you?"

"She did, as a matter of fact, but I didn't want to ruin anyone's fantasies." I scroll through my phone for the information. "It's a basketball player from the Nets, that pet-psychic lady from Long Island,

Scout rears back, affronted. "You couldn't."

"I know, I get it. You and Eva are inseparable. I'm the chicken in the bacon-and-egg breakfast. You guys are the pig."

"What the fuck are you talking about?"

"The chicken is involved and the pig is committed." I've had five drinks and I'm not in any shape to explain myself. "I just don't want to triangulate."

"You can't," Scout says, and there's a controlled anger in her voice. "I just mean, you don't seem to have her best interests at heart. I thought you would have her back."

"How do I not have her back?"

"Well, you felt compelled to tell me that she's getting paid ten grand for her appearance tomorrow."

"Jesus, I didn't realize I was being deposed." With a little edge, I say, "And after all, you're best friends."

"I'm just saying be extra careful with the information you're slinging around. I mean, if I mentioned that you'd told me she was getting paid for that Levi's thing, she'd freak." She considers. "But I would never. I don't want to create drama."

thought of spending three hours in a midtown coffee shop with Scout hopped up on Red Bull makes me want to put spikes in my ears.

"You can't hang out at the hotel," she says. "What if Eva comes in with that guy?"

"Am I going to turn into a pillar of salt? It's been a long day and my shirt smells."

Scout fires up a clove. "We wouldn't even be here if it wasn't for her. Don't be such an ingrate."

Before I can fling her into the path of an oncoming bus, she twirls around with her arms in the air. "Look at where we are," she says.

A homeless woman squatting in the doorway of the Norma Kamali store raises her head and says, "Best fuckin' city on the planet."

Apparently the movie of my life involves wise homeless ladies whose advice must be heeded, because I let Scout drag me toward Fifth Avenue. "Let's go have an adventure."

Turns out Scout's idea of an adventure is a short ride on the N train and a walk through Times Square to the Paramount Hotel. She and Eva had an epic stay here once, that ended with Scout kissing a Native American bellman named Bodaway in the ice-machine room while Eva was entertaining Johnny Depp or someone in her suite.

Eva finally texts at midnight. I'm so bored. He kept talking about books. What r u guys doing? Come home.

Scout and I link arms and weave through the drunken tourists as we leave Times Square and walk up Seventh Avenue. When we near our street, Scout turns to me, taking both my hands in hers, all caffeinated seriousness. "Eva is my best friend."

"I know that," I say. "And I don't ever want to come between you."

"Let's get Red Bulls at the bodega and find a coffee shop," Scout says.

"You know what?" I say. "I'm really wiped, and I need to go over all the press stuff for tomorrow."

"What press stuff? I thought she just had Kelly Ripa in the morning."

"She has Kelly Ripa, then Jon Stewart, which tapes at six P.M., then there's a red carpet at the Levi's store for some new limited-edition denim jacket or something."

"That's so gay," she says. "I wanted to go to Brooklyn tomorrow. There's a tarot reader in Park Slope who's supposed to be amazing."

There are so many things wrong with that statement, but Scout's use of the word "gay" to mean *boring* or *stupid* is an irritant and she knows it. It's one of those button-pushy things friends do to each other, I guess, but I'm not in the mood.

"Unless you want to pony up ten grand for an hour of Eva's time, then you're going to have to deal with the *gayness* of the schedule," I say. "Here, let me give you the *Reader's Digest* version of your tarot reader: You've been through heartbreak. You feel creatively stifled. A recent disappointment weighs on you heavily."

"Fuck you," Scout says, but she's laughing. "Wait, Eva's getting ten thousand dollars to show up at the Levi's store? That's fucking re-tarded."

Well, first of all, the only thing worse than *gay* as a put-down is *retarded*. And second, I'm immediately twanged with guilt that I just talked about Eva's income.

"Listen," I say. "I don't want to be a buzzkill, but I need to get some work done. I'm going to head back to the hotel and hang in the lobby or whatever."

The thing about needing to work is only marginally true, but the

Sixty

On the walk to Má Pêche, Scout starts lecturing me on how to be Eva's friend. "You have to give her space when she wants it," she says. "You get that she's under a microscope ninety-eight percent of the time, right?"

"And *you* get that I'm not here as a friend, right?"

Scout stops in front of an oddly placed Benihana restaurant. "I honestly don't know what is wrong with you. The universe keeps throwing you a life preserver and you still act like you're drowning."

I don't know what to say to that, and we stand there awkwardly for a minute, then start walking again.

At Má Pêche, Scout orders pineapple upside-down cake as her entrée and the waiter doesn't raise an eyebrow. To his credit, he's equally gracious when I order an El Diablo and tell him to hold the cassis and the ginger.

"So basically you want a glass of tequila," he says.

"You got it," I say.

When we finish dinner, it's not even 9:00 P.M. The bill is almost two hundred dollars and the only thing I ate was a dish of ice cream that is famous only because it tastes like the leftover milk from a bowl of cereal. I pay with Eva's card and we head up the curving staircase and through the lobby to the street.

spa shower and fluffed-up clothes, I suddenly feel like I'm rattling a used Starbucks cup for change over on Sixth Avenue.

"Holy fuck." I give the Prada box to Eva, then start unpacking candles. "You guys look beyond amazing."

"Tony's going to be here any minute," Eva says. "I made you guys reservations at Má Pêche."

"Má Pêche?" I say. "In the Chambers Hotel?"

I've never been to the restaurant, but I stayed at the Chambers once when my ex-husband and I were first dating. Even at my glammed-out best, I felt like an imposter just sitting in the lobby.

"I can't go to Má Pêche looking like this," I say, gesturing to my anemic hair and wilted white T-shirt.

"You're fine," Scout says. "C'mon, let's get out of here. We're so invading Eva's space right now." She grabs her new Rebecca Minkoff studded clutch. "Text us after your dream date. We won't come home until the coast is clear."

going to have him here for dinner. Oh, shit, that reminds me. Can you go to Diptyque or wherever and get me a shitload of candles? The lighting in here is like a morgue."

It isn't, but I'm not going to argue, nor am I going to point out that the only Diptyque stores in New York are nowhere near midtown. The "or wherever" part is what I'm taking to heart. One hour and $575 in tips and merchandise later, I'm back at the door, carrying a large brown-and-white-striped bag stuffed with a variety of candles from Henri Bendel, which I had the concierge coordinate and execute, and the Jeffrey bag with the shoes Eva so desperately needs. I'm feeling pretty perky, because I also snuck in a shower at the hotel spa, and had room service bring me a bourbon on the rocks. They even gave my clothes a tumble with some Febreze or something, so I don't smell like the waitresses' locker room at a Vegas casino.

When I walk in the door, Rihanna's "Umbrella" is blaring from Eva's travel speakers, there's an empty bottle of Cristal on the coffee table, Eva's standing barefoot on the desk chair and shimmying in the Stella McCartney like she's in front of a sold-out crowd at Madison Square Garden while Scout is wearing a Rachel Pally caftan that I've been coveting since I saw it in one of the tabloids on a pregnant Jessica Simpson. It's black-and-gray-patterned, with a floor-sweeping hem and open sleeves that show just enough shoulder to keep it from looking staid. That's a three-thundred-dollar dress. A drop in the bucket, but still: I'm fucking envious.

And holy shit, Scout's face. Minka worked some kind of esthetician voodoo, and Scout looks like a twenty-first-century Greek goddess, her eyes lined in kohl, her hair pinned on her head in a loose pouf and cascading down her back in abundant curls. Despite my

"I'll call right now," I say.

"This is such a bummer," she says, as anguished as if I've just told her one of the Rosebuds died. "How did this even happen?"

"Why don't I jump in a cab and go down there while Jess figures it out?" Scout says, then tells me, "Text me once you've handled it?"

"Scoutillish, you're so awesome," Eva says.

I punch in the phone number for Jeffrey from the receipt I've stacked with the others on the coffee table while Scout stands with her hand on the doorknob, waiting for someone to call her off her fool's errand.

"This is Jess with Eva Carlton," I tell the associate who answers the phone. "I think you left a bag out of a pickup I made earlier."

"Ohmygod," the guy says, his voice escalating from ennui into obsequiousness. "We've been freaking out. We didn't have a number. It's right here. We're so sorry."

I give Eva a dorky thumbs-up. "We'll have someone come down and get it right now."

"Absolutely not," he says. "Tell me where you are and we'll bring it to you right away."

"Parker Meridien on Fifty-Sixth. Take my cell"—I spool out the number—"and call me from the lobby." I turn to Scout with what I hope is a convincing smile. "Stand down, soldier."

Eva's wrapped up in her phone screen, not even paying attention anymore. "Dude. Tony texted me a poem! You want to hear it?"

"I don't really get poetry. That's more Scout's kind of thing."

Eva reads us the poem. He compares her eyes to a jungle cat, a panther, and, just for emphasis, a tiger, too. I can't tell if it's poetic or if he saves the good stuff for the *Mississippi Review*.

"He's been on night shoots for the past three days," she says. "I'm

and giggling and clutching to-go cups of frozen hot chocolate from Serendipity, I've hung all of Eva's purchases on a borrowed rolling rack.

"Hey," Eva says, flipping through the thousands of dollars of fluttering clothing. "Thanks for doing this. I hope it didn't cut into your morning off too much."

This is the part where a good assistant says nothing. Well.

"My morning off?" I say. "I've been running around nonstop since you left for the *Today* show."

"Really?" she says, sounding like this is the first she's heard of it. "I told you to take the morning off."

"Yeah, then you started asking for shit before I even had a cup of coffee."

Eva shoots an exasperated look at Scout and then me. "What are you talking about? We've been waiting for you to show up all day. I thought you were just chilling."

I can't think of a single thing to say. Correction: I can't think of a single appropriate thing to say.

"Oh my God," Scout pipes up. "It's almost five. What time is Tony going to be here?"

"I'm meeting him in the lobby at six thirty," Eva says. She takes a fluttery green washed-silk Stella McCartney tunic from the rack, tags still dangling from the bodice: $1,855.

Why don't I have my own room, again?

"I'm thinking this with those gold Prada flats I got." She scans the room, looking for shoeboxes. "Where are the shoes from Jeffrey?"

"There weren't any shoes." I gesture to the rack and the side table where I've laid out the various accessories. "Everything is right here."

"There were three pairs of shoes. No, two. I didn't get the Demeulemeesters."

Fifty-nine

I'm crossing back through Times Square when Scout finally answers: OMG, we're having the most amazing meal at this place Eva found, Pure Food and Wine. She says get your ass over here now. We got you food.

Pure Food and Wine is a fancy raw vegan restaurant I told Eva about last week. It's owned by the same goddamn woman who owns One Lucky Duck. In fact, there's a One Lucky Duck annex *that's part of the restaurant.*

Maybe if I'd slept more than fifteen minutes in the past thirty-six hours it wouldn't feel like a personal slight, but I haven't, and it does. When we pull up to the hotel, I swipe Eva's credit card in the machine in the back of the taxi and add a 75 percent tip, bringing the total to over two hundred dollars. Fuck her expenses.

The driver's expression is easily the best moment I've had all day.

I wait until I'm in the elevator before I text Scout back.

Just got this. AT&T sucks. I'm already at the hotel.

Then, to Eva: My phone is acting up. Just got back to hotel. Have all your stuff. Will unpack and hang now.

By the time Eva and Scout come in from their excursion, flushed

SCOUT: Dude, where areee you? You're taking foreverrrrr.

EVA: There are bags at McQueen and Scoop, too.

EVA: Also Matthew Williamson.

EVA: Remind me to tell you about the candles.

ME: I'm on my way back. Where should I bring juice?

SCOUT: Eva says get all the stuff first. We're on the move.

I feel like I'm doing one of those connect-the-dots puzzles from a kids' magazine, but instead of ending up with a drawing of a kitten or a teddy bear or a pointy-eared rabbit when I'm done, I just have some rapidly warming juice and the meter on my cab, which has clicked into three digits and is washing me with a fresh wave of anxiety about expenses.

I HAVE EVERYTHING! I'm feeling so triumphant that I use an exclamation point. Where r u?

There's radio silence from both Eva and Scout for twenty minutes while I text and retext each of them, my triumph fading into lower-case letters and lesser punctuation.

Where r u guys?

R u there.

Hello?

Guess I'll head to hotel and drop this stuff off.

We're heading up West Street and the little red dot on my map is finally visible in the top left-hand of my screen when Eva texts.

Can you stop at Liquiteria and get me an All Greens with extra ginger? Get Scout one too.

I groan and the driver shoots me the unibrow from the front seat. "Hold on," I tell him. "One more stop." I do a location search for something juicy and closer. Of course, One Lucky Duck.

ME: I'm almost there. I'll grab you something similar from One Lucky Duck.

EVA: Ew, no. Never heard of it. Oz says Liquiteria is the shit. Anyway, we're done here. Going to Alexander McQueen. Text me on your way back and I'll tell u where we are. Oh, and can u pick up my bags from here? I don't want to carry.

Eva's good at just ignoring things—questions, people, speed limits—that aren't part of her plan. It's infuriating but really kind of aspirational.

"Okay," I tell the driver. "I need to go to Liquiteria in the East Village, then come back here."

The driver gestures to the meter.

"Not a problem," I say.

"For me too, then," he says, with a snaggle-toothed smile.

The scene at Liquiteria is like the first day of a warehouse sale at Barneys. I wait for an eternity to order, while my phone blows up with a volley of texts from both Eva and Scout, and Viggo circles the block a hundred times.

The cabdriver bellows out the window and pounds his open palm on the hollow metal of his door for emphasis. He's covering my range of emotion far better than I ever could, so I stick the phone out the window and point it in his direction, giving my mother the full audio version of his wrath.

Which backfires, because he thinks I'm capturing a video for *Cabbies Gone Wild* or something, and he turns his red-faced ire in my direction.

"You got fucking problem?" he says, sounding like Viggo Mortensen's ruthless Russian mob cleanup man in *Eastern Promises*.

"Gotta go," I tell my mother, then hang up and explain to the driver, "I was just letting you yell at my mom."

He snorts a laugh. "For that, I charge extra."

"Well worth it," I say, then lean back and close my eyes.

The Larry Moss thing makes me feel like I swallowed a lawn mower. My mother is a stalker, and God knows, Eva's already got plenty of those:

"Belinda, girl, why'd you divorce Slater?"

"When are you coming back to Mount Adams?"

"Why don't you come to dinner with your acting coach?"

My phone buzzes just as we're inching past Washington Square Park. It's Scout: Marc Jacobs was a bust. SoHo is so played. On our way to Jeffrey. Divert.

I'm four blocks away and now I have to cut across lower Manhattan to catch up. I pull up the address on my phone, because it's somewhere I've read about a million times but never actually been.

"Change of plans," I tell the driver. "I need to go to Fourteenth and Washington."

He furrows his unibrow. "In the Meatpacking?"

"Yep."

"So you're an intern?"

"I'm an employee. I really think I have something happening here. And the Eva connection sure didn't hurt."

"What Eva connection?" I say as the taxi driver bypasses Times Square and continues on Fifth Avenue in the crazy snarl of midtown traffic.

"We-e-ell," my mother says. "I may have mentioned that you and Eva have a relationship."

"Take Park," I snap at the driver, who shoots me an aggrieved glance in the rearview. "What does that mean, 'a relationship'?"

The driver hooks a left onto Forty-First Street, where we immediately get stuck in a honking swarm of stopped cars. He makes eye contact with me in the rearview mirror and shrugs an *I told you so*.

"It doesn't *mean* anything," my mother says. "I just told him that you're traveling with Eva, handling her press."

"You said what?" I take a breath that doesn't calm me. "Eva's been working with him for years. You think he doesn't know who her players are?"

"Oh, that reminds me, how was the *Today* show? I saw the whole thing. She looked amazing."

"Mom, this is not a great time for me. Can we talk when I get back?"

"Do you need a ride home from the airport?"

"Since when do you have a car?" I say, my agenda antennae quivering at high alert.

"Rick's letting me use his."

"No, I'm fine," I say, then start making hanging-up noises. "Okay, then . . ."

"Well, why don't you come to dinner this weekend? I invited Larry and his lovely codirector, and told them you and Eva would round out the table. I'll make Irish stew."

seat and a low table with a cellophane-swathed basket spilling Cheez-Its and M&M's.

"Do you want me to take you to the staging area?" Blake asks.

"No need," I say. "I'm just dropping this off."

I put the folder on top of Scout's knockoff Gucci bag and grab a sleeve of Oreos from the basket on my way out.

When I get back to the hotel, Scout texts: Where did u go? We missed you! We're going shopping in SoHo. Meet at the Marc Jacobs store at 10. Mwah.

At ten of ten, I've wrangled the room into shape, taken a shower, and made myself relatively presentable in Gap khakis and the Prada work boots Tyler gave me for our two-week anniversary. I'm feeling a little nostalgic for his benign coffee neuroses right now, I'm not going to lie.

I'm outside a few minutes later, and "Love the Way You Lie" sounds on my phone as I'm telling the cabdriver, "Mercer and Houston."

I know it's my mother, but I answer anyway. There's something bothering me about our last conversation, but I can't put my finger on it. Her recent attentiveness makes me wonder how much the inevitable bill is going to set me back.

"I got the job with Larry Moss!" she squeals. "The beginners' workshop, Tuesdays and Thursdays from six to ten."

"That's great. Is that what you wanted to tell me in person?"

"No," she says, uncharacteristically short.

I give it a second. "Okay. So when do you start?"

"Already did," she says. "Last night. I'm going to audit for the next couple of weeks, then I'll start doing some real work."

"When do you start getting paid?"

"Don't be bourgeois," she says. "I'm practicing my craft."

Fifty-eight

I wipe my armpits with one of the damp towels Eva left on the floor. I don't use the clean one, because I have big plans for it after I get back. I grab the Tony dossier, start for the door, then stop short. There are piles of makeup and hair products, Scout's dirty laundry, and Nag Champa incense boxes littering the floor. There's no way I can let a maid clean this room. One iPhone photo and it's a cover story for next week's *National Enquirer.*

EVA CARLTON LIVING LIKE HOMELESS PERSON IN FIVE-STAR HOTEL!

There's not enough time to handle it now, so I hang the Privacy Please sign and take off.

By the time I get through the phalanx of *Today* show pages and security guards and the giant metal detector, Eva is already live and charming the hell out of Kathie Lee and Hoda, which, let's face it, is not the easiest thing to do when you're nine times hotter than either of them were in their prime.

A chipper Blake Lively lookalike escorts me to Eva's temporary dressing room, marked with a chalkboard with her name written on it in pink calligraphy and says, "Don't you love your job? It must be *delirious* to travel around with her."

"It is," I say. "In fact, I'm hallucinating right now."

She opens the door into a closet-size space with a tiny gray love-

Fine with me. Hot coffee, power nap, and a quick makeover to the trashed room and I'll be golden.

Except I'm halfway through my first cup when Scout texts: Eva left that thing you gave her about that guy. Can you run it over?

I hesitate with my hand on the keypad. Wouldn't a normal person pretend they didn't get this text right away? I look longingly at the granite-and-marble bathroom. I could be in the shower, right? Maybe I'm in the shower. What's fifteen minutes in the big scheme of things?

SCOUT: You there?

ME: Got it. OMW.

SCOUT: Great. Also, Eva says please deal with the Town Car situation, whatever that means.

the front again, I slide it across the counter with two twenties and smile beatifically. "Are you positive you don't have turkey bacon?"

He looks me up and down. "Eight minutes," he says with a grunt that sounds kind of approving, if I had to give it a tone rating.

I hear Donna's voice in my head. *"You catch more flies with honey."*

Yeah, honey and forty bucks.

I wonder what she wanted to talk to me about.

When I get to the Town Car idling in front of the hotel, I'm clutching the cooked bacon, a Styrofoam clamshell with four pre-salted and peppered peeled eggs, and a plastic container of hummus that I know Eva won't touch, but I thought it was important to have options. I also have a breakfast sandwich for Scout and another clamshell of fruit salad for me.

Eva's going to be pissed about the Town Car. *I hate that I can hear the driver breathing,* she'll say. *I'd rather just take a cab.*

What she'll mean is that she'd rather take a stretch or a blacked-out Navigator or Escalade, but I'm feeling okay because the transportation wasn't my call. At least I won't be there while Eva spools out a chipper question about the marquee at Radio City Music Hall, visible down Sixth Avenue, or some other touristy question that only I—or in this case, Scout—will be able to parse as annoyance.

Twenty-seven minutes later, I'm standing on the sidewalk as the Town Car pulls into morning traffic with Eva and Scout. Eva has appropriated my fruit salad—*Ooh, that looks amazing,* she said—and I'm holding the container of hummus and the empty, eggy, Styrofoam box, which is dripping salted water onto one of my dirty black ballet flats.

Fifty-seven

Minka, Todd, and I crush into the elevator at the same time and we ride down fifteen floors to their less-upscale floor. I'm not entirely bummed that their accommodations are unspectacular. Yup, I'm just that petty.

"See you this afternoon," I say.

"Later," says Todd in his frat-boy voice, and Minka flips me a little hand wave.

It's rough to come back from the moment where your boss chastises you in front of the other help. If they shine me too hard, it will be awkward once it's blown over, but if they commiserate, it could end up biting them in the ass later.

In the deli across the street, the guy behind the counter laughs when I ask for turkey bacon. "We have bacon bacon," he says. "You want it?"

"Can you make it *look* like turkey bacon?"

He flicks his gaze past me. "Next," he calls. Subtle, dude, but I was raised by a woman who elevated dismissiveness into an art form. You can't shame me over bacon. My first instinct is to turn this into a knock-down, drag-out thing, but instead I veer off toward the grocery section of the store and grab a package of turkey bacon from the meat case. I take my place back in line and when I get to

slathered in deli mustard, with a full sour pickle and a Dr. Brown's cream soda. Which, sadly, is not on the menu for me right now.

"I'll get it sent up." I grab for the phone, stung that I'm left out of their plans but kind of looking forward to a moment alone to grab a shower.

"Go to the deli across the street. It will be faster and, like, a tenth of the price."

"I'm a sweaty mess." I don't point out that she's not paying for her own food. "I just got off the redeye."

"And I'm going on live national television in an hour," Eva says without inflection, like she's just making an observation.

I set the phone down.

"You're awesome," Eva says, slipping into the bathroom without a second glance.

Without so much as a glance between them, Minka and Todd start disassembling their setup.

"You can leave that," Eva tells them. "I'll need touch-ups before I go to Jon Stewart."

"Let's eat," Todd says. Always good to have a lumbering male presence in the room with all this estrogen.

"Yeah, I'm starving," Scout says from the bed, muffled through the king-size pillow she's positioned over her face.

Eva vaults onto the bed in her underwear and her tiny white tank top and curls up next to Scout. "I want you to come with me right now. There'll be a ton of food in my dressing room."

Scout groans and sits up, letting the pillow fall to the floor. "I'm so rank. Do I have time for a shower?"

"No," I say. "I've got to get in there, and we need to be out of here in fifteen minutes."

"Go ahead," Eva says to Scout. "Just hurry up." Then, to me, "Why don't you stay here and unpack me? You can have the morning off."

I should be relieved, but instead I have a burning sense of . . . shame? Maybe self-loathing. Why doesn't she want me to come? I mean, meeting Kathie Lee Gifford isn't on my bucket list, but still. I'm not good enough?

Scout upends one of her giant bags onto the carpet, creating a mountain of debris, and I say, "Why don't I come back and deal with it once you're done with the show?"

"There's no time for you to get yourself together," Eva says. "And I want you to go down and grab me hard-boiled eggs and turkey bacon to take in the car."

Turkey bacon? Yeah, Eva is only a vegan when she's in L.A., but who am I to judge? I'd kill for a hot pastrami sandwich from Katz's,

Fifty-six

I'm not a great traveler. For starters, I sweat in enclosed, forced-air situations like airplanes and high-rise New York hotel rooms. And as an added bonus, I'm also a sweller. My hands and feet plump up like Cajun sausages on a charcoal grill. As a result, I've learned to travel only in breathable fabrics and comfortable shoes (read: at least a half-size too big), which gives me a Bozo-visits-the-big-city kind of vibe.

It doesn't lend itself to feeling put-together, so when Eva glances at me, I'm already a little defensive.

"What?" I say.

"Did you bring me that thing about that guy?"

"Of course," I say, and dig the manila folder from my bag.

Antonio "Tony" Cavalucci. IMDb gave me nothing but the pre-production notice for the movie he's in town to shoot, starring every Method actor you've ever heard of. When I deep-dived into his Internet presence, I discovered that he's a recent grad from Juilliard—drama division, naturally—and an actual poet, with a couple things published in the *Mississippi Review* and *Tin House*.

Eva flips the dossier onto Minka's neat piles of makeup and stands from her director's chair, raising her arms overhead like she's about to do a Sun Salutation. "Can we clear the room? I need to get dressed."

However, the single thing that takes up the most space in the room is Eva's shitty mood. I feel the chill before a word is spoken.

"Rough flight?" she asks me without looking up from her *OK!* magazine.

"It was fine." I dump my bag in the corner. "You okay?"

"I didn't sleep last night. Room service sent up some kind of lemon tea that kept me up all night."

Eva's body is her temple. I mean, she takes prescription pills by the handful and barely eats enough to keep an eight-year-old boy alive, but she'd never defile herself with caffeine. Getting a dose of caffeinated tea at midnight when she's expecting chamomile is like a hot shot.

"Dude, that's brutal," I say.

She shrugs and tosses the tabloid onto the carpet, then the front door slams and Scout lumbers in under the weight of her giant green duffel bags.

"Scoutilla!" Eva cries, leaping from her perch to wrap herself around Scout's girth, as if Scout is a eucalyptus tree and she's a koala bear in pink lace boyshorts. "I thought you'd never get here."

Kind of an inauspicious beginning for the girls' weekend, but maybe I'm just un-slept. That's it. I'm tired. Everything will get better from here.

"Eyes front, Diego," I say. "Let's do this."

Scout heaves herself from the sofa. "You know, you're kind of a bitch when you're working," she says, tugging her bra into place with both hands. It's like a ten-car pileup on the interstate. Diego is transfixed. I can't really blame the guy.

When we get to the twenty-ninth floor, I can hear old-school Eminem blaring as soon as we turn the corner into the hallway. We have to wait for the end of "My Name Is" before there's any chance our pounding will be heard.

Todd opens the door, with a white towel draped over one shoulder and a handful of makeup brushes. The room is maybe five hundred square feet. Huge by New York standards, but not exactly a suite. Eva's Louis Vuitton luggage is strewn throughout the area I'm sure they call the living room, which contains a half-size sofa and a tiny built-in settee under the window, with a spectacular view through a couple gargoyle-bedecked marble buildings and into Central Park.

Minka has set herself up at the work desk adjacent to the settee, draping it in a white linen cloth I'm sure she snagged from room service and spreading her vast array of palettes and pots and jars in neat rows. The coffee table is the staging area for hair, with a couple sets of hot rollers, a few curling irons with various barrel sizes, a straightening iron, and two yellow Solano blow dryers all plugged into the heavy-duty orange extension cords that snake around the back of the sofa.

Sidebar: If I owned a hotel, I would design a few rooms specifically for B-list celebrities doing press. Electrical outlets that aren't hidden behind furniture, extra counter space, a half-bath in the main room so your people have somewhere to pee. You know, the little things.

A manager-type person glides in from a room behind a smooth, burled door. "How can I help?" he says, all unctuous smile and eye contact.

I go with the honey option, although vinegar is boiling in my throat. "Hi, I just got off a red-eye and Eva Carlton is expecting me in her suite, and I'm expecting her hair and makeup people—and the driver who's going to take us to the *Today* show. So my first step is to get to her room."

"I understand," he says. "But the privacy of our guests is of the utmost priority, and I don't have you on my reservation list."

From behind me, Scout says, "No problem, we'll get some breakfast and figure it out."

"Can you please let me handle this?" I hiss over my shoulder.

Scout bristles and takes a step away from me, holding her hands up in a gesture of mock supplication. "Sure, because you're doing such a bang-up job of it."

I turn back to the desk, dredging up a smile from the bottom of my frayed resource bag. "I'm going to be here three more days. I'll need cars, restaurant reservations, and directions to a twenty-four-hour juice bar or something equally improbable. Please, *please*, I am begging you, let's not get off on the wrong foot."

He sighs and his smile grows marginally less fake. "A twenty-four-hour juice bar?" he says, with just a twitch of an amused smirk.

"And a thick vein of bentonite clay."

He scribbles a number on a piece of Parker Meridien notepaper, folds it in half and passes it across the counter like I'm buying a gram of cocaine. "Diego will show you up," he says.

Diego is a skinny kid wearing a name tag that says Alejandro. He just stands there, openly watching Scout's copious tits strain against her flimsy white tank top as she finishes rebraiding a red pigtail.

First of all, shift change at the Parker is clearly imminent, because we're greeted by a lone bedraggled clerk who looks like he hasn't slept for a week.

"Can I help you?" he says, eyeing the mountain of green canvas that suggests Scout's about to deploy to Iraq and not check into a marginally five-star hotel in midtown Manhattan.

"Hi," I say. "I'm checking in with Eva Carlton."

"Photo ID and credit card."

I slide my driver's license and Eva's Amex across the marble counter.

He taps on his computer, then slides my cards back across the counter. "Sorry, you're not on my list. And Ms. Carlton has a do-not-disturb on her phone.

"I'm her assistant," I tell him. "There's a car coming to pick her up for the *Today* show in an hour."

"Unless you're on my guest roster, there's not much I can do for you."

"Manager, please," I say, my tone edging on rude.

"Excuse me?"

"Did I stutter? Get me your manager if you can't solve my problem." Yep, over the falls into pure, entitled rudeness.

He whirls and disappears through a paneled door that I didn't even realize was there.

"What the fuck is wrong with you?" Scout hisses. "He's just doing his job."

"So am I," I say. "Not well, at the moment, because I'm sure that Minka and Todd are already in the building."

Their day rate is $3,500, plus-plus. Travel is double. Come to think of it, why am I worried about their whereabouts? For what they're getting paid, they can wait in the lobby for a while.

I check the time on my phone. Eva has an 8:20 call time for the *Today* show—she's in the netherworld of the fourth hour with Kathie Lee and Hoda—and her hair and makeup people are due in her suite in just over an hour. She is the kind of girl who shows up camera-ready, so there's no leaving her carefully cultivated face to the vagaries of the local talent.

"Okay," I say. "You can stay here and wait for your bag, and I'll see you at the hotel later, or you can come with me and we'll get them to deliver it once they figure it out."

"You'd leave me here?" Scout asks, an undercurrent of abandonment in her voice.

"Eva's going to wake up in an hour. I'm at least that far from the hotel, even if I luck out with a cab. I'm already screwed."

"You suck," she says.

There was a long moment a couple years ago when Scout was Eva's assistant, so I can't fathom what she's not getting about the severity of this situation.

"Go ahead and go," she says grudgingly, and then, like a scene from a movie, the baggage carousel grinds to life and spits out her ridiculously huge bag.

If I'd been smarter, I would have booked a car to take us into the city. But in the last-minute melee of changing my ticket, going back and forth from LAX to make sure that Eva got off without a hitch, and swinging back to pick up Scout and bring her to Eva's, where Janine reluctantly dispatched a second studio car, I just forgot. Fortunately, the taxi line is manageable and we're cruising into midtown Manhattan before I have time to get obsessive about it.

We pull up to Le Parker Meridien at a perfectly serviceable 7:25 A.M., and I breathe a sigh of relief.

And then everything promptly falls apart.

Fifty-five

I don't understand people who can sleep in coach on airplanes. I
mean, the whole thing is like that feeder tube that Temple Gran-
din devised for the slaughterhouse. It's terminal, even on Virgin
America. There's only so much you can accomplish with a white
leather trimmed seat and the ability to order a cocktail from the
touch pad in front of you.

And I'm not the kind of person who can skip a night's sleep and
remain even moderately even-keeled. By the time Scout and I are
waiting at baggage claim in New York, at six in the morning, I'm
ready to lose my shit.

First of all, Scout packed two giant duffel bags, only one of which
has managed to make it across the country, even though there were
no connections. She heaves it off the baggage belt and wrangles it
onto the metal cart she's rented and we watch the empty, twirling
baggage carousel.

"Dude, seriously," I say. "What could you possibly need that isn't
already in here?"

"I dunno," she says, defensively. "My journal. Candles. A yoga
mat."

She's not kidding. She's brought her whole life to Manhattan for
three days.

"Ew, no," Eva says. "There's no way I'm flying in first while my friends are in coach. That's gross."

"Well, we could come tomorrow morning. Although you'd be on your own for the *Today* show."

"Not an option," she says, and I hear the bleeping of her elliptical as she slowly starts moving again.

"That's the best solution. I'll have Janine swap my ticket."

"You'd really do that?" Eva says, and there's such a sincere note of gratitude in her voice that I feel like an asshole for not suggesting it sooner.

"Sure," I say. "It's for the greater good, right?"

"We're going to have a fucking awesome time."

I smile. "Can't wait."

"But, Jess? I really need you there in the morning. Can you just take the red-eye? For me?"

Well, now I've done it. I've put myself on an overnight flight across the country, which, if you ask me, is like volunteering to take tickets for the ferry across the River Styx.

"Sure," I say.

"You're the best. I'm almost done here. I'm going to hop in the shower. Can you bring me my shake and get my stuff ready for the car?"

"On my way," I say, which suddenly strikes me as a good idea for a tattoo.

"On my way" in looping cursive, somewhere between the edge of my collarbone and the swell of my tits. Not ruling it out.

my stomach. I don't want to light the feminist world on fire, but the truth is that girls aren't good at threesomes. Someone always ends up feeling left out, and if there's a left-out position in the room, I will move into it, redecorate, and stay awhile.

"Awesome," I say. "What do I need to do?"

"Here's the thing. She doesn't have any money, so I figure she can stay with us. She'll just sleep with me, or whatever. Hopefully they'll give us a great suite."

"Cool," I say.

"I think it'd be weird to have her fly in coach while we're up front, so why don't you see if you can get her on the next flight out? Just tell her ours is full. That way it won't be awkward."

Frankly, lying about our flight kind of makes it awkward already. But okay. Unfortunately, though, the cheapest flight I can find Scout is almost fifteen hundred bucks, and I'm talking coach, not even premium economy. There's room on our flight, but it's over thirteen hundred dollars for a middle seat in the main cabin. Not that Eva can't afford it, but it seems like a shitty thing to do, especially when I'm flying for free, or, at least, free to Eva.

When I call Eva back, I can hear the sound of her fancy Life Fitness elliptical clunking away in the background.

"What's up?" she asks, panting slightly.

"It's ugly, dude. The cheapest ticket is over thirteen hundred bucks, either on our flight or on the redeye. Coach, I mean."

"Jesus," she says, and I hear her grind to a halt and give me her full attention.

"I know," I say. "It's brutal."

There's a moment of silence, in which I contemplate what I'm about to do. "Here's what I'm thinking. Why don't I let Janine swap my ticket for two coach tickets?"

Fifty-four

Eva calls at nine on the morning we're leaving. I'm throwing a few last-minute things into my one carry-on bag—underpacking feels like the polite thing to do so Eva doesn't have to pay overage charges for her five bags—and getting ready to head to her house. She's not due to wake up until ten, but I'm scheduled early, to make sure she's protein-shaked and cardioed before the studio car picks us up.

Okay, I have another confession to make. I told Eva the flight was at 1:00 instead of 2:15. They'll hold a flight if your airplane has a private tail number, but let's be honest, Richard Branson isn't going to keep a plane to New York waiting for anyone but Angie and Brad, not that they ever fly commercial. It's a survival tactic. We are not missing that plane.

"Hey," I say. "You're up early."

"Oh my God," Eva says, all giddy and awake. "I have the best news ever."

"You won the lottery," I say, which is kind of comical, because let's face it, she already has.

"Better. Are you ready? Scout's coming with us to New York! Could you die? It's gonna be epic."

I'm happy. I really am. But I also get an oogy feeling in the pit of

luggage—the checkerboard kind, not the logo kind. I mean, what are we, Russians?

I'd love to complain about all the work, but the truth is that I'm jittery with excitement.

I'm taking a mini vacation to New York.

Fifty-three

I'm a detail person, and there are a million to arrange for New York: flights and shops and restaurants and hotel rooms for Eva's makeup team, which is really just a chubby girl named Minka and her husband, Todd, who does nothing but hold her brushes and make off-color jokes.

Eva never does her own makeup when she's going out in public, despite always having me buy the stuff that makeup artists use on her in photo shoots. Thousands of dollars' worth of products from lines they only carry at Barneys or Fred Segal or once in a while Bergdorf Goodman, which is a pain in the ass because you need an unintelligible and vaguely European accent to work at a Bergdorf's makeup counter, and their website only has half their shit, so I always have to call.

If my life were a movie, I'd need a montage sequence here: eleventy billion trips to Opening Ceremony and American Rag and Maxfield's and Decades; garment bags piled in the back of my car; me struggling under their weight as I climb the two flights of stairs from the driveway to her bedroom; sitting on the hardwood floor in Eva's bedroom surrounded by a pile of discarded clothes and empty shopping bags; the slow layering of the Louis Vuitton

"I'm really crazed right now," I say. "But soon."
Soon as in never.

When I hang up, my phone beeps to tell me I've missed a call. Fucking T-Mobile. Get your shit together, will you? I'm in Beverly Hills, not Botswana. It's Megan.

"Boof," her recorded voice says. "I'm thinking Koreatown. El Cholo, Margaritas. Five P.M. tomorrow. Just be there."

I get her voice mail when I call back, and I say, "Nothing makes me happier than tequila, chips, and you—not necessarily in that order—but I can't. I'm bailing tomorrow for a *very important business trip*. Details to follow. Tequila mandatory."

Her text comes in while I'm fast asleep. When you get back then. I can't wait to see you.

She seems happy, which makes me happy too. I'm bummed that we can't connect, but I'm also kind of stressed about the trip, so it's easy to let it slide.

was one of the happiest memories of my childhood. There was a girl at school, the shy daughter of an uber-famous acting couple, and she kept her show horse at Winbrook, out at the end of Cross Creek Road in Malibu. It's been gone for years now, but back then Donna would drive me out every Saturday for a private lesson. Sometimes the girl and her parents would be there, which, in hindsight, probably had something to do with Donna's willingness, but I just remember week after magical week of cantering around the ring while Donna whooped encouragement from the bleachers.

"You took me every Saturday for a whole summer," I say. Well, she'd forgotten me a week or two, but there's no reason to mention that now. "You threatened to get into the ring and wrestle Daisy to the ground that day I got thrown. Fucking Daisy—that horse hated me."

Donna laughs. "I wanted to kill her when I saw you go flying." Her voice gets soft around the edges. "You gave her a candy apple."

"It wasn't a candy apple, it was a green-apple Jolly Rancher you had at the bottom of your purse. You *told* me it was just like a candy apple." I find myself smiling at the memory. "I have to say, Daisy loved me after that."

"You catch more flies with honey," she says.

"An adage you adhere to about ten percent of the time, but okay."

"Listen, there's something I need to tell you," she says, and the dramatic edge in her voice starts my alarms ringing. She's not talking to me anymore, she's performing. "Something important."

"Now's not a great time."

"I should tell you in person."

Because I haven't put in enough time, sitting in the front rows of her life. "I can't do it before I go."

"Really?" she says. "Can't I just stop by your new place later?"

"Mm-hmm."

"The *Today* show, whatever that Kelly Ripa thing is now, and Jon Stewart."

"You know who I love?" she says. "David Letterman. I mean, so smart."

"Yeah, not this time."

"That's too bad," she says. "So where are you staying?"

"Le Parker Meridien, midtown."

"Lovely," she says. "Does the assistant need an assistant?"

"She does not," I say, and I'm more than slightly skeeved out by her question and my response in the third person, but I continue unburdening myself anyway. "I just got into a whole thing with my boss's PR person about how I didn't need to fly first class, being as I'm the hired help and all."

There's a small whoosh of release in my chest. Sometimes I need to say things out loud, even if it's into a vacuum.

"Darling, that's awful. There's no accounting for some people. What did Eva say?"

"She totally has my back. She told her PR girl that I travel like talent."

There's a beat of silence, beneath which I can hear my mother's gears turning.

"Anyway," I say. "I'm going to be out of town for a few days."

"That's a shame. I was hoping we could go out to Malibu and have lunch, maybe take a drive past Winbrook Stables."

It's so out of left field that I actually look at my phone, like there's going to be a clue to her intentions in the glowing screen. "What?"

"You know, Winbrook," she says. "Riding lessons? What were you, eight?"

Manipulator. I was ten, and of course I remember. That summer

Janine says—in entirely too many words—that if there's anything else we need, she's here to help.

"You're a peach," I say. "I'm sure Eva hasn't even remotely considered what she'd do without you."

Janine laughs, a reedy, high-pitched giggle that probably has all the dogs in a three-block radius howling. "Perish the thought," she says. "I'm here for you guys."

"We love that about you," I say, and end the call.

I crank the stereo and light a cigarette, rolling down all the windows in Eva's Jaguar and opening a half-empty Fiji water bottle and jamming it between my legs to use as an ashtray. I get a thready, jacked-up adrenaline rush when I stand up for myself, even if I don't do it graciously, and now I need someone to talk me down.

I call Megan and get voice mail.

"Boof, hasn't your visa to New Guyland expired yet? You're pathetic. In the best way. Call me."

It's a testament to my adrenaline rush that when my phone rings, I answer before the ringtone registers. I'm that coked-up girl sitting at the end of the bar with bright eyes and a clacking jaw, willing to have a conversation with any warm body in the immediate vicinity.

"Cupcake," my mother says. "There you are! I was starting to get worried."

"Sorry," I say, and immediately regret leading with an apology. "I've been slammed."

"Tell me everything. How's your new arrangement?"

"It's really good, actually."

"Do tell."

"Let's see," I say, like I'm racking my brain to think of what it is I want to tell her. "I'm going to New York to do press for Eva's new show."

Fifty-two

I'm driving down Santa Monica Boulevard toward Pressed Juicery, inordinately pleased about the phone call I'm making.

"Hey, it's Jess for Eva Carlton," I tell Janine's assistant.

"Oh, yes, hi," she says, and I can tell from her tone that Janine has been ranting about me since I hung up on her.

I make the *Lion King* request, then I say, "Also, can you please tell Janine to call Eva immediately about the travel situation? I just got off the phone with her and she's waiting for Janine's call."

There's a millisecond of silence before she tells me she'll relay the request directly.

"Wish I could be a fly on the wall for that conversation," I say, and the assistant whispers, "Me too," before we say our good-byes.

Here's a tip: don't mistreat the fucking assistant. Only owners are allowed to beat their slaves in Hollywood.

I'm not even past Doheny when Janine calls. "I'm so-o-o sorry about our misunderstanding," she says, oozing syrupy contrition. "I just got off the phone with Eva. I'll have the itinerary to you within the hour, and the *Lion King* tickets are no problem, of course. Third row, center. And they'd love to have you backstage after the performance for a meet-and-greet."

"Great," I say. I'm not willing to give her a single extra syllable.

Also—that poet I met at M Cafe a while back? I promised I wouldn't Google him. But you can. ☺ Will u work your Internet voodoo and find out about him? His name is Antonio Cavalucci.

She actually met him at the Newsroom, but I know exactly who she means. And it turns out that he's the reason we're going to New York. Of course, big surprise, he doesn't look like a poet, he looks like an actor playing a poet. Floppy blond hair, three-day stubble, vintage concert T-shirt. He's in Brooklyn for three months, shooting a movie with an A-list cast on par with Al Pacino and Julia Roberts. No big shocker that Eva's suddenly willing to do TV press. She hates doing press. She says she feels like someone's going to push her off a cliff when she's on live TV, which I'm sure is true, but you'd never know it from watching her.

Are you on your way? her next text reads. I'm lonely.

Coming right now, I tap back immediately.

"Oops," I say. "There's my other line."

I click off while she's still yammering about there being no need to involve Eva at this juncture. It's a risk, but I tap out a text to Eva, choosing my words as carefully as the opening sentence of an SAT essay.

> Janine wants to tell the studio I don't need a first class ticket. Also, and I haven't wanted to tell you this, she is really strident for a PR person. I'd hate to think she's as abusive to anyone else while she's representing you. Yikes.

I hit Send, then reread the message a half dozen times, reviewing each of my word choices. Fortunately, I don't have long to wait, as my phone buzzes with a string of texts from Eva almost immediately.

> Ugh, yeah, she's a leftover from my first manager. Sorry she was a bitch. Of COURSE you are flying with me. Please call her assistant and tell her to call me immediately.

> Use the word immediately.

I feel a frisson of vindictive pleasure in my chest.

> Also tell her assistant we want orchestra tickets to Lion King while we're there. It's cheesy, but you will die. It's such a spectacle. You need to see it on Broadway.

I'm basking in the glow when the phone buzzes again.

"Thanks for getting back to me so quickly," she says. "The studio has Eva booked on the Virgin America flight into JFK at one forty on Wednesday, returning Monday at one."

"Sounds great," I say. I used to try to engage Janine in banter, but it always felt like shouting into a pile of wet laundry, so I finally just gave up.

"I'll e-mail her itinerary this afternoon. I'm still waiting for a call time from Jon Stewart."

"Holy shit," I say. "She's doing Jon Stewart?"

"Please tell me you'll be able to contain your enthusiasm when you're on set," she says drily.

"Of course," I say, and I'm grateful she can't see me, because I'm grinning like an idiot, unable to contain my leprotic enthusiasm.

"The only other thing I need is the name of her traveling companion."

"Oh, that's me."

"No," she says, in that mock-patient way people do when they aren't willing to say what they mean. "I mean who is the person who will be flying in first class with her?"

"Still me."

"Really?" she says. "That's . . . unnecessary. If she's not going to use it, I'll have the studio move you to coach."

First of all, it's not the fucking PR hack's business what Eva does with her extra studio ticket, and, second, well, there is no second. She's a bitch. I struggle to not call her out, but there's something about her smarmy pause that pushes me past the bounds of personal-assistant decorum.

"You know what?" I ask. "Why don't I tell Eva what you suggested, and I'll have her let you know how to handle it?"

She launches into an indignant, spluttery rant.

Fifty-one

"I want you to come with me to New York," Eva tells me on the phone a few days later. "I'm doing a bunch of press, but we'll have plenty of time to do fun shit too. It will be a mini vacation."

"That sounds awesome," I say.

"Call Janine and she'll give you the details. Then why don't you run by Pressed Juicery and grab me the usual and come up to the house? We'll figure out what needs to get FedExed, and you can pack me."

"On my way," I say.

It's cute the way Eva phrases her requests like they're up to me. "Do you want to?" she'll say. Or, "You know what would be great?" I'm not being facetious. It's really charming.

Janine, Eva's publicist, is not so charming. I guess she uses up all her charm kissing her clients' asses. She's a major pain, but Eva loves her, so I'm always sweet as pie, even when I have to spend the first five minutes of every phone call listening to staticky hold music and then reexplaining who I am.

Today, Janine picks up the phone as soon as her assistant clicks me onto hold.

"Hey, Julie," she says. Calling me by something other than my name is always her opener. It's such a common diss it hardly even bothers me. Hardly.

That's what happens when you're a personal assistant—your life gets absorbed into the bigger, shinier life of your boss. For me, right now, that's a perfect fit. There's nothing that I'm not willing to drop on a moment's notice in service of Eva's needs. I'm a big, dry sponge absorbing everything she pours onto me.

"We'll figure something out," I tell Kirk, but I'm not sure if either of us believes me.

chaste kiss. I feel his lips move into a smile on mine, and then I'm smiling back.

"There," he says, straightening.

Of course, a chorus of voices in my head threaten to drown out the sweetness of the moment. *Oh, Jesus, my breath. My face is probably as shiny as a headlight. Holy fuck I just kissed Kirk. Uh-oh. Cinnamon and peat moss. Delicious.*

"Well, come in." I open the door wide and lead him into my relatively clean little space. "Let me just . . ." I pull the duvet up over my rumpled sheets and toss a pile of tabloid mags under the nightstand. "Here, sit."

Kirk sits on the edge of the bed and there's something really cute about his obvious discomfort at being in my apartment, which is really just a glorified bedroom, and finding himself perched on my bed with me in my pajamas.

"Your place is cute," he says, taking in the wrought-iron bed and the wall of random, unframed oil paintings of dogs I've been collecting from garage sales for years.

I sit beside him, both of us with our feet on the floor like we're shy teenagers, and we sit in companionable silence for a long moment, slurping our coffees.

Which, of course, is when Eva texts: Where are you? I have an audition in Burbank at 9:30 and I desperately need one of your magical protein elixirs! Want to take you shopping after. Can you come nownownow?

On my way, I text back, and tell Kirk, "She just booked an early audition."

He looks crestfallen. "Well, give me a call when you've got the time."

Fifty

A knock wakes me at seven thirty a few mornings later. I crawl from my bed, looking exactly as bedraggled as you'd imagine, and when I open the door I find Kirk smiling at me, holding two venti Starbucks cups.

"I thought you were an early-morning-hike sort of girl," he says.

"Muh," I croak.

He extends a cup. "Triple-shot, bone dry, nonfat cappuccino?"

Holy shit. He remembers a drink I bought in Starbucks months ago. Tyler's drink, but still. Big points for trying.

"Thanks," I say as I take it from his outstretched hand. It's heavy, way too milk-laden to have ever passed muster with Tyler.

"I, uh, came by to check the hydrangea," he says, smiling.

I take a sip of the tepid drink. "Still alive. That Miracle-Gro is the shit."

"And . . ." He looks at his coffee, then my face, then behind me into my apartment. "Uh."

"What?"

"There's something else I've been meaning to give you."

And very slowly, like he's afraid I'm going to shy away, he touches my chin and tilts my head upward. He gives me a soft, sweet, almost-

the voice mail she uses for people she's never going to interact with, I find Eva and some boy stacked on the bed in a tangle of smooth limbs.

The boy's back is broad and V-shaped, a hooded cobra spread across Eva's slim torso. They're as motionless as Renaissance statues.

Renaissance statues of people fucking.

I freeze. I wait for the sound of breath, a bead of sweat trickling down a muscled arm. Nothing. We are an Annie Leibovitz photograph.

And I'm trapped in a loop: I must deliver the shake to the bedside table, but I must not remain in the room, I must deliver the shake to the bedside table, but I must not remain in the room.

Finally, I whisper, "I brought your shake," and I set it on the table and turn and scamper away.

In the kitchen, it hits me: that back is familiar. Maybe I've seen it on TV, maybe in a music video or a superhero movie, but I *know* that back. For some reason, almost recognizing the back makes everything worse. I lean against the cool silver fridge and take a big, disgusting sip of the dregs of Eva's mud-shake from the VitaMix.

Prison Dude had skulls tattooed across his freckled biceps, and there was a rapey-looking white van parked nearby. My pulse spiked and I intercepted him. Okay, so it turned out he was the CEO of a graphic-design company and he asked, very politely, for Eva's autograph for his mother. But the fear was real, and so are the letters talking about people chopping off her feet, so I can't complain about the personal gate-code thing. I'm still struck, sometimes, that Eva trusts *me*.

Anyway, I'm still tossing supplements into the blender when the executive assistant finally transfers me to speak directly with Eva's manager. And she says that the subcontractors who Eva's jerkoff uncle hired to redo the floors never got paid.

"Really?" I say. "This is why you're calling nine times in a row at seven in the morning?"

As far as I can tell, it would be alarming news if Eva's uncle *hadn't* stiffed them.

"Just relay the message," she tells me.

So, at exactly eight, I creep into Eva's bedroom with her shake and a vitally unimportant message, and, oh, look, she's having sex.

Here's my question: if you *know* your assistant will arrive at 8:00 A.M. and she's never, not once, been even a microsecond late, wouldn't you make it a point to, I don't know, not be having balls-out, naked, full-frontal intercourse?

Yet, on this specific day, when I unlock the door with my Medeco key, balancing the Sonne shake in one hand and the most recent pink-paged sides from the production company in the other, outlining the changes to her manuscript for her shoot tomorrow, and with a stack of the magazines she denies reading—*National Enquirer* and *Star* and *OK!* and *People* and *Us* and *InStyle*—under my arms with the sheaf of messages I transcribed from the extra phone number,

and you're breaking his heart. You need to go stand by your man, you know what I'm saying?"

How do you even respond to that?

Ex-cons are the worst. During my third month with Eva, I spotted a tattooed ex-con beelining toward her as we were waiting in line for a veggie dog from Pink's. She'd been at a charity event where there was a Pink's truck, and everyone freaked out about how good it was. She spent the next three days waffling about whether she wanted me to bring her more.

Finally, she caved and I drove down the hill and got her a couple. But when I brought them back, still warm, they weren't right.

"I wanted that red onion stuff they put on top," she said.

"I asked, but they didn't know what I was talking about."

She heaved a sigh, then brightened. "I'm dying to get out of here. Let's just go down there."

"Really?"

"My treat," she said. "You know you want to. C'mon, I'll drive."

At Pink's, the line was blissfully short. We got to the front without incident, until the high school girls behind us—who didn't have the slightest idea who Eva was—overheard her veggie-dog order and wanted them too. Veggie dogs are an off-menu item, and they won't dig them out unless you're at least a tiny blip on the Hollywood radar screen. Which, of course, makes them that much more desirable.

On the bright side, they don't taste good. Keeping them off the menu is like a public service.

Anyway, that's when I saw the prison dude cutting in Eva's direction. There's a gleam in the eye of a TV fan that is easy to spot once you've seen it a few times, an unlikely mix of apprehension, excitement, and entitlement.

with a crazy stalker who loved her feet so much that he wrote her passionate letters about how he wanted to keep them in a box on his mantel.

There are different types of fans—soap, prime-time, movie—and Eva has them all. Soap opera fans are particularly rabid, even the "normal" ones. I'm putting normal in quotes, because is there anything normal about a grown woman who waits outside the guard gate at a studio waving a sign that reads EVA, I LOVE YOU FOREVER?

She once did a film with a couple A-list actors, on the level of, say, Mark Wahlberg and Robert De Niro. She played the young one's wife, which consisted of her acting charmingly exasperated and writhing around on his lap in her underpants with her hair in Lolita-esque pigtails. Some fans only know her from that film, and we tend to run into them in restaurants and airports. Maybe that's just where they have enough time to ramp up to an approach. They're usually harmless, whispering and snapping furtive photos, chirping like birds, then taking flight at the first sign of her annoyance.

I think it's because movies are an event, in a theater on a giant screen with the action occurring in a single, larger-than-life, two-hour period. There's a distance built into movie star fans' admiration. Movie stars are giant gods.

With television fans, it's different. They *know* their quarry, their prey. They watch a show on a screen that renders the stars smaller than they are—and trapped in their living rooms, to boot. Plus, fans of serial shows tend to get seriously invested. They call the actor by the name of the character and refer to a story line as though it's something the actor actually did. These encounters happen in malls, grocery stores, coffee shops, anywhere there's a crowd. It's one of the many reasons Eva sends me to most of those places alone.

"Hey, Belinda, why'd you do that to Stetson? He loves you, girl,

Forty-nine

The next Thursday morning, my job is to get to Eva's early, deliver her shake to her bedroom, then prepare the gym for her work-out. The gym is a mess. Eva let her creepy uncle renovate it after her mother begged nonstop for a month. I don't think he was even a contractor. He took a fifty-thousand-dollar deposit, tore down one wall, then disappeared. One of the downsides of fame is that every-one crawls out of the woodwork with their hand out.

I'm in the kitchen, dumping protein powder, cold-pressed apple juice from Pressed Juicery, and fifteen supplements into the blender when her manager starts blowing up all the phones in a sudden need to reach Eva now, now, *now*.

First the manager's receptionist calls, then her secretary, then her executive assistant, with me delivering the same message: *Sorry, she's not available.* Eva told me to answer her phone whenever I'm in the house, but also instructed me to never—ever!—divulge any personal information about her to anyone.

I'd arrived twenty minutes earlier, buzzing myself into the iron-gated compound with my personal code. Everyone who works for Eva has their own, like a fingerprint, so she can track our comings and goings. It's one of the things that Daniel LoCicero, arrogant security consultant to the stars, recommended after Eva's encounter

"I assure you, my office protocol about the dissemination of information is completely solid. Now." He flips the first page of my written history. "You've been sexually active since . . ."

"Since I was fourteen," I say.

"STDs?"

"Not that I know of."

"One pregnancy, no children. And that was when?"

"Fifteen."

"Oh." A pause. "I'm sorry."

"It was a million years ago," I say.

Then, out of nowhere, I feel myself tearing up.

"It's okay," he says. "Take your time."

I wipe my eyes. "I'm done. Next question?"

Forty-eight

Even though Dr. Brian Lee—Eva's potential new gynecologist—looks like a reject from an early '90s Benetton ad in his pumpkin chinos and his untucked white oxford button-down, he's all business when he sits across from me in his sprawling office. "So," he says, flipping through my paperwork with a manicured hand. "What brings you to my little slice of heaven today?"

"I'm the stunt vagina," I say, and there's a flash of suppressed laughter in his eyes as he opens the manila folder on his expansive glass desktop.

"Go on," he says.

"I work for Eva Carlton. She sent me in as the advance team."

He laughs, showing a mouthful of perfect veneers.

"Great teeth," I say, violating another major rule in Hollywood: don't acknowledge the beautiful work that's been done. "Dr. Sands? Dorfman?"

"Oh," he says, shrugging. "Just good genes."

"So that's how it's going to be," I say. "I like it. No one wants her vaginal rejuvenation splashed all over Page Six with accompanying photos."

"Is that a big worry for you?"

"If you mean 'you' in a *royal we* kind of way, then yes."

Scout eyes me. "Why are you doing that right now?"

"What?" I ask, but I know what she means.

"Why are you stonewalling me? Dude, she's my best friend."

So awkward. "I know, it's weird. But she asked me to keep all the work stuff separate."

"Jess," Scout says, sounding like someone trying to have a conversation with a toddler. "She doesn't mean me."

"Oh, I know," I say, but of course she does mean Scout. She specifically *said* Scout.

It feels fake and uncomfortable and, if I'm telling the truth, kind of powerful.

The silence returns. Thicker than ever.

"We're going to go upstairs," Eva eventually tells me. "Can you make me a tea?"

I am so bad at the whole "girl talk" thing. Really, I'm like a cartoon. And I don't ever learn.

Example: a few weeks later, Eva meets a new boy at the Newsroom Cafe. She comes home and tells me, "He looks like a poet."

"What does that mean?" I ask. "Narcissistic and poor?"

She doesn't laugh.

Example: Scout and I are standing outside the Friday-night AA meeting on Rodeo Drive, fielding questions that inquiring sober boys always want answered. Eva was sober for a while when she first got to Hollywood. It's not a secret; she talks about it in interviews all the time.

"Hey, where's E?" asks the nightlife impresario she dated for a while.

"Working, I think," Scout says.

One by one, boys float into our orbit, make their inquiries, and are sent away with no pertinent information. It's easy. In the car on the way to get coffee at Swingers, we laugh about it.

"Boys are so transparent," I say.

"I know, right?" Scout checks her reflection in the rearview mirror. "Where is that hooker, anyway? She told me she was meeting us. I've left her, like, three messages today."

"Yeah, I don't know," I say. "I thought she was coming."

I think I sound pretty nonchalant, though I know perfectly well that Eva had no intention of coming to the meeting, that she's getting a massage at the house and then having dinner with her agent.

"You can tell her," Eva says, and I immediately think they're going to say that Nikki's taking my job, because that's exactly how narcissistic I roll.

Nikki nods pinkly, and Eva tells me, "Nikki has a new suitor."

That may sound forced, but Eva loves the word "suitor." It's rubbed off on me, too. She also loves the word "haberdashery," which she uses in place of "clusterfuck." "It's a haberdashery," she'll say, when nothing is going right. So far, I've managed to resist using that one myself.

"Okay," I say. "Um, congratulations?"

They share a smile and Nikki gushes, "I've been seeing one of my clients."

"Who?" I ask, and there's so much buildup that at this point if it's not Bill Clinton or Brad Pitt, I'm going to be severely disappointed.

Eva smiles like she just ate a canary and names a megacelebrity who has fallen into a tangle of drugs and weight fluctuations over the past decade.

"Wow, really?" I say. "That's kind of epic."

They welcome me into their fluffy circle as Nikki continues the story, which involves late-night massage sessions that turn into sex that turn into him on the phone with his assistant at three in the morning ordering hot dogs from Pink's, and Nikki not knowing whether she should bill him for her massages.

"Fuck yes, you should," I say.

"He's so sweet," she says, eyes misted over with glitter and delusion.

"Dude, he kicks you out when he's done. Does the assistant even bring you a chili cheese?"

"Ohh." She shudders. "I don't eat meat."

"Right," I say. "So that's a no."

Forty-seven

Eva and Nikki are curled on the bentwood settee in the kitchen, having an animated conversation that abruptly stops when I walk in, like a needle scratching across the record of their pink angora intimacy.

"Hey, dudes," I say, setting the bags onto the tile counter.

"Hiiiiiii," Nikki baby-whispers.

"Did you get my umeboshi?" Eva asks.

I wave the plastic container of bloated pink fruit in her direction. "Right here."

"You rule," she says, and turns back to Nikki expectantly.

Nikki looks uncomfortable, like I just walked in on her changing her tampon or something. There's a long, hideous silence.

"Am I interrupting something?" I ask, which is the worst possible question to ask when you're actually interrupting something.

"No, no," Nikki baby-whispers.

"Don't mind me," I say. "I'll be out of your way in a sec."

I'm unpacking agave syrup and pomegranates as fast as I can, but I know I've taken an assistant-size shit directly onto the bowl of cornflakes of their pre-massage girlfest.

"Oh, Jesus, *what*?" I finally blurt out.

Eva and Nikki exchange a meaningful look.

Eva is currently in a *filmmaker* stage and it's exhausting. In the short time I've worked for her, she's ricocheted through several pet projects—a memoir; a clothing line; a photography book of her famous friends, naked; and, now, documentary films.

She had me buy her a four-thousand-dollar camera from Samy's on Fairfax and when she got back from South Africa, she had forty-two hours of footage of herself tromping through shantytowns and orphanages in her Rag & Bone cargo pants, looking concerned and beautiful with her hair cascading down her back in shiny waves. There are a thousand pictures of Eva sitting in the dirt and making rope bracelets for wide-eyed African orphans who manage to convey both shyness and a clamorous need. That part of it is heartbreaking, especially when I think about what the money she spent could have done for any of the orphanages she visited.

She had her lashes done before she left and her eyes are dark-fringed and expressive when she raises them to the camera, speaking volumes about her character's—I mean *her*—anguish over the squalid poverty she's ameliorating via documentation. To be fair, there are fifteen minutes of footage of a bedraggled Nikki gamely perched on an upturned trash can in the middle of what appears to be a town dump. Her blond hair hangs in clumps, her white cotton T-shirt is smeared with dirt, and crescent moons of sweat seep from her armpits.

Off-camera, Eva asks questions like "How do you feel seeing all this suffering firsthand?" and Nikki fake-smiles her way through answers that are peppered with trite clichés about the universe never giving us more than we can handle.

it with Eva about 60 percent of the time and the rest I'm as blissfully ignorant as she's pretending to be. Scout's not exactly subtle. It's one of the things I like about her.

Here's the thing: Eva and Nikki went to South Africa together last month, and Scout was pissed that Eva didn't invite her. Frankly, I was pissed she didn't invite *me*, but it doesn't take a rocket scientist to figure out that Eva wanted to take a friend who could also give her daily massages. Being between Scout and Eva is worse than missing the trip, though. Now Scout's either being all weird with me or blurting out confessions about how much she resents Eva, and Eva's either ignoring the friction completely or dropping casual asides about how disappointed she is with Scout, which I have to stuff into some dark place in my gut and forget.

Eva's trip to Africa was a whirlwind decision after her spiritual adviser told her that Clytemnestra—the ancient alien being she channels by the hour—said there was a powerful lesson for her to learn by *taking care of the children.* This reading happened to coincide with a rerun on OWN about the school Oprah built in South Africa, and the next thing I knew I was grinding the American Express Platinum concierge to get a free first-class companion ticket so Nikki could go along "for good energy."

Eva went all "of the people" while she was there. She tossed her cell phone into a nest of cobras at Kruger National Park—at least, that's what she said in the e-mail she dictated to the concierge at the Saxon, where she was staying, at fifteen-hundred-dollars a night for a junior suite villa. I'm guessing she didn't get anywhere near within throwing distance of a cobra. It's more likely that she had the bath butler take the phone away to put in the hotel safe when he came in to draw her nightly milk-and-honey soak.

Okay, yeah, I'm still a little pissed about being excluded, but also

Forty-six

A few weeks later, I step into the kitchen, toting bags of ginger tea and umeboshi plums, and surprise Eva *in flagrante confesso* with her masseuse, Nikki.

Eva doesn't let just anyone massage her since a bad experience in Telluride when the masseuse called her by her character name for ninety minutes, then sold a story to the tabloids about her cover-up tattoo. Now she has Nikki.

Nikki looks like a Barbie doll. Not in an impossible boob-to-waist-ratio way—she's actually a few pounds overweight, by Hollywood standards—but she wears an awful lot of pink, most of it angora, and her eyes are always layered in sparkly pink and pale-blue shadow. And she talks in a baby voice that rivals Marilyn Monroe singing a birthday ballad to John F. Kennedy. She's mesmerizing.

She and Eva have really upped the game on their friendship lately. It's causing major friction with Scout, and I'm getting daily calls where Scout demands to know Eva's whereabouts, then gets passive-aggressive when I tell her I don't know.

"That's weird. I always knew where Eva was when I was her assistant," she says in the same affected voice that Eva uses when she's feigning ignorance about something that she's irked about.

Actually, Eva's much better at it than Scout. I figure I only catch

assistants. One for the house, one on set, and one free floater. It's embarrassing."

"It's a good thing he's cute."

"Yeah, I guess I should be glad he's not stringing along four side dishes." She sets her bread aside. "But I'm starting to worry this isn't going to end well for you."

"I just like complaining. It's still a pretty awesome job."

"Just remember that we teach people how to treat us."

"Thanks, Deepak," I say. "Which reminds me, I read that the Dalai Lama asked a private-jet company to comp him for a trip."

"What's your point?" Megan says, scooping up a last mouthful of cheese before tossing her napkin into the bowl.

"My point is, even the Dalai Lama has a Hollywood sense of entitlement. And he looks like a turtle."

Forty-five

"I blame you for this," I tell Megan.

We're sitting at a rickety table at Doughboys, both slurping French onion soup, which is the only permissible way in L.A. to eat a raft of bread smothered in cheese. It's *soup.*

"How do you figure?" she says, twisting a string of melted Swiss cheese around her finger and pulling it off with her teeth.

"You were anti-Tyler from the beginning, and you know how much stock I put in your opinion. Now I've—as Donna would say—jumped out of the frying pan and into the fire."

"You're so full of shit," she says, laughing as she tears a hunk of crusty baguette. "You couldn't get out of there fast enough when you thought Eva wanted you."

"Hey, now," I say. "I'm the one holding the rain stick. It's my turn to bitch."

"Right, my bad. Carry on."

"She runs out of gas, like, once a week. And what's worse is that a considerable part of my job is running interference between the four boys who think they're *thisclose* to getting her to say 'I do.'"

"That's not good," Megan says.

"I *know,*" I say. "And I'm totally not exaggerating."

"Oh, I believe you about the redundancy," she says. "JJ has three

hall Ranch Road and the 5. Production sent a van for me. Please get it to set by noon. Also Barbara coming to house at 2.

Barbara is her on-call hair-removal expert, for the record.

No problem, I text back.

It is what it is.

I've gotten way off track, here. I do feel bad about this thing with Dave. She's crying more softly now, and I'm saying whatever.

"How did you hear about it?" I say, during one of her snuffling pauses.

"The fucking bitch from *Soap Opera Digest* who pretends to be my friend called me," she says, then pauses. "Oh! Wait. That's Scout, calling me back."

And she's gone, to talk through her trauma with Scout. Which is fine. Honestly, it is. I kind of suck at being the shoulder to cry on.

I quickly learned that I didn't need to deal with the valet and the paparazzi and the snotty hostess if I had a stash of Koi to-go bags (a one-time $50 tip to a busboy) and the black plastic clamshell containers they use for their takeout orders (Smart and Final, $6.99/pack of 50).

Boom, done.

Eva's edamame actually comes from a hole-in-the-wall in a strip mall down at the bottom of the Laurel Canyon hill in the Valley. She would die if she knew, and something about that makes me a little gleeful.

In Eva's bedroom, Amanda, her in-call manicurist, is kneeling at the foot of the bed, massaging extra-virgin coconut oil into Eva's nonexistent calluses, and she politely averts her eyes when Eva whips her head in my direction.

"Jess, I'm not a fucking moron," she says. "When I need you to take care of the car, I'll let you know."

My face flames with humiliation, even though Amanda keeps her gaze focused on an imaginary point on the floor. It's really bad form to gawp when a fellow underling is being taken to task. Best to paste an un-stare onto your face—which, if you've spent any amount of time here, you'll have perfected.

I mumble an apology and Eva dismisses me with a pile of dry cleaning and two new pairs of Louboutins that need to go to Pasquale for red rubber soles.

I drive away seething with resentment, and when I get onto Nichols Canyon, I pull to the side of the road, between an empty lot and a faux-Italianate villa, and grab an empty bottle of Fiji water, which I beat repeatedly on the dashboard as I scream.

It's so much cheaper than therapy.

I wake up the next morning to this text: Car out of gas on New-

Or to refill your tank when you run out of gas, which starts happening with Eva even more frequently. Somehow, she always manages to imply that it's my fault, and at first I hated myself for not driving to her house at two in the morning to make sure she had enough gas for an early call. But somewhere along the line it's just become another irritation. I try to make sure there's gas in all of her cars, I really do, but she'll get in a groove, driving either the Cayenne or the G-class, and won't let me near it.

"I'm good," she says one day, when I know she has an early call time out by Magic Mountain, and she's been driving the same car for a week. "I'll let you know when I want you to take it."

At first I think there's something shady in the car, so I peer in the tinted windows when I'm getting the mail, but there's only a heap of empty water bottles and protein-shake cups, a pair of battered, ancient white mukluks from Kitson, and a pile of call sheets and sides from the episode she's shooting in the hinterlands of Valencia.

Back in the house, I try to push past her resistance, knowing she must be getting close to empty. "Are you sure you don't need gas?" I say, keeping my voice neutral and bright.

She's sitting on her unmade bed in a Calvin Klein bandeau bra and a pair of black Agent Provocateur Luna briefs, leafing through a *W* magazine and eating the edamame I brought her from Koi.

Okay, random confession: the edamame isn't really from Koi.

Koi is a celebrity-laden restaurant on La Cienega with overpriced food and a permanent coterie of paparazzi lingering outside hoping to catch Mel Gibson or Dennis Quaid or some other faded yet permanent A-lister doing something sake-infused and regrettable. There's nothing memorable about it, food-wise, other than the crispy rice batons that taste like delicious forty-dollar tater tots, but someone once told Eva that they have the best edamame in town.

Once the initial bloom of romance withered, Bobby grew increasingly suspicious of Eva. I'd get a dozen phone calls, one after another until I finally answered.

"What do you mean, she had a fitting?" he'd ask. Or a read-through, or an audition, or a looping session, or whatever excuse she'd proffered.

"I don't know," I'd say, muting my phone keyboard and tapping out a hasty message as I talked. Bobby knows you're not at Fox. He's on his way to the house. "She said she'd be home as soon as it was done."

"Stall. I'm on my way." Or "Why are you even talking to him?" Or "Tell him my phone died and I'm out of gas near my therapist's office."

I'd hear her on the phone with him later, saying, "I don't even know what Jess's problem is. I told her three times I was going to the movies with Kelly. It's like she doesn't even listen."

And I understand, I really do. One of the benefits of being a famous actress is that you have a retinue of people to do your dirty work. Housekeepers, gardeners, pool cleaners, sure, but I'm really talking about bodyguards, personal assistants, agents, lawyers, and managers—the people who protect *the talent* from having to soil their psyches with awkward conversations.

Do I sound bitter? Envious is closer to the truth.

Who wouldn't want a hired shark to negotiate a job contract? Or a brawny hulk to keep people away? Or a me, to explain to the woman at the dry cleaners that it's a mixture of period blood, Astroglide, and chocolate soy milk on the two-thousand-dollar Dania-down eiderdown comforter so you don't have to?

"Pulp Fiction."

"Because?"

"Because you said the thing Marcellus Wallace says to Bruce Willis after he gets ass-raped by Zed in the basement—"

"Scout's phone is off," she says, cutting me off. "And I need her. Can you go over to her house and tell her to call me?"

"Dude, are you serious? It's three fifteen and you have to be in Valencia at nine."

There's a crackling, charged silence and I'm about to tell her I'll do it—because that's pretty much the first tenet of being a good personal assistant—when she kind of sniffle-squeaks and says, "Dave cheated on me."

"Oh, shit," I say. "What happened?"

"A Claim Jumper hostess in fucking Tallahassee happened," she says, then bursts into noisy sobs.

I try to say all the right things, but I've been working for Eva long enough to realize that she has a very fluid definition of fidelity. I mean, Eva was dating Rafe when I started working for her, and a quirkily sexy Adrien Brody lookalike named Bobby, who'd directed her in some straight-to-video rom-com a couple summers prior. Oh, wait, I'm forgetting that when she met Bobby, she was with an A-list stylist who everyone thought was gay. Bobby was with his high school sweetheart who, despite a six-figure investment in the best doctors in Beverly Hills and a standing appointment at the tanning salon, still looked like a crème brûlée in an Alaia dress.

Bobby got a thickly outlined tattoo that trumpeted TRULY, MADLY, DEEPLY EVA across his waxed left shoulder, but Eva had forgotten to mention that in addition to the stylist, she had a string of old accounts and eager new suitors, all of whom she kept on the hook in a steady rotation of clandestine meetings and late-night rendezvous.

I'm still wandering in the outer fucking darkness, I don't know. All I know is that it hurts.

Eva calls at three in the morning while I'm dreaming that I'm poised on the edge of a shimmering blue Olympic-size swimming pool, in a long line of swimmers dressed in identical black maillots. It's a race and I'm waiting for the starting bell when the girls around me all suddenly knife into the water and I'm standing there alone.

I wake up, breathless, and answer the ringing phone. "Hello?"

"Oh," Eva says. "I thought I'd get your machine."

It's kind of cute that she speaks in colloquialisms that have fallen out of favor. She calls voice mail "the machine," the DVR remote "the clicker," and her treadmill "the walker." But it's also one of those actressy affectations, like saying you don't exercise, or you're secretly a big dork who plays video games and eats pizza all day. I can't tell you how many random people have told me that Eva is so *normal*. It's adorable. And by adorable, I mean fucking infuriating.

I know she didn't think she'd get my "machine," and I also hear a strained tone in her voice, so I say, "Are you okay?"

"Actually," Eva says, "I'm pretty fucking far from okay."

She's paraphrasing Marcellus Wallace from *Pulp Fiction*, which makes me laugh, but then I trail off and she doesn't say anything and we sit there for a minute.

"Don't you hate that?" I say.

"Hate what?" she says.

"Uncomfortable silences. Shit, I can't remember Uma Thurman's line."

"Jess," she says, aggrieved and patient at the same time. "I have no idea what you're talking about."

bedroom is locked with the deadbolt, so I slide the script under her door in two pieces and drive home, waking up to check my phone every hour to make sure she hasn't called.

In the morning, when I bring her protein shake into her darkened bedroom, the script is still by the door, untouched. That afternoon, she realizes I didn't bring her the original from her trailer, and calls me.

I'm shopping at Walgreens for her bulk bathroom purchases, my cart filled with dozens of tubes of toothpaste, bottles of green Listerine, tampons, squat tubs of Aquaphor.

"Where did you get that script you brought me?" she says, light and innocent, like she's just curious.

I get a prickly chill down my spine, and I pause in the feminine hygiene aisle, pressing the phone to my ear as I fumble in my purse for my headset.

"I called Bombo and he e-mailed it to me," I say.

Bombo is the jocular second second assistant director on the show. I adore him. He was a personal assistant for years, so he understands my job.

"I told you the script in my trailer had my notes," Eva says.

"I . . . didn't hear that."

"I specifically told you."

Except she didn't. I know that. Presumably she knows it too. So what is she lying for? It's just the two of us on the phone. What's her endgame?

"Sorry," I say.

"Never mind," she says, disappointment dripping from every syllable.

Fail.

Maybe this isn't my path. Maybe I haven't found my way. Maybe

the morning because she saw a new mascara or phone accessory that she wants right away.

Plus, she lies to everyone, all the time. And no one ever—I mean *ever*—calls her on it. Not the producers when she shows up two hours late, citing car trouble or an accident on La Cienega. Not her yoga instructor, who waits outside the gate for an hour, buzzing the intercom every five minutes.

"Is the gate still broken?" she asks him. "I am so sorry. Jess told me she got it fixed."

I chafe against her passive-aggressive blame, but it's kind of what I signed up for. And I'm not willing to be the first person to call her out. Seriously, no one is. Certainly not her mother or her sister, who bitch about her with such venom that it hangs in the air like a noxious green cloud, then hurtle through the hallway to greet her with effusive hugs when they hear her at the front door.

Some of Eva's lies are innocuous enough: her alarm didn't go off; she can't attend the party because she has an early call time; she'd *love* to make a donation, just get in touch with her business manager. That kind of thing. But there's another layer, a different kind of lie, which, when pointed in my direction, always ends with me feeling shitty about myself.

Like, after Eva forgets her script in her trailer, she calls at midnight and asks me to bring it to her house so she can work on it before her call time the following morning. I'm twenty-seven miles from the location shoot in Valencia. It's a two-hour round-trip. I call back to ask if I can have someone from production e-mail it to her.

She doesn't answer. I call back three times over the next half hour and it just rings straight through to voice mail. I have production e-mail the script to me; I print it and drive it to the house. Eva's

Forty-four

My mother and Eva actually *do* have something in common: their curious and flexible relationship with the truth. Maybe it's an actor thing. You don't have to be a *successful* actor; just declaring it as your major is enough to lump you in the category of profligate truth-stretcher. I'm not sure how Megan missed the memo.

Part of the problem with Eva is that everyone in her world is at least a little in love with her. For starters, she's gorgeous. I could pour a bunch of energy into a lyrical description of her masses of chestnut-brown hair, her huge, almond-shaped eyes, her petite and curvy body, but just imagine the most beautiful woman you've ever seen and multiply her by the factor of being rich and famous in Los Angeles, with easy access to the best dermatologists, plastic surgeons, personal trainers, estheticians, and yoga instructors, add a sprinkle of fairy dust, and you have Eva. She's genetically gifted and geographically blessed, the kind of beautiful that makes men run into telephone poles like a scene from a Three Stooges movie.

The notion that everyone is in love with Eva goes a long way toward explaining why people put up with her constant lateness, her tendency to forget promises, and her complete disregard for a normal schedule. For example, she thinks nothing of calling at three in

I knock on Christian's door to see if he can provide any insight. He answers wearing a spangled caftan with his limp, newly bleach-blond hair rolled in orange-juice cans.

"Oh, dear," he says, waving his freshly manicured nails. "I met Mommie Dearest today. She asked if she could come in to arrange them, but I told her I didn't have the authority."

"You're sweet," I say. "I'm sure you're minimizing the crazy."

He places a pearl-nailed hand on my forearm. "We all have *mothers*."

"Thank you," I say, plucking a lemon leaf from the bouquet, the only greenery I think he'd allow, and tucking it behind his ear. "You are my savior."

"We look out for our own here, darling."

Which almost makes me cry.

Over the next forty-eight hours, I get about twenty texts from my mother. Her agenda couldn't be clearer if she projected it from a klieg light like Commissioner Gordon summoning Batman.

The highlights:

Really want to bring you your housewarming gift.

Just noticed. Much in common between Eva and me.

Big news. SO EXCITING. I have an interview to teach at the Larry Moss Acting Studio in Santa Monica. Fingers crossed!

She's clearly done her homework. Eva's been studying with Larry Moss for years, ever since Milton Katselas croaked and the Beverly Hills Playhouse lost its top-tier ranking.

Think I met Eva's mother once. Small world. We should all get together, the 4 of us.

Lamb chop, why aren't you answering me?

I left a little something on your doorstep. Your sweet landlord (lady?) offered to bring it in so it wouldn't get sun parched. Please let me know you've received it.

There's a nosegay of yellow dahlias propped up against my front door when I get home after that last text. The frightening thing is that I've never given her my new address. I swear, my mother should get residuals every time *Single White Female* plays on cable.

notice a Mickey Fine bag on the countertop, the stapled, white paper torn open at the top.

Mickey Fine is the twenty-first-century version of Schwab's Drugstore. It's packed with pricey lotions and potions and it has a café in the back with an overly solicitous waitress who is a pro at talking you into side dishes and desserts. It's also one of the only pharmacies in Los Angeles that still delivers. It's totally a rich person's store.

I shoot a glance in Donna's direction—she's wrapped up in some tabloid detail of Eva's life and completely ignoring me—and peer surreptitiously into the bag. There's a Mason Pearson hairbrush, a box of Roger & Gallet Bois D'Orange soaps, and a white bottle of OxyContin with a yellow label.

Jesus Christ, she's so old-school and predictable. When I was a kid, she dabbled with Quaaludes and other prescription drugs. She never tried to hide it from me.

"I'm having a *Valley of the Dolls* day," she'd say.

I haven't thought about it much, at least not recently, but I guess I figured that she was done with that stuff sometime in the '90s, like most people. When am I going to get it through my head that Donna is not most people?

"I have to jet," I say, and I beeline for the door with my package before I do something stupid like try to have a conversation about her recreational drug use. It's so not my business. Or my problem.

I don't even bother with the elevator; I just stumble down the staircase, almost going ass over attitude on a slick spot on the third-floor landing. It doesn't help that I'm carrying a thirty-pound kitchen appliance in a box I can barely wrap my arms around.

Donna pushes her tortoiseshell glasses into her hair and opens her arms to beckon me into a hug. "Not exactly, lamb chop," she says with a weary sigh. "And I'm not the one who got a present."

I raise the package in my arms to show why I can't come in and hug her. "From my old boss."

"Really?" Donna says. "The composer? I was just reading about him the other day. Did you know he went to the Yale School of Music and Juilliard?"

No, because my middle-aged mother Googles better than I do. "Of course," I say.

"Very fancy. Speaking of which, I have a housewarming gift for you too." She taps on her keyboard. "And I'd love to meet Eva. She sounds delightful. Did you know she had a guest appearance on *Roseanne* when she was a kid?"

"Jesus, Mom, are you reading her IMDb page?"

"Maybe," Donna says. "Wow, that tattoo is unfortunate. What does it mean?"

"It's Sanskrit."

Donna rolls her eyes. "Not even close, sugarplum. But okay, let's say it *is* Sanskrit. What does it mean?"

"I've got to run. I'll call you later."

"I'm going to download one of your Eva's films."

I'm not sure what to say to that, so I retreat into the kitchen and open the fridge to see if there's a bottle of water I can snag. There's just a pitcher of murky green tea, a few bottles of Trader Joe's Chardonnay, and a drawer full of wilting produce from the farmers' market.

"Do you need something?" Donna says from the other room.

"I'm good," I say, filling a glass from the faucet. "Thirsty."

"Should I open some wine?" she says.

"I have to run." I set the glass in the sink without taking a sip, and

total crapshoot. Parking in this neighborhood is so bad that she could be parked a mile away and I'd never find it. I don't see anything, though, so I park by the Coffee Bean and slink into the building like a cat burglar. I mean, if cat burglars had keys.

There's no package waiting under the row of metal mailboxes. Shit. Donna must have signed for it. My guess is that she's probably back in bed, though, and the lure of an unexpected gift is a powerful draw, so I pile into the elevator and tiptoe down the wide, creaky planks of what used to be my own hallway.

I slide my key into the lock in perfect silence before realizing that it's unlocked. I creep inside, and the scent of her perfume assails me, but I don't hear anything. I edge into the kitchen and there's the package.

It's big and square, and I immediately forget my stealth mission. I pull a knife from the block and slice the flap open. It's a Sous Vide Supreme and a note from Tyler: *Thanks for all the help, Jessie. You're a lifesaver. Still hoping you'll come back and cook for me someday . . .*

I'm smiling at the note—especially "lifesaver," which is maybe inadvertently sweet—when Donna hears me.

"Jess, is that you?" she says, a note of alarm creeping into her usually modulated voice.

I have a brief flight-or-fight moment, but fuck it. I came all this way.

"It's me," I say, stepping into the living room, which still surprises me with its beautiful rug and its velvet ottoman, to which Donna has now added a chocolate-brown linen-slipcovered sofa. Through what used to be Megan's open bedroom door, I can see her reclining on her perfectly made bed, an open MacBook Air on her lap.

"Jesus, did you win the lottery?" I gesture around at the new purchases.

Forty-three

The next day I wake up feeling like I got hit by one of those open-air tour buses, the kind that ferry tourists around the hills, hoping for a glimpse of Nicolas Cage taking out the trash without his hairpiece on. Whatever. It was totally worth it.

Luckily for me, Eva has a late call time and I don't need to be at her house until noon. I'm lying in bed, idly staring at my new hydrangea and wondering how long it will take me to kill it, when an e-mail dings on my phone. It's a delivery notification from UPS, and my response is Pavlovian. The slightest glimpse of a boxy brown truck makes me fantasize about surprise packages from secret admirers, and this e-mail injects the fantasy straight into my heart. And that's even before I see that the delivery originated at Sur La Table.

There's only one problem. It seems the package was successfully delivered to my *old* apartment.

As I'm showering, I weigh the attraction of Sur La Table against a drive across town and my ongoing need to avoid Donna. If the package had come from Amazon, forget it. Even Pottery Barn would be iffy. But who am I kidding, it's Sur La Table.

When I get to Main Street, I spend a few minutes zigzagging up and down the nearby streets to see if Donna's car is around. It's a

gorgeous actor faces luminescent in the gloom, like some kind of modern day Vermeer.

"Jesus," I say. I mean, how can people *look* like that?

They don't understand, or at least pretend not to. "Do you have a lime?" Eva asks.

"I need a lime," JJ says.

"In the basket on the counter," I tell them.

"Ooh," Eva says, looking at the wine bottle in my hand. "Is it too late to get a glass of that?"

She plants a kiss on my cheek, and I notice she's completely lipstick-less; it's just her bare, reddened lips skimming my foundation-slicked skin. Figures that when I'm finally fully made up, she makes going bare look even better.

"You throw the greatest parties," she says, snagging the bottle and heading for the stairs.

JJ grabs a lime from the kitchen and gives me a thousand-watt actor smile. "You do," he says. "And you look amazing."

"I owe it all to my fairy godqueens."

"They're artists," he says, "but they're working on a damn fine canvas."

The rest of the evening passes in a glittery swirl. Scout even rallies after her energy drink and does a campy rendition of "Amazing Grace" that brings down the house. But there's something scratching at the back of my consciousness. I run my mind over Kirk's gift and Eva's bare mouth, JJ's slightly forced flattery and Christian's amazement that Eva Carlton was at his party.

I don't know.

It was a pretty great night.

texts, deleting her messages unheard. Megan just nods and listens, and when I'm done talking I feel cleansed, like I've been to confession. I've forgotten how that feels, talking to a friend who knows all your shit and doesn't care.

"I missed you, too," Megan says, and I immediately feel my eyes well up.

"You're wearing entirely too much mascara to get weepy," she warns me.

We watch Scout sing "Love Me Tender," to tepid applause— wrong room—then retreat sulkily to the corner, smoking her cloves. I give Megan a look, and she shoos me away, so I cross the rooftop and flop down on a pouf beside Scout.

"Are you okay?" I asked. "You seem kind of over it."

"I'm just wiped," she says. "Those little metal kids wore me out."

"We're so old."

"No shit," she says, and we hand her clove back and forth a few times. "This is beautiful, Jess. You outdid yourself."

"Dude, I didn't lift a finger. This is all my neighbors."

"Don't broadcast that. Just bask in it."

"Thanks. I think I have a Red Bull or a Monster in the fridge. You want?"

"More than anything," she says.

I kick off my shoes and trot barefoot down the stairs to my dark apartment. The bathroom door is shut, with a sliver of light coming out from underneath it. I hear a groan and the rush of water in the sink, and suppress a shiver of disgust. Is a stranger pooping in my tiny bathroom?

In the kitchen, I grab the lone blue Red Bull can for Scout and a bottle of red wine, then rummage in the drawer for a corkscrew. When I head out of the kitchen, I meet Eva and JJ in the hall, their

struckery, everyone settles into burning down the house, drag queen karaoke-style.

About an hour in, we're all so committed to the karaoke process that Megan and JJ have decamped to my apartment downstairs to rehearse the John Travolta/Olivia Newton John duet from *Grease* and Eva has wandered off to someone's apartment to check out a short brown wig she wants to borrow for her Patsy Cline number.

Fortunately, I'm already working my Ann Margret vibe, so all I have to do is let my natural tone-deaf instincts take over on "Bye, Bye Birdie" and I'm a hit.

I'm watching the next singer when a slender arm slips around my waist.

"I've missed you," Megan says, resting her head on my shoulder and plucking my lit cigarette from my fingers.

"It's your fault," I tell her. "What does JJ have that I don't?"

We look across the roof to where JJ is unself-consciously flirting with a pair of drag queens. What does JJ have that I don't? Other than beauty, fame, talent, and Megan?

"A penis," she says.

"Now those," Bruce says, passing, "are a dime a dozen."

Megan shrugs. "He's right."

"Really?" I say. "Because I've got a whole ashtray full of loose change downstairs and not a penis in sight."

"Personal choice, Boof. You've got plenty of dimes, that's for sure."

"I miss you," I say, which is an odd segue, but Megan gets it. One of my favorite things about Megan is that I never have to explain myself.

We scrunch together on a pouf and Megan tells me about her life with JJ, throwing in a little shade because I haven't visited. I tell her about my life with Eva, and how I've been avoiding my mother even more comprehensively than usual. I confess that I'm ignoring her

as they should, considering they just walked into a rooftop fairyland on the unlikely corner of Formosa and Lexington.

I'm torn about who to greet first, so I go with a lamely generic "Hey, you guys," the significance of which is not lost on Megan, who shoots me double finger guns and says, "Hey, guy," in a tone that calls me out on my shit without being too embarrassing.

I teeter across the uneven carpets in my stiletto heels and dispense hugs, starting with Megan, then working my way through Scout, Eva, and finally JJ, who is resplendent in a tight white T-shirt and perfectly faded Levi's.

"An RSVP would have been nice," I say.

"Boof, we suck," Megan says. "I've been meaning to call you for days."

"Dude, you knew I was working," Scout says.

Eva turns her full-wattage smile on Megan. "We met at Scout's birthday," she says, extending her hand. "I'm Eva."

"Huge fan," Megan says, taking Eva's hand and shaking it firmly. "And you remember JJ."

Watching actresses collide in the real world is like an episode of *Wild Kingdom,* all invisible pheromones and subtle posturing. It's interesting that Megan doesn't claim ownership of JJ, like, *my boyfriend, JJ.* It's a smart maneuver, because . . . well, we've already covered the whole desperation thing. So unattractive.

JJ's got one of those smooth actor faces that doesn't betray emotion except when there's a paycheck involved, and he's blandly polite as we chat. It doesn't take two minutes before we're sucked into the party. This is a rooftop full of drag queens and they came to sing some serious karaoke. They are not here to fuck around.

Sure, there's a momentary hush when they realize that my guests are JJ, Eva, and Megan—plus Scout, who—let's be honest—is kind of always working a drag-queen vibe. But once we get past the star-

"Get a cocktail and pick your song list," he says, steering me toward the shirtless champagne-giver. "Are your friends coming?"

"I don't know," I say. "No one told me."

"Darling," he says, tilting my chin upward with the backs of his knuckles and regarding me with his smoky, lash-fringed eyes. "You need an upgrade in the friendship arena."

"Are you and Bruce available? I think you fulfill all my requirements."

"We have a waiting list." He hands me a stem of champagne. "But you're welcome to submit an application."

"Well, at least Kirk sent a note."

"Who's Kirk? A *boy*?"

"Yeah, I guess. I— His sister's in town, he couldn't make it."

"He could've brought her."

"They're from Ohio."

"Honey," he says. "Where do you think *I'm* from?"

I give him a look. "Mostly Chanel."

"Flattery will get you far in the world, my love. Oh!" he says. "Kirk? Kirk with the plant?"

"What plant?"

He leads me to the corner, where a gorgeous hydrangea is blooming out of a terra-cotta planter. A little burlap satchel is propped in the planter, and when I open it, I see crystals of Peruvian blue magic.

"This came for you," he says.

"Um," I say, trying to sound offhanded. "Was there a note? Did he come himse—"

Christian gestures toward the rickety wooden door that leads up from the stairwell. "Looks like your dance card might be full after all."

Megan, JJ, Scout, and Eva are all standing there, looking as dazed

front of his face like he's about to swoon. "Stop calling me dude. Do I look like a *dude*?"

On the day of the karaoke party, I'm not sure if anyone's coming. Scout's in the midst of wrapping up a West Coast tour for another badly behaved metal band and Megan and JJ are MIA again. Kirk can't make it. I considered inviting Pete and Jayne from the Date Palm, but that seemed too desperate.

One of the best things about attending a party thrown by drag queens is that there are plenty of volunteers to help me with hair and makeup. I end up looking like a cross between Ann Margret and Jackie Onassis, in a fitted black shift dress from H&M, a sweep of cat-eyed, black liquid eyeliner, and an amazing cascade of clipped-in hair extensions that Christian's sometime boyfriend, Bruce, happened to have in his makeup bag. The tar-papered and cyclone-fenced roof has been transformed into an intimate supper club, with a profusion of ratty old Oriental rugs on the ground and a cluster of low tables and worn brown leather seating poufs. There are candles everywhere and an abundance of stemless single white orchids and gardenias floating in squat, clear glasses.

"This is insanity," I say to Christian, gesturing to the narrow stage at one end of the rooftop, the stacks of sound equipment alongside, the shirtless waiter sporting a tanned six-pack and a silver tray of champagne glasses.

"Welcome to Hollywood, darling," he says, brushing his rouged lips against my cheek so delicately that I'm certain he hasn't left a mark. He's working a whole Norma Desmond in *Sunset Boulevard* vibe, all arched eyebrows, marcelled hair, and slinky satin gown. "You know Bruce is the events manager for the Hotel Figueroa? He appropriates certain elements when they're not in use."

"No kidding," I say. "Good choice in boyfriends."

Forty-two

My apartment in Hollywood is half the size of Eva's closet. I'm not complaining, I like living in cozy spaces. There's something about lying in my bed at night and being able to see all of my worldly possessions that I find soothing. I have lights wound into the wrought iron of my bedframe, and one of my favorite moments is after I've washed my face and brushed my teeth and I climb into bed, with the glow from the hundreds of tiny white lights illuminating the narrow space that belongs only to me. It's kind of magical.

It's not, however, conducive to having a housewarming party, which is a bummer, because I'm feeling kind of saucy right now, what with Donna safely distanced and my new, glamorous job for Eva.

I'm not a big believer in the notion that *things happen for a reason*, but when Christian, my building manager, tells me he's throwing an impromptu—and very against the rules—karaoke party on the roof on Friday evening, and I'm welcome to bring my friends, it seems like kismet.

"But there's a caveat," he says. "Everyone who attends *must* sing."

"Dude, my friends are all actors and addicts. Do you think that's an issue?"

"Rule number two," he says, fanning his polish-tipped fingers in

ME: I'm on set right now, but I'll be happy to take a look at what's on the market and give you my completely unprofessional opinion, if you want it.

I fill a fresh cup with ice and transfer the contents of Eva's juice into it, adding a squeeze of lemon and a sprig of mint from the drink condiments Gino has arrayed in white bowls on the counter.

TYLER: Unprofessional, my ass. You're a pro, even if you don't know it.

TYLER: Oh, and a candy thermometer? Do I have one of those?

TYLER: Where do I keep the slotted spoons? I know they're here somewhere.

I spend fifteen minutes answering Tyler's frantic questions, then another ten soothing his panic about his party. I have to say, I miss Tyler a little. In retrospect, that job was simpler than this one. Even the craziness was simpler.

On the other hand, I'm still glad I left. I mean, I may be sitting around acting jaded on set, but I'm pretty much fizzing with glee.

before they start rolling again. The craft services trailer is basically deserted, just a couple prop guys scarfing Gino's amazing macaroni-and-cheese bites. Gino, the craft services guy, has mad skills with a mini muffin pan. He turns out baby meatloaves and lasagnas and savory meat pies, all in the perfect bite-size shape of a mini muffin. I pop a macaroni-and-cheese into my mouth before sitting down on the wheel well of the trailer to check my phone.

TYLER: Jessie! I miss you!

TYLER: You there? Need your help. I got talked into hosting a fundraiser. The cook wants a sous vide. What's a sous vide?

Weird. Why is Tyler asking me about a sous vide? Is his Google finger broken?

ME: Hey, you. It's like a water oven. You cook the food inside sealed plastic bags.

TYLER: That's a thing? Do I have one?

ME: Yes it's a thing. They're amazing. They make meltingly tender protein. Paleo people love them. You don't have one.

TYLER: Which one should I get? Will you tell me what I need?

So random. It's flattering that Tyler wants to consult me about a kitchen purchase, even though I know it's just another facet of his agoraphobia: he'd rather ask someone familiar than reach out to a stranger.

ME: Well, if they were all winners, I wouldn't be playing this shithole.

KIRK: That's so bad I'm no longer embarrassed about food fuck.

ME: Truck you.

KIRK: Laughing. You're redeemed. Okay, are you buttered up?

ME: ?

KIRK: Tyler asked me to butter you up.

ME: Uh-oh. Buttered as I'll ever be.

KIRK: Stand by.

I flip my phone facedown as the assistant director yells cut, for at least the fifth time, and Eva beelines over to me.

"I'm never going to get out of here," she says.

I hold out the pomegranate juice, which she contorts her neck to reach, taking a minuscule sip from the straw. If she gets even one drop of condensation on her white satin halter top, it will shut down production for at least twenty minutes.

"Going again, people," the AD says, glaring at me over the back of Eva's head.

I shoot him a saccharine smile. She'll come when she's ready; it's so not my job to wrangle her in that way.

Eva takes another sip and wrinkles her nose. "Will you go put some ice in this?"

"Sure," I say, eager to escape the darkened tension of the set and spend a few minutes at craft services.

I slip my gear into my grungy messenger bag and tiptoe away

KIRK: So, that lot in Pasadena I'm looking at seems like a good place for a food fuck.

ME: Um, what?

KIRK: Shit. Autocorrect. Food FUCK.

KIRK: NO. Food truck. FOOD TRUCK. A ravioli-centric food fuck.

KIRK: I give up.

ME: Ha. The bottom is when u stop digging. But a ravioli truck isn't a half bad idea, IMO.

I realize I'm smiling at my phone like I'm on a date with it.

KIRK: What would we call it?

We? What would *we* call it?

ME: Dirty Pillows.

KIRK: ??

ME: You know, from the movie Carrie?

KIRK: Not a clue.

ME: Classic Stephen King. Prom. Bucket of pig blood. What's wrong with you?

KIRK: I know the movie. I just don't get the reference.

ME: It's a play on breasts, which are kind of ravioli-ish if you think about it.

KIRK: Not your best work.

- MAC oil-blotting papers, because she likes to blot her own face grease even though there are two people on set for that specific purpose.

All the phones are set to silent, of course, but I still notice when a text pops onto mine.

KIRK: Food trucks. Pro or con?

ME: Pro, with caveats. Why?

He doesn't answer right away, and I find myself watching my phone instead of keeping an eye on Eva, who is deep in conversation with this week's director, a repurposed actor from an '80s cop show who spends an inordinate amount of time bullshitting with the actors and ogling the scantily clad extras.

ME: I'm bored and you're taking too long. Spill.

KIRK: I'm at Tyler's. He's talking about you.

KIRK: Again.

ME: FYI, he cannot be trusted. Unless he's saying nice things.

KIRK: He says you're a culinary idiot savant.

KIRK: Oops, now he claims he didn't say idiot.

KIRK: You're right. He cannot be trusted.

ME: You sound drunk.

KIRK: Drunk on you, maybe.

I read that last line a few times, scrolling to the beginning and back again and again.

Forty-one

A few days later, I'm on set waiting for Eva to wrap a scene. I'm sitting on the floor, leaning against a giant coil of lighting cables and clutching the following:

- Eva's iPhone and Android, both of which are amassing text messages at an alarming rate.

- A sweating pomegranate-and-ginger juice in a clear plastic cup from Urth Caffe.

- Dossiers on three potential new personal trainers, sent over by her publicist, although I already know they're all rejects.

- Two peeled hard-boiled eggs, with a paper napkin holding a blend of Maldon sea salt and freshly ground pepper to sprinkle on them when she's ready to eat.

- My Moleskine notebook, so that I can take down any requests she has when she walks off set.

- My own phone, a white iPhone identical to Eva's, which caused a clusterfuck last week when I accidentally swapped them and got an X-rated text message from a famously debauched musician whom she denies even knowing.

Scout flicks a nonexistent ash from her clove out the window. "What do you mean?"

"Eva's boobs."

"Yeah," Scout says. "What about 'em?"

"Well, it's none of my business, but she's told me a bunch of times that they're real."

Scout is an Egyptian sphinx, albeit one holding a brown cigarette.

"Come on, dude," I say. "You've hugged her."

Scout shrugs.

"They're bolt-ons," I say.

"Really?" Her voice is a perfect impersonation of befuddled confusion. "I so don't know what you're talking about."

"Come on. Are we pretending that Eva's C-cups aren't an expensive gift from Harry Glassman's silver scalpel?"

"Trust me." Scout laughs. "They're real."

I grab her pack of Djarums. "Can I have one?"

I take one and listen to a long silence.

"I'm just saying," I finally tell her, stepping into uncharted girl triangle territory. "I don't get how she's all 'I believe in owning your truth' and she can't admit that she's had her boobs done."

"We all have secrets," she says.

mixed company; *pussy* and *twat* if we're talking about sex. *Va-jay-jay* only if we're trying to make the other person laugh, and always in the Oprah voice. I could go on, but you get the point.

So tits are not a big deal. Except apparently they are.

"Okay," I say. "I want to ask you something."

Scout gives me an exaggerated side-eye and grabs a skinny red pack of Djarums from the center console. "Uh-oh."

"Uh-oh is right," I say.

I'm talking about the clove cigarettes. Scout loves to rub my face in the fact that I still smoke at twenty-nine, when she gave it up at twenty-one. But every so often, she gets a wild hair and instead of bumming an American Spirit or a Parliament like a normal person, she smokes cloves or Honeyrose cigarettes, which is the weird product that actors who don't smoke use when their characters have to smoke on camera. It's made of marshmallow root, clover leaves, and rose petals soaked in honey, which would be delicious if we were talking about a dessert syrup at an Indian restaurant and not some pretentious hippie product.

They're disgusting. And that's coming from a smoker. But do you know what's worse? Clove cigarettes, which is what Scout pulls out after flicking open the pack with a chipped fingernail.

I don't have the heart to tell her that there's as much tar in a clove as in a Marlboro, but without the filtration. So I just say, "Wow, you're punishing me and I haven't even said anything yet."

Scout exhales fragrant, toxic smoke through her nostrils. "So what's your drama?"

"No drama. It's so not a big deal."

"I can tell from the buildup."

"It's just . . . weird, because Eva keeps mentioning that her tits are real . . ." I let my silence fill in the blank.

Forty

One thing that Eva refuses to confide in me is the fact that she has fake tits. I mean, it's not any of my business, but she doesn't just *not tell me*, she mentions on a regular basis that they're real.

She's not shy about being naked, and her tits are magnificent C-cup teardrops with precisely the right amount of droop. You can't tell by looking that they're gummy silicone orbs, but I knew the first time I hugged her, because there's something unmistakably foreign about the feel of even the best-looking specimens.

Like I said, no big deal. I'm absolutely a fan of better living through chemistry and surgery, although I've been a C-cup since I was thirteen, so a boob job is the last thing I need. But Botox, Restylane, sure. And if I had the money, I'd get my nose fixed to look more like the girls in line at Urth Caffe and Whole Foods.

It's L.A., for fuck's sake.

Because I'm so very discreet, I just flat-out ask Scout about Eva's tits one day when we're driving home from Astro Burger. It's not that we don't talk about this stuff, because we totally do. We are to vagina as Eskimos are to snow—we have hundreds of words and each one conveys a slightly different meaning. *Bird* is our no-nonsense, elevator-friendly go-to; *vag* and *cooch* when we're not in

autograph seekers. And while I will admit that the clothes at Les Habitudes are spectacular, there's something about the request that makes me wonder, especially because Eva insists that it's only because there's one new shop she wants to go to, and *come on, won't you please, please, please?*

As if it's in doubt. I mean, I know she's better friends with Scout, but every time she wants me I feel special.

grabbing my hand. "Have you ever had a Red Haute at the News-
room?"

I shake my head.

"It's this beet and ginger juice thing. I swear to God, it will get
you high."

In my peripheral vision, I see Owen Wilson trying not to stare at
Eva, who appears completely oblivious.

"There's spirulina and bee pollen and flaxseed oil," she says. "It
sounds gross, but it'll change your life."

An hour later, we're heading for Les Habitudes and she's right,
I'm still buzzing from the Red Haute. Halfway down Robertson, we
run into an autograph guy with stills from everything Eva's ever
done, including her first, nonspeaking role on what might as well
have been a reboot of *Logan's Run.* I don't know how they do it, but
whenever Eva and I show up somewhere—anywhere—there's a
bearded dude thrusting a handful of 8×10 or 11×14 photos under her
nose and asking for a signature like he's trying to fulfill a kid's last
wish.

The autograph guys are almost worse than the paparazzi. A
skilled paparazzo can get a shot of every nose hair from twenty feet
away; the autograph guys have to get right up on their prey, clutch-
ing a wad of black Sharpies in their sticky fists. They're almost al-
ways pushing the far side of middle age and significantly overweight,
rumpled and acting abashed as they deftly flip each signed photo to
the bottom of their stack and beg for another, *C'mon, just one more.*
But when you turn off the faucet, those fuckers get as mouthy as the
paps, which is unexpected coming from men who look like Santa
Claus on a Hawaiian vacation.

There are about a thousand low-key places we could shop that
wouldn't entail navigating a bustling sidewalk filled with paps and

the window. On the other side of the street, his friends egg him on with whoops and catcalls.

"Oooo, you nervy, Russell!"

He catches sight of Eva and strikes a pose, leaning forward in an exaggerated bend, like he's frozen in his tracks. "Belinda, girl," he yelps. "Why you hiding?"

Belinda was Eva's soap opera character's name. When Eva left, Belinda got into a tragic accident on a winding mountain road. They never found the body, which is handy if they want to carry on the Belinda story line, though this is not something that Eva and I ever talk about. In Eva's world, talking about work is much more intimate than talking about a visit to the gynecologist.

The light changes and Eva arcs onto Robertson, a bland smile on her face, eyes shielded behind her mirrored Chrome Hearts sunglasses. She clicks a tiny button on the steering wheel and the syncopated rhythms of the Fugees' version of "Killing Me Softly" drowns out the Adam Lambert lookalike as we pull away.

We glide on in our dark bubble, not talking. I feel like it might make it worse to admit that I noticed the adoration. Eva keeps her eyes on the road, singing along with Lauryn Hill. By the time we pull into the underground garage, the song has ended, and the white-shirted valets whisk our doors open and we step out onto the red carpet that leads to the elevator.

Owen Wilson is talking on his cell phone as he waits for his car, and there's a group of youngish girls circling a braying, skinny girl with bleached-blond hair and a plaid fedora who I'm pretty sure is Miley Cyrus. It's a whole different world down here, and Eva's shoulders visibly soften as she shakes her hair in a cascade down her back and pushes her sunglasses to the top of her head.

"C'mon," she says, plucking the ticket from the smiling valet and

Thirty-nine

Shopping on Robertson with Eva feels like a girl date, like I'm hanging out with Scout or Megan. Eva drives us in her sleek black BMW 7-series. Everything on the car is matte black—the paint, the rims, the bumpers. Even the windows are tinted a dark charcoal gray, so densely pigmented that inside the car it feels like a wintery New England afternoon and not a blazing Los Angeles summer day.

I ask if she gets pulled over a lot, because here in California it's illegal to have windows so dark you can't see into the car.

"At least once a month," she says. "I have a doctor's note and usually they let me off with a warning, but I've had to have it stripped and replaced a couple of times." She laughs. "That's going to be a part of your job."

I laugh too.

We stop at the light on Robertson and Santa Monica, and a parade of boys streams across the wide redbrick crosswalk. The windshield isn't as opaque as the side windows, and we sit staring forward into space, pretending not to notice everyone trying to see in.

A bold boy in a black tank top and a healthy swipe of eyeliner stops on the center median to get a better look. His face contorts in frustration and he steps out into the street like he's going to rap on

past the first week of somersaults before I faded into a role as water bearer and towel girl.

And then cheerleading. A poster appeared on the corkboard outside the headmaster's office: COME ONE, COME ALL, it read, the Big Lie of fake Hollywood egalitarianism.

There were eight places on the squad, but after my tryout, when the roster went up on the headmaster's corkboard a few days later, there were only seven names. I never stood a chance.

Well, look at me now. Look at me fucking now.

"You're never gonna get ahead if you don't get your shit together. You need to meet the right people in this town," she told me.

At Eastcove, the right people were everywhere. Like Carrie Newcastle, whose parents owned practically every magazine on the newsstands. My mother had tipped me to her importance from reading the school roster, and I dutifully ingratiated myself.

Carrie was kinder than I'd expected. Meaning that unlike most of the kids, she sometimes talked to me.

One morning, after my mother dropped me off in the beater Dodge Dart she'd picked up in Idaho, Carrie asked, "Is that your housekeeper?"

"My father's secretary," I said.

When I slid into the passenger seat after school, my mother asked, "Was that Carrie Newcastle?"

"Yeah," I said. "She asked about you."

"About me? Like, how?"

"Like, she wanted to know who the pretty lady was who dropped me off."

My mother's eyes glittered. "Stick with me, baby."

I looked out the window as we pulled away down the wide, residential street, where a uniformed gardener was trimming a box hedge with what looked like a pair of cuticle scissors. There wasn't really anything else to say.

After ingratiating myself to Carrie didn't pan out, my mother's attention switched to cheerleading. Suddenly *that's* how I would move up a notch. I'm not sure why she thought I could do it. I'd failed miserably at her previous attempts to make me an athlete. There were a few ballet lessons from a man with a droopy mustache in a storefront in a strip mall in West Los Angeles, and a halfhearted season of gymnastics at the YMCA on Sixth Street. I barely made it

me and two other scholarship kids, one of whom was an Olympic hopeful and one a math wunderkind who ate her lunch alone in the girls' bathroom every day and was, for all outward appearances, completely okay with being a total misfit.

I, on the other hand, was just the poor kid with no special skills. And to all outward—and inward—appearances, I abjectly pined for acceptance, which was in short supply at Eastcove. And that was before I tried out for cheerleading. Not that I wanted to.

Donna had just returned from another failed engagement, this time to a man she met at Chez Jay. His name was Bob and he sold paper for Boise Cascade. Or something. I never knew the truth about my mother's suitors. Before she met Bob, she'd been talking about taking me away from Gloria's for good, getting us an apartment by the beach where we could smell the ocean from our windows and walk to Patrick's Roadhouse for biscuits in the morning before school.

I was all in. Then she met Bob and there was a whirlwind of dinner dates where they'd drag me around to clubby steakhouses like a chaperone. I ate filet mignon every time, because my mother said it was the best. I cut it into tiny bites with my oversize utensils, chewing the small pieces until they were liquid in my mouth.

Once they took me to the pier and I stuffed myself with popcorn and cotton candy while they made out on the wooden benches like teenagers. I ate a soft pretzel dipped in mustard, then puked yellow sludge all over the beige leather of Bob's Cadillac Seville. I remember the electric blue of Donna's bra straps sliding down her tanned shoulders while she held my hair back and Bob smoked and paced the weed-choked paths between cars.

She moved to Idaho with him a few days after that. She wasn't gone long. When she came back, she had a renewed purpose.

Thirty-eight

When I was twelve, I got a scholarship to the Eastcove School. Donna was so overjoyed, you'd have thought I'd gotten into Harvard Law. Eastcove is—or at least was—a luxurious dumping ground for celebrity offspring, plus a smattering of working teen actors whose parents wanted to maintain the illusion that they were giving their kids a normal life.

I went to school with a couple kids you'd still recognize, working child actors who shilled for pudding cups and board games. Twelve-year-olds with charismatic gapped teeth and freckled noses who made more from one national commercial than their parents made in an entire year. It completely skews the balance of power, when your kid out-earns you in a single afternoon, just by welling up with tears because no one got pet insurance for poor Buster. It makes things awkward when little Jimmy wants to have his thirteenth birthday party at the Peninsula, goddammit, and he doesn't give a shit that they have a twenty-five-thousand-dollar catering mini-mum for a Saturday night, and no, Mom and Dad, you can't invite your friends from the old days, because that would be completely humiliating.

There were other garden-variety rich kids, the sons and daughters of bankers and lawyers and CEOs, but no poor ones. Except for

you-need-something-ladies? maneuver, and the women avert their eyes and fall silent.

"Impressive," I murmur.

Eva slides down in the water and closes her eyes, resting her head on the stone lip of the pool. "It's my squid ink," she says, and it takes me a second to realize she's talking about defense mechanisms. It's a snappy little rejoinder that catches me off guard after the three-o'clock debacle. I honestly can't figure out how much of Eva's wide-eyed ignorance is deliberate.

I close my eyes too, and listen to the hum of the women chatting in Korean in the scrub room. There's a strict no-talking policy at Beverly Hot Springs, fiercely enforced by the most decrepit of the underwear ladies, who rides herd on the room from a white plastic chair by the cold pool, shushing anyone who dares raise their voice above a whisper. The rule doesn't apply to the employees, who chat nonstop while they're administering their special scrubby torture, and when Eva's lady comes to collect her, she and Eva squeal with delight and carry on about how long it's been in a mixture of broken English and Eva's overly loud compensatory lack of Korean.

The white chair patrol just nods, but the blond girl chuffs in irritation, and I realize that she's a model I've seen on billboards. I smile and shrug, but she doesn't acknowledge me.

Hollywood is full of rules that apply to some of the people all of the time, some of the people some of the time, and some of the people none of the time. I sink deeper in the water and wallow in the knowledge that I've possibly moved up a notch.

Eva delicately edges into the water, holding her arms out like wings to skim the steaming surface, then sinking in up to her neck in one swift motion. I lumber down the steps after her and hit like a cannonball.

We file past Liv, who catches Eva's eye and gives a subtle nod, which Eva returns. Liv's gaze skates over me then flickers away, pausing for an instant on the two scripts with their bright red CAA covers that I'm holding at shoulder level to protect from the water and steam. They are members of a club I don't belong to, but before I have time to contemplate exactly how that makes me feel, a wrinkled Korean woman in droopy black lace underpants whisks Liv to the back room, which is where the brutally invasive scrubbing happens.

Eva and I watch with fascination as Liv Tyler's naked ass sways away from us. It's pink from the water and creased by the uneven blocks of the stone ledge she's been sitting on.

"Dude," Eva whispers. "Liv Tyler."

"Dude," I whisper back. "I know."

"Are you kidding me?" Eva says. "Her body is sick."

I glance at the remaining women in the pool, a couple mid-forties women who are not being subtle about their interest in Eva, and a skinny blond girl reading a giant hardback copy of *Infinite Jest* and twirling a strand of hair in the manicured fingers of her free hand.

"Three o'clock," I murmur, flicking my eyes to indicate the nosy women.

"What's at three o'clock?" Eva says, not quietly.

"I'm noon," I say, even lower. "One o'clock, two o'clock, and *three* o'clock is very interested in what you're doing."

I give another eye flick and Eva slowly turns her torso toward the women, then snaps her head at the last instant. It's a dramatic *Did-*

film Quentin Tarantino ever made, or even Tila Tequila, you're completely off base.

We're running late, so we quickly change out of our street clothes and trot into the grotto, wrapped in the tiny, coarse towels they dole out at the front desk.

And there's Liv in the steaming water, hair piled in a sloppy bun on top of her perfect head. She's used the stretchy cord attached to her locker key as a ponytail holder, and the large brass key is dangling from her topknot like a Christmas ornament.

Eva grabs my arm with both of her hands and gestures minutely with her head.

"I know," I say, and Eva leans in to mouth an almost silent scream in my ear. I don't care how inured you are to the idea of celebrity, Liv Tyler naked in a steamy grotto is too awesome to ignore. We pause at the steps to the large, rock-encrusted hot pool. Liv is five feet away, sitting on the smooth stone ledge, submerged in the bubbling water up to her delicate collarbone.

Eva drapes her towel over the metal bar at the top of the pool stairs, an oddly utilitarian touch in all this steam and rock and nakedness. She pauses for a moment and everyone in the room, including Liv and me, take in the splendor of her body: her skin taut and creamy, her proportions perfect, her breasts lush and teardrop-shaped, her ass full and high above lean, sculpted thighs.

I get a really good look at the tattoo Scout told me about, the sloppy purple-and-black monstrosity. Jesus, it's big, like the size of a baseball, which might be less tragic on a supermodel, but Eva isn't even five-foot-three and her hips are smaller than my waist. It looks like a giant bruise and I'm not going to lie, there's something about the unsightly self-inflicted flaw that makes me love Eva a little more. And helps me get comfortable with dropping my own towel.

way and tells me to take the day off because she's treating me to a body scrub/body care combo at Beverly Hot Springs. Of course, she neglects to mention that it's a wet treatment, and the woman who's giving me the treatment is also practically naked, in a black lace bra and matching panties.

At first I think the woman is fucking with me, but it's a quirk of not only that Korean spa but every one I've ever been to since. The distinctive thing about Beverly Hot Springs, aside from their faux-rock grotto, is that they're more of a celebrity draw than Nobu Malibu on a Saturday night. Don't get the wrong idea, though. The décor is still an alarming cross between the break room at a Korean barbecue restaurant and the famously sperm-encrusted Jacuzzi at the Playboy Mansion.

Supposedly their water—Beverly Hot Springs's, not the Playboy Mansion's—comes from an artesian well, the only one in L.A., originally tapped by a wealthy oil baron in 1910. That's exactly the kind of marketing that appeals to the celebrity mind-set: something rare enough that it's difficult to obtain. There are a hundred Korean spas in the three-mile radius of the part of Hollywood called Koreatown, but Beverly Hot Springs is the only one where you're likely to see Liv Tyler with her perfect tits bobbing in the rarefied alkaline water.

Which is exactly what happens when Eva and I take our first trip there together a few weeks later. I'm trying to play it cool, but I can barely contain myself. Of course, before you start imaging porntacular scenes of Eva and Liv and the underwear ladies, I should mention that the women who do the body scrubs—all of whom have adopted uber-American names from decades past, like Rita and Helen—are well over forty. And they're on their feet all day, slinging buckets of water, so if you're picturing every Asian woman in every

The only room that's fully furnished is Eva's bedroom: king bed swathed in Frette linens; a double wide, full-length mirror leaning in the corner; a scarred wooden dresser she's had since she was a waitress, drawers always askew and spilling wispy panties and bras.

The other three bedrooms serve as closets for her ever-expanding wardrobe. She has a habit of acquiring bags of clothing on memo. She also somehow acquired four tiny dogs—two dachshunds, a Chihuahua, and a bulgy-eyed mutt. They're all named Rosebud, but on the first day, when I made the requisite sled comment, Eva looked so blank that I just pretended I hadn't said anything at all.

None of the Rosebuds are housebroken, so one of my daily duties is to patrol the house for dog shit. You wouldn't think this would be difficult, but the floors are all a deep chocolate brown not dissimilar to the color of at least two of the Rosebuds' shit piles.

Also, Eva is in the habit of disrobing as soon as she walks in the front door, leaving a trail of clothing from door to kitchen, kitchen to bathroom, bathroom to bedroom. Ditto for her post-workout routine. As soon as she hops off the elliptical—in a room she calls "the gym" although it's really just a walled-off former garage—she peels off her sweaty sports bra and Lycra yoga pants and drapes them across the iron railings that line the three stories of stairs from the ground floor to her bedroom.

The Rosebuds go crazy over her damp-crotched underwear, gnawing out the cotton linings and leaving their thread-laden poop all over the place. Every time I walk into the house it's like walking across the Uzbekistan–Tajikistan border circa 2004, but instead of losing a limb I end up with a flip-flop full of dog shit and underwear bits.

However, for every tenth shit-flop, there's a Willy Wonka golden ticket into a magical world.

One random morning, Eva sleepily appears in the kitchen door-

Franklin entrance and the Mulholland gates where you can see from downtown to Century City—that is, if you can jockey for position among the actors and models wearing their yoga pants and calling to their ill-behaved and unleashed dogs.

Ten years ago it was a great place to break a sweat and take in the view of the city. Now it's like being on Robertson Boulevard, but with exponentially more dog shit and the possibility of stepping on a rattlesnake. At least the paparazzi are much lower-key, though they're always there, hoping for the money shot of Angelina Jolie or Reese Witherspoon pulling her yoga pants out of her camel toe.

The only time I voluntarily do Runyon is early in the morning, when the fog curls around the eucalyptus trees like smoke and the vermin are still sleeping in their holes. But Eva doesn't do mornings. Her days off usually start at around eleven.

I never say no when she calls, of course. Mostly because I like being seen with her, but I also feel like it's part of my job. What's flattering is that *she* thinks of these outings as a thing we're doing as friends. Of course, this means she won't think anything of asking me to work for the next seven days straight if she has shit she wants done, but that's a small price to pay. Certainly smaller than joining her at the sugar spray tan place that makes me look like an Oompa Loompa with vitiligo, even when she gets me the extra exfoliant thing that smells like Lemon Pledge and Clorox.

Eva lives in a Tudor-style house at the top of Nichols Canyon that she bought with the money from her first show. Two million dollars, and it still needs work. It's three stories, turreted and bricked on the outside and sprawling and Mediterranean on the inside, with decorative half-timbered walls and terra-cotta floors. Everything in Los Angeles is a mutant hybrid. A nineteenth-century architect ghost peers through the leaded windows and weeps into his flounced cuff.

Thirty-seven

Eva and I have a loose relationship about money. When I started working for her, she asked me what I needed to make. The way she described her schedule sounded like there'd be plenty of days when she wouldn't need me at all. It was basically a part-time job. So I pulled a number out of my ass: eight hundred bucks a week.

For hanging around with Eva Carlton? People pay ten times that for her to spend a couple hours at their daughter's bat mitzvah.

Eva sipped her caffeine-free peppermint tea and offered me a thousand a week. Fifty-two grand a year. Maybe I'd failed at marriage and sucked as a barista, but goddammit, at least I'd be able to pay my rent.

Of course, it's impossible to keep track of my hours because there's such a permeable line between my job and our friendship. Like, sometimes Eva calls in the morning when she's not working and says, "Let's do Runyon."

Runyon Canyon is a dilapidated old park in Hollywood that spans one hundred fifty acres from Franklin to Mulholland, with miles of dirt roads and some falling-down amenities behind chain-link fences. There's the ruined foundation of an old Frank Lloyd Wright mansion and a weedy, cracked tennis court that has been off-limits since I was a kid. There's a vista point midway between the

"A replay?" I say. "You're already adopting sports vernacular. You know you have to throw a Silpat liner on that cookie sheet before you start scooping your perfect little dough balls onto it, right?"

"I'm hanging up. I miss you."

"I miss you too, Boof."

"Of that guy's hairy butt crack."

"That's her boyfriend. Well, her 'alleged' boyfriend. There are some side dishes being served around here, but I'm not privy to the details."

"Already bored with her," Megan says. "Back to Kirk, please."

"I don't know. We had this amazing breakfast. He ordered three kinds of pie at Urth. Then Eva called and I dropped everything to go to her and now I feel like an asshole."

"Don't beat yourself up, Boof. You went to do your *job*, not to— what did you call it?—pick up a side dish. And boys like to chase. It's in their Cro-Magnon brain stems."

"They like to chase *you*," I say. "But it's not that. I feel like an asshole because I was . . . y'know."

"Eating three kinds of pie?"

"Excited about Eva wanting *me* to commiserate with her. I sound so gross, Boof. Tell me I'm not gross."

"You're not gross. You're human. Maybe a little more codependent than the average bear. But I can't really talk."

"What does that mean?"

"I'm the asshole who's getting on a plane to follow her boyfriend to Vancouver tomorrow. He's doing a cameo for the new Judd Apatow movie."

I smile at the phone. "Next thing you know, you're wearing a dirndl and baking cookies while he's watching the Super Bowl."

"Ouch," Megan says. "I promise, promise, promise that we'll get together as soon as I get back."

"You're kind of overselling it with the triple promise."

"And I want updates on the Kirk front," she says. "I'm guessing he'll be asking for a replay within the next twenty hours."

Thirty-six

Megan finally crawls out of her honeymoon suite and calls me. I feel like I've left her a thousand messages over the past few days, but as much as I want to be petulant, I'm just glad to hear her voice. "Boof," I say. "I thought you were dead."

"Sorry. We went to Telluride and I left my fucking phone at the house."

"Total technology fail," I say, even though I'm only 42 percent sure she's telling the truth. I mean, Megan's not a pathological liar or anything, but she'll stretch the truth to spare my feelings, and if she's been too lazy or blissed-out to call me back, I know better than to take it personally. "It doesn't matter."

"Tell me everything," she says, and I can hear the whir and click of a lighter, the crackle of burning tobacco, and her smooth exhale.

"I'm having a moment about Kirk. He took me to breakfast this morning and I bailed on him because Eva was having tabloid drama, and—"

"Hold on, hold on. *Imma let you finish,* but can we talk for one second about those pics? I mean, *what* is happening there?"

"Some asshole up the hill must've let a photographer into their yard. That's the only way you could get pictures by her pool, even with a long lens."

"Already?" he says. "What's up?"

I hesitate. Dave is Eva's co-star boyfriend, but she's got at least two other high-profile boys on the side. I don't know what I can say, so I mumble, "Eva's having a thing."

What I don't say is, *a friend. She needs a friend. Me. I'm her friend. I'm friends with Eva Carlton.*

"No problem," he says. "It was good to see you, Jess."

I forget to say good-bye. I forget to pay for breakfast. I blink twice and I'm gunning my beater Mazda uphill toward Eva's house. She needs me. I blush at my assumption. But there it is. So not pretty. The truth is that by the time I hit the front door, I've forgotten Kirk completely.

"Uh-huh," I say, not sure I'm liking where this is going.

"But it's not 'escape risk' or 'fugitive risk,' it's *flight* risk. Like you might suddenly sprout wings and take to the sky."

"That's me? I'm a flight risk?"

"Such a flight risk," he says.

Then he asks about my job, and when I stonewall he tells me about his. It turns out that he owns Fleurs et Diables, and he's thinking about expanding. He asks my advice about building on his home service versus opening a nursery, he asks about shop fronts and neighborhoods and he listens to my answers. Apparently he took "third-generation Hollywood" to heart—good thing it's true—and he gets opinions out of me that I didn't know I had.

We're so engaged in the conversation that I barely notice the yoga sylph sitting four inches from us, dressed head-to-toe in Lululemon, flicking her cat-eyed gaze at Kirk. I barely notice her interest in his voice and his laugh, and I barely notice her dismissive shrug when she inspects me. I barely feel a happy flicker of triumph.

Then Kirk says, "How solid is your eleven A.M. call time? Can you come with me to Pasadena?"

"What? Now?"

"Yeah. You know where Hortus Nursery used to be? There's a lot for sale. I want you to look at it."

That's when my phone bleeps. It's Eva: Got a call from Soap Opera Digest this morning. There are paparazzi photos of me and Dave and they're not good. I'm a mess. Don't care about Bella and Country Floors. Can you come here ASAP? I need a friend.

The weird thing about fame, I'm slowly learning, is that it doesn't always protect you from the peccadillos of human relationships. In fact, it tends to exacerbate them.

"I can't," I tell Kirk. "I have to go."

"Wow. Now, that is middle America."

I'm not sure what I mean, but he doesn't take offense. He tells me about his family. He's the youngest of four kids, and the only one who left Ohio. His sisters are both married, both with two kids. He doesn't tell me that each has one boy and one girl, but that's how I see them. His brother works at the corporate headquarters of White Castle and probably coaches Little League.

"Did you have golden retrievers growing up?" I ask. "A lemonade stand?"

He laughs. "Well, that's how I tell it."

"But the truth is different?"

"It's too early for the truth. I'm trying to impress you."

Which is sweet enough that I feel an inappropriate flush creeping through my torso and across the gossamer fabric of my favorite La Perla bra, which I hand-washed in the sink last night so I could wear it as my stealthy first-date armor.

"You make everything sound so . . . intentional."

"Isn't it?" he says.

"God, no. With me, it's all impulse and overreaction."

He laughs again. "Yeah, well, that's why you're such a—"

"I'm such a what?" I interrupt.

"You're so going to take this the wrong way."

"Still waiting."

He takes a sip of his twelve-dollar orange juice. "You know what's a weird phrase?"

"Right now? I'm thinking 'that's why you're such a . . .' is pretty weird."

" 'Flight risk.' That's a weird phrase."

I frown. "Like a criminal you're afraid is going to run away?"

"Yeah, because when you hear 'flight risk,' you picture someone all skittish and furtive and—" He gropes for the word. "Nefarious."

"Did you?" he says innocently. Except then he smiles and says, "I'm happier if you still owe me a meal."

I'm afraid I'm blushing, so I lower my face to sip my coffee. It's a perfect Urth Spanish latte: one part condensed milk, two parts espresso, a layer of thick milk foam. I know, I know, I'm veering into Tyler territory, but seriously, it's like drinking a bucket of sex.

"Wow," Kirk says, watching my face. "You like your coffee."

"I'm easy to please."

"Really?"

"Yes," I say. "Well, no. Actually, fuck, I don't know. I don't ever know what I want until I get it."

"We'll do an experiment," he says. He loads a forkful of pumpkin pie and offers it to me.

For a moment, I hesitate. Are we really going to do this? Pie-based public flirting? Part of me wants to say something snotty and superior, but the rest of me wants the pie. And the flirting.

I take a bite, then swoon as the layers of cream and sugar and nutmeg hit my tongue. "Yeah, I'm easy."

"The product of three generations in Hollywood," he says.

I'm way too flattered that he remembers all the crap I say. I'm still afraid that I'll start blushing, so I grab my fork and inspect the pies. There's a chunk of something with whipped-cream topping that I can't identify. Banana cream? Coconut? Doesn't matter. He had me at pastry.

"Three failed generations," I say. "But that's boring. How about you? Where are you from?"

"Guess."

"San Diego," I say. "You're a military brat."

"Columbus, Ohio," he tells me. "My mom's an accountant, my dad's a schoolteacher."

giant hoodie and her Frankenstein-y husband, who can't decide what they want and are having a bit of a standoff with an exasperated barista.

Kirk is sitting by the window in a patch of sunlight, the table already littered with glasses and plates: a big green bottle of Pellegrino with two squat glasses flanking it, juicy chunks of lime glistening between shards of ice; a glass of pulpy, red blood-orange juice; a couple dog-bowl-size lattes; a pecan sticky bun as big as my head; and—this is the part where I fall a little bit in love—a plate with a few different pieces of pie, including the crazy, mile-high pumpkin pie that is an Urth Caffe signature, as fluffy as a layer cake. How can you not fall in love with a man who orders three kinds of pie for a coffee date? I mean, especially in L.A., but I'm pretty sure it would hold true in Anchorage, Alaska, or Marrakech, Morocco. A three-pie breakfast date is a hands-down, global winner.

Normally when I find myself patronizing Urth, it's for Eva's decaf chai almond-milk latte or one of their off-menu juices—pomegranate, celery, and ginger is her usual combo. When I succumb to their insane pastry case, it's in a shameful, surreptitious, to-go kind of way. I'll plow through a lemon bar or a cup of double-dark hot chocolate in my car on the sly as I wait for the long red lights to turn green in crosstown traffic.

But Kirk has created a banquet for us in a place where people look at you funny if you ask for your salad dressing any way but *on the side*.

I slide into the chair and pick up an oversize latte. "You read my mind."

"I didn't," he says, clinking his bowl with mine. "It's all completely selfish."

"Except for the part where I said I was paying."

Thirty-five

Country Floors is an insanely priced tile showroom on Melrose. And of course, Kirk gets the reference. We're not so very different, Kirk and I, with our jobs that grease the wheels of celebrity fabulousness. And yet, there's something about him I shy away from. Maybe I'd rather live vicariously through Eva—and even Megan—than settle for my own life. Except this *is* my life now. Finally.

Of course, it's not like Kirk made any offers to sweep me off my feet.

Still, I'm up at sunrise, jerking into wakefulness while most of the people in the building have just sluiced off their pancake makeup and are moisturizing their aging knees and elbows. Or whatever drag queens do at five in the morning. Honestly, I have no idea.

I paw through my clothing choices and decide on black, boot-cut fitted pants and a kitten-soft, long-sleeved T-shirt that I snagged during one of the round-robin returns to the Ralph Lauren store when I worked for Tyler. It's good. Sleek, sexy, but not trying too hard. Trying too hard is the biggest offense a girl can commit in this town.

I stroll into Urth at the perfectly serviceable time of 10:10 A.M. and find a dozen boys and girls in line, including Avril Lavigne in a

I check my phone a dozen times before I fall asleep but there's no response. Whatever. It was just a whim.

I wake up to two texts from Kirk.

Who's gone all uptown on me?

And then:

Love to. See you at Urth at 10.

I dial Megan immediately. It goes to voice mail, but instead of leaving a blathering message, I fire off a rapid succession of texts.

Boof, I feel like we broke up and we're enacting the no-contact rule. You suck.

I have many important things to tell you ABOUT MY LOVE LIFE, but I'm not telling you shit until I'm looking at your face.

Then, later, when she still doesn't answer:

Don't beg, it's unseemly.

I really miss her.

A sick feeling coils in my stomach at this betrayal of Scout, but Eva texts me later that night: What did you say to Bella? You're the first assistant she hasn't wanted to murder. You're awesome.

I read the final two words seven times. I am glowing.

Another text arrives: Meet her at Country Floors on Melrose tomorrow at 11. We love her. Don't talk about Jeremy.

Jeremy is Bella's son. He was an assistant director on a Lifetime movie Eva shot a few years ago, but it was so bad it never even made it to air. You could say the same about her relationship with Jeremy. Their brief fling didn't survive the duration of the location shoot, but Eva held on to Bella afterward. Bella is one of the most sought-after decorators in Los Angeles, and Eva's not the kind of girl to let a failed romance stand in the way of a potential six-page spread in *InStyle*.

Jeremy is currently engaged to a doe-eyed starlet, but that doesn't stop him from leaving Eva long, sexually charged voice-mail messages on a regular basis. I cringe when I transcribe them for her *daily update*, which is a written accounting of the messages on her second-most-recent cell-phone number. The people calling it don't know that Eva has moved on to a new, more exclusive contact number, so they say the most intimate and inappropriate things, which I dutifully take down verbatim and present to her daily in a manila folder.

The good news about Eva's edict for me to meet Bella tomorrow is that it gives me the morning off. I'm thinking about this while I'm lying in bed, and I do something that's been on my mind for the past couple weeks.

I text Kirk.

I have a big bucks meeting at Country Floors tomorrow for my new boss. Still want to cook for you. Breakfast instead? Urth at 10? I'll buy.

"Eva's not interested in sisal or an Aubusson," I tell her, though I have no idea what Eva likes. "You're going to have to get on board with her style."

"Really?" Bella regards me with sudden interest. "And what are *your* thoughts on floor coverings?"

"A sea-grass rug with a serged edge, not bound, in this room. I wouldn't bother doing anything to the floors, because I'd take the rug to a nine-inch border all through here." I gesture to the wide rectangle of the living room. "Upstairs, I'd rip out that faux-terra-cotta tile and bring the wide-plank hardwood through the hallways. There's no reason to fuck with the original floors in the bedrooms—though I'm not a fan of peg-and-groove—because they're authentic to the period of the house, although I'd refinish them to match whatever happens in the common areas."

Bella shoos off a hovering intern with her ringed hand. "Interesting. What else?"

"I'd leave the subway tile in the master bath, but I'd rip out that heinous Jacuzzi and put in something porcelain and curvy. And I'd take a sledgehammer to the glass brick separating the dressing room from the closet."

"What about this?" she says, gesturing to the rickety dining table that Scout gave Eva when she moved in, an "heirloom" from her own childhood.

I hesitate for a moment. Part of me wants to defend the table, out of loyalty to Scout. But a bigger part needs to spare Eva from any future embarrassment—and that thing, while adorable in a garage sale kind of way, is not what Bella has in mind.

"Donate it to Out of the Closet," I say. "Or it goes out on recycling day."

Bella laughs. "Well, aren't you a treasure!"

Thirty-four

Does anyone ever think they have bad taste? My guess is no. That's the only way to explain fanny packs, garden gnomes—which, admittedly, have a certain post-*Amélie* ironic appeal—and Spandex.

Eva has not one, but two, interior designers, but that hasn't stopped her from buying a pair of bent twig rocking chairs, currently the only furniture in her living room, and a molded resin wall sculpture—intended for a garden but displayed above her walk-in fireplace—of fat-cheeked bas relief cherubs draped in diaper togas, clutching bows and quivers of pointed arrows. Bad taste in home décor is Eva's only visible flaw, and it makes me feel protective, almost maternal.

The number one interior designer, Bella, is Eva's ex-boyfriend's mother. She is sixtyish and British—although, oddly, her son is not. Bella is mostly gracious and very *jolie laide* in her cap of silver hair and her tea-length floral dresses. She strides through rooms, tsking and measuring, followed by a retinue of fresh-faced interns who huddle and whisper. In other circumstances, I'd find her intimidating, but I just worked for a man with seriously honed tastes, so when she starts pontificating about how desperately this room needs a sisal rug—*because, God knows, we couldn't possibly consider an Aubusson for this client*—I get testy.

Thirty-three

One thing about falling in love with a celebrity is that they're so Google-able. Before my first day working for Eva, I knew all about her dating history: the one-named A-list pop star, the dozens of actors who courted her, the brief marriage to a teenage heartthrob when she was nineteen. I knew her original hair color, the names of her brothers and sisters, and the (fake) Sanskrit meaning of her unfortunately placed back tattoo that looks like a paisley bruise. Though months later, I learned that the unwieldy art was a cover-up for the name of that heartthrob first husband, inked just above her perfect ass in looping, cursive script.

Of course, I never mention the things I learn from Google-stalking Eva. I just hold them close.

The only person I could tell about my shameful behavior is Megan, and we keep missing each other. I had to tell her about Donna hijacking the apartment in a phone message, for fuck's sake. Her texted response was perfectly Megan: Boof, I will crush her head with a cinder block if you want, but honestly, who cares? Let her have it. I hope she finds joy there. Hahahahaha, j/k.

school kids from the AV squad who gets plugs, laser hair removal, and a production deal needs to fuck it out with pubescent aspiring starlets until the wheels fall off the fucking bus."

"Yeah, but—that's not the damage."

"Then what is?"

A silence spreads across Eva's bedroom, until I say, "When I told my mother."

"What did she say?"

"She said that the Chinese word for 'crisis' is the same as the one for opportunity."

Eva's lips narrow.

"She said, 'What's behind door number two for a girl like you?'"

I lie back on the bed and look at Eva's beamed ceiling.

"She said, 'One day, you'll thank me.'"

Eva crawls up into my lap and rests her head on my shoulder. "I'm so sorry," she says.

And I'm crying, but it's not a twisty-faced, anguished kind of cry. It's more like my eyeballs are leaking. My heart feels like that commercial with stop-motion photography, the one where the peony goes from bud to bloom in seven seconds.

"I guess at that point," Eva says, "he did. So, then what happened?"

"I remember walking down a long hall on a shaggy white rug that ran all the way down to a set of lacquered double doors, like the entrance to a restaurant. I said it felt like walking on baby animals, which made Trent laugh, and then he hugged me from behind. He was shirtless from the pool, and his chest hair felt like a pot scrubber."

Eva wrinkles her nose and twists her perfect lips into a moue of distaste. "I do not like where this is going, at all," she says.

"Yeah, it's everything you'd think," I say. "So, the next thing I remember, I woke up in this puffy white bed. For about one second everything felt okay. There was moonlight coming through the drapes around an open sliding-glass door. I could hear the waves outside. The room was spinning, but not too bad."

I look at the full-length mirror, across Eva's bedroom, the two of us reflected back with our heads so close it looks like they're touching.

"Oh, God," Eva says. "This is killing me."

"And he was lying right there and then we started kissing. I mean, it wasn't awful, just the kissing, but his tongue felt wrong. Too wet. Too big. He tasted like mustard. He was talking to me, but I couldn't understand, from the champagne and the pill and whatever. I tried to get up, but he just rolled me how he wanted me and said, 'Don't cry, cherie. I'm not going to hurt you.'"

I shrug. "Which was, of course, a giant lie. You can figure out the rest. It was as gross as you would expect, and then it was over and he drove me home."

"Ew, it's like Roman Polanski."

"Not really," I say. "I mean, at least he didn't fuck me in the ass."

"It's so disgusting," Eva says, her voice sharp. "Every fucking high

with champagne and cigarettes. What if he looked at me and realized he'd made some horrible mistake?

"Are we gonna do this, beautiful?" Trent said.

Trent shot four rolls of film of me under the waterfall, barely pausing to reload his camera. *Chin down, now look at me, no, not like that, only with your eyes, yes, perfect, hold it. Shake your hair. Now push it back with your left hand. Turn just your head toward me.*

I was freezing and the skin on my fingertips was wrinkled but I didn't care because Trent was telling me in several languages that I was beautiful. *Bellissima, belle fille. Krasivaya, dusha-devitsa.*

"Good, great," he said. "Now, lose the top."

I ducked my head. "I don't know."

"Baby," he said. "French *Vogue* is gonna shit when they see these. You look like a movie star on the beach at St. Tropez."

So I took my top off and he shot me under the waterfall until my toes went numb. Then he set his camera aside, and stepped into the steaming Jacuzzi. "Come here. You must be freezing."

I swam underwater to the stairs, then padded across the teak deck toward the steam from the Jacuzzi.

"Here." He uncapped an amber bottle and shook a white, oblong pill into his hand. "Take this."

"What is it?"

"It'll warm you up."

He passed me the champagne bottle and I put the pill on my tongue then filled my mouth with so much champagne that I'd had to gulp it down.

He leaned back and closed his eyes, like he had all the time in the world.

stack of fluffy white hand towels in a silver basket. I ran a brush through my hair and slicked on some lip gloss. My eyes were shiny and wide-open, like I was surprised about something. I took my pink bikini from my purse and slipped it on under my dress.

The swimming pool was spectacular, a black-bottomed kidney shape with a Jacuzzi and a tumbled-rock waterfall down at the deep end. There were twinkle lights in all the trees.

Trent had a flash attachment for his camera, a big, round disk with a little bulb at the center that sizzled and popped every time he clicked the shutter.

I perched on a wrought-iron lounge chair and pulled my dress over my knees, looking up into the big, black eye of his camera lens.

"Beautiful," he said.

Pop. Pop. Pop.

"Lie back and put your hands behind your head. Like that. That's great."

Pop.

"Move your dress up higher on your legs. Fantastic."

Pop. Pop.

Then I was in the swimming pool, my dress billowing around me and the lights from the bottom of the pool shining through the white stripes gone sheer in the water.

"Perfect," he said.

Pop.

He wrapped me in a big, white towel. "Take off that dress and I'll get some shots of you under the waterfall. You look amazing."

He topped off my champagne and I was shy about stripping down to my pink bikini, even though I'd worn it to the beach and the swimming pool at SMC all summer. It felt different in the dark,

there, so I figured at least we wouldn't be alone, but when we walked in through the unlocked front door, there was no one."

"Shit," Eva says.

"Yeah. Then, y'know, we split a bottle of champagne, and he took me outside and stopped in front of this golf cart with a fringed canopy. He asked if I'd ever driven a golf cart. I was peeing my pants."

Eva edges closer to me. "What did you say?"

"I told him to ask me again in five minutes."

"Oh my God, do not stop talking," Eva says, and she flips her bare, tanned legs across mine, like she's not going to let me up until I finish the story.

I tell her that Trent laughed, hooking his leg around the console between us in the golf cart and mashing his foot on top of mine onto the gas pedal. I tell her that I burst into squealing giggles as we went careening down the path toward the ocean. We swerved and swooped downward until we reached a contemporary, two-story house. It was dark inside, but I could see straight through the sweeping walls of glass to a lit-up black-bottomed swimming pool and the waves cresting in the ocean just beyond.

"Whose house is *this*?" I asked.

Trent pushed my hair over my shoulder, letting his fingers linger on my neck for just enough time to make me shiver.

"Darling," he said, like he was talking to a small child. "This is the pool house."

I was grateful for the dim light of the driveway to hide my embarrassment. "Well, obviously."

Trent clinked the open bottle against my wineglass and we both drank before heading inside.

Everything was fine. Trent showed me to a bathroom near the front door with white hydrangeas in a mirrored silver vase and a

a teary rumple into an eager sponge, sopping up the details of my story like it's spilled wine.

"That's when I moved out," I say, and I'm not sure why, but I'm not feeling nearly as freaked out as I was a couple minutes ago. There's something easy about just telling the fucking truth.

"So what did you do? Did you get emancipated?" Eva sweeps a pile of magazines onto the floor with her UGG-booted foot. "Here, sit."

"No," I say, flopping down beside her. "I just, you know, found a roommate on Craigslist and got a job at a catering company that hired undocumented workers."

"Is that how you started cooking?"

"No," I say. "I made shitty sandwiches in a commercial kitchen that girls in booty shorts and tank tops sold door-to-door in office buildings."

"Seriously?" Eva says, laughing. "Who does that?"

"I know, right?" I say.

We sit in her darkened bedroom for an hour, swapping mother stories, which absolutely cements my girl crush on her. I find myself telling her about meeting Trent Whitford, about that first failed photo shoot on the beach.

"Two days later," I say. "My mother hoses me down with Calèche like a cosmetics-department lady and says she convinced Trent to give me another chance."

Eva's big eyes get even bigger. "What did you say?"

"I told her I wasn't going," I say. "She told me I was."

"So you did?"

I shrug. "He took me to 'this killer beach pad' up past Paradise Cove, all palm trees and hibiscus and bougainvillea. I remember thinking that my mother would shit herself. There were other cars

a white cotton romper with frilly eyelet around the leg holes and a pair of suede, knee-high UGG boots.

"Do you ever think things would be easier if you'd had a different childhood?" she says.

I freeze with my arm still outstretched toward the space I've created to hang up a handful of Rag & Bone denim. "What do you mean?"

She doesn't answer, so I gather up the wire hangers and dry-cleaning bags and step into the bedroom, where I find her hugging a pillow to her chest and peering up at me, her eyes wide and engaged.

"My dad used to beat the shit out of me for little things," she says. "Like forgetting to pick up the dog bowls from the kitchen floor. He'd drag me out of my bedroom and into the living room. I guess it wasn't satisfying if he didn't have an audience."

I feel like I've hit the emotional jackpot, but I'm clueless how to proceed. "That's hideous," I say, internally cringing at the hollowness of my tone.

"My mom would beg him to stop, but she'd always close the living-room curtains so the neighbors couldn't see."

"Wow," I say, "that's as bad as what your dad did."

She shoots me a sharp frown and my stomach plummets. Then her face crumples and she starts to cry. "You're right," she says, wiping her tears with the scalloped edge of the white Frette sheet. "You're right."

"I never met my dad. Donna calls him the sperm donor."

"Who's Donna?"

"Oh," I say. "My mom."

"You call your mom Donna?"

"Yeah, she lost 'Mom' when I was fourteen."

"What does that mean?" Eva says, and she's morphed from being

when you bend down to tie your shoes. Boys are Labrador puppies, eager and sniffy; girls are coyotes, lurking in packs, waiting for a weak animal to cross their path.

And for the first month, my working life with Eva feels like one long date with a boy I'm really, really into.

"Oh, you like Okkervil River? I *love* Okkervil River." Truth is, I barely know who they are—a couple guys with train-conductor beards and a skinny girl playing a lute?—but I forge ahead anyway. "My favorite song? Um, you know, that one they play all the time, I can't remember what it's called."

This is where a normal person would let the silence happen. Nope.

ME: What's your favorite?

EVA: Right now it's "Stay Young."

ME: Yeah, I really like that one too.

The way Eva flips through magazines while we're talking doesn't do anything to ease my worry about my inadequacies.

Why can't my insecurity take the form of uncomfortable silences? That would be such a gift. Instead, I rush to fill any open space with words that clatter like the beads from a broken necklace onto the sidewalk.

Then a crazy thing happens. We start talking about our childhoods.

I'm standing in Eva's capacious closet, hanging up dry cleaning; she's sitting cross-legged on her king-size Duxiana bed, piles of magazines strewn around her, a couple scripts folded back to various places, scribbled with notes in red ballpoint pen. She's wearing

outfits, piling discarded clothing like a haystack on my unmade bed. I let imaginary conversations unspool in my head where I'm witty and poignant and just the right amount of self-effacing.

I know I'm deep into a friend crush, but it feels intoxicating and perfect. For the first time, I'm exactly where I'm supposed to be. I'd always imagined that all I needed was one victory for myself—hell, one *moment* for myself—to lay the ghosts of my childhood to rest, to start my own life instead of feeling Donna looming over me. But this is even better.

I feel the first rough swells of love when I finally start working at Eva's house. She acts like she doesn't know what to do with me, like she's never had an assistant before. Maybe it's because her previous assistants were all culled from her handful of close friends, either ones who went way back or ones like Scout, whom she met when she was a cocktail waitress at Skybar on Friday and Saturday nights. Or maybe she was just trying to make me feel comfortable, like I was a part of her family. I'm such a sucker for women who want to make me a part of their family.

Sadly, I'm still in a phase with Eva where I'm hypercritical of everything that comes out of my mouth, constantly taking the temperature after every sentence I utter and beating myself up for always sounding too something: too eager, too agreeable, too desperate to please.

I think it's the flip side of the problem that most girls have with boys, all fluttery and insecure about their breath or if you can see that little bulge of back fat over their bra straps. Weirdly, I don't have that. Boys are easy. Girls see everything and tuck it away to use against you later. Girls smile in your face and then spit in your hair

oven with the convection feature I've only read about in cooking magazines.

She's still brushing me off, even though I'm pretty sure we're past the *Star* magazine suspicions. Maybe it's just the privacy issue. She told me on my third day on the job, "This is the most important thing you need to learn: I don't like people knowing my business. Especially about money. And that includes everyone."

"Okay," I said.

"A lot of people—my manager, my mom, even Scout—are going to want information from you, stupid shit that may seem unimportant, but it's the most important thing, above anything else, that you protect my privacy."

Which is easier if I'm never in her house, I suppose. Whatever. My new kitchen is the size of an airplane bathroom, but there's something to be said for working at home in your underpants.

My first big purchase with my Eva money is a Mazda GLC that I buy for two thousand bucks. It's metallic gold and I tell myself that the upholstery smells like Cheetos, but it's really closer to feet. It's a three-door, and there's a hole in the hatchback where someone removed the wiper-blade mechanism, but other than that, the car is cherry.

I start running errands for Eva—easy things like picking up clothes from the dry cleaners or purchases from Barneys and Fred Segal. It's amazing how quickly the anorexic salespeople at Les Habitudes morph into caricatures of fawning kindness when I say who I work for. I'm not gonna lie, I love it.

It takes me ten days to fall for Eva. I find myself doing all of the silly, obsessive things most girls do when they're pining after a guy: I check my phone every thirty seconds to make sure I haven't missed a call or e-mail; I spend inordinate amounts of time choosing my

Thirty-two

The move into the new apartment is freakishly smooth, and working for Eva is literally a dream come true. And I mean *literally* literally: I've dreamed of this a hundred times. I'm talking on the phone with Eva Carlton like we're friends, I'm making plans and running errands for Eva Carlton.

For the first time in my life, I'm inside the circle of *real* celebrity. That's not me with my nose pressed against the glass, that's not me feeling left out, left behind. Maybe I'm not famous, but I'm famous-adjacent, and the glow from the nearby klieg lights is good enough for me.

Also, this is pretty much the easiest job I've ever had. For the first few weeks, I hardly even see Eva—which is thoroughly disappointing—because she's on a break from her soap and working on a different show, which she mockingly calls *Thirtysomething High*. She's in practically every scene because they're maximizing the time they have her, stockpiling pieces of story that they'll drop in for weeks or months after she's gone.

Mostly my job is cooking for her at my new apartment, then delivering the food to her before she gets home. I keep offering to cook at her house—I'm dying to get all Top Chef on her completely unused six-burner Viking range and Bosch double wall

"So you're leaving?" she calls through the closed door, five minutes later. "The room will be free?"

"Yeah," I say.

"Let me know if you need any help, buttercup."

Like nothing happened. Which pretty much encapsulates my drama with Donna, right there in one interaction.

Donna raises a hand in my direction as if she's warding off evil spirits. "Just stop," she says wearily. "For someone who's so fucking smart, you're acting like an idiot," and the resignation in her voice makes me cringe. She's still my mother, after all. "Everything I've done, I did to take care of you. Of you, of Gloria . . . and now Emily. Don't you get that?"

"To take care of me? To take care of—" Now I'm the one who's yelling. "I don't give a fuck about Emily. She's another fucking fabrication in your lizard brain. Screw Emily. Let her die already."

"She's falling apart." Donna crumples into a faux-leopard-upholstered Louis IV chair I've never seen before. "One T-cell at a time. All she wants is to connect with her kid before it's too late."

It's not like I ever bought into the existence of Emily, but now I'm utterly confident she's a figment, because Donna has taken it completely over the top. She doesn't have enough empathy to care this much about anyone other than herself. It's a rookie manipulation mistake, and, frankly, I'm a little surprised at her.

I stand there for a minute, listening to myself breathe too heavily. Then I say, "And is there one good reason why Emily's kid might want to connect with her?"

"Because they're family."

"Family," I say, "is not a fucking excuse."

"Never mind," Donna says, burying her face beneath her perfectly manicured hands. "Just go."

"Not a problem," I say, though there's something sitting so heavily in my chest that it feels like I've swallowed an anvil.

I drag my moving boxes into my room and slam the door, hard, behind me. Because I'm twenty-nine. Going on nine. I pack all my stuff, my head throbbing and my jaw clenched.

pulls a bunch of scallions and a bag of gluten-free crackers from the bag. "Are you still eating gluten?"

"Those are Megan's favorite wineglasses," I tell her, my voice quavering. "In fact, this is Megan's favorite apartment, and did you hear me? You have to leave."

"Oh, I've made other arrangements."

"What does that mean?"

"Well," she says. "I talked to those nice landlords of yours."

"The landlords?" I repeat. "You talked to the landlords?"

"They're so sweet," she says. "It seems there was some unsavory business about the lease not being in your name, but I've worked that all out."

"What does that mean?"

"I took over the lease from that girl you and Megan were 'housesitting' for. What do you think of the new walls in my bedroom? It's called sandalwood."

I don't say anything. I can't. Star constellations explode like fireworks in my peripheral vision.

"Or tell me about *your* new place," she says, into the silence.

"You're kidding, right?"

"Now you're just being difficult," she says. "It's ugly. And you know what else?"

"Here it comes," I say. "Let me guess: 'I sacrificed everything for you'?"

Donna rolls her eyes theatrically and takes a big sip of her wine.

"No? How about 'You had everything handed to you on a silver platter, and you dumped it in the trash bin'? Or is it the old chestnut about how you got screwed by the network in fucking 1922, when you were seven years old, and you should still—"

I whirl around to double-check I haven't accidentally wandered into someone else's apartment. But no. My room is completely untouched, down to unmade bed and the desiccated pear core on my nightstand. I'm in a parallel universe.

I'm still standing there gawking when I hear the front door open.

"*Hel-lo*," my mother singsongs, heading into the kitchen with an armload of Whole Foods bags, a pineapple top and a wine bottle protruding from the recycled brown paper. "What are you doing here?"

"Well," I say, shooting for a measured tone and utterly failing. "I live here, for starters."

"Really?" She sets her bags on the countertop and regards me coolly. "Because last I checked, you'd pretty much abandoned ship."

"Yeah, about that," I say, grateful for the transition, however awkward. "I found an apartment."

Donna springs into animated enthusiasm. "You did? That's so great, buttercup. Where? Tell me *everything*."

Everything? Is she kidding? I don't even want to tell her the zip code. "I'm just here to pack my shit. And to remind you that you need to be out in a couple of days."

I'm waiting for the screaming to start, but instead she opens the refrigerator and plucks a half-empty bottle of white wine from the door, her nails clacking against the door handle as it shuts, just forcefully enough to tip me that she's having a feeling.

"Would you like a drink?" she says, taking two of Megan's Riedel wineglasses from the cupboard.

The outward lack of a reaction to my bombshell makes me edgy. "Would I like a drink from *my* refrigerator?"

She uncorks the bottle and fills her glass. She takes a sip, then

Thirty-one

The elevator at my old place isn't working, so I drag a giant stack of folded moving boxes up the dilapidated stairs. I pause outside my door and listen. All is quiet. I slide my key into the lock and the door swings open into the dim entryway. The first thing I notice is the absence of Donna smell. In fact, there's a distinct aroma of floor wax and orange peels. *What the fuck?*

I flick on the light in the long, narrow hallway, which illuminates a scene I can barely parse. The floors are burnished to a dark sheen and there's a beautifully worn Oriental rug in the living room with a faded brown velvet ottoman smack in the middle. A wide, wooden tray sits on the end table with a handful of glass candles alight and guttering. There's a stippled milk-glass vase on the kitchen counter with a profusion of lavender blooms cascading from its narrow neck.

I repeat: *What the fuck?*

"Hello?" I say, into the empty room.

I cross the living room and peer through the open door of Megan's old bedroom. The walls are freshly painted a buttery, sandy ochre and there's a queen-size bed with white-and-tan patterned linens, including a flounced bed skirt of crumpled saffron linen. It looks like a page from a Pottery Barn catalogue.

I bet he looks amazing in sequins and heels.

His accent is a cross between Marlene Dietrich and the ebulliently gay Carson Kressley. I'm a little scared of him, but his enthusiasm for Eva is infectious and I sign a one-year lease at nine hundred dollars a month. The apartment is tiny, but the kitchen is retro and tile and has a big window—and he'll let me move in immediately.

There's something magical about Eva, and it's rubbing off on me.

two hours a day. I spend most of my time looking for a cheap studio apartment in Hollywood.

Then yesterday Eva asked if I could make her some meals so she'll have something to eat when she gets home from the night shoots she's on all week. I offered to cook at her house, of course, but she sweetly stonewalled me. I think she's waiting to make sure I'm not going to take pictures of her laundry hamper and sell them to *Star* magazine.

It's fine with me, except I can't cook at home because of Donna. I *have* no home because of Donna; if she's there, home isn't. But that doesn't really matter. It's past time to walk away from the apartment. Megan's gone.

So, I'm about to be homeless and if Eva wants my food after next week, she might have to be satisfied with stuff I cook over a beach bonfire. I can barely even cover a security deposit.

Then I hand my rental application to the manager of a twelve-unit building in Hollywood, populated entirely by drag queens, and he squeals when he reads what I've written under "Current Employment."

"You work for Eva Carlton?" His eyes light up like he just heard about a sale on size-12 women's shoes at Nordstrom. "I called in sick when my TiVo broke and she was supposed to marry Jason."

I have no idea what he's talking about, but I smile and nod as he breezes past the security deposit and the fact that I haven't had an apartment in my own name in years, and that there's a tiny problem with my Visa bill, which I haven't paid more than the minimum on since the divorce. Good thing my affiliation with Eva is distracting the manager—who, by the way, is receiving me in his tiny studio, next door to the one I hope to claim, wearing a black Fernando Sánchez silk dressing gown with a burgundy rolled collar, his thin brown hair scraped into a bun on top of his angular head.

receptionist called to make sure I received the file and she sounded like Joan Cusack's character in *Working Girl*.

I shouldn't have been intimidated, but I was. She sounds like she'd fly out here and kick my ass if I don't remember that Eva needs an extra 5,000 IU of vitamin D when she works more than two nights in a row. I'd asked why, and the receptionist asked, in a nasal, icy voice, exactly where I'd gotten my culinary training, again?

"Oh, shit," I said. "That's Eva on the other line. Thanks!"

I hung up before she could ask anything else. I bet she knows where to get goat-milk Parmesan cheese, the whore.

I leave two messages for Eva's manager, Melanie—we haven't talked since she ditched out at the Ivy—but she never calls back. Finally, I just buy sheep's milk Romano from Bay Cities on Lincoln and I'm hoping for the best. Of course I Googled it, but the real in-the-know stuff in L.A. is never online. I'm sure there's some grizzled old dude in Rolling Hills who makes five hundred pounds of the stuff a year, and you have to get on a waiting list behind Beyoncé's chef and the guy who buys for Mozza, and that's *if* someone recommended you.

I'm totally up for the job, but I'm flying blind right now, because Eva is easing me into things. She was effusively vague about the details of the job on the phone, and the sum total of my personal-assistant duties so far has been making a couple phone calls to people who want to shower her with free crap (Juicy Couture, no thank you; Alice + Olivia, yes, please), and running meals up to her house from restaurants that don't deliver.

She's paying me a thousand dollars a week and using me for only

Thirty

The next Wednesday, I'm standing in Scout's minuscule kitchen at seven in the morning, cooking six dishes to drop at Eva's house, both in the antiquated oven and on the greasy, temperamental stovetop.

I'm not at home because my mother's perfume gives me nightmares, endless labyrinths of Calèche-scented flowers beckoning like giant Venus flytraps. I woke up sweaty in my dark, empty room two mornings in a row, then packed a bag and fled to Scout's. Just until I find a new apartment.

Which will be easier if I don't get fired, because I've completely overextended myself. Almost everything I'm cooking is completely outside my comfort zone because Eva is vegan. Well, she's Hollywood vegan, which means she'll eat feta cheese and goat-milk Parmesan, but not cheddar or Swiss or Gouda.

"My old chef used to make me these amazing crackers, and goat-milk Parmesan was the only ingredient," she told me. "I've been dreaming about them for weeks. But it has to be goat milk; it can't be cow. Oz will freak."

Oz is Eva's celebrity nutritionist. She had his office e-mail me the ingredient list for her protein shakes and it's thirty items long. His

her enjoy her slice of paradise without being dragged back down to my level. Which is pretty low: I don't even return Eva's call immediately. I want to bask in the glorious possibility before the brutal reality slaps me in the face again.

Instead, I creep into the kitchen to reread the note Megan left on the counter: *Boof, I miss you already.*

She also left all her kitchen stuff. I mean, why wouldn't she? Why take a rusty Jack LaLanne juicer and a box of mismatched pots and pans to what is surely a Cordon Bleu kitchen at JJ's house? It doesn't matter. The last thing I want to do is cook while my mother's here. Or even eat. The whole house smells like her, a combination of the cheap Chenin Blanc she drinks when she has to buy her own alcohol and her expensive perfume, Calèche, which she's worn since I was a baby.

They say that the sense of smell is the most powerful trigger of memory, and my happy apartment is now a Willy Wonka tunnel ride into my fractured childhood.

My phone rings. I've already given Eva Lorde's "Royals" for a ringtone. Holy shit. It's her.

"Hello?" I say, like I have no idea who's on the other end.

"Jess?" Eva says. "It's Eva."

Not a manager, not an agent. Eva herself. "Hi! Hello. Hi. Yes." I'm the stuttering fat kid who accidentally bumped into the head cheerleader in the cafeteria line.

She laughs. "So are you going to come work for me?"

"You know what?" I say. "I totally am."

After we hang up, I stand in the kitchen, motionless, for a long moment. I open the refrigerator and stare at the empty shelf where Megan kept the celebratory reserves.

Everything changes.

Twenty-nine

I play the message again, and feel both a scary jolt of pure joy and a pang of homesickness for Megan. I want to call her in from the other room and make her listen to the message two or three or ten times. I want to pop a bottle of morning champagne and watch *House Hunters International* with her.

I think about calling her all the time, but the cell reception at JJ's house—sorry, *JJ and Megan's* house—is atrocious, which is ridiculous since there are more celebrities per square inch on that street than on the back lot at Sony during pilot season.

Still, I know if I pull the fire alarm and admit everything, she'll be up my ass so fast I'll need stitches. There's some comfort in that. I even rehearse the message: "So are you guys fucking on JJ's Hastens bed and drinking a bottle of Cristal? My mom is killing me, but I got a job with Eva Carlton, and it's bringing me back to life. Give me a call when you have a sec!"

But I don't call Megan. She's so caught up in . . . whatever you get caught up in when you move in with your hot new boyfriend in his fairy-tale castle in the Hollywood Hills, and are, I don't know, ordering delivery from Il Covo and getting a pedicure in your new walk-in closet.

I know she'd want me to call, but something in me resists. Let

Then JJ says, "She is. You're right. I'm not going to fuck this up."

Erase.

"I'm leaving for a location shoot—" It's Eva, her voice instantly recognizable through the traffic noise in the background. "San Francisco the day after tomorrow. I know it's late . . ." A horn blast obscures her words. ". . . from the production company and I'll bonus you more if . . . one I want."

Save.

"Leave here?" She gestures toward the living room doubtfully. "This apartment?"

"Yeah," I say. "Sooner rather than later."

"We can't leave. I don't have anywhere to go."

"Believe me, I'm aware of that."

She gives an offhand shrug. "You'll figure something out."

"This is not my problem," I snap, a flush of anger in my cheeks. "Don't you make this my problem. I'll figure something out? Yeah, I used to have a lot figured out. A job, a roommate, a fucking life."

"And that's *my* fault? I gave up everything to raise you."

My heart starts pounding like I'm jacked on street speed. I mean, I've never actually been jacked on street speed, but I've seen *Crank*, with a sweaty, adrenaline-filled Jason Statham, so, same thing. "You're kidding, right? You couldn't have done less to raise me if you were dead."

"You're overwrought," she says calmly. "You should take a bath and we'll discuss this when I get back."

I pivot on my heel, cross to my doorway, and yell, "There's nothing to discuss."

Slamming the door evokes every conversation we've had in the past ten years, and when I try to click the lock into place it spins around without engaging, like a giant metaphor for our whole relationship.

The next morning, there are three messages on my voice mail. The first is a hang-up from my mother, her throaty breathing a giveaway before the line goes silent and the automated voice says, "End of message."

Erase.

I glance at the clock over the stovetop. It's 7:15.

"You're kidding, right?" I say, dumping the sludgy contents of the least-dirty mug into the trash. "Why are you even awake?"

"Rick and I are going to the farmers' market," she says. "You should come. It would do you good to get out in the world."

I rinse the mug. "I'd love to, but I've got shit to do."

"What could be more important than spending the morning with me?" she says coquettishly.

"Spare me, Donna. Let's not pretend that you're here for any other reason than you incinerated another living situation and I'm your goddamn safety net."

My hands are quivering as I toss the mug into the sink, where it crashes into a stack of Megan's white IKEA plates.

"Darling, no," my mother says, wrapping her arms around me in a fragrant hug, her moist skin cool and slightly sticky against mine.

I feel like Charlie Brown when Lucy holds out the football. I know she's going to snatch it away as soon as I come in for the kick, but right now it feels good to let her hold me and stroke my hair.

"Is everything okay?" she says. "Tell me what's wrong."

"I'm tired," I say in a quavering voice.

"Oh, sparkle pie," she says, and I burst into noisy tears that immediately devolve into even noisier hiccups.

And then, God help me, I tell her the truth about waiting for Eva's call. Jesus, such an amateur maneuver. I blame it on Megan's absence.

"It doesn't matter," I say, sniffling and wiping my eyes. I step back and steel myself against her. "The bottom line is, I quit my job. I have no income. We're going to have to leave the apartment." I mean, it's not like I'm not going to forgive her in exchange for a little sympathy and a stupid hug.

Thinking of you. Call me if you want to talk.

And I do. I do want to talk to him. But the whole thing's more than I can wrap my mind around right now.

Then the text comes. From Scout. With Eva's phone number.

I shade the screen with my hand and look at the numbers. I'm no longer two degrees of separation from Eva Carlton. I'm one. I have her personal phone number on my personal phone.

When I get home, the lights are on, but the rooms are empty. The kitchen is a disaster and there's a blanket—no, wait, that's my duvet—spread out on the living-room floor. There's a pile of sodden bath towels on the floor of the bathroom, and an upended bottle of my Peter Thomas Roth conditioner in the sink.

I don't care. I can't stop smiling. I call Eva and leave a chirpy, enthusiastic message on her voice mail, then sit at the kitchen table and wait for the call.

Flash forward: twenty-four hours later, and the call still hasn't come. The reality of my mother in my house slaps me in the face at every turn. Her damp, neon-pink thong underwear drying on the shower rod; a pile of Gauloises cigarette butts in a *Jade Wolf* coffee cup on the living-room floor; the opened pile of mail sitting on the kitchen counter. I don't even know how she got the mailbox key. It's yogurt time.

When I step into the kitchen the next morning, my mother's standing there with a full face of makeup and her purse on her shoulder, sipping coffee from a juice glass, because all the cups are dirty and piled in the sink.

"Hello, lamb chop," she says. "It's so good that you're getting plenty of beauty sleep now that you're not working."

"I hate you, too," she says, disappearing into her closet. "But keep it in mind." Her voice is muffled by the sound of wooden hangers clattering onto her bed. "And remember, it's *your* house, not hers."

Yeah, your mouth says.

"I've got a really bad idea," I tell her.

"You mean *another* really bad idea."

"Do you think Eva was serious about the job?"

The clatter of hangers stops, and she appears in the door.

"I know, it's the worst idea ever," I say.

"Are you kidding? She's been waiting for you to call."

Hope blooms in my chest. "I've been waiting for *her* to call."

"Idiot," she says. "I'll text you her number."

"You really think she's been waiting?"

"I know she has," Scout says, then Weston wanders in and she can't see me anymore.

My phone buzzes with a text when I'm still on the stairs, but it's not from Scout. It's from JJ.

Help me. You're my only hope. It's our two-week anniversary. Where am I taking Megan? Something special. This is big.

Really, you fucker? You want romantic advice from me after you snatched Megan away to New Guyland?

Montage in Laguna Beach, I text him. Soft pretzels with Dijon, popcorn with truffle salt, and champagne on the balcony. I think for a second, then add: She is the best thing in your life.

A few minutes later, I'm unlocking my bike from the metal pole in front of Scout's when my phone buzzes again. *Jesus, now what, JJ?*

But it's from Kirk.

on, he's Lenny from *Of Mice and Men*. He's going to moon around in the hallway with wilted daisies and a love note written on a paper towel."

Scout pulls the wadded-up toilet paper from between her toes. "If we're riding the Steinbeck analogy all the way, then she'll be dead and he'll be petting her when you get home."

"Is that the part where I get to shoot her in the head?"

"Exactly," Scout says.

"That's the sweetest thing you've ever said to me."

"You're so fucking broken." Scout laughs.

"Yeah. And for the record, we're talking about more of a *Whatever Happened to Baby Jane?* situation. No one is mentally deficient and well-meaning in this scenario."

"Except you." She crosses the room to plant a sage-smoked kiss on the top of my head. "You're welcome to stay, but I have to get dressed. Weston's taking me to Baja Cantina."

"Virgin margaritas," I say.

Scout turns in the doorway and regards me with a tolerant look. "The point you're missing," she says gently, "is that you're all growed up. If your mom's raining on your parade, deal with it."

Ouch. "Can't I just pay you to deal with it for me?"

"Sure, but I don't take postdated checks."

"Can I pay you in chewing gum and French kisses?"

"Only if you want to marry me," she says.

"I totally want to marry you," I say. "I'll even turn a blind eye to your biker lovers."

Scout laughs again. "You know you can stay here. I mean, you might have to fight for couch space with Tank, but those tattoos were just a prison thing. He's totally not a white supremacist."

"I hate you," I say.

Twenty-eight

Scout doesn't understand my frustration, or maybe she's playing dumb because she doesn't have time for me—she's getting ready for a big date with Weston. She relegates me to the balcony to smoke my cigarette, because she just saged her apartment. I'm already in a bad mood, and her use of the word "sage" as a verb doesn't help.

"You realize that you're hopelessly mired in the '70s," I say. "You're doing more damage to your lungs with that hippie shit than I am with cigarettes."

I exhale a stream of smoke through the closed screen door and she fans her newly manicured nails in front of her face.

"Hardly." She's sitting on her living-room floor, painting her toenails a metallic green that looks like someone's midlife crisis car. "And why do you even care who your mother fucks?"

"You're missing the point."

She caps the bottle and ineffectually blows on her wet toenails. "One of us is."

I stub my cigarette into an empty planter box littered with bottle caps and a deflated Mylar balloon that reads I LOVE YOU.

"Okay," she says. "What's the point?"

I slide the screen door shut behind me and flop onto her brown canvas papasan chair. "She doesn't want to fuck my neighbor. Come

"Okay, first of all, I'm pretty sure he's an unemployable vet with PTSD and not the heir to the Post-it fortune, and second, who paid for all this?"

"Don't be gauche," she says, giving the bubbling pot a final stir. "Now, hurry up and do something with yourself. You don't want to sit down in *that*, do you?"

I beeline to my room, lock the door, and call Scout. "I'm at DEF-CON five. Please tell me you're home and I can come over."

"I'm in traffic on the 10," she says. "But if you take your time, I'll probably beat you."

"I'm not taking my time," I tell her. "I'll be on your porch."

I don't bother changing, or even looking in the mirror. In the hallway, I brush past Rick, who's wearing a button-down shirt and a pair of too-tight blue Sansabelt dress slacks and clutching a bouquet of supermarket mixed flowers. If I hadn't seen the way he eye-rapes Megan when she's on her way to yoga, I might think it was sweet.

When I get to the bottom of the stairs, I call Megan. It rings five times and goes to voice mail. I hang up without leaving a message. The only thing I can think to say is "save me," and there doesn't seem to be much point in that.

I nurse a cup of mint green tea at the Coffee Bean for two hours, smoking four American Spirits and checking my phone compulsively for a message from Eva. No message. No text. I spend the rest of the day shifting between various wireless hotspots, checking celebrity blogs on my laptop. Nothing holds my interest. I can't even drum up a modicum of enthusiastic snark over the fact that Kim Kardashian has a baby named North West. It's a sad day.

Eventually I go home, where I get a double whammy of Donna smell before I even step through the door: the usual whiffs of wine, perfume, and hair spray—and a new, yet completely recognizable scent. Donna is making Irish stew.

I find her in the kitchen in a full face of makeup and a slinky dress, stirring the stew in Megan's one good pot, a white nine-quart Le Creuset enameled Dutch oven that her mother gave her for her twenty-fifth birthday, a subtle reminder that Megan should be on the fast track to domestic bliss.

Carrot peelings speckle the counter like confetti, and the stainless-steel trash can overflows with crumpled pink butcher paper and an upended green wine bottle.

"Hello, lumpkin," my mother says in the purring voice she usually reserves for mixed company. "I'm making us dinner."

I sweep a handful of her debris from the countertop into the trash pile. "Where did all this come from?"

She waves her arm toward the front door. "Rick and I had a little excursion today. He just went home to freshen up."

"You went shopping," I say incredulously. "With the creepy neighbor. And now he's coming for dinner?"

"He's delightful," she says. "Did you know that his father invented the Post-it note? And he's never had lamb stew, so how could I resist?"

multicolored blooms spilling from five-gallon buckets. He grabs a double bunch of white-and-pale-pink blossoms and thrusts them into my hand.

I bury my nose in the petals and inhale a slight whiff of roses and lemon, sparking a vague recollection of an etched crystal bottle of Gloria's on a high shelf in our pink-tiled bathroom.

"For me?" I say.

"For you."

I've spent half my life turning my face toward the warmth of fame, like a sunflower orienting to the sun. I've spun elaborate and detailed fantasies about the red carpet and the Academy Awards. I know exactly what I'd say, what I'd wear.

But give me a bunch of peonies wrapped in brown paper and breakfast at the Pantry and I don't know what the fuck to do with myself. I honestly don't know.

Here's the thing that comes out of my mouth: "I want to cook for you."

When I get home, I drift through the apartment and see that Megan's door is cracked open. No noise inside. My mother's not here. A wash of relief warms me, and I creep into the bedroom. Her bed is in the wrong place. My mother shoved it against the wall.

I lay down in the space where Megan's bed used to be and look up at the ceiling.

I can't live here. Not with her.

As I'm thinking the words, the key scrapes in the lock.

I pass Donna in the doorway. If she's coming in, I'm going out.

She says, "Sweet pea, do you want—"

And I'm gone.

"I do," I say. "But I'm trying to play to the room."

He laughs and gives me an appreciative head-to-toe once-over that reminds me I'm dressed like a semi-homeless person from the 1980s. Seriously, the Iris Fucks shirt? While he looks like the tear sheets they used to create the vibe for Bradley Cooper's *GQ* cover?

Kirk leads me to the far corner of the massive room and loads giant spools of invisible nylon thread and white floral tape onto a brimming cart.

"What's that for?" I ask.

Kirk looks at me sheepishly. "I'm making an orchid wall for Rachel Zoe's fashion show."

"I hope you're getting seriously *paid*," I say. "I've heard she's a handful."

"She's fine. And it's not always about getting paid."

"Really?" I say. "Because I heard she's an anorexic drug dealer who can't keep her former clients from selling her out. And also, why on Earth would you do what we do if you weren't getting paid?"

"Wow, slag much?"

"Three generations in Hollywood," I tell him. "My grandmother slagged Judy Garland. You might want to get used to it."

"And you might want to get *over* it," he says. "Bitter only poisons the bearer."

"Dude," I say. "You need to find a Chinese restaurant with better cookies."

This is where my smart-ass attitude is supposed to win him over, but it falls completely flat. He just gives me a long look that makes me feel like I've failed some kind of secret test. Which, of course, pisses me off. Fuck him and his secret tests. He should pass *my* tests.

I'm working up a righteous anger when he steers us into a stall that contains every peony in Southern California, a profusion of

Then Kirk kills the engine and opens his door. "Stay there. I'm coming around."

He leads me down a couple flights of stairs, one hand on my arm and the other at the small of my back. I hear the clunk of an emergency exit door; then we emerge into a cavernous space that's teeming with activity and it smells like I'm standing in the middle of a lavender field in Provence. No, the rose garden at the White House. Or an orchid farm in Ubud.

"Are you ready?" Kirk says, then he pulls the bandana from my eyes.

I'm looking down a long aisle of buckets brimming with bundles of freshly cut flowers. There are roses and daisies and hydrangeas and snapdragons in every color of the rainbow, stuffed into five-gallon buckets and stacked on risers as far as my eyes can see.

It's not like I've never been to the flower market before, but not this early, when they only let industry professionals shop. When they're open to the public, their stock is diminished and their prices are tripled. This is like a backstage pass to Coachella, except much more fragrant.

I'm still gawping at fifty thousand square feet of fresh flowers when Kirk grabs an oversize garden cart and herds me down the aisle. He squeaks to a halt and chats with a green-aproned woman who starts piling boxes of cellophane-wrapped white dendrobium orchid stems onto his cart. It's an obscene amount of floral excess.

"Are you throwing a party for Jennifer Lopez?" I say.

"You're closer than you even know."

"Let's see," I say. "Birthday party for Mariah Carey's twins?"

His grin flashes. "Do you *have* a reference that's not stuck in the last decade?"

I flash back to the day at the Date Palm when I cracked Kenner for the same lame thing. Jesus, I'm more nervous than I realized.

we're having a comfortable moment or an awkward one. Silences are weird that way. Or maybe it's just me. Kirk looks perfectly happy.

I have no idea where we're going when we glide onto the Sixth Street off-ramp downtown. The only time I've been down here this early was once when I had jury duty at the courthouse. "Do you have a court date?"

"Do you really not know where we're going?" he says.

"Not a clue."

He's adorably elated by my response. "In that case, you need to put this on."

He reaches into his glove box and pulls out a tattered red bandana tied in a knot like a cowboy's neckerchief.

"So you've got a western fantasy thing," I say.

"No," he says, laughing. "Over your eyes."

Ted Bundy, mountain lion, ax murderer. "Um, what?"

"Jess," he says, patiently. "Would you relax?"

There doesn't seem to be an overwhelming flight-or-flight thing happening, so I figure, what the hell? I pull the bandana over my eyes.

"What's that smell?" I say.

"Oh, that's Ruby," he says.

"Is Ruby your girlfriend? She needs to wash her hair a little more often."

"Ruby is my bulldog," he says. "You're wearing her favorite accessory."

"That explains it," I say.

He tells me that she's fastidious, then launches into the story of how he adopted her as we pull into a parking garage. *Uh-oh.* I'm a sucker for a dog story. I hear the bleep of the ticket dispenser, the closed-in whoosh as we ascend through the winding ramps, the squeak of rubber tires on the slick concrete.

"Liar," he says. "What're you doing with your keys?"

I look at the ninja star in my hand. "Meditating?"

"Right, like janitorial prayer beads," he says.

"Yeah," I say, then look at him and count to three slowly before looking away. I read an article in some women's magazine that it's a foolproof flirtation tool.

There's a nanosecond of silence, which doesn't have enough time to become uncomfortable. "If you're done with your hike, you want to grab breakfast?" he says.

Wow. That shit is on point.

"I don't know, I've got, uh—" I almost say *Tyler,* but of course I don't have him anymore. "Places to be."

"Come on. I'll buy you breakfast and have you back by eight."

We walk down the hill and onto the paved path toward the parking lot, and I make a show of checking the time on my phone. "You're so full of it. We're not going to be back by eight unless you're taking me to McDonald's."

"Who said I'm not taking you to McDonald's?" He opens the passenger door of his Volvo, and I realize this is the real Kirk, not the white Range Rover Kirk, and I'm kind of smitten. "Don't underestimate the power of an Egg McMuffin."

"Fine," I say, sliding into the charcoal leather seat.

It's not until I watch him walk around the front of the car that I become painfully aware that I'm wearing Target sweatpants and an oversize sweatshirt that says IRIS FUCKS in sparkly silver letters across the front—an ironic homage to Harold Robbins and his potboilers from the 1970s.

I barely have enough time to duck my nose toward my left armpit before Kirk settles in behind the wheel. At least I don't stink. We drive down PCH and onto the I-10 freeway in silence. I'm not sure if

Today, Yoga Guy is absent, and I plod alone up the hill toward Skull Rock, breathing in the chaparral-scented silence. When I get to the ridge, the first fingers of rusty orange sun are just cresting over the hills. I climb up onto the rock's lowest ledge and tuck my legs under me, rubbing my hands together. My breath is faintly visible in the chilly morning air, even though it will be pushing eighty degrees by the time I get home. It's kind of heaven, this stillness in nature.

Except for my fucking brain.

My brain is not a stillness-in-nature kind of brain. It's more of a hateful drone: *Your best friend abandoned you and your mother is in your apartment; there's no getting away from her, she's always there . . .*

I hear the crunching of trail dirt behind me, and my brain tumbles down Maslow's pyramid from "self-doubt" to "murderer, rapist, mountain lion!" I feel a big male presence standing over me. It's either Yoga Guy or Ted Bundy, and it's definitely not Yoga Guy. There's nowhere to go; Skull Rock is perched at the top of a slope that descends across a narrow footbridge over a boulder-strewn ravine of California sagebrush and coyote shit. The only way out is past whatever is lurking behind me.

I lurch to my feet and whip around, turning my car keys into a neck-maiming ninja star, only to crash into a solid mass wearing faded-green cargo pants and a pair of Timberland boots held together with duct tape.

"I thought that was you," the prison escapee says.

It's Kirk. Fitted black T-shirt. Muscular arms. His hair mussed and a smile on his face.

I feel myself returning the smile. "I do love a pre-dawn hike," I say.

Twenty-seven

Every now and then, when life feels particularly shitty—like, say, when I've quit a job without having another locked down, and my absentee mother shows up—I get the urge for an early morning hike. I'm talking *first thing*, before the dawn breaks over the Coffee Bean. I'm not what you'd call a morning person, but there's something about the still air that makes everything a little more bearable.

So the morning after Donna's arrival, I tiptoe out of the house, to Temescal Canyon, by the beach near Tyler's house. I've walked Zelda there a few times, on Kirk's recommendation. She loved it— there are rabbits and deer and a trickling waterfall—though Tyler would have shit himself if he'd realized I'd taken her into the *wild*. Lyme disease! Rattlesnakes!

Sure, I'm running the risk that I'm going to be murdered by a prison escapee, but it's a worthwhile tradeoff to be able to hike in the cool silence and watch the sunrise.

The other people at Temescal this early keep to themselves, with the exception of Yoga Guy—there's always a Yoga Guy in L.A.—who dresses in neon spandex and stands on the grass at the trailhead, contorting himself and emitting a stream of atonal *om*-ing. Sometimes I have to hike all the way to the ridge trail just to get out of earshot.

"Fine with me," I say. "She's *your* dying friend."

"Yes, she most certainly is," Donna says, and there's a warble of sadness in her voice. Hat-tip to Donna for her theatrics. Yawn.

"Have you heard from Scout's actress friend? What's her name again? Ava?"

Okay, this is another thing that Donna does that really bugs me: she pretends she doesn't know who people are. I want to let it slide, but I can't help myself.

"Really? You can't remember the name of the person you tormented Scout about for twenty minutes the other day?"

Donna tosses her hair over her shoulder like a sorority girl. "It wasn't twenty minutes, it was more like two. You girls are so dramatic. So have you?"

"No."

The disappointed set of Donna's mouth still kicks me in my gut like a kangaroo, but before I can figure out how to respond, she flips an imaginary switch and gives me a brilliant, spangled smile. "It will all work out, lamb chop. Let's go be good party guests."

Of course she wants to be in the room where the wattage is. It's a family trait.

"You're missing the point," Donna says. "I wanted to teach you how to dream."

"And here I am, living the dream."

My sarcasm goes right over Donna's head, or, more likely, she's choosing to ignore it. "Well, you're closer than you've been in years, lamb chop. Don't be so hard on yourself. Life is short, and we don't always get to see it all the way to the end credits."

Oh, barf. Now she's Gandhi in a Pucci dress.

"I mean, if I've learned anything from taking care of Emily all these weeks, it's that you need to carpe the hell out of the diem."

I'm pretty sure she's not translating that properly, but there's no point in correcting her.

"So, how is Emily now?" I say. I ignore Donna's fabrications about 92 percent of the time, but sometimes I get petty and can't help tormenting her a little bit.

"She's fine, I mean, as fine as she can be, considering," Donna says, suddenly enamored by the armful of gold bangles snaking up her arm.

"What's wrong with her, again?" I say, all faux concern.

"Stage IV anaplastic astrocytoma," Donna says, and it rolls off her tongue like she's performing a walk-on role on *Grey's Anatomy.* "Do you know what that is?"

"Well, I know what the 'stage IV' part is," I say. "It's when the handsome, white-coated doctor tells the pallid yet beautiful patient to get her affairs in order."

"Exactly," Donna says.

"You seem kind of jazzed for someone whose friend is dying."

Donna's face crumples like a wilted peony. "You have no idea what I'm feeling. Look, I'm tired. I had a long drive. Can we please just let this go right now?"

"Says the girl wearing a T-shirt from a band who peaked before she was born," Donna says with a tilt of her wineglass.

Busted. That's the irritating thing about Donna: she's pretty spot-on most of the time.

"Tell me everything about your world, lamb chop," she says, glancing toward the living room. "You're certainly keeping good company these days."

I nudge the door shut with my foot. No one needs to hear this. "I'm not *keeping company*, Donna. This is my house."

"Well, of course, sugarplum," she says. "But JJ Kelly? We're talking a whole different universe from your composer." She says *composer* like she's saying *hobo* or *garbage man*, all blue-collar judgmental.

"Gross, Mom," I say, and immediately hate my fourteen-year-old's response. "He's not my employer, for fuck's sake. He's my best friend's new boyfriend."

"That's not all he is," she says, lowering her voice to a throaty growl and sparkling her eyes like she's flirting with me. "Don't pretend you haven't noticed. I almost fainted when he opened the door. It was like something out of a dream sequence. Who expects to knock on a door in a place like this to have JJ Kelly open it and take your bag? And he was so friendly. He hugged me!"

Against my will, a small smile rises on my face. "Yeah, he's pretty great," I grudgingly admit.

"Do you remember when we saw *Joseph and the Amazing Technicolor Dreamcoat* at the Pantages?"

I absolutely do. It was a magical afternoon. We ate Milk Duds and Donna poured a little airplane-size bottle of Bailey's Irish Cream into her cappuccino and let me have some.

"Yes," I say, yawning. "It was like a Bible-study class, starring Donny Osmond."

She's right, of course. JJ's been working as an actor since he was nine. In fact, I'm sure Donna's in the other room trying to figure out how to monetize her proximity to a solid B-list television actor. And probably going through Megan's lingerie drawer.

I peek through the doorway of Megan's bedroom and see Donna's fake Louis Vuitton suitcase gaping on the bed, a profusion of silky fabrics and worn denim spilling from the sides. Then I step forward and can't see anything except Donna. She's five-four in heels and a size 2 at the outside—but her presence fills the room to the point of suffocation.

She's kneeling on the settee in front of the dresser, brushing her blond, highlighted hair and regarding herself in the mirror. She's wearing what appears to be a vintage Pucci caftan, a swirl of ice-cream pinks, with a dangerously plunging neckline.

"Buttercup," she exclaims, rising and holding her arms out like Jesus welcoming his flock.

"I brought wine," I say, shielding myself with the bottle before she can envelop me in a bony, silk-clad hug. Seriously, I could slice prosciutto on her collarbone.

"Yes, please," she says, plucking the glasses from my hand.

"You look great," I say as I pour.

"You too, muffin," she says, but her lip curls at my ratty Sex Pistols T-shirt.

I sip my wine, unsure how to handle that blatant lie so early in the conversation. The air between us is warm and sticky, like engine oil.

"I've been trying to call you since I hit the Grapevine," she says, lying again. "It went straight to voice mail. I was so thrilled that Megan and her new paramour were here to receive me."

"Jesus, Mom, why do you say shit like that? You sound like such a poseur."

Megan laughs and pulls a stack of plates from the cupboard above the sink. "We might have stopped at the Farmacy earlier."

The Farmacy used to be the go-to medical marijuana emporium for young Hollywood. Now it's just an overpriced tourist trap, but it is right down the street, and I'm sure that JJ's face gets him special treatment.

"Are you stoned right now?" I ask. "I don't want to harsh your buzz, but can you please explain how my mother is in your bedroom, dressing for what appears to be a dinner party in her honor?"

"It's not a conspiracy, Boof," Megan says, slinging an arm around my neck and leaning her head on my shoulder. "She got here forty-five minutes ago and we were on our way to get food, so we thought we'd make it easy for everyone. She's been driving all day. She needed a shower."

"Yeah, well, a heads-up would have been nice," I say. I sound like a pouty child.

"I'm sorry," Megan says, and she's not insincere, but her sparkly mirth is completely annoying. "Why don't you go in and catch up with her? We've got this."

JJ is unloading a paper sack filled with bottles of red wine, and I can't help but notice that it's the good stuff, I mean, domestic, but still.

I point at a bottle of Duckhorn Cabernet. "Can I get a glass of that first?"

JJ peels the foil from the bottle and uncorks it expertly. "Just like the old days."

"You were a waiter?"

JJ nods. "I knew those shifts at Outback Steakhouse would pay off someday."

Megan laughs and takes a sip from the bottle. "You're so full of shit. You've never worked a day job in your life."

"Will you please just get out there and do some damage control?"

Megan laughs. "You're ridiculous. Okay, I'm going. But tell me you're happy for me, or—or at least not pissed that I'm leaving. I'm in lo-o-ove."

I'm the worst friend ever. She's practically incandescent, she's so happy, and I'm making her worry about me. "It's awesome. You and he—I don't know, you fit. I'm totally happy for you."

"And you know I'll take care of the rent for a couple of months if you need it, right?"

"You just enjoy JJ," I say, tugging a pair of sweats onto one leg and hopping around the room.

"You sure you're okay?" she asks, pausing with her hand on the doorknob, and my heart breaks at her genuine concern.

"I'm great, as long as you get out there before my mom starts blowing your boyfriend."

"Jesus!" Megan says, somewhere between entertained and horrified. "You're so dramatic."

"Oh, Boof," I say to the door after she's gone. "You have no idea."

When I finally summon the courage to leave my room, it feels like we're having a party. Megan and JJ have brought enough food to feed a dozen people: a caprese sandwich with fat, oozing tomatoes and thick slices of fresh mozzarella on a crusty baguette; a farmer's salad piled with grilled artichokes and spangled with shavings of fresh Parmesan; a Mediterranean platter with the biggest kalamata olives I've ever seen. There are containers of soup and an extra bag of breads and a pastry box that I'm sure has an assortment of their amazing pies.

"What the hell?" I say. "How many people are we feeding?"

She kicks the door shut with her foot and flops onto my bed. "She's not that bad."

"Oh, okay," I say, like I've had a sudden and impossible change of heart.

She rolls onto her stomach and looks at me through her tangle of curly hair. "I need to tell you something."

"Uh-oh." I regard her suspiciously. "What?"

"JJ wants me to move in with him."

"Wow."

"I know." She clearly wants to be serious but can't contain her enthusiasm. "I mean, it's a step. I mean, whoa, right? I mean—moving in together."

There are at least five reasons that this statement guts me. The first two are—*Oh my God, don't leave me* and *What am I going to do about money?*—with a laundry list of the seven deadlies (envy, jealousy, lust in particular) making up the balance.

"That's awesome!" I say, forcing myself not to chug from the Hendricks bottle. "And . . . fast."

"I kno-o-ow," she says, dragging her words out into a groan. "But I'm completely smitten, Boof. I feel like a schoolgirl."

"He's amazing," I say. "You're great together. He wanted to cook you breakfast."

"And—don't freak out—it's kind of good news that I'm doing it right away, because then your mom can have my room, you know?"

Before I can throw myself around Megan's waist and cling like a limpet, I hear my mother's trilling laugh from the living room.

"Oh my God," I say. "Please tell me you didn't leave her in there alone with JJ."

"Jesus, Boof, don't be a weirdo. What do you think is going to happen?"

breasts over the top of the knotted towel and I feel like I'm in one of those humiliation dreams where I'm naked at the school assembly.

"Mom," I say, then stop. I've got nothing to say to her.

"You never told me you had such a hot sister," Rick says to me, but really to Donna.

I roll my eyes so hard that I think I've pulled a muscle, but Donna just smiles and murmurs something about him being too kind.

Then the elevator door creaks open and Megan and JJ come spilling into the hallway, loaded down with bags of takeout from Urth Caffe and laughing about god-knows-what and that's the point where everything fades to black-and-white and I realize it's because my whole life has turned into a Woody Allen movie.

"Boof," Megan says, still giggling. "You found your mom."

"Yeah, thanks for the heads-up."

"Wait," Rick says. "Which one is Boof? I'm confused."

"That makes two of us," I say, and I shoulder my way past Donna into the apartment and leave everyone standing in the hall.

I click the inadequate lock on my bedroom door and flop onto my unmade bed. My mother is here. In my house. I crack the Hendricks and take a warm, stinging swig. It burns like roses and rubbing alcohol on the way down and I lie there in the muted glow from the streetlights and try to think of what to do next.

Two seconds later, Megan jimmies my bedroom lock with her ATM card, then regards the tableau of me in my underwear with my laptop and Hendricks between my legs.

"Boof," she says. "What are you doing?"

I frantically motion for her to come in and shut the door. "What does it look like? I'm hiding."

I smile, happy that Megan's home . . . then my mother's unmistakably throaty laugh sounds from behind the front door.

My palms and armpits pop an immediate cold sweat. I lean my head against the door to listen more closely. Nothing. I wonder if I'm having a guilt-induced aural hallucination.

I dig my phone from my purse and fire off a text to Megan: ru kiddng me boof? Is donna in the apt? Did you let donna in?

I watch the screen like it's a countdown timer on a bomb. No answer. I press my ear to the door again, and it flies open. I stumble straight into my mother, who is wrapped in two of Megan's best bath towels and has some kind of goopy orange potion slathered onto her face.

She's holding Megan's phone between her thumb and forefinger and I can't decide if the moment is more Lucy and Ethel or *Fatal Attraction*, because there's the stumbling and the sticky face mask and other comedic elements, but there's also my sociopathic mother standing half-naked in the foyer and I had no idea she'd even arrived.

"Hi," I say.

"Monchichi," she says, dripping syrup and reproach. "I've been texting you."

The guy from across the hall steps out of his doorway toting a trash bag and stops dead beside me, goggling at my mother in her post-bath splendor. He bears more than a passing resemblance to the Dude in *The Big Lebowski*.

"Hey, Megan," he says to me.

"Hi, Rick," I say without making eye contact or correcting him.

My mother extends a slender hand in his direction. "Hello, Rick. I'm Donna. It's lovely to meet you."

Rick is mesmerized by the swell of my mother's augmented

Twenty-six

If you crane your head out the window of my apartment and look west, you can catch a glimpse of the Pacific Ocean between the high-rise condos on Neilson Way. That's the upside to my building. The downside is that when the elevator is out of service, I'm living in a five-story walkup. The apartments have nine-foot ceilings, so the flights are longer than normal, and tilted at a death-defying angle. I get bruises on my tailbone just thinking about it.

I mash the call button on the elevator and wait with a growing sense of dread as seconds tick by and I don't hear the creaky sound of old cables. Finally, I shoulder my purse and a bottle of Hendricks from the liquor store next to the Circle Bar, and trudge upstairs.

The phone doesn't ring while I'm walking upstairs. Nothing from Eva. Nothing from Scout.

On my front door, there's a scrap of paper taped with a piece of black electrical tape. At first I think it's an eviction notice, and my heart turns to water. Then I see what it really is, and the water turns to wine. It's a gift certificate for a box of Teuscher chocolates.

There's a phone number scrawled on the back, with a little sketch of a daisy. *Call me*, it reads. *kirK*.

I'm smiling at the note when I hear a voice inside the apartment.

"Are you sure?" he says. "I mean, *sure* sure?"

Deep breath. "Yeah," I say softly.

"I'll have Steve cut your final check today," he says.

God, I hope I'm making the right decision.

God, I hope Eva calls.

God, I hope.

God.

His mouth twists into a wry smile. "That was the *nicest* thing she said."

"She's a treat," I say. "But I guess that's a good quality in a guard dog."

This should be the moment in the movie where the music swells and I realize that I'm working for a nice guy who's maybe just a little neurotic, and who's maybe just a little plowed under by his shark-skinned entourage. But instead I find myself tabulating pro/con columns at lightning speed in my head. Three failed movies? What happens if there's a fourth? And, seriously, a composer? I mean, sure, he's viable in a certain subset in this town, but come on. He's no Eva Carlton.

"Listen," Tyler says. "I'll put a stop to it today, I promise. In fact, fuck the trial period. Let's call this a done deal."

"I really like you," I say, and my voice comes out squeaky and uncertain. "But I don't think this is the right fit for either of us. You need an alligator. I'm a chameleon, at best. I'll get eaten alive here."

"It doesn't have to be like that," he says, putting a soothing hand on my shoulder. Uh-oh. Kryptonite. "Just give it a month."

Ugh, why can't he be an asshole right now? It's so much easier to blow off someone abusive. But I'm having a selfish swirl of need: dinners at the Ivy, location shoots, the whole nine.

"I can't," I say. "I have to trust my gut on this one."

He grinds out his cigarette on the counter, and I think, Here comes the tantrum. But he just stands there in silence, looking crestfallen, and then, right on cue, Zelda wanders into the room, beelining over to me to start licking my bare, flip-flopped foot.

"See?" he says. "Zelda's the best judge of character I know."

I think about making a joke about spilled gravy, but instead I dig the Hermès ring with the keys to his cars out of my pocket and set it gently on the marble counter.

I'm no psychic, but I'm clear he knows exactly what I'm talking about. I've broken one of the cardinal rules of Hollywood: don't breach the wall of the entourage. Managers, agents, business managers, and even assistants all earn their keep by being the emotional buffer between the talent and the outside world.

"Come on, Tyler, that's bullshit. You just don't want to get dragged down by the help."

He widens his eyes. "Jess, you know me better than that."

"And Steve gave me a talking-to about my 'tardiness' on my first day, which was, in fact, exactly when you told me to be here."

"Shit," he says, and furrows his brow. "That's totally my fault. I got my times mixed up and I was having a moment when Steve called."

"Fair enough," I say. "We all have moments."

He takes a deep breath. "Okay, truth, Jess? I'm barely keeping my head above the waves. My last three pictures were shit. It's a death knell. And someone's gonna realize I don't deserve all this, and—and I just can't deal, sometimes."

"Wow," I say.

"I honestly feel like I'm going to shatter into a million pieces from the time I wake up until the minute I fall asleep."

"I get it," I say. "I mean, I think everyone feels that way. You're only as good as your last trophy, right?" Jesus, what *is* it with me and the sports metaphors today? "I mean, I think it's pretty universal."

He looks at me blankly.

"I realize it's not a competition," I add hastily.

"That's where you're so wrong," he says. "Everything in this town is a competition. Every-fucking-thing. It's exhausting."

We stand there in silence for a moment. Then I say, "Did she really say 'insubordinate'?"

There's something about the way she launches into her grievance without any of the niceties that boots up a few angry, self-protective synapses in my brain.

"I don't know what to tell you, sweetheart," I say, when she pauses for breath. I'm on my bike, as per usual, stopped on the side of the road at San Vicente and Seventh Street. I can't ride and talk at the same time, especially not to her. I'd drive right into oncoming traffic.

"What did you just call me?" Cassidy says.

"I'm doing the best I can. If I'm not living up to your expectations, maybe it's time to throw a flag on the play."

I actually say that, "throw a flag on the play." I think I'm channeling the high school quarterback I had an unrequited crush on, because I barely know what it means.

As expected, Cassidy clicks off without another word. That's another Olympic event in these parts: the upper-hand, end-of-conversation decathlon, featuring severed connections, slammed doors, ignored texts, and deleted e-mails. Cassidy is a gold medalist. By the time I walk into Tyler's house, a scant five minutes later, she's already brought the hammer down.

Tyler's standing in the immaculate kitchen in a pair of gray boxer briefs, holding an empty coffee cup and looking forlorn. "Jessie, I just got off the phone with Cass. What the fuck happened?"

"What have you heard?"

"She said you were completely out of line." He knocks a cigarette out of one of the packs on the counter and flicks on the burner of the stove, dipping in to light it. "She actually used the word 'insubordinate.'"

"Did she also mention that she called to rag on me for a dog-food issue?"

"No way," he says. "I had no idea."

Twenty-five

When I was in high school, I was always in awe of the girls who flirted with everyone and had a different date every weekend, but I'm a serial monogamist. With everything, really. Not just boys. I do it with friends, with food, even with clothing. When I find a pair of pants that make my ass look like Italian sculpture, I buy six pairs and wear them constantly. When I fell in love with kale, I ate it three times a day for months. Then came an equivalent pork phase, to balance it out.

My point is, I'm not good at juggling. And I have to say, after Eva's offer I find myself kind of wrecked. She said she'd call, so now I'm spending every moment waiting for the phone to ring. But at the same time, I'm still working for Tyler, and it certainly doesn't suck. I mean, he's a pain in the ass, but he's my pain in the ass. Plus, without him, Eva would never have asked me to work for her. Staff poaching could be a Celebrity Olympics event. I'm not a fan. I owe Tyler. Plus, I like him—though I still haven't learned to negotiate the roiling waters of his management team. Maybe if I didn't have Eva's offer lurking in the periphery of my mind—oh, who am I kidding, it's all I'm thinking about—I'd be a little more conciliatory when Cassidy calls two mornings later to bitch that I've fucked up the ratio of kibble to wet food for Zelda.

"I mean, not that I wouldn't have talked to you with Melanie here, but . . . well, let's just say that she's been complicating things for me lately."

"Right," I say, deadpan. "Because that's not cryptic."

Eva looks across the table at Scout. "You never said she was funny."

"I figured you'd get that all by yourself," Scout says.

"We like funny," Eva says. "Hot is fleeting, but funny lasts forever."

"Next you'll say I have a good personality," I tell her.

Eva laughs loudly, her head back and her teeth as white and even as a toothpaste ad. "Okay, A, you're gorgeous. B, I'm straight."

She pauses and looks at me intently. I guess she needs to clarify that.

"Right on," I say. "What's C?"

"C is, I want you to work for me."

Scout sets her oversize cup on its oversize saucer. "Please. Your grandmother was a train wreck. And the Portuguese thing is going to haunt you forever."

A tiny furrow ripples across Eva's smooth forehead, then disappears when she bursts into delighted laughter and throws her arms around Scout's neck. "That is why you're my best friend," she says affectionately. "You always speak your truth."

Scout leans back as Eva crawls onto her lap and crosses her legs like she's about to bust a yoga move. I'm not uptight about public displays of affection, but it's a little weird that we're sitting in the middle of the Ivy and Eva's acting like she's in her pajamas in her living room.

"Are you okay?" she asks, catching something in my expression. "Am I freaking you out?"

"Not at all," I say.

"Bullshit," she says, but she keeps smiling.

The waiter materializes at Eva's elbow. "Can I get you anything else? More tea?"

Eva stands and stretches her arms over her head like she's just crawled out of bed. Her shirt rides up to expose her stomach and we all stare at it for a moment, flicking our glances away as she straightens.

"Just the check, please," she says.

"Oh, no Miss Carlton, your friend"—he gestures to Melanie's empty chair—"took care of the bill on her way out."

"Wait," I say. "Did she leave?"

Eva digs into her Marc Jacobs handbag, then scrolls through the texts on her phone. "Apparently. Which is good, because I want to talk to you about something."

"Uh, okay."

I'm supposed to say no, but, c'mon. Of course I eat the ice cream. I always eat the ice cream. And this time, the remarkable thing is that I don't feel guilty about it. Eva's enjoyment is contagious. No, not contagious. It's *empowering.*

When I was a little kid, my mom would pick me up from Gloria's every few months and take me out for ice cream, just the two of us. It always felt like a big deal. I'd kick my foot against the passenger door in her old GTO (so much cooler than the RAV4 that came afterward) and try not to show too much enthusiasm, because she always told me that a lady never shows emotions. Which was patently ridiculous, coming from her.

So now I mumble something about how eating ice cream reminds me of my mother, and Eva perks up. She wants to know all about my mother. I can tell from her tone that Scout already filled her in but told her not to say anything.

I give her the short version, and I see her realizing that I'm holding back.

"Did you grow up around here?" she asks.

"In Santa Monica, mostly. But all over the place when I was living with my mom."

"Oh, did you live with your dad in Santa Monica?"

I shoot a glance at Scout, who is feigning fascination with her phone. "My dad wasn't around. I grew up with my grandmother, really."

Eva's face softens into a genuine smile. "That's awesome. I loved my *abuelita.*"

"Are you Mexican?" I say. "I read that you're Portuguese and French."

Scout snorks.

"What?" Eva asks innocently.

"Melanie and I are about to part ways," Eva continues when he leaves. "She just doesn't know it yet. Her weirdness has nothing to do with you."

I wonder why Eva is entrusting me with this information. I mean, we're only meeting for the second time. Still, Scout is nodding along and making encouraging eye contact with me, so I get a warm, fuzzy feeling that makes me think Eva might actually really like me. And it doesn't hurt that she wants to know everything about me. She curls into the chair and tucks her bare feet under her butt like she's settling in at a pajama party and finds me the most fascinating girl in the room.

It makes me feel a little dizzy, with a happy drunken buzz like a contact high from being in her presence. And the dessert. If you've never been to the Ivy, it's worth the trip for the fifteen-dollar banana split, which isn't a banana split at all, but a dinner plate piled with ice cream and fresh fruit—raspberries, blueberries, strawberries, and, yes, token chunks of banana. A separate, full-size plate holds a cluster of pitchers and tiny bowls—toasted, chopped almonds, freshly whipped cream, buttery house-made caramel, and thick, bittersweet hot fudge. It's a travesty. It's heaven. I've been to the Ivy dozens of times and I've never seen anyone order it, except for a birthday, where it melts on the table as people drink coffee and smoke e-cigarettes. It's a dessert for women who star in their own movies. No one else in Los Angeles would dare order it, at least no one with a vagina.

For once, Eva really digs in. She takes big, showy bites, pouring caramel onto a spoonful of ice cream and banana and jamming the whole thing into the pot of almonds before bringing it to her lips. Just watching her eat is making me split my pants.

"Eat this," she says, shoving the plate in my direction. "It's sick."

The ringleader knows her window is closing, and shoves her phone at me. "Can you take our picture?"

"Of course." I take the phone, frame them in the viewfinder, and slip my forefinger over the lens. "Say cheese, ladies."

They smile and I click the shutter, pleased with the flat, red square it records.

"Got it," I say, and instead of handing the phone back to them, I head toward the front door, looking over my shoulder. "Come on, I'll walk you out."

"You shouldn't have intervened," Melanie tells me when I return, her voice sharp as an ice pick.

"Mel, stop," Eva says reproachfully, and turns to me. "I'm sure I have grease all over my face. The thing with your finger was inspired."

"It totally was," Scout says.

"Do me a favor, Mel," Eva says, and Melanie immediately stiffens. "Jesus, don't freak—I just want you to switch places with Jess."

Melanie drops her gaze and mutters something about putting the bags in the car. Eva seems unfazed by her passive tantrum and pats the empty seat as Melanie slouches toward the valet, laden with her purchases.

"Maybe I should go?" I say, which is completely impractical, since I came with Scout in her car, but I'm grasping for something to defuse the tension.

"Don't be a dork," Scout says.

"Mel's been my manager since the beginning," Eva tells me, leaning in conspiratorially. "She's kind of a handful."

I'm not sure how to respond, and before I blurt out anything inappropriate, the waiter sets heaping plates of ice cream and bowls of confections onto the table.

artichoke, and I'm already exhausted. When you go out in public with a celebrity, it's like everyone's watching every move you make, always. The walls are breathing, listening. On the other hand, it's intoxicating. It's gauche to say that, I know, and I can see how it would get old fast. Especially if you had a cold sore and PMS. But right now, my exhaustion is almost postcoital, basking in Eva's reflected heat.

So I'm feeling sort of replete and triumphant when the women at the next table stand to leave—then suddenly stampede closer and surround Eva in a tight half-circle.

"I'm so sorry!" the boldest one gushes. "But I just have to tell you that I'm such a huge fan of yours!" She rattles off the name of Eva's soap opera, and one of her favorite plots, which means nothing to me. For all my pop-culture obsession, I managed to completely miss the boat on soap operas.

"I've been watching you since your very first day, back when you were just a baby," she continues.

Eva flashes a megawatt smile that doesn't extend to her eyes. "Thank you so much. That means a lot to me."

Scout and Melanie scowl so fiercely that I'm a little intimidated, and I haven't even done anything.

"We're eating," Scout says, icily. "Do you mind?"

They launch into stammering apologies, but make no move to leave. Then the ringleader clears her throat. "Do you think we could get one quick picture?" She brandishes her iPhone. "It'll only take a second."

"Of course you can," Eva says, and the women pack themselves around her chair.

"Excuse me!" Melanie barks to the blond hostess, who is nervously scanning the room for our missing waiter. "Do you *see* this?"

❈

Ten minutes later, I'm watching Eva Carlton eat onion rings like she's auditioning for webcam porn, her fingertips and lips glistening with grease as she dangles the dripping shreds above her glossy lips. She licks a droplet of ranch from the corner of her mouth, then sticks her forefinger into her mouth up to the second knuckle and licks it clean.

The part of me that isn't falling a little bit in love with her thinks, I bet that's the only onion ring she'll eat all night.

I'm more than content to listen to her and Scout catch up, until we hear the unmistakable sound of an iPhone camera shutter nearby. I turn in time to see our waiter descend on a table of women with Elizabeth Taylor hairdos—circa her bloated wheelchair period, not *National Velvet*.

They look chastened as the waiter wags his finger like a stern father, then launches into a speech he's clearly given a thousand times about the sanctity of protecting the guests of their establishment. Which is kind of comical when you consider the double layer of paparazzi out front—the A-list paps getting the prime sidewalk frontage while the B-team settles for long-lensing it from across the street in front of the Newsroom Café—but it's a nice touch.

Eva relaxes as the women huddle around their table, suddenly very intently not looking in our direction, their own version of the Midwest un-stare, not nearly as subtle.

We're half done with dinner when Melanie returns, laden with oversize white paper shopping bags from Indigo Seas. "They had everything," she tells Eva. "I got you eight place settings."

Eva lights up. "You're like a fairy godmother."

They chat about the dishes while Melanie eats the remaining

Eva squeezes Melanie's forearm. "That would be great. I think they're getting ready to close."

Melanie fakes a smile and pushes away from the table as the waiter approaches. "Sure. No problem."

The waiter is so used to working the un-stare that there's no indication that he recognizes Eva or appreciates her little wisp of a black tank top, the spaghetti straps drooping dangerously from her tanned shoulders. She hands him the oversize menu, smiles at him with her minky eyes, and rattles off a special order that is pure truck driver with a splash of foodie: "Can we get the onion rings and an order of fries to start and"—she tips the menu back from his hand to peer at it briefly—"a couple of artichokes and—ooh, for the onion rings, can you ask them to make me some of that yogurt ranch stuff they do with the fresh herbs?—and a Caesar salad, with absolutely no anchovies, but a ton of shaved Parm; in fact, can you bring a plate of just shaved Parmesan on the side, and definitely some of the garlic bread, but, wait, on the Caesar, can you add a whole bunch of those oven-roasted tomatoes?" She looks up fetchingly at him. "You're getting all this?"

He assures her that he is, so she keeps going as I surreptitiously look around the room.

Having dinner at the Ivy with a celebrity is completely different from being part of the civilian population, no matter how much you tipped the host for that table on the patio, the one everyone has to pass on the way to the bathroom. For what it's worth, even if you slide the hostess a couple one-hundred-dollar bills, you're not getting that table unless no one of Kathy Griffin–level celebrity or higher is in the house.

I'm just saying. There's a caste system in play, and money doesn't override it. Though it helps.

they've been in the makeup chair for hours or backlit or Photo-shopped, they look exactly like everyone else? Yeah, it's bullshit. Eva looks like a Vargas painting of a Gauguin Tahitian princess. She glows like a spotlight is brushing the tops of her perfect cheeks and pooling shadows into the deep spaces where her collarbone pushes away from her neck. And I can see from where I'm sitting that she's not wearing any makeup. Okay, maybe a little Benetint and some lip gloss, but seriously. This isn't a smoke-and-mirrors situation. Eva has the luminous, unlined skin of a well-hydrated six-year-old.

"I'm so excited you're here," she says, and her enthusiasm feels so authentic that I get as flustered and blushy as Scout, and am suddenly grateful for the low lighting.

The pale woman ends her phone call and squints in my direction. "Who are *you*?"

The muted disdain in her voice makes me feel like I just got caught committing a felony. *Who am I? Oh, you know. Just your run-of-the-mill famewhore whose mother tried to arrange this dinner like a playdate.*

"Melanie," Scout says, like she's reproaching a naughty toddler. "Jess is my friend from Venice. I told you she was coming."

"Mel," Eva says, smoothly. "Will you do me a huge favor? Run next door to Indigo Seas and see if they've gotten any more of the serving plates in?"

Indigo Seas is the heinously expensive store attached to the Ivy that sells their signature, hand-painted tableware plus a variety of overpriced flea-market finds. It's the kind of place where you can spend seventy-five-dollars on a vintage (read: used) tea towel. Celebrities eat that shit up.

"Uh . . . right now?" Melanie says, frowning.

Twenty-four

We get to the Ivy thirty minutes late. Eva is already there, which makes Scout falter as we approach a table tucked into the back by the fireplace. Apparently we're hiding out, because this part of the restaurant is the no-man's land reserved for well-heeled tourists and below-the-line creatives who don't get recognized by the laser-eyed hostess or her assistants.

Eva looks up with a winning smile, and Scout launches into an explanation of our tardiness with elaborate details about traffic. As Eva cranks up the wattage, Scout flops into the next chair, and her purse drops to the floor, spilling keys and a lipstick that rolls under the floor-length white tablecloth. I've never seen her off-center like this, not even with Weston, and I realize she's sort of flustered and crushy. It's pretty cute, really.

I smile to Eva, then to the pale, matronly woman beside her, who's having a murmured conversation into her Bluetooth headset. She keeps her eyes focused on the colorful, hand-painted plates on the white tablecloth in front of her, but Eva fixes me with her open gaze and I can't help but notice, even in the dim candlelight, that her eyelashes are spectacular. It looks like she has mink caterpillars fringing her impossibly huge brown eyes.

You know how people say that if you see a celebrity before

"I swear, this has nothing to do with Stagey McStage Mom. We can talk about that later. I'm on my way to get you right now. Be ready in ten."

"I can't," I say. "I can't spend a hundred bucks on a chopped salad and a gimlet."

"You don't have to spend a hundred bucks," Scout says into my sudden silence. "Just pay what you can afford."

"That's ridiculous," I say. "I can't let your best friend subsidize me. I don't even know her."

"Great," Scout says. "See you outside in ten."

She hangs up and I watch Billy Bush juggling eggs or lemons, I can't tell which. Okay, fine. This is about me, not my mother. Dinner with Scout and Eva. Why not? So what? I mean, it's not like I have anything else to do. It's not like I care about having dinner at the Ivy with Eva Carlton. It's not like I'm a *fan* or anything. I'm just curious about an employment possibility.

Twenty-three

Scout calls the next evening, while I'm lying on my bed listening to old Fiona Apple on repeat and staring at the television flickering a tabloid show on mute. Even with no sound, Billy Bush irritates me, with his cheesy smirk and his carefully gelled hair.

"Dude," I groan in lieu of a greeting. "Why is Billy Bush so smarmy?"

Scout laughs. "More important, why is your mother like one of those reality-show stage momagers?"

"For a thousand reasons, but I'm terrified to ask why this is coming up right now."

"She just spent twenty minutes on the phone with me, not quite telling me to push you to meet Eva."

You know how people say they see red when they're angry? Not me. I get sparkly constellations of little white stars that cascade like fireworks when I close my eyes. "I'm going to need to call you back," I say through clenched teeth. "After I track her down and murder her."

"Okay, deep breaths, no sudden movements. It's weird, but she's not wrong. I happen to agree that you and Eva are a perfect fit. Put down the remote and come to dinner with us at the Ivy."

"You're fucking kidding me, right?"

when he left, the deck looked fantastic. And as long as I'm being honest, so did he.

And he's even hotter standing here in his civilian clothes.

"Hey, Jess," he says. "What's up?"

I raise my coffees and quirk a brow. "I'm doing a coffee run and exploring the veterinary frontier of coconut water."

He immediately says, "Zelda's panting."

"Not bad."

"Give me another one," he tells me. "Facts about Jess."

"Um. I kill at Mediterranean food."

He eyes me briefly. "A party. For friends. You cooked so you'd have an excuse to hide in the kitchen."

"That's not the only reason," I tell him, impressed in spite of myself.

"C'mon, let's see if I can go three for three."

"My mother says she's coming to L.A.," pops out of my mouth.

"Is that . . . good?"

I look at him. "It's like a box of Teuscher chocolates, wrapped in foil layers of shame and rage."

He looks alarmed. "Oh. Are you okay?"

"I've gotta go," I say, and shoulder through the crowd, my heart suddenly beating way too fast.

Why did I say anything about my mom? Why did I ruin a perfectly happy flirtation? I let my brain grind on the humiliation of the encounter for a few minutes, then I force a lid on it and drive to the liquor store for the cigarettes. I call the vet. I stop at Whole Foods and grab some more coconut water. By the time I get back to the house, I've fallen into the rhythm of doing my job, and my worries are more like the distant buzz of a wasp than the ululating siren of an ambulance. There's something really soothing about taking care of Tyler, of anyone, really. You'd think I would have made an excellent wife.

⚜

A few hours later, I'm in the queue at Starbucks when my phone blows up with a rapid-fire string of texts, all from Tyler.

My cigs are stale. Pick me up a carton on your way back?

Tyler keeps his cigarettes in the freezer, which apparently doesn't stop them from getting stale. I've replaced the carton twice this week.

TYLER: Zelda's acting weird. Think she's dehydrated. Can u call the vet and see if we can give her coconut water?

ME: Dude, she's hot. We're all hot. She's fine. Sure.

TYLER: Can you stop and pick up some coconut water?

I tap out a grudging No problem and scoop my drinks from the counter. Halfway to the door, I feel a hand on my bare arm and I scowl.
What now?

When I turn, I find Kirk, for once not dressed in his Fleurs et Diables tee. Instead, he's in a pair of perfectly worn green cargo pants and a faded orange T-shirt I want to bury my face in because it looks so soft.

By the way, he had been teasing about the whole kirK thing. When he came last week, he spent more time shooting the shit with me than on all the little snippy, clippy things he does to the plants and he copped to the fact that he was just fucking with me. And even though he spent most of his scheduled time chatting me up,

"Aw, Boof, are you bummed? Come stay here," she says. "There are three bedrooms for you to choose from."

"I have to be at Tyler's first thing," I tell her. "And I have a full day of bourgeois acquisition duty."

"Air-conditioning and a pool," she says. "Come when you're done?"

I roll onto a less-sweaty patch on the bed. "I'll call you," I say, though I'm already feeling twitchy that she'll be able to see my Donna-based shame if she looks me in the eye.

I've never told her the whole truth about my mother. And something else is keeping me from ditching my life and joining her. My job for Tyler? Not exactly. It's more about his celebrity, I guess. His easy, low-key celebrity. He has all the fame among all the right people, with none of the hassle—no paparazzi or tell-alls or un-stares. But I'm not satisfied. It's not enough. I always wanted to slip into this world, and now I have . . . barely. I'm still on the outskirts, though. I'm in the suburbs of celebrity, with picket fences and lawn ornaments.

So am I jealous of Megan, my best friend, because she's gone all the way downtown—so to speak—with JJ? That's a pretty ugly picture of myself, but I can hear my mother whispering in my ear: *Megan's dating a star. What are* you *doing?*

"Are you okay?" Megan says. "You sound weird."

"Yeah, I'm okay."

"Then why do you sound weird?"

"I'm weird but okay."

"Are you sure?"

"I'm just hot, Boof. Go jump in the pool."

"Okaa-a-y," she says, unconvinced, and I hang up before she can ask again.

Twenty-two

The morning after Scout's birthday party, I wake feeling jumpy and I can't immediately identify the cause. Then it comes into focus: Donna wants something from me, and my culinary audition for Eva ended without a job offer. Of course, Donna will probably just fade away—that's her specialty—and Scout will probably come through in the end. Still, I'm rattled, my bones loose in their sockets, my skin clammy and cold, even though I'm sweating from the warm air.

Part of the problem is that I'm alone in the apartment, since Megan and JJ are shacked up at his sprawling Spanish compound. And it doesn't help that we're having a heat wave, the kind of blistering, late-summer swamp that seems to get worse every year. We're usually immune down by the beach, but it's so hot in our apartment right now that even lying naked on my bed, five minutes after a cold shower, the fan is blowing at me like a hair dryer.

Also, Donna's been silent since that last text, which is freaking me out. Is she serious about coming to L.A.? Is she plotting something?

When the phone rings, I twitch before realizing it's Megan. I answer despite myself, and she launches into a burbling monologue for two minutes until it dawns on her I'm hardly responding.

lap. I exhaled and didn't know what to do. He was watching the road like he didn't even know I was there. His hand was hot on my thighs through my clown dress, and I felt prickles of self-conscious shame.

He pulled from the lot and headed north on PCH. I stared out the window. I noticed my hand trembling a little when I took another drag.

"I just remembered," I said, in someone else's voice. "I told my grandmother I'd come straight home. After the beach."

Three miles farther on, he edged the Aston into a turnoff and turned southward, heading for home. He didn't say anything, so I told him how much fun I had.

When Trent dropped me at the apartment, my mother met us at the curb. First time for everything. She gave Trent those three Euro cheek kisses. Her laughter was as light and silvery as tinsel.

I was rinsing sand from my hair when the bathroom door opened. Through the shower curtain, she said, "It wasn't a total loss. Trent thinks he can get better pictures of you another time."

"I don't want to."

"At least he hopes he can."

"Mom. I don't want to."

The shower curtain opened and she eyed me. "This is your one fucking chance. Show a little gratitude."

"He's creepy."

"If he were a nobody," she said, "he'd be creepy. But he's Trent-fucking-Whitford. How many Independent Spirit Awards have you won?"

"He just—" I turned off the shower. "I don't want to."

"You don't have to want to," she said.

cigarette pack and lit it with the glowing coil of the cigarette lighter. He raised an eyebrow and extended the joint in my direction. I hesitated before shaking my head no. I didn't want to disappoint him any more than I already had, but weed just made me worry that everyone was staring at me. Even more than I normally did.

Trent inhaled, exhaled. "You party, right?"

"Yeah," I said, willing my voice to stay in its normal octave. "Of course."

"Really?"

"Sure. Yeah."

He stared at me.

"What?" I said. "Do I have something on my face?" My mom always said that when she caught me looking at her. It sounded better when she said it.

Trent smiled, and he looked kind of cute for a second. "I have a friend with a killer beach pad right up the street."

"Oh. Is it far?"

"Up past the pier." He started the car. "We can drink a little champagne, get some better pictures."

I took a cigarette from his pack and pushed the lighter in. Trent shot me an amused look, like I was a kitten tangled in a ball of yarn, but when the lighter popped up he pulled it out and held it to my dangling cigarette.

I steadied his hand with mine and looked at him through my mascara-fringed lashes. My eyes were nothing special, but when I threw a couple coats of Maybelline Blackest Black on my lashes, I felt like something out of a *Cosmopolitan* article on how to get your man.

Sure enough, Trent left his hand there, hanging in the air, as I took another drag off my cigarette. Then he lowered his hand into my

"Get over on those rocks." Trent gestured to a steep formation of rocks above the high-water mark, where swarms of gnats and sea flies clouded the air. "We're losing the light."

"Like this?" I asked a minute later, trying to position myself gracefully on the jagged, bird-shit-encrusted rocks.

"You look like a mannequin."

There was a flat set to his mouth, and his eyes told me I was already failing. This was just another exercise in futility, another of my mother's setups that would end in humiliation.

He started clicking away, but he was frowning and gesturing for me to—what?—do something different? Be someone different? An offshore breeze ruffled my hair in what I hoped was a flattering way. *Chin up, butt under, tits out.* Whatever he wanted, I was doing it wrong. The hot, crayon-colored sunset melted into the Pacific horizon and I was sweating on a pile of slimy rocks.

Eventually the sun slipped away and the light faded into a gray dusk. I was cold and hungry, and already picturing the way that my mom's face fractured into two pieces when she got really mad, as though the lower part of her jaw wanted to get as far away from the rest of her angry head as possible.

Trent started packing his camera body and lenses into black leather bags. I clambered off the rocks and looked down the beach. A family was walking toward the trail: a dad in sunglasses and a young-looking mom with a good boob job. They were swinging a blond boy between them, playing like they were going to throw him into the surf.

I could tell he wasn't afraid they'd really do it.

Back in the parking lot, Trent threw his camera stuff into the backseat of the Aston and slid into the driver's seat and shut his door before he leaned over to unlock my side. He pulled a joint from his

I started to wonder where we were going, but I was too intimidated to ask. If I blew this, my mother would be so pissed that her head would explode.

Finally, we pulled into the parking lot of a state beach I didn't recognize. It was off-season, and there were only a couple cars in the lot. Trent slid the car to the edge of the bluff and killed the engine. We sat there for a minute, watching the sun shimmering on the water and the breaking waves on the crescent of sand and rocks fifty feet below us. A handful of surfers floated in the water by the rocky point, and a crumpled yellow beach towel and a Styrofoam cooler lay on the damp sand at the foot of the unpaved trail that led down from the parking lot. Other than that, the beach was deserted.

Trent climbed out of the car, exposing a sliver of skin between his jeans and his black cashmere sweater. "Come on, the light is going to be perfect in about fifteen minutes."

He shouldered his camera bags and I grabbed my extra clothes and makeup as he headed toward the trail. When we got to the beach, he unfolded a tan Pratesi woven blanket and unpacked lenses and celluloid filters and a pile of film, even though he ended up choosing a normal Canon that didn't use analog film.

"Is this dress okay?" I asked.

"You look like a clown."

But he wasn't interested in the other outfits I brought along, the jeans and T-shirts I packed in the bottom of my tote bag so my mother wouldn't see.

"Should I put some makeup on?" I asked, sheepish that I was bringing it up when he seemed so uninterested in my appearance.

He eyed me for a moment, but didn't answer. Clearly I was an afterthought, and he only came to capture the rugged beauty of this secluded little beach for a segment for *National Geographic*.

but there was a pile of cameras and lights in the backseat, and I saw the twisted end of a joint poking out from the pack of Benson & Hedges cigarettes sitting on the wood-grained console between us. Maybe my mother wasn't completely full of shit. Maybe this was my big break after all. We drove down Wilshire Boulevard and the late-afternoon sun was hot and bright in my eyes.

Trent glanced at me, his eyes hidden behind a pair of black Ray-Bans. "Don't you have sunglasses?"

I shrugged and sat up taller, trying to shield myself behind the sliver of a sun visor.

"Here," he said, and offered me his.

"I'm okay."

"Take them," he said. "The last thing you need is to ruin that perfect forehead."

"Okay, Grandma," I said, and he scowled without looking at me, then laughed.

"How old are you?" he asked.

"Fifteen."

His gaze skimmed my bare legs, then crossed the folds of my circus-striped dress. "Really?"

There was something in his voice that sounded like an accusation, like my mom showed him a Photoshopped version of me and it turned out I wasn't picture-worthy after all.

"Well, my birthday is next month," I said.

The purr of the car engine vibrated through the floorboards and I crossed my legs, first one way, then the other, trying to find a position that didn't make me look like a dork. We rode up the Pacific Coast Highway without speaking, the hum of the car and the ambient ocean noises our only soundtrack as we zoomed past Chautauqua, then Temescal Canyon, then out beyond Sunset and Topanga.

and furrow-browed. He came to Gloria's place, and when Donna opened the door, she kissed him on the cheek—once, twice, then a third time, like she was from one of those eastern European countries where there are a hundred words for pierogi.

I was sitting next to Gloria on the couch and I could feel the distrust radiating off her in waves, but she just sipped her cold coffee and erased a string of letters from her crossword, blowing the wormy eraser bits onto the carpet like she was making a wish on a dandelion.

"Jess," my mother said with an arm-waving flourish, "I'm thrilled to introduce our generation's own Orson Welles, the amazing Trent Whitford."

Trent barely looked at me when we shook hands. Probably because I was wearing a stupid red-and-white-striped Marimekko minidress that my mother had bought at Theodore the previous weekend, instead of the slinky black dresses I tried on that skimmed over my body. She'd said the shapeless clown suit made me look approachable. I didn't know what she was talking about, but I felt like a little kid dressed up for a birthday party where there's going to be a magic show.

I'd insisted on wearing my fave white T-shirt over it, and she'd finally said that was okay because it looked like I wasn't trying too hard. Yeah, as *if.*

Trent wanted to shoot pictures of me on the beach while the sun was setting.

"I promise, I'll have her home early," he said, and his teeth were tiny and white like Freshmint Tic Tacs.

As we walked to his car, a low-slung, silver Aston Martin that looked like it could fly over water, I started getting excited. I mean, sure, Trent's hand lingered as he guided me into the passenger seat,

lit cigarette. Only in Houston we didn't call it the sofa, we called it the divan.

Donna ran into my room, scooped me from my bed, and fled into the street, running from door to door until she found a neighbor who was awake. I wore pajamas decorated with teapots and toasters; Donna was naked until one of the neighbors gave her a fur from her refrigerated hall closet. We stood in the street and watched the house burn to the ground.

We lost everything in the fire, including Donna's desire to be married.

"I'm not made to be married," she said. "I'm not Mrs. Anybody, goddammit."

On the drive back to California, I squeezed over on the bench seat so close to her that our legs touched from hip to knee.

I saw snow for the first time on that drive; my mother pulled onto the side of the highway and we stood in our T-shirts and tennis shoes, heads thrown back, tongues out to catch the tiny flakes. She was good at those kinds of things, the details that other people might pass right by.

It was the bigger stuff where we ran into trouble.

Whatever she wants from me, Donna cannot come to L.A. She can't show up and pretend everything is normal. I refuse to drink a bottle of wine with her like we're friends. I refuse to warm to the amusement in her voice and smile at her wacky fucking escapades.

Because if I do, what happens next? I'll forgive her. And nothing scares me more than that.

When I was fourteen, she got me in front of a director named Trent Whitford. He looked like an old Seth Green, all red-haired

Twenty-one

When I was four years old, Donna met a rocket scientist at a party. She pried me out of Gloria's house and we were on the road to Texas within weeks. Donna and the rocket scientist got married in a civil ceremony at the courthouse the day after we arrived in Houston. There was no honeymoon.

I don't remember the drive to Houston, or arriving, or much about the house where we lived, but I remember that my rocket-scientist stepfather was tall, with a sheaf of shiny black hair and a dimple.

Or maybe that was Bob Crane from *Hogan's Heroes.* I was watching a lot of Nick at Nite.

This is what I remember for sure: eating Campbell's Bean with Bacon soup, the lush, green stalks of bamboo that lined the backyard by the alley, a nameless maid coming down the back stairs with a basket of laundry, walking to Dairy Queen with one of the neighborhood children and his Mexican nanny. I remember wide walls of glass that looked out onto an expansive and empty yard, a silver martini shaker beaded with condensation on the kitchen counter, an empty, narrow glass pitcher with a long glass stirrer.

Three months after we moved to Houston, the rocket scientist burned the house to the ground by falling asleep on the sofa with a

But no. There are seven texts from my mother, and my hands break into an icy sweat at the last one.

Sugar beet, we need to talk.

CALL ME. Please.

I raised you better than this, Jessilynn. Call me this instant.

I really need your advice. You're my rock.

The last two almost make me laugh. First of all, no one's called me Jessilynn but her since I was three. Gloria had my name legally changed to Jessica because she was convinced that Jessilynn would doom me to a life in a double-wide trailer. And second, the only person who Donna relies on is Donna. Fact.

Worried about you.

So she's playing both sides of the deck. I'm her rock and she's worried about me. She's shameless. I take off the sunglasses. My lips are chapped despite the gloss. I lock the doors and hunch over the phone. I compose a text and hit Send before rereading it.

I'm fine, Mom. I've been fine for the past ten years and I'm still fine. Just tell me what you need.

I wait there in the car, just staring at the glowing screen for several long minutes, but there's no reply.

Scout grabs Eva's hand. "Come outside, I want you to meet Weston's brothers," she says, and pulls Eva toward the door.

One minute Eva's gushing about my food, and the next I'm alone at the food table while the party's moved to the balcony. Even Megan and JJ are out there.

All the air just got sucked out of the room. I'm in a celebrity vacuum. This is a Los Angeles hazard, like a sand trap on a golf course or a pileup on the freeway. If you fall into a celebrity vacuum at a party, call it a night. You're done. You'll spend the rest of the party with your nose pressed against the glass, looking for the invisible door back in.

I grab my purse and knives and slip out the front door without saying good-bye. Mostly I'm relieved. I can only take so many hey-how-are-yous and where'd-you-get-that-cute-shirt conversations and awkward pauses.

But what the fuck just happened with Scout? I feel like she just twatblocked me with Eva, which is weird, because my blind audition was her idea in the first place. It's like she set me up with her hot, platonic friend and then spent the night flirting with him or something. I don't know. Maybe I'm overreacting. Still, it doesn't feel good.

When I get outside, I shoo a couple hipsters off the bumper and slide behind the wheel. Say what you will, there's something empowering about getting into the driver's seat of a sleek, black Porsche, even if it's not yours.

I throw on my sunglasses and slick on a coat of lip gloss, just because I can.

My phone buzzes with a text and I figure it's Megan, who's just realized I've ducked out and left her at a party she wasn't invited to in the first place.

bread and cheese, big dollops of hummus and yogurt dip and piles of thick-cut salt-and-pepper potato chips.

That's when it dawns on me that Eva's still waving around that first piece of flatbread. She takes big, showy bites of food when people are watching, but doesn't eat otherwise. It's like performance art of someone eating. And the weird thing is that no one else notices. In fact, the Hello Kitty girls are crowded around, exclaiming over the fact that Eva's such a pig.

"I don't know how you do it," says the one with the cat-eared bob. "If I ate like that, I'd be Adele in a week."

Eva pops a green olive into her mouth, smacking her lips as she sucks the herby oil from her manicured fingertips. "Life's too short. I never deny myself anything. And Adele is pretty hot."

Cat Ears slides a piece of feta onto her plate and glances at Eva for her approval.

"Have you tried this eggplant thing? It's a-maz-ing," Eva says, piling baba ghanoush onto a baguette slice and offering it to the girl like a gift. "You'll die."

Cat Ears takes it like Eva just handed her a Cartier love bracelet. This is the point in the party where I'm starting to fade. It always happens, and usually sooner rather than later.

I start sidling toward the kitchen, but Eva touches my arm and says, "I want to crawl inside your food and live there."

"Ha-ha, right?" I say, then cringe inside. There's nothing more telling than answering a compliment with a questioning "Right?"

"I'm going to start parking outside your house, begging for scraps," Eva says.

"You're sweet," I say, light-headed from her flattery—or her proximity.

"And you're the Food Whisperer," Eva says. "We need to talk."

It's captivating, I have to admit. And when she nibbles a plump kalamata, every man—okay, every person—in the room feels it somewhere deep in their brain stem.

Scout spots me. "I've been looking all over for you! Come meet my best friend in the whole entire world."

Like I said, Scout gets a little hyperbolic. I'm surprised she's not calling Eva her conjoined twin. For the record, this is a room that a landlord would call "cozy," so it takes me three shortened steps to get from the front door to Scout, but it's still like walking through crossfire. JJ watching Eva; Megan watching JJ; Scout watching Eva; me watching Megan watch JJ watch Eva. It's the Wimbledon of un-staring.

When Eva smiles at me, it feels like someone turned on a heat lamp. She raises a piece of flatbread slathered with hummus and says, "This food is ri-*dic*-ulous."

"Thanks," I say, with what I hope is a humble shrug, but inside I'm fist-pumping like an Olympic champion. "Only the best for our Scout."

"I can't believe she's been hiding you from me. Why can't I get food like this every day?"

"Have you ever been to Papa Cristo in Hollywood? Their food is a thousand times better."

She twists her perfect features into a pout. "I never get to go anywhere. I'm always working, and the food on set is so dismal I want to kill myself."

"Wow," I say, deadpan. "That sounds unbearable."

She laughs, then makes a big show over the spanakopita.

Her enthusiasm is contagious. She's the Pied Piper of the food table, luring everyone in with gestures of delight, and soon the table is crowded with pixie girls and bikers, piling plates with chunks of

Two cigarettes later, Billy wanders off in the direction of a drum circle, and I'm ready to face the party. My plan is to cut Megan and JJ loose, throw some sparklers in the hundred-dollar cake I brought from Sweet Lady Jane—which, seriously, a hundred dollars for a birthday cake?—and slip out before things get ugly. Except the energy has shifted when I get back inside. Megan is sprawled across JJ's lap on one of the gray leather couches, and the boisterous camaraderie has subsided to a more genteel level. I mean, if you can call a room full of bikers and party girls "genteel."

Scout and the hoodie girl, no longer hooded, are standing at the food table, laughing about something that nobody else seems to understand. And I realize that's it's not gentility; it's a taut web of attention: everyone is un-staring at Hoodie Girl.

Hoodie Girl is Eva Carlton, of course. And Scout was right about one thing: Eva is inconceivably hot. I'd seen her on celebrity blogs—and TV, of course—plus Scout's got pictures of the two of them plastered all over her refrigerator like it's a shrine, so it's not like I didn't know she was gorgeous, but in person her skin looks like it's been burnished with gold dust, and I don't mean in a makeup-y way. She just glows. She can't be more than five foot two and, I don't know, a hundred pounds, but she's working her curves like a pinup model on the nose cone of a World War II bomber. She's ditched the hoodie and her tiny black dress drips off her skin like fresh paint. It's a simple tank-top thing that ends at mid-thigh, and she's wearing what at first glance look like mid-calf lace-up Doc Martens, but they've got to be Prada or better. Little differences. The whole effect is *Oh, this old thing?* Which makes it all the more stunning.

She's picking through the crudité platter, tilting her head back to drop first one green bean and then another into her mouth like a sword swallower.

the Martha Stewart/Rachel Ashwell aesthetic from the turn of the century. Never met a Mason jar I didn't like. But the table looks magnificent, and Megan and JJ are surrounded by men, chatting amiably on the balcony, so I decide to seize the moment and smoke a cigarette. It's either that or linger by the table hoping for accolades from the Hello Kitty crowd.

In the downstairs lobby, I pass a sylph wearing a napkin of a black cotton dress and an oversize James Perse hoodie, emphasis on the hood, which is pulled over her head like she's a size-0 Unabomber. Her eyes are shrouded in oversize Chrome Hearts sunglasses and she's holding an iPhone to her ear and murmuring something in a voice so muted I can't make it out.

"After you," I say, holding the door open with an exaggerated flourish.

She doesn't break her stride and I find myself watching her tanned thighs as she climbs up the stairs without acknowledging me.

"No, really, after *you*," I call as she disappears on the third-floor landing.

Downstairs in the sunlight, I spot a couple homeless people circling Tyler's car, peering into the windows for anything worth committing a felony over.

"Nothing to see here, homes," I say, injecting bravado into my voice that I don't feel.

They shuffle away and I sprawl on the fender and inhale the sharp tang of nicotine.

Much better.

"Got one to spare?" a gravelly voice asks.

I turn and there's Billy Idol, bumming a cigarette. I un-stare like a motherfucker and offer my pack, and he leans against the car and we smoke, side by side, without speaking.

"Well, there's the sangria I made. And there's Stone Pale Ale. But there's no *lavande*-spiked French lemonade."

Megan laughs. "Sangria's even better."

"It kind of is," I agree, then check our progress.

There's a wide white ceramic platter piled with slices of creamy feta cheese and fat kalamata olives glistening with herbs and oil. There are baskets heaped with sesame-crusted flatbreads, pita triangles, and the Bread and Cie baguettes I managed to salvage from the biker's paws. There's a platter of perfect crudité, in shades of green and white: blanched asparagus, tiny French green beans, sugar snap peas, cucumber, and jicama, all bundled in stacks and surrounding a spicy tzatziki dip I've scooped into a hollowed-out Savoy cabbage. The hummus and the baba ghanoush have been appropriately reapportioned into large ceramic ramekins and garnished with pine nuts, smoked paprika, and a drizzle of extra-virgin olive oil. The savory pastries are almost ready to come out of the oven, and I've got the next batch ready to go.

"You're off the hook," I tell Megan. "Go have fun."

"Let's not go crazy with the *f* word," Megan says, pulling off the kitschy apron I gave her.

As she moves through the living room, at least four sets of eyes track her progress, like predators on the African veldt. For all of Megan's one-of-the-boys behavior, she still knows how to pull focus in a roomful of men. I'm not even sure she does it deliberately. It's so far from my frame of reference that she might as well be conjugating Latin verbs with her glutes.

After a few finishing touches, I elbow my way through the crowded room and clear a swath of space on Scout's warped IKEA desk, arranging the food on a tablecloth I whipped up from a sheet of brown butcher paper and lemon leaves. Yeah, sure, I'm mired in

"Listen," Megan says, turning to face me. "I know it's been weird since I got back."

I cycle through a thousand possible responses, trying to pick one that acknowledges that while JJ is electrifyingly hot, and standing too near him makes my stomach hurt, of course all that lust is nothing personal. Celebrities do that: spark the most intensely personal feelings in an utterly impersonal way.

I say, "Okay."

"I can't even wrap my mind around what is happening with him." Megan's brow furrows faintly. "It's so weird. He's a great guy, Jess. I mean, he's the real thing."

Shit. She's not talking about me; she's talking about herself. I fucking suck. "I have no doubt," I say. "But I've got a roomful of hungry bikers and a bunch of fucked-up food. Let's clear this wreckage."

The next hour passes in a pleasant blur of baking, assembling, and plating. Even when I'm not cooking, I always end up in the kitchen at parties: it's the only safe place for a girl like me. Small talk and forced conviviality always feels like an audition. Megan acts as my sous chef while JJ runs interference in the doorway. He's good at it, the perfect distraction for anyone who decides they need to help. Two particularly determined girls try to wedge their way into the kitchen, and I understand the impulse, but there's no room. It's every misanthrope for herself.

JJ tells them there's spiked lavender lemonade on the balcony and propels them away with a broad palm on each of their lower backs.

"He's so great," Megan says with a sigh. "And now I want some of that lemonade."

"Boof, you know it's all PBR and Shasta out there. Maybe a box of Franzia."

"As if you'd let that travesty unfold."

"You are?" she asks, clearly dubious.

I grab the hummus and baba ghanoush and start deconstructing her efforts. "Go on," I say. "Shoo."

She glares at me for a moment before turning on her Converse-clad heel and flouncing away. Her skirt looks like she's about to compete in the women's figure-skating finals in 1988. Jesus, Scout's friends.

I chase off the other one, who is wearing a drum-majorette jacket, replete with brass buttons and epaulettes over a pair of thick Wolford tights that are completely inappropriate for the eighty-degree weather. She's made a mess of my beautiful asparagus, which is now a tangle of bright-green seaweed on what looks like a leftover plastic platter from a Super Bowl party.

I say a silent prayer that no one fucked with the spanakopita and goat-cheese tiropita I spent three hours layering and wrapping, and when I open the refrigerator I'm relieved to find the trays of geometrically folded triangles untouched beneath the layers of clear plastic.

Megan comes into the kitchen, holding the feta block like a sacred chalice. "Remind me not to go back into that room without pepper spray."

"Where's JJ?" I ask, immediately regretting my level of interest.

Megan plops the cheese on the counter. "Handling his business with the boys. Look at him."

I glance into the other room and see JJ being hugged by the baguette-tearing predator, who is bellowing, "Yeah, dude!" as he flops poor JJ around like a rag doll.

"He's like a catnip mouse in a lion cage," Megan says.

"Ehhh, he's holding his own."

We stand there for a moment, watching the surreal spectacle.

Bread and Cie baguette into large chunks and piling them alongside in a sloppy heap.

"Shit," I say to Megan. "This is my nightmare."

"Boof, please. These people are hardly expecting a five-course meal from Le Bernardin. Just tell me what to do."

JJ is immediately swallowed up by a group of men who look like they'd carve your heart out for the extra storage space. Except they're squealing like schoolgirls and thumping him on the back as they recount their favorite scenes from *Malibu 90265*, which was the show that catapulted JJ to stardom. It's in endless reruns now, millions of dollars in syndication money for JJ, I'm sure. I'm more amazed that this rag-tag crew of recently incarcerated felons recognizes him from that decades-old show, but I guess there's not a lot to do in the joint after you work out, right?

"I need that cheese," I tell Megan. "Do whatever it takes."

"On it," Megan says, and she heads into the fray.

In the kitchen, one girl is dumping triangles of fresh pita bread and thin, green stalks of blanched asparagus onto a single platter while another appears to be trying to create a yin/yang symbol with hummus and baba ghanoush in a mixing bowl.

"Hey, thanks for helping." I pluck the slotted spoon from her hand. "We've got it from here."

"Are you the caterer?" she asks reproachfully. "You should have been here two hours ago."

I'm getting that buzzy adrenaline thing again. "Then you must be my waitstaff."

Yin/Yang looks affronted. "I'm a guest of Scout's!"

"Yeah?" I say, like I'm about to get all remorseful about it. "Guess what? Me too. So how about you go throw some ice in the drink cooler on the balcony?"

Megan is wearing an old white Pixies shirt and short denim cut-offs with a pair of ancient, perfect cowboy boots she's had forever. She looks fantastic, but I can see what Suicide Kitty Girl was saying about the nipple thing. Whatever. If I had a body like Megan's, I'd wear a string bikini to the opera.

"Yeah, I think it'll be fine," I say, sending the file to the trash. "I'm really sorry. I just didn't see you there, ogling the celebrities."

Her face crumples like a brown paper lunch sack.

"Sorry, that was harsh," I say. "But seriously, they're not zoo animals."

"Fuck you!" she says loudly. "I was just trying to get a picture for my niece, you ugly cunt."

Wow, not what I was expecting. I'm getting that buzzy adrenaline rush that happens before confrontations when Megan and JJ descend on me from either side, loaded with food, steering me toward the door to the building.

"Boof," Megan says, laughing. "You're a bulldog today."

"Yeah," JJ chimes in. "You had Paula Deen shaking in her Crocs."

I can't help but laugh. "I love that you know who Paula Deen is."

"Honey, I'm from Tennessee," he says, snapping his fingers out in a wave. "She was my mama's patron saint."

"Good to know," I say. As he rounds the corner into the lobby, I mouth quickly at Megan, *Uh-oh, racist mother-in-law*, and she flips me off, to limited effect, since she's concentrating on balancing four half pans of savory Greek pastries.

Upstairs, there are at least thirty people in Scout's living room and even more spilling onto the tiny balcony hanging precariously over the alley. It's a pretty even mix of ex-cons and manic pixie dream girls. Someone set my thirty-dollar block of feta on a stack of soggy paper towels and one particularly menacing dude is tearing a

It's a huge deal, because I've got four man-hours of prep to do and the party is already getting under way, but I'm not going to argue.

"No, it's fine," she says.

Then Weston slouches in and leans against the kitchen door-frame. "I'll help, babe," he tells Scout without making eye contact with me.

"You will, baby?" she says in a little-girl voice I've never heard her use before. Jesus, all she needs is a lollipop and she's ready to shoot some kind of submissive, big-girl alt-porn.

"I'm good," I say, and bolt for the front door.

Before I get there, a wave of girls I assume are Scout's friends come bursting in, tittering about JJ.

"Did you *see* that girl he's with?" says one who is sleeved in tribal ink and wearing a pair of Halloween cat ears in her dyed-black bob.

"I know, right? Like, honey, I can see your nipples from here."

This from a pale girl who looks like Marilyn Manson's little sister. She's marginally ruining the effect with a battered pink Hello Kitty lunchbox she's got slung over her shoulder like a purse, but still. Glass houses.

I brush past them with a chirpy "hi" that makes me hate myself, and run downstairs. Out on the street, Megan and JJ are sitting on the fender of Tyler's car, kissing like they're getting paid overtime to do it, as a touristy-looking middle-aged woman unabashedly uses her phone to record the event.

I bump into her, hard, and the phone clatters to the ground.

"Oh, jeez," I say, scooping it up. "I am so sorry. I really need to watch where I'm going. Here, lemme make sure it's still working."

She's still gaping at Megan and JJ as I'm mashing buttons, trying to find the delete key. It's a fucking Android. I have no idea.

is about to go off the rails entirely. And that's before Scout comes bouncing into the tiny kitchen dressed like a Harajuku Girl from a vintage Gwen Stefani video: her red hair in two high ponytails fastened with black fabric flowers; a white button-down shirt tied under her giant breasts and a blue plaid schoolgirl skirt riding low on her ample hips; her wide, tanned belly with its leaping koi and mermaid tattoos exposed unself-consciously. She's wearing enormous platform shoes and towers over me when she sweeps me into a sweaty hug, even though I'm taller when we're both barefoot.

"I was starting to get worried about you," she says, and I hear a slightly elevated tone in her voice that makes me wonder if she's fighting with Weston.

"Long story," I tell her. "I had to make a last-minute market run."

Scout eyes the bags on the counter. "Is this everything?"

"Not even close," I say. "I'm going to the car for another load right now."

"I'll help."

"No need. It's just one more load."

"That's crazy," she says. "I'm coming with."

"Seriously, I've got it," I say, with forced offhandedness. "I asked Megan to help me do some prep. She's downstairs too."

Scout gives me an exaggerated head turn, like she can't believe what she's hearing. "You invited Megan to my birthday party?"

"Not invited. Pressed into service."

Scout stares at me with one arched eyebrow and a motionless everything else.

"Dude," I say. "You're welcome."

Scout gives a grudging smile. "Yeah. Thanks."

But it's her party, so I say, "Listen, if you want me to tell her I don't need her, I totally will. This is your day. It's no big deal."

question that's on the tip of my tongue every time I'm within a quarter-mile radius of Weston, which is *What the fuck are you thinking?!* Weston's not a bad boy with a gentle side, he's a bad boy with a sociopathic inner child and a mile-long criminal record. But Scout is totally smitten.

A thick clot of bikers in the living room makes Scout's cramped one-bedroom apartment feel exponentially smaller. As I shoulder my way through to the kitchen, I glimpse a familiar face sitting on a faux Eames chair that Scout salvaged from a Dumpster on Electric Avenue on her way home from a meeting. How do I know that guy?

Because it's Billy Idol.

Scout is nine years sober, which has a weird way of obliterating the fences in the Hollywood caste system. Her ex-con boyfriend is digging into the same bag of Tostitos as a musical icon from the 1980s—*Hey, bro, great meeting at Chinatown the other night, amirite?* Billy and Weston are both working a very similar vibe, in fact, in their ratty denim vests and armloads of tattoos. It's just that one of them is worth forty million dollars, and the other is waiting for the balance of his prison earnings account to be released in the form of a money order and sent to his halfway house in the city of Downey.

I blow past them and dump my crap on the counter in the minuscule kitchen. It's nine cubic feet of Formica countertops, a three-quarter-size electric stove with crusty heating coils, and a refrigerator that looks like it came from the set of a '70s sitcom where a plucky mom doles out platitudes and meatloaf.

As soon as I finish unpacking—before I've even seen Scout, who must be in the bathroom primping—I get a text from Megan that says: We're out front. WTF, it's like the Rock Store with all the bikes. Come get us?

A curling finger of dread in my stomach tells me that everything

Twenty

I thread between a dozen Harleys on my way to the front door of
Scout's building. The sidewalk looks like a holding pen for the
extras on *Sons of Anarchy*, all beater American bikes and denim
vests barely covering biceps tattooed with partially disguised swas-
tikas and cartoon-titted girls on candy-striped poles.

This is so not my tribe, and I'm more than a little uncomfortable
as I slog my eco-friendly bags stuffed with artisanal cheeses and
rustic breads and dips up the stairway to Scout's third-floor apart-
ment. We're half a block from the ocean, on the alley that locals call
Speedway. I guess everyone calls it Speedway, but if you're a tourist
and you Google it, you'd think it was a street. It's not. It's a drunk-
ass, crack-smoking, bike-stealing alley, fifty feet from the sandy
shores of Venice Beach.

It has a certain *Endless Summer*-y cachet, but it feels a little shady
when I'm pulling up in a one-hundred-thousand-dollar car, loaded
down with party accoutrements. And the truth is, I'm already ner-
vous because of Scout's boyfriend, Weston. He's a six-foot-four, re-
cently released ex-con with long hair like a wood nymph. Here I'm
supposed to say that on the inside he's a cuddly teddy bear, but he's
so not. On the inside, he's a domestic disturbance. And even though
Scout and I are tight, I don't know her nearly well enough to ask the

"I know, Boof," she says. "He's right here, he's already on it."

"Here's the thing," I blurt, then fall silent.

"What thing?" she asks.

"I'm going to need help at Scout's. That asshole tanked some of my stuff and I have to make more on the fly." Like I said, Megan and Scout aren't exactly tight, so it's weird that I'm going to press her into service at Scout's party, but I'm out of options. "I'm doing a quick grocery run, then can you meet me over there?"

"You're killing me," Megan says. "You know my kitchen skills are nonexistent."

"I don't need you to make soufflés," I say. "I just need some extra hands."

"Fine," she says. "But only if there's going to be feta."

"Five pounds of it," I say. "The good French kind too."

"All right," she says. "Text me the address."

"Done," I say. "See you there."

"I'm bringing JJ," she says. "He's good with his hands."

"Tell him to keep his shirt on," I say. "And bring my murder weapon."

rettes, a chunk of zucchini. My hand brushes JJ's as we both reach for a cleaver, and a sizzle of electricity runs up my arm. Holy crap, I'm so fucking inappropriate.

The pap, who's been muttering into his Bluetooth headset, blurts out, "Hey, JJ, is it true you hooked up with Megan Campion? I hear she fucked her director on *Stones*."

There's no truth to the pap's accusation, but it's exactly what it takes for JJ to snap. He leaps to his feet. "Why don't you say that again, asshole?"

The pap pales but keeps the camera steady.

"Go on, shitbag," JJ says. "I fucking dare you."

"I heard," the pap says, "that she took it up the ass to get her first job."

JJ raises his hand like he's going to shove the guy and that's when we all see—oh, holy shit—that he's still holding my Wüsthof Trident Classic 20cm cleaver in his right hand, the steel blade gleaming in the early afternoon sunshine.

"JJ! Just walk away." I try to inject a calm tone into my voice. "Dude. Just walk away."

JJ squares his shoulders, then turns and heads back inside, my best cleaver still dangling in his right hand. The pap keeps the camera running until JJ's gone, then sprints across the street to his Escalade and peels off with a tire-squealing flourish.

Disaster. I grab my phone from the debris on the sidewalk and call Megan.

"There was a shitstorm down here," I say, and tell her everything.

She starts laughing halfway through, so I don't think she really gets what just happened.

"You need to tell JJ to call his publicist," I say. "There's gonna be footage of him holding a fucking cleaver on YouTube in three minutes."

marble wrapped in cashmere. I shiver involuntarily, even though it's already pushing eighty degrees.

I flinch away—must not lust for Megan's boyfriend—just as the pap swings his video camera into place and our arms collide in what would be a comical tangle if this were a Farrelly Brothers movie and not my life. The trays of vegetables go flying and my purse and canvas knife bag spew everything onto the pavement: my prized Wüsthof carbon-steel knives, my Henckels kitchen shears, my tampons and American Spirits all falling to the ground amid chunks of red bell pepper and mushrooms.

"Back up, fucker!" I scream into the pap's face. "Step the fuck off!"

He's a little taken aback, but he does just that, putting three feet of sidewalk between us without lowering his camera, which is blinking a little red dot that lets me know he's got this for posterity. I don't give a shit, because footage of some nobody screaming at him is less than worthless, just a waste of his time and battery life.

I kneel and survey the damage. Half of my marinated and skewered vegetables are ruined, and there's a gouge in the paint on Tyler's car where my chef's knife julienned it. I'm already ten minutes late for Scout's and now I'm going to have to come up with more food before guests start arriving and there's no time. And I'd wanted everything to be perfect for her. For me. And, I'm not going to lie, for Eva, too.

I shoot a glance at JJ. "Dude, just go. Tell Megan we had an incident."

"I was going to make her breakfast," he says, sort of forlorn.

"Grab the feta and run."

"Don't be ridiculous." JJ kneels to clean the mess. "Let me help you."

I start scooping items into my purse. Bamboo skewers, my ciga-

B-lister heading into Planet Blue a block up the street. Stumbling into the scenario of JJ Kelly, shirtless and barefoot, trailing behind me as I plod along with trays of food is just a happy coincidence.

"Hey, JJ, how's it going, man?" His tone is jocular as he maneuvers for his shot. "Is this your girl?"

JJ ignores him and I angle away, but the guy holds his ground, his shutter clicking over my shoulder, and his lens so close that I could reach out and swat it if my hands weren't full.

"What are you doing down here?" he continues. "Hey, man, did you forget your shoes? Big night last night?"

He's wedged directly between me and Tyler's Carrera, which he let me take home, probably not expecting that I'd illegally park in the passenger zone in order to load my food. I glance over my shoulder at JJ, who has pasted a bland glaze of affability across his face and is still completely ignoring the rapid-fire questions.

"Hey, why you gotta be like that?" the pap asks, his tone getting increasingly antagonistic. "I'm just trying to say hey, you know." He keeps clicking while he fumbles in his bag for a little video flipcam. "Who's your friend? She's a little thick to be your date, boss. Is she your sister? Do you have a chunky sister you're hiding from the world?"

"That's enough, bro," JJ says, without breaking his expression at all.

Paparazzi are like schoolyard bullies, by turns obsequious and cruel. The money shots are the ones that involve high emotion. If they can provoke a shove or a swing or a gob of spit, all the better.

"Just go, JJ," I say. "I've got this."

"Not a chance," he says. "I'm on a feta mission."

I scuttle closer to the car and JJ reaches to open the passenger door for me. His bare body brushes up against me and he feels like

bags, he trots forward to help. He seems to have forgotten his shirt, which is kind of surprising, though I'm not about to complain. His body is perfection, but he's not the kind of guy whose pecs are better-looking than his face. (You know the kind I'm talking about. Any excuse to strip down and flex.)

He grabs two trays and I follow him through the lobby. There are muscles in his back that I've never seen before. I mean on anyone. That's why I look so closely. Scientific interest.

Baja Santa Monica is pretty much a paparazzi-free zone. Rent-controlled apartments and tiny beach bungalows aren't exactly a hotbed of celebrity activity. But get a half mile to the south, on Abbott Kinney Boulevard, and it's a different story. There the paparazzi lurk in blacked-out SUVs, scanning the doorways of Gjelina and Shima and the Tasting Kitchen for their prey, or they sit across the street from the Farmacy in hopes of catching a celebrity buying his own weed.

When Lindsay Lohan was renting a house on Venice Boulevard, the sidewalk in front of the Brig—which is normally a low-key, albeit hipstery, local bar—looked like lunchtime at the Ivy. It really fucked up my late-night visits to the Kogi truck, which was tragic because they have the best Korean short-rib tacos with kimchi on the planet. And they're only two bucks apiece, which is the best deal you'll get for anything on Abbott Kinney, anytime, ever.

Anyway, our street is hardly a celebrity hotbed, with its hippie grocer and fratty Irish pub, which is why I'm completely surprised when a sweaty Persian dude with a backward ball cap steps into my path and starts clicking away. His camera has a lens so huge it could capture the license plates of the cars in the parking lot three blocks away, and it's pretty clear from the hardware that JJ is not his original target. He was probably hoping to get a shot of some fading

there's a roiling pit in my stomach that feels like I haven't eaten for a week.

"Okay, turtledoves," I say. "I'll leave you to it."

I pick up the tray of skewered vegetables and shoulder my canvas knife bag on top of my purse and my laptop bag, which I don't need for Scout's party, but I'm afraid to be away from my technology for three minutes in case one of the Kardashians breaks a nail.

"Slow down!" Megan calls from under JJ's torso. "He's coming, he's coming."

"Good bounceback," I say.

Neither of them responds. Actors are such a crappy audience. Well, if they won't laugh at my bawdy humor, I won't wait. Instead, I ratchet down the four stories to the street in our old rattletrap elevator. One thing about having a rent-controlled apartment in Santa Monica is that the common spaces look like you're living in a pre-glasnost Soviet tenement. Prices and prizes. For the record, I would have taken the stairs if I hadn't been so loaded down with party crap, because our elevator is just waiting for its moment of fame on the eleven o'clock news: *And, in other news, a woman perished today in Santa Monica after being trapped in the elevator in the One Life building for three days with only hummus and kalamata olives for sustenance. Her neighbors described her as 'You mean that girl with the frozen yogurt?' Now here's Fritz with the weather.*

On the other hand, the stairs are worn and slippery from years of use, so if you catch one wrong, it propels you downward like a waterslide.

By the time I reach the lobby, JJ is already leaning against the row of dilapidated mailboxes. He looks like he's just been air-dropped in from another planet, he's so resplendent amid the faded linoleum and plastic plants. As I step off the elevator, juggling my trays and

know she stole from a wardrobe trailer because there is no way she paid $175 for underwear. She looks at me imploringly. Her mascara is smeared under her eyes and she's really working the whole orphaned kinderwhore thing.

"Don't look at me like that. I'm walking out the door right this instant," I say. "Order it from Urth."

"No," she mock-whines. "I want it now."

"Daddy, I want an Oompa-Loompa," I mimic. "Come to the car, then, because the feta wagon is pulling out of the station."

"I'll walk you out," JJ says from the doorway. "Just let me find some pants."

He stretches into a yawn and clasps his hands over his head in an ersatz yoga move that's more bodybuilder pose than anything else. He's wearing what I think for a moment is a swimsuit but is actually a pair of form-fitting, gray 2(x)ist boxer briefs. And holy crap, his abs are ridiculous. Seriously, I stop counting at six. Plus, his hair looks like he just came from a salon where he paid $275 for an artfully mussed bedhead, made all the more alluring because I know that's not the case.

"Back in a flash," he says, striding toward Megan's room like a Greek statue come to life.

Megan takes a running start at his retreating form and leaps onto his back. He's completely unprepared and they stagger sideways and collapse onto the leather sofa, which skids a couple inches and bumps against the wall, rattling the oversize, glass-framed poster from *Jade Wolf* that dominates our living room.

They're gorgeous together, a tangle of long, lean limbs with her creamy white skin against his natural tan. They look like they're about to shoot the box art for a quirky indie rom-com. I should be thrilled for Megan. She's my best friend, for God's sake. But instead

Nineteen

Late the next morning, I'm packing the last load of food to truck over to Scout's house when Megan and JJ come stumbling out of Megan's room. They look like they just finished fucking twelve seconds ago, which is highly probable. I wouldn't know, because I've had my headphones super-glued to my ears since they started going at it like wolverines an hour ago, all of which was perfectly audible through our thin apartment walls.

At first it was kind of cute—young love and all—but it eventually just got scorchingly hot, like listening to a particularly well-made porn flick. Except a porn flick where the actor looks like JJ Kelly. Then it turned creepy, like a porn flick where the actress is your best friend. Finally, it made me kind of sad and lonely. All that in the span of four minutes.

"Oh, good, you're still here." Megan brushes past me with a hip bump to get to the refrigerator. "I'm craving a feta cheese omelet."

"Already in the car, Boof," I say.

"You made omelets?"

"No, the feta. It's in the car."

She doe-eyes the empty cheese drawer. "This is a catastrophe."

She's wearing a baggy tank top that reads CARPE DIEM in flaking silver glitter, and a pair of ruffled Agent Provocateur knickers that I

nymed cop shows. Then he had an awkward phase, which is where most child actors become restaurateurs or golf pros. Not JJ. He mined his dorky phase, landing a sitcom role where he wore wide-collared polyester shirts and danced wrong.

Then one day, he turned hot. Not in a he's-kind-of-cute way, but in a holy-shit-who's-*that*? way. And after that, he disappeared for years. Until he finally took a small part in an independent film. Just a cameo, but he threw himself into the role of the heroin-addicted hit man who falls for the daughter of a Russian crime lord. Sure, his character dies in the first scene, but those four minutes gave JJ a major Hollywood makeover.

JJ Kelly was back, on the edge of great things . . . and dating my roommate. I'm positive that I know more about him than Megan does, which kind of skeeves me out.

"This looks serious, Boof," I say, throwing a knee-length batwing T-shirt dress with a ripped neckline over leggings and a tank top. "How did you guys even meet?"

I've seen the cast list for Megan's pilot. If JJ Kelly were on it, believe me, I would have noticed.

"He did a cameo." Megan peers into my mirror to inspect what looks like a carpet burn on her left elbow. "The director is a friend of his mom's. I wasn't even supposed to be on set but I left my journal in my trailer, and I didn't trust a PA to bring it back without looking in it."

My laserlike focus pinpoints the most important question. "Am I in your journal?"

"Whole chapters." She piles her hair on top of her head and looks at me via my reflection in the mirror. "If I hadn't forgotten my journal, I'd never have met him. Meant to be, right?"

Megan knows I don't believe in "meant to be." Meant to be implies there's a reason for every fucked-up thing that's ever happened—not just to me, but to Donna, to Gloria, telescoping all the way out to the world in general, Bosnia, the Gulf War . . . Come on. Everything most decidedly does *not* happen for a reason. And Megan knows that, which is why she loves to torment me about it.

"Yeah," I say, deadpan. "It's fate. Like that hickey."

"It's not a hickey." Megan raises a self-conscious hand to her neck, then points at the door and stage-whispers: "*JJ Kelly!*"

I laugh. Even celebrities are awed by celebrities. Although, granted, Megan is C-list, at best, and JJ is on the cusp of A, even if he hasn't been all that visible lately.

I'm not going to pretend I'm not intimately acquainted with his résumé. He played the handicapped-yet-wise son in a dysfunctional oil family before the advent of competitive reality shows and acro-

I hold my hummus-encrusted hands up in an apologetic wave. "I'm pretty slimed. You might not want to risk it."

Also, I'm profoundly aware of my breasts bobbing against the slack fabric of my bikini top and the breeze blowing on my girl parts through my pajama pants.

"That's ridiculous," he says, pulling me into a bear hug.

I really should enjoy this more, but all I can think about is my vast acreage of sweaty skin pressed against his body, which even through his goofy shirt feels as cool and hard as a granite countertop. When I raise my eyebrows at Megan over his shoulder, she just shrugs, like *Who, me?* and plunges two fingers into the vat of hummus on the countertop, swirling some into her mouth with a flourish.

I disengage from JJ's hug and cant my body away from his view. I mean, I try to practice a modicum of healthy body acceptance, but there are limits. I'm standing in front of Michelangelo's *David* wearing a clown nose and a fat suit.

Megan makes a little humming noise of food enjoyment. "Boof, are you kidding me? Is there crack in this?"

She scoops again, then extends her hand toward JJ. He opens his mouth like an agreeable baby bird to take the proffered mouthful from her outstretched fingers, which she immediately puts back into her own mouth.

They stand there for a moment in a little porny hummus bubble.

I flee to my bedroom and start throwing on layers of clothing. I mean, I know he's here with Megan and all, but I watched the hell out of every single episode of his sitcom, and now he's in my fucking kitchen.

A minute later, Megan slides into my room and shuts the door behind her, flinging herself against it dramatically and contorting her face into a silent scream. She's an actress. She pulls it off.

the chaos in our tiny kitchen. "Did you open a catering company while I was gone?"

"Do caterers get paid?"

"Yes."

"Then no. How was—"

There's a shuffling in the hallway, which we euphemistically call the foyer.

"Baby, get in here," Megan calls, and in he comes.

He's not Ryan Gosling or Bradley Cooper, or even James Franco, but he's close: JJ Kelly.

I can't un-stare. He's too close. And un-staring is for public. This is way too private. So instead, I act casual—but not too casual—as if I'm used to celebrities on the level of JJ Kelly cluttering up my kitchen. I'm desperately trying to calculate the exact amount of off-hand cool that proves on some cellular level that I have not, in fact, calculated any of it.

"Holy fuck," I gasp, pulling up my sagging pajamas and throwing a dirty tea towel over my shoulder like a bandolier.

Not exactly what I was aiming for. But JJ Kelly, come on. His beauty is completely undiminished by the fact that he's wearing a godawful, multicolored Hawaiian shirt.

"I brought home a souvenir," Megan tells me.

"Did you have to declare him at customs?" I ask.

Megan shoots me a look, like, *Don't even start.*

JJ plucks a cucumber from the counter as if he's standing at the craft services table and pops it in his mouth, looking me up and down with an amused smile.

"JJ," Megan says. "Meet Jess."

"JJ Kelly," he says, extending a well-muscled arm in my direction. "Megan's told me so much about you."

Eighteen

I start the prep work for Scout's party on Friday night, chopping and simmering until I collapse after midnight, stinking of sweat and splattered with extra-virgin olive oil. I start again the next morning, producing industrial amounts of hummus in a non-industrial-size kitchen.

The party's on Sunday, so I don't leave the house at all on Saturday—not even for frozen yogurt—and I'm skewering marinated vegetables like a motherfucker when Megan gets home from Hawaii at three in the morning.

I'm shambling around in a culinary daze, wearing a stretched-out bikini top and a pair of men's pajama bottoms that have a gaping hole in the fly. I don't recognize the sound of her key in the lock at first, then she bolts into the kitchen and leaps onto me like a lemur. Tiny people do that.

"Boof!" she shouts. "I missed you."

She smells like cigarettes and coconut oil, which for some reason makes me want to cry.

"What are you doing here? I thought you were gone for another week."

"There's union drama. We're cut for at least a week." She takes in

"C'mon, please?" I sound beggy and rushed, which is not going to help my cause. "At least give me a number."

He straightens a stack of folded sweaters. "Not for sale. The customers love them."

I look toward the dressing room. There's a duck-lipped lady in a child-size pink Polo shirt perched on one of the chairs, a fluffy white dog clamped under her arm and a Louis Vuitton dog carrier open on her lap.

"If he has to call you himself," I say, "I'll lose my job."

I can tell from his appraising stare that he knows this is patently untrue, but I paste on a mask of earnest concern and wait it out. It's part of the dance.

He busies himself with the arm placement of a headless mannequin perched in a saucy pose atop a leather-inlaid mahogany table. I try to burn a hole in the side of his wispy-haired head with my laser focus while he makes a pretend show of considering my predicament, all pursed lips and head cocking. A blonde in a blue silk bias-cut dress materializes and stands on tiptoe to whisper in his ear, pitching her whisper perfectly so everyone within twenty feet hears that Sharon Stone is in the women's department.

"Four thousand," the manager calls over his shoulder as he trots off. "Twenty-four-hour memo or you own them."

"Fine," I yell back, and a bubble of accomplishment fizzes up into my chest.

He turns at the end of the aisle, hand poised like a model on the burled wood column that bifurcates the men's and women's selling floors.

"Four *each*," he says, then whirls off to air-kiss Sharon.

row. I'm guessing most of it, but that's okay; I'm going to have to talk to the manager in person about the chairs anyway. Not a word has been mentioned since Tyler first saw them, but I know it's coming.

Sure enough, the next morning there's a pile of clothing on the ottoman in Tyler's living room, hangtags fluttering in the ocean breeze coming in through the French doors to the deck. I can tell from the height of the stack that it's every single piece he brought home yesterday.

I give Zelda a treat, then find Tyler, smoking and cheerful, in his Aeron chair in the studio.

"Hi, Jessie." He pushes his bulbous headphones back on his head to partially expose the ear closest to me. "I need you to run a few things back to Ralph Lauren."

"Sure. No problem."

Tyler blows a smoke ring and looks back to the tiny monitor wedged between the Casio keyboard and his elaborate computer equipment on the fourteenth-century Italian farm table. I hear the bloopity-bleep of the piece of coded film he's working on as it rewinds. A gorgeous A-list actress, made movie-star-dowdy in a pink waitress uniform and black cat-eye glasses, moonwalks backward to reseat herself on a park bench next to her costar.

"And you know what?" he says. "See if they'll consider selling those beat-up old chairs in the men's dressing room. They'd look great in the sunroom."

An hour later, I'm waddling around the sales floor after the Ralph Lauren manager, trying to "convince" him to sell the chairs while clutching the bags of decoy purchases I need to return.

"Not for sale," he says cheerfully.

blazer straining across his gangly back. To a casual observer, the manager looks like the socially awkward one, but I've lived here long enough to know that he's a land shark in a worsted-wool coat. I can practically see cartoon dollar signs gleaming in his big black pupils. It's immediately clear to me that the currency for this transaction is cash, not celebrity.

"Come on in," he says. "We've been waiting for you."

There's a whisper of irritation in his voice, which I'm guessing means that our tardy arrival will end up costing extra—a lot extra—somewhere down the line.

Tyler does a perfunctory lap of the men's department, loading my arms with cashmere sweaters and long-sleeved cotton T-shirts he already owns by the dozen. He has a brief flirtation in the full-length mirror with a wool skeet jacket that looks like a saddle blanket, then diverts to have an animated conversation with the bespoke tailor about the differences between Purple Label and Black Label suiting.

Finally, on our way to the dressing room, he spies a target.

"Hey, when'd you get these?" he asks, gesturing idly toward a pair of perfectly dilapidated leather club chairs in the dressing-room vestibule.

"Those old things? I think Ralph had them sent out from the ranch." His voice is an award-winning performance of casual disinterest.

Oh, Jesus. Ca-fucking-ching.

Forty-five minutes and six thousand dollars in wool and cashmere later, we're headed west on Wilshire in a cocoon of tissue-stuffed shopping bags and tinted windows.

Tyler is finally smoking his cigarette and I'm playing a game with myself where I try to figure out what's going back to the store tomor-

edly questioning the benefits of working for a celebrity who nobody knows, but all that evaporates when Tyler tells me we're going shopping. Together.

Our destination is the flagship Ralph Lauren store on Rodeo Drive. They know Tyler there, and the manager lets us come after closing time to shop in seclusion. Sure, there's a drawn-out scene getting Tyler out of the house and into the limo he's arranged, but the driver's unflappable bonhomie tips me to the fact that this isn't the first time he's experienced it. This is more like it.

The Ralph Lauren store is meticulously arranged with artful tableaus of estate-sale antiques to create a luxurious shopping experience that falls somewhere between a British colonial veranda and a billionaire's dude-ranch living room. Tyler greets the staff with effusive handshakes and hugs, and if you didn't know that it took forty minutes for us to get out of the driveway, you'd never glean it from Tyler's demeanor. He's wearing his requisite Levi's and unlaced Timberlands and, in a nod to our host, a perfectly worn-in, vintage Ralph Lauren car coat with a brown corduroy collar. He has a pair of Oliver Peoples sunglasses threaded through his shirt collar and an unlit cigarette hanging from his mouth. He looks for all the world like a man who just happened to be in the neighborhood.

Ostensibly, we're going to shop the newest clothing collection, but Tyler's already told me that they bring a trunk show to the house at the start of every season. I'm not sure what we're doing here—not that I care, because Tyler finally left the house—but I suspect that Tyler wants to get his mitts on the display pieces, the one-of-a-kind stuff that's not for sale. In Hollywood, "not for sale" is just a euphemism for really, really expensive.

"Hey, man," Tyler says to the manager. "What's going on?"

The manager gives Tyler an awkward head hug, his blue RL

Seventeen

At some point, I realize that Tyler doesn't leave his property. I mean, not ever. First I figure out that the only person driving his cars is me, even though he insists otherwise. Then it dawns on me that he never takes Zelda past the mailbox, even though he talks about walking her all the time.

I'm a big fan of quirky personality traits, but Tyler's behavior is beyond that. I'm sure it has its own *DSM-5* code. Not that I can't handle his agoraphobia, but all the subterfuge around it makes me edgy and stressed.

My anxiety isn't helped by the fact that I keep running into the brick wall of Tyler's small-scale celebrity. I mean, he's a hot ticket in a certain inner circle, but it's a limited crowd. I keep finding myself sidling into his office to sheepishly explain that I've failed at getting comp tickets to *The Book of Mormon* for his brother and sister-in-law or scheduling a facial at Tracie Martyn for his mother. It's embarrassing.

The problem is there's a chasm between Tyler's current status and the perks he enjoyed in the years following his Oscar win. Tracie Martyn is booked solid for the next twelve weeks, and I can't even get the publicist from *Book of Mormon* to return my call.

I teeter between berating myself for being a failure and aggriev-

I'll figure something else out.

The next day, I'm standing in the produce section at Gelson's, filling a giant paper bag with fresh mangoes, which are currently the only thing Tyler wants for breakfast and lunch, when the "something else" hits me.

I'm in a grocery store. A really good one. I'm in a really good grocery store where I have a charge account.

And what's a couple hundred dollars to Tyler? The monthly food bill hovers around two grand, from what I've seen. Tyler won't notice. His dog has an eleven-hundred-dollar collar. So I load a couple cases of Stone Pale Ale into the cart with only the tiniest of twinges. I continue through the aisles, choosing Tyler's usual supplies and adding all the party extras I need. At the checkout counter, I lose my nerve—or maybe I just remember the expression on his face when he sipped my coffee—and I tell the girl to put the party stuff on my card instead of the account.

On the drive back to Tyler's, I'm torn between hating myself for running up my credit-card bill—which I already can't pay—and for almost charging the party supplies to Tyler. I'm falling into a weird Hollywood sense of entitlement, even though I'm a bottom-feeder. But by the time I'm lugging my party supplies up my worn, slippery stairs, I've gotten over my pity party and I'm patting myself on the back for taking the high road. Yay, me.

Sixteen

I'm still thinking of a dozen things I need to buy as I slog the grocery bags for Scout's party into the rickety elevator at my apartment. At least it's working for once, and I don't have to brave the deathtrap stairs. I unpack everything in the kitchen, and open a bottle of the cheap red I bought in quantity. *Yikes.* Almost undrinkable. I add brandy, oranges, and limes to my mental list. That shit needs a sangria overhaul.

"Thanks, Eva," I say, taking a swig. "Way to foist it onto the little people."

I still need Bread and Cie baguettes, kalamata olives and feta from Papa Christo's—and a cake from Sweet Lady Jane to tie a ribbon on Scout's birthday triumph. I'm another two hundred in, and I haven't even bought beer. I can ply the girls and gay men with sangria, but Scout's got some biker-y, ex-con pals who'd sooner light their pubes on fire than be caught drinking alcohol with fruit in it.

I open the drawer where I've stashed Megan's Hawaiian windfall, then close it again without taking any. Megan and Scout never really hit it off. They're polite to each other, and Megan barely notices how Scout answers Megan's small-talky questions with the cadence of a teenager. She probably wouldn't even care, but somehow using her money to fund Scout's party feels wrong.

walk-in refrigerator, and once he sent her home with five pounds of veal shanks. I was afraid to ask why. I bought a copy of *The Silver Palate Cookbook* and made osso buco, following the recipe as carefully as if I were making a hydrogen bomb using canned tomatoes and a bottle of cheap white wine.

I'd never gotten along with my roommate, but that night, she poured wine in my glass and laughed at all my stories. For once, I was the star.

I read that cookbook from cover to cover, at my job behind a battered metal desk at a body shop specializing in low-riders. When I realized no one was paying attention to *American Chopper* and *Monster Garage* on the ancient television bolted to the wall, I switched it to the Food Network, where I devoured Rachael Ray, Emeril Lagasse, and the Barefoot Contessa as they whisked and pureed. I expected a lot of disgruntled *cholos*, but they just sprawled on the stuffing-sprung sofa, eyes glazed as a smiling Ina Garten dumped forty cloves of garlic into a Le Creuset Dutch oven.

When my roommate came home the next week with half a case of frozen chicken breasts and a three-pound box of shriveled white mushrooms, I made coq au vin. She called some friends and we had an impromptu party, ten of us crowding cross-legged on the floor around our flea-market coffee table.

After dinner, everyone raised their glasses in a toast.

"To Jess," my roommate said, her smile wine-stained and broad.

"To Jess," her friends echoed, and we clinked our mismatched glasses across the flickering tealights and the coffee cups filled with the flowers I'd plucked from the neighbor's front lawn.

Maybe I'm a bad daughter, maybe I'm a curmudgeonly friend and a resentful employee, but I *know* how to cater a party—and I want Scout to shine on her birthday.

Before I dropped out of high school, a team of career-aptitude experts handed out Scantron answer sheets and put up a slide presentation where we had to pick between two statements about ourselves:

I never leave others in doubt about where my opinions lie. or
Very few people know what I am really thinking.
On the whole, I am satisfied with my life. or
I am always searching for new possibilities.

In hindsight, I'm not convinced they weren't Scientologists. They shared a few students' results with the whole assembly—the exciting ones, like pilot or artist. But my only occupational suggestions were dental hygienist and tax assessor.

I've been thinking about that a lot as my thirtieth birthday nears. Everyone I know *does* something. I just do other people's things. Except for cooking. My cooking belongs to me.

My grandmother's idea of a fancy meal was lasagna with hamburger meat and two jars of Ragu. My mother only made one dish, which she called "Irish lamb stew." It was lamb stew with a can of Guinness. She made it to impress new boyfriends, and I still can't smell a lamb chop without getting a mental montage of greasy dishes piled in the sink and me in front of a television, picking at my cuticles and wondering when she was going to come out of the bedroom. When we ate alone, she'd just set a can of tuna on the table and we'd hack at it with forks.

One of my first roommates was a hostess at an Italian restaurant on Pico. The chef used to pinch her ass and try to coax her into the

Fifteen

Turns out when Scout said Eva was going to pay for her party, she meant Eva was going to *contribute*. That's the only explanation for the envelope Scout slipped under my door last night, which contained just under five hundred bucks.

Come on. I mean, a dinner party for ten, maybe. But Scout's invited everyone she knows to this thing. She does that. At first—I mean, after we got over the hump of our unfortunate first impression—I thought she had the biggest family on the planet, because every time she'd bring someone into the Date Palm she'd introduce him as her brother. After the third time, I figured that she's one of those guys' girls who doesn't have a lot of female friends. But she does it with both genders. Everyone is family.

I'm not in a position to be critical; I don't have a lot of friends, period. But Scout's mom is dead and she doesn't have any siblings, so everyone's my brother this, my sister that.

Anyway, she invited fifty people, and with less than five hundred dollars, it's pretty clear we're not going to be toasting with Eva-funded Cristal. By the time I get out of Costco—don't judge, they have an excellent cheese department—I've already spent two hundred dollars of my own money. For once, I don't care. This really *isn't* about me: Scout deserves better than a ten-dollar-a-head party.

"That's kind of awesome. But, um, I'm already working."

"And Eva is already . . . Eva."

This is true. Eva is *Eva*. Tyler is merely Tyler. I cannot deny the fact of this, though I take umbrage at myself for the thought, suddenly feeling defensive of Tyler. He's an uber-successful composer. Sure, that's no almost-A-list celebrity, but it's pretty awesome.

"And Eva has boundaries," Scout continues. "She doesn't need a wife, she just needs someone to bring food to set when she's working."

"I don't know," I say.

"Why not?"

Good question. What's making me nervous about this? Not just the feeling that I'd be bailing on Tyler. "Uh . . . the last thing I need is to work for your best friend, who, by the way, I've never even met. It's a recipe for disaster."

"A recipe, ha."

"I'm a comic genius," I say. "Can we just talk about your party?"

"That's the thing," Scout says. "Eva's going to pay for it, so she wants you to do vegan."

"She's coming? So it's not just your party, it's my audition?"

"Nope, not about you," Scout says. "I was thinking a whole Mediterranean thing, kind of macrobiotic, like M Café."

"I don't do macro," I tell her. "Get your miso and spelt cakes somewhere else."

"It doesn't have to be full-on macro. How about hummus and falafel? It *is* my birthday."

"You're incorrigible," I say.

But the truth is, I'm flattered. And I like the idea of cooking for Eva Carlton, even if there's no way I'm going to bail on Tyler. Also, I kill at Mediterranean food.

"Yeah, okay," I say. "I'm in."

hush indie movie. The combination of talent and secrecy was like catnip.

"So what's the bigger plan?" Scout asks, chewing thoughtfully. "Cooking school?"

"I can't believe you remember that." I mentioned it *one* time, when we were lying on the grass in front of the boardwalk in southern Venice, sharing a boba tea. "That's not in the cards. It's sixty grand for CIA. And I'd learn more just working in a restaurant."

"So do that."

I toy with my vegan Cobb salad. I'm a good cook, but I don't think I have what it takes to do it for a living. "A commercial kitchen's too loud and shouty until I know what I'm doing."

"Eva's looking for a cook," Scout says, like she just remembered.

"Really?" I cover a twitch of excitement. A cooking job for a celebrity is the best of both worlds, combining my skill and my obsession. "She is?"

"Well, a personal assistant who cooks. She's been looking for a while and, uh ... I might've mentioned that you're working for Tyler."

"You *might* have?" I say.

She stabs a chunk of veggie sausage and forks it into her mouth. "I've wanted to get you two together forever."

"Me and Eva *Carlton*?"

"Yeah, except she'd never hire an assistant who didn't already work in the business—I mean, unless it was a friend. But now you've spent a couple weeks with Tyler, you've clearly got all the prerequisites under your belt."

I laugh, but it comes out like a seal bark. "Two weeks working for a B-list composer is 'all the prerequisites'?"

"Sure," Scout says. "For a friend of a friend."

"Two."

"So the same guy doesn't do both?"

"I wish. If they both show up while I'm not there, it'll be a catastrophe."

"Because Tyler can't handle a dog groomer and car detailer?"

"Celebrities are like gas," I tell her, sharing my most recent revelation.

"Bloated?" she asks, as the food comes. "Sulfuric?"

"They expand to fit their space."

Tyler used to be perfectly capable of corralling vendors, but now that he's had me for a few weeks, he's grown incapable of even the simplest tasks. He called me at two in the morning last Monday to ask where we keep the string.

"What string?" I said, groggily.

"You know, like to tie up a package or whatever."

"I . . . I'm not sure," I said. "I don't think we have any."

"Oh," he said, and we sat in silence for a moment. I could hear Zelda tick-ticking across the hardwood floor.

"Can it wait until morning?" I said.

Tyler sighed. "I guess."

I stopped at 7-Eleven on my way in and bought the only string they had, one of those old-timey white balls covered in plastic wrap. I set it on the counter with his coffee and foam cups.

"What's this?" he said, peering at it like it was a meteor that had landed in the kitchen.

"It's string," I said. "To tie a package or whatever."

"Right," he said, and wandered away.

His nonchalance pissed me off, until he abruptly changed gears and called me into his studio, where he serenaded me with an acoustic piano version of the new song he's been writing for a very hush-

Fourteen

The Santa Monica Swingers is a carbon copy of the Hollywood original, at 70 percent scale. Real estate, yo. The food used to be California comfort and now it's all kale and quinoa with a side of soyrizo. I'm making it sound worse than it is, but you'd have to tie me down to get me to eat soyrizo.

We sit at a booth and order from a waitress in ripped fishnets and booty shorts who looks like she's driving straight to a Derby Dolls practice after her shift ends. There's a good crowd for a Wednesday afternoon, a mix of tattooed bartender types with skinny arms and train-conductor facial hair and out-of-work actor types with artful bedheads and faint-orange Mystic tans. The girls are the same, minus the facial hair.

"Tell me again why we're here," I say.

"What?" Scout says, frowning. "I like the tofu chilaquiles."

"Ugh, your taste in food," I say. "Okay, speaking of cooking, let's talk about your party. I don't have a lot of time."

"Antiques to photograph?"

"Yeah, well, they're not getting any younger," I tell her. "Plus, I have to be back at the house by four to meet the dog groomer and car detailer."

"Wait," she says. "Is that one person? How many people is that?"

"What's wrong with that?"

She hits the perfect note of feigned innocence, like it hasn't occurred to her that this might be a little desperate. I mean, I'd never throw myself a party. That's just sad and lonely. Not like lying in your bed on Saturday afternoon, judging your friend for wanting to have a good time.

"Absolutely nothing," I say.

"Good," she says. "Because I want you to cook. Let's have lunch on Wednesday and we can talk about it."

"Okay, but it has to be fast and cheap," I say.

"Swingers, one o'clock, see you there," she says.

Thirteen

I'm lying in bed on Saturday watching *The Real Housewives of Orange County*, slightly hungover from the bottle of Valpolicella I plowed through the night before, when I feel a reality-TV shame spiral coming on. I mute the TV and call Scout, hoping to ward it off.

She answers on the second ring. "What are you doing?"

"Reading back issues of *The New Yorker* and giving myself a pedicure."

"No, seriously."

"Googling ex-boyfriends and drinking jasmine tea," I say. "Writing a condolence note to Lisa Rinna about her lips."

"Wow," Scout says. "And you found time to call *me*?"

"I'm about to cross over to the dark side of the moon."

"I have no idea what that means," she says. "And I can't wait for you to tell me. But first, let's talk about my birthday party."

Well, shit. I can recite the phone numbers of every landline of all thirteen apartments Donna lived in when I was a kid, and I can't remember my friend's birthday? I suck.

"I am so on that," I say.

"I don't need you on it. I'm on it."

"You're throwing yourself a party?"

freshly grated nutmeg and four cheeses—Gruyère, Parmigiano-Reggiano, Fontina, and Vermont white cheddar; French toast with thick-cut slices of challah bread, stuffed with cream cheese and Bonne Maman strawberry preserves and dunked in a rich cream-and-egg bath perfumed with Madagascar vanilla and freshly grated orange zest.

Seon-Yeong didn't hide the fact that she wanted Robbie back. He scoffed for the first few months. He scoffed for almost a year. Then I started catching glimpses of the truth behind his sea-green eyes: I'd been a mistake.

Our parting was amicable enough; the only hiccup came when the mediator paused with her pen above the box on the dissolution form about money. Since Robbie had sold his shares in the record company after we'd married, there was a huge amount of joint property and we hadn't even thought about a prenup.

"You're not taking anything?" the mediator asked me. "I'm not even sure the judge will sign this."

I'm nobody's idea of a martyr, but that money wasn't mine. I didn't want to punish Robbie, and I'd never seen him as a career move. What I wanted—what I needed—was something of my own: a job, a dream, one moment that was for nobody else but me. Or maybe all I'd wanted was approval. Maybe I would've said yes to anyone who told me I was spectacular.

So good-bye, Robbie. Good-bye, tiny, unhappy children. Snip. Cleanly excised from my life like they never existed.

Seoul, about their two young children and the fact that they hadn't had sex since his daughter was born. We spent a week in New York, a crazy montage of whirling autumn leaves and brown paper cones filled with roasted chestnuts and an abbreviated *Pretty Woman* moment where I tried on clothing in a SoHo boutique. We chased a lost dog in Central Park, then took a cab to Brooklyn to find its frantic owner, who plied us with lumpy, hand-crocheted hats that we wore nonstop for the rest of the trip.

When we returned to Los Angeles, Robbie came clean to his wife. We moved into his partner's beach apartment, where I'd pack him gourmet lunches with ingredients we shopped for together at the Bristol Farms on Rosecrans. He sent me a case of professionally cellared 1973 René Lalou champagne after we had it at Patina and I said it tasted like sex and flowers.

Seon-Yeong and the kids moved to San Francisco to be closer to her family, and Robbie asked me to marry him, cracking open a tiny velvet box at the Ivy, just two days after his divorce was finalized.

Of course I said yes.

We postponed a honeymoon in favor of setting up our new life in San Francisco to be near his kids. Suddenly, I was a suburban housewife and part-time stepmom.

The only thing I knew about being a stepmom was what I'd learned from Gloria, who, of course, wasn't my stepmother, but it seemed like a good enough place to start. I read bedtime stories and created elaborate craft projects involving glue sticks and construction paper, pipe cleaners and googly eyes. I cooked child-friendly meals from scratch: spaghetti with hand-rolled pasta and tender, melting meatballs with three kinds of ground meat (veal, pork, and beef) and slow-simmered sauce with San Marzano tomatoes and fresh herbs; macaroni and cheese with a velvety béchamel with

❧

Take Robbie, my ex-husband. Robbie basically bridged the gap from my wayward adolescence into my mid-twenties, a desolate period where I knocked around making ends meet with temp jobs and bad dinner dates with older men. I met Robbie after I'd crawled my way up from an assistant manager position at a gym in Venice, where my primary duty was to distribute shipments of gray-market Italian steroids, to a gig I really enjoyed at a boutique online travel agency for people too wealthy or aspirational to have their assistants bother with the details.

Robbie was a partner in a smallish record label called Death/Friends. "Record executive" sounds glamorous, but he spent most days crunching numbers and, every few months, hopping on a plane to follow a tour. I arranged his travel for months before we met in person. After I got him a suite at the Majestic in Cannes, four days before the start of the MIDEC music conference—a feat of uncanny skill—he sent a huge basket of white hydrangeas and roses, with a FedExed note in what turned out to be his own handwriting.

You are spectacular, it read.

And in that moment, the scent of flowers perfuming the air around my tan burlap cubicle, I believed him.

In the weeks that followed, Robbie needed a lot of travel arranging. He started asking for his itineraries to be delivered to his office, by me specifically, and he always timed it so he could take me to lunch. Never anywhere fancy—Phillipe's for French dip, or one of the nameless places on Olvera Street for enchiladas and beer. I told him things I'd never told anyone. I even told him about Trent Whitford.

He told me about his marriage to a Korean woman he'd met in

66

I hear the bedroom door creak open, and Tyler pads into the kitchen.

"Hey, sparkle," I say with a buoyancy in my voice that I'm channeling from a long-ago childhood moment when my mother was lurching around the kitchen, struggling to hold a cup of coffee in her shaking hands. "How are you?"

"What's that?" he says.

I've got the loftiest puff of foam rising above the edge of the milk pitcher, and I waggle it in his direction. "Intelligentsia coffee and the most ephemeral foam you've ever seen, from cows untouched by human hands."

"Really?" He cocks his head at the GS/3. "I thought that thing was toast."

"I'm the coffee whisperer," I tell him. "You know I have a Venice boardwalk pedigree."

I pour the espresso into the cappuccino cups with a high-handed flourish, then scoop foam as glossy and stiff as meringue onto the top of each one. Tyler reluctantly takes the warm cup from my outstretched hand. He sniffs like a cat nosing a long-dead grasshopper on a perfectly manicured lawn.

Then he takes a tentative sip and sighs in pure pleasure.

I dump the coffee grounds and the milk leftovers into the Herbeau Luberon farmer's sink, rinsing the debris into the disposal with the Frattini pull-down faucet. There isn't one thing in this kitchen that isn't an architectural marvel and a name brand.

"Oh my God, Jess," he finally says. "This is nectar."

"Thanks," I say, shrugging like it's nothing.

And maybe I'm not cooking anything except ravioli, maybe I'm not even moving forward in any perceptible fashion, but that's okay. My pleasure at Tyler's approval eclipses all else.

Here's the thing: approval is an issue for me. Big. Thanks, Donna.

At least the week ends in triumph. On Friday, I skip Starbucks. Instead, I slip into the kitchen twenty minutes early. Zelda sniffs for a biscuit as I rummage through the refrigerator, pulling an unopened bag of bourbon micro-lot espresso roast from the freezer, and a glass bottle of Broguiere's organic milk. Everyone in the neighborhood gets at least one bottle delivered two times a week. No one on the street talks to each other, but they all share vendors: the milkman, the dog groomer, the car detailer who arrives armed with Q-tips and baby wipes to extract grime from Bentleys and Range Rovers and Carreras. We're all in this together, yo. Our people make the village.

I leave the antique French wine carrier by the front door on Wednesdays, and on Thursday mornings it's filled with two glass bottles of milk, fresh from the cow. It's the most expensive milk on the planet. No matter that we don't use milk in this house. It's part of the décor.

But not today. Today I'm going to tackle the cappuccino machine and make Tyler a coffee.

The La Marzocco GS/3 is a metaphor for my life: big, shiny, and superfluous. I grind beans in the burr grinder, tamp the grounds into the holder, and fire up the gleaming beast.

The plumbed-in line isn't feeding water into the reservoir, so I dump in tap water and hope for the best. A few minutes later, a stream of inky brown espresso flows into the oversize ceramic cup. I feel like I just discovered penicillin. I pour a few inches of milk into the pitcher and plunge the steaming wand into it. The sound is like a freight train. I'm used to it from my stint at the Date Palm, but Zelda tucks her tail between her hind legs and creeps into the living room.

thropologie. Still, Tyler's convinced it's the magic that makes his tea roses bloom year-round.

The whole process takes twenty minutes, start to finish.

Monthly charge: $1,500.

I must say, though, the deck looks fantastic. It's a weeping profusion of white roses cascading from hand-painted Italian urns. There are rosemary bushes neatly trimmed into topiary balls and rectangular planters lined with green moss that's been hand-cut into checkerboard two-toned patterns. There are dwarf kumquat trees with waxy, white blossoms and bright-orange fruit, and an arbor of rare, white bougainvillea shading a fifteenth-century Italian church-altar table, surrounded by eight folding wooden chairs with leather hassocks.

I made the mistake of calling them gardeners.

The little buff one said, "We're botanical stylists," with an Arctic chill in his voice.

I swallowed a snicker. "Right. Got it. I'm Jess."

When the regular-size buff one introduced himself, I wasn't sure if he said Kirk or Kurt, so I said, "How do you spell that?"

He arched a perfect eyebrow. "It's Kirk with two *k*s. But only the second one is capitalized."

"So unique," I say sweetly. You're a freak, kirK, but you really fill out that T-shirt. Also, I need to know who does your brows, because they're spectacular. The flower boys, by the way, are completely straight. In any other city, if I described a buff man with perfect eyebrows driving a white Range Rover and holding a plant mister, that might involve different connotations.

Welcome to Hollywood.

never changes. I'm just saying the same thing over and over like a parrot.

I've made ravioli from scratch four times in six days, transforming flats of fresh artichokes from their raw, spiky state into a smooth puree. Each artichoke has to be steamed and scraped to collect the meat; each sprig of thyme is fresh-plucked from the garden and hand-stripped. It takes a metric fuck ton of artichokes to make a single cup of puree.

When that's done, I make the pasta dough and let it rest before rolling it into thin, translucent sheets on the Atlas roller. Some days this works better than others. I often have to scrap a batch and start again because I've misjudged the ratio of wheat flour to semolina. There are machines that can do this in a fraction of the time, but I make it by hand because Tyler said the pasta from the machine tasted funny.

It's endless. The only thing I'm trying to say with my food at this point is *You're bugging the shit out of me.*

I'm elbow-deep in the ravioli process—steamed hair, flour-encrusted shirt and all—when I meet the boys from Fleurs et Diables. Fleurs et Diables is the company that takes care of the blooming plants on Tyler's deck. The whole operation is two guys in tight white T-shirts emblazoned with stylized devils lounging on a carpet of rose petals. They pull up in their branded white Range Rover once a week, snip a few things, then ceremoniously sprinkle "Peruvian blue magic" here and there. It's allegedly some kind of powdered rain-forest spore they smuggle in from the Amazon, but I'd bet all the money in my bank account—granted, that's about $47—that it's Miracle-Gro in a burlap satchel they bought at An-

tion. With the remainder, I was laying out neat rows of pictures I'd taken the afternoon before at several Melrose antiques stores.

Fries momentarily forgotten, he flicked his gaze across the glossy images and heaved a sigh.

"What?" I said.

Tyler extended his little finger and pointed down the rows of three in rapid succession. "Fake, fake, hideous. Not what I asked for, mediocre, probably fake. Not bad, ooh, really fake, annnd . . ." He picked up the last photo to study. "Not even Biedermeier."

If he was right, then half the fancy stores on Melrose Place were selling fake antique furniture at escalated prices, which I highly doubted, but still. He certainly knows his shit. It didn't even matter. The point was that I'd failed. Or at least felt like I'd failed. Or maybe there was a moving target and I wasn't even sure what success looked like anymore.

Tyler glumly waggled a fry at Zelda, who launched from her perch on the Roche-Bobois sofa that has become the bane of Tyler's existence.

"You know what I'm in the mood for?" he said. "Ravioli."

I leaped into the void left by my Biedermeier debacle. "I can do that! I made fresh pasta all the time when I worked for Wolfgang."

"Really?" Tyler perked up. "You can do that?"

"Absolutely," I said, even though the truth is I worked for Wolfgang for less than six months, mostly as a secretary. Still, sometimes they'd let me in the prep kitchen to do scut work.

Cooking is pretty much the only thing that's ever come easily to me. All the feelings I stumble over putting into words—*I'm sorry, I suck, I love you*—are far easier for me to express through food. Cooking for Tyler would be an ideal situation, except the menu

Twelve

The second week of my trial period starts rough. There's a new girl at Starbucks; she looks confused when I place my order, and I feel a queasy tremor of dismay. I really hope she understands that *bone dry* means she has to wait until the milk has settled in the metal pitcher before scooping only the foamiest of foam into the cup. Yep, that's my life right now.

Tyler is full of quirky charm, but he's also becoming increasingly particular by the day. And it's not only about coffee anymore. He's decided that all he wants to eat are diced, fresh mangoes for breakfast and handmade artichoke ravioli for lunch, which I sauté in clarified butter and sprinkle with fresh thyme picked from the terra-cotta pots artfully jumbled beside the carport.

At least it gives me a chance to shine.

"I'm so sick of 17th Street Café," he said last week when the fries were too limp, even though I'd had them packaged separately and to prevent condensation opened the Styrofoam clamshell during the ten-block drive to the house.

"This," he said, holding aloft a wilted example for my inspection, "is disgusting."

"Mmm-hmm." I was giving him about 30 percent of my atten-

would fall into place. So she kept dredging up auditions, which inevitably ended in halfhearted choruses of "We'll be in touch" from as early as I can remember until the month before my fifteenth birthday.

That's when she got me a big break, the kind of once-in-a-lifetime chance that changes everything. That's when she put me in front of Trent Whitford, a critically acclaimed director whose movies rarely make much at the box office, yet he still gets mentioned in the same breath as Kubrick and Scorsese.

There's a lot of shit that ensures that Donna will never make the short list for Mother of the Year, but this is the one thing I still can't get over.

asked if I wanted some Adderall. The humiliating part is that I still blew him after that.

The sexual hierarchy is weird in my life. When Megan's around, I'm the sassy sidekick, the girl who the boys all cozy up to in order to get closer to her. I'm embarrassed to admit it, but that's a comfortable role for me. And it takes the place of having to worry about my own life. It's easy to be that person. God knows I had years of practice with Donna.

Not that Megan's anything like my mother, but there's a certain type of woman who just pulls focus when she walks into a room. Angelina, Charlize, any number of Jennifers. It's what this whole town is built on.

My mother had it.

Megan has it.

Me? Nope.

But being in Megan's orbit makes my own star shine a little brighter. When she's gone, it's like an eclipse, the dark side of the moon. Am I still shining if nobody sees?

According to my mother, no. Just another of my failures. I was a shy child with lank hair and a pudgy body despite her constant, grinding efforts. I wanted to hide in my bedroom and read books, but instead there were photo shoots and salon appointments and painful auditions where I gamely tried to act like I was enjoying imaginary bowls of pudding. My mother stood in the back of the room in her Guess jeans, mouthing the words that turned to lead when they passed my lips. The memory still brings the blushing snakes up my neck.

My mother believed in Scientology and Rolfing and expensive haircuts. She believed in bad karma and good tans. More than anything, she believed that if I booked a movie or TV show, her life

Eleven

The next day, Megan leaves three drunk messages at five in the morning, telling me I should come to Hawaii, that I *need* to come to Hawaii. There's some problem with the shoot, so she's stuck in Maui indefinitely, boo-hoo. But when I call back, it goes straight to voice mail.

"No permanent job offer yet," I say after the beep. "But I haven't been fired. I'll call that a victory. Enjoy the sun!"

I add the last bit because I saw a picture on one of the tabloid blogs of her sitting by a big hotel pool in a black catsuit and a giant straw hat. The caption read "Megan Campion takes her sunscreen seriously." Yeah, well, she's playing a fucking vampire.

Then I get a FedEx envelope with a bunch of hundred-dollar bills and a note: *The per diem on this show is insane. Shove half in a drawer for a rainy day. The rest for a plane ticket. ☺ Miss you.*

A smiley face? She's definitely getting laid.

I haven't had sex since a random friend of Pete's—the Date Palm manager—came to town to look at business schools. In my defense, I'd just finished a three-day juice fast and my stomach was so flat it seemed like a waste not to let someone appreciate it. Totally lost on the business-school dude, who drank four shots of tequila, then pinched the inch of flesh above my Hanky Panky boyshorts and

But celebrities are treated differently, of course. Even the sticky-pawed toddlers waiting in line with their stay-at-home moms gawp in appreciation when Pamela Anderson blows in wearing sheer white leggings and knee-high faux shearling boots. Actually, little kids are the only ones who stare.

The rest of us—patrons, baristas, and even the occasional homeless person—have perfected the L.A. art of the un-stare. It's just one of the many tacit understandings that make this city function: we pretend, at least in public, that we're not interested in the gods who walk among us, usually by studiously attending to a small grooming matter or the contents of our cell phones whenever they come into range.

I don't even have to bother with the un-stare today. Jake Gyllenhaal and Taylor Kitsch could be oil wrestling in the middle of the floor and I wouldn't take my eyes off Tyler's milk order. I've opened with a gambit of rudeness, and that's a good way to end up with something in your drink that is unfit for human consumption. I mean, hypothetically, of course. I'm sure no one at Starbucks would ever do anything like that. Certainly not the girl who is radiating death lasers at me as she plunks my order on the counter and growls "Have a nice day" at me through gritted teeth.

Ten

On Friday morning, I lose it with the Starbucks barista, who insists on letting milk dribble into the cup as she's scooping the foam.

"I need just foam," I say. "Absolutely no milk."

"But it's made of milk," she says, her brow furrowing in confusion.

"I'm not asking for a nutritional breakdown," I say. "I need a venti cup of all foam. Just foam. No liquid."

She frowns and crosses her arms over her milk-stained, green apron. "I have a lot of other customers and this cup will take three pitchers to fill with just foam."

"Well, you better get on it then." I immediately regret my tone, but I can't show weakness by backpedaling now. "I'll be right here."

Great. One week in, and I've become the asshole coffee orderer.

Whatever. It's not like this particular Starbucks, on the corner of Seventh and Montana in the rarefied flats of Santa Monica, is any stranger to special requests. The neighborhood surrounding the deceptively down-home shopping street is filled with the kind of aw-shucks celebrities who lean toward large dogs and immaculately restored old American muscle cars. I'm usually in line behind a couple of them, wearing artfully tattered vintage concert tees and Havaianas and special-ordering coffee like it's their day job.

"All very tempting," I say. "Hopefully the offer will still be open when his Cruella de Vil manager shitcans me."

Megan fake pouts as I take the wad of brightly colored fabric from her bag and start untangling it. "Hopefully, but you never know."

She's so adorably full of shit.

I flip her off and light a cigarette from the crumpled pack on her bed. "That's not all I do, I'll have you know."

"Oh, of course, my bad. You also walk his dog."

"And take Annie Leibovitz–like photos of fabric."

"Just admit it's a hell job."

"It's not, Boof," I say. And frankly, I'm more into Tyler than I am Maui right now. They're both hot, but only one of them is having a meeting with Brad Pitt's Plan B production company next week.

"Just for a few days," Megan wheedles. "You can stay in my room, and I'll get you paid on production's dime. You won't even have to do anything."

"Why do you think I'm such a slacker?"

"You're not a slacker," she says. "You just need to find your niche."

"Boof, my niche isn't sleeping on your pullout in Maui, trying to find something to do all day while you're being a TV star."

"Shut up, slacker," she says. "Just come. Linus will live."

Megan calls Tyler Linus, based on the wrong Peanuts character. She means Schroeder, but I haven't told her because I find her confusion adorable.

"I would love to come to Maui and be your beck-and-call girl, but I just can't bail. This is my first real job since Robbie and I broke up." It's more than that, of course, but I don't know how to articulate it, even to Megan. Going to Maui with Megan—even though I love the shit out of her—still puts me on the wrong side of the velvet rope. She's not big enough to have an entourage; I would just be a tagalong.

"Mai-tais, room service, cabana boys." Megan gives up on sorting a tangle of bikini tops and chucks the whole thing into her open suitcase.

doesn't like the resolution on the pictures I take with my iPhone, so he sends me out with a Polaroid One Step, which has been obsolete for about a million years. He has a stash of film that Kenner bought off eBay for God-knows-what per cartridge.

Turns out they're used to it at Villa Melrose and Bountiful and the other places he dispatches me to visit, but still, the eye rolls are endemic.

"Oh, you're Tyler's new assistant," a girl who could be Gwyneth Paltrow's younger, hotter sister says to me as I'm awkwardly trying to grab a snapshot of a dresser that looks like it was made from discarded barn siding. "He's got such a great eye."

I copy the information from the back of the tag onto the damp, square photo: fourteenth-century Italian shaving cabinet, sourced in Bagno Vignoni, twenty thousand dollars.

I don't know whether to laugh or cry.

My third day passes without incident and I'm still on the phone arranging a restoration carpenter to fix Tyler's French doors when I get home and Megan starts bleating incomprehensible enthusiasm at me from her bedroom.

I finish with the carpenter and poke my head in her room to find her packing. Gary Scott Thompson came through. The pilot is on.

"Throw some shit in a bag!" she says. "We're leaving tonight."

"I can't," I say, flopping onto her bed. "I'm employed now, remember?"

"Trial period," Megan says. "And I'd like to point out that you've graduated from making coffee to ordering from Starbucks. You've hardly broken the glass ceiling."

"What the fuck else would I be talking about? Tyler said it was completely undrinkable."

"I know. Starbucks, right? I should make his coffee myself."

There's a seething pause. "Every detail is equally important in Tyler's world," Cassidy finally says. "If you can't handle the simple tasks this week, then you're not going to make the cut. Do you hear me?"

"I hear you," I say.

"Great," she says, and clicks off.

"Okay," I say to the dead phone in my hand. "Nice talking to you, too. Have a great day."

When I walk into the house, Tyler's bedroom door is shut. I can hear Zelda snuffling around on the other side. There's a Post-it on the door that reads:

Can you run up and get me a coffee before you wake me up? Two cups: triple shot of espresso in one and (in a separate cup) a venti nonfat milk foam. Milk foam, not milk.

It's becoming clear that Tyler is a bit off-kilter. Although I have to say, with an Oscar and two Grammys and an impeccable taste level, he's so out of my league that if he weren't a little crazy, I'd have no chance. Not that I have a chance now. Frankly, I'm still pinching myself that this is even happening. I mean, only a couple weeks ago I was stacking quarters from my tip jar and wondering if I had enough money to get a burrito *and* a bottle of wine after work.

When I get back with the coffee—which Tyler pours as carefully as a chemistry experiment into an Arte Italica mug without remark—we set up my day's schedule, which consists of discussing which clothing stores, fabric stores, and antique stores I'll need to visit to obtain snapshots of merchandise he may want to acquire. He

In addition to the Carrera and the vintage 280SL Mercedes that lives under a car cover tailored better than anything in my closet, Tyler has a restored mid-'70s pistachio-green Ford Bronco, with a layer of mud along the sides that looks like it was painted on by a prop stylist. I'm there and back in nine minutes, mostly thanks to the fact that I hit a lull at what is normally a bustling Starbucks location.

Tyler makes a face when he takes his first sip. "Too much milk."

"Here," I offer. "Try mine?"

He wrinkles his nose. "Don't be silly. It's fine."

"I can run back and get you another. Or maybe I can look at your espresso machine. You know I have a degree in barista service."

He laughs. "Don't worry about it, Jess. I'm pretty low maintenance about this kind of stuff."

Uh-oh. Death knell. When people say they're low maintenance in L.A., it inevitably means that they're anything but.

For the record, that was the last day Tyler's coffee was "fine."

Cassidy calls when I'm pedaling down the bike path the following morning. I've given myself an extra half hour to get to the house, just to be on the safe side, and I am so ahead of schedule I'm thinking of stopping at Patrick's Roadhouse to treat myself to a breakfast burrito.

"This is Jess," I say.

"How hard is it to get a coffee order right at Starbucks, Jacqueline?" Cassidy snaps. "I honestly don't get it."

I twitch, but ignore the deliberate wrong-name thing. "Good morning, Cassidy," I say, with my most passive-aggressive chirpiness. "Are you talking about Tyler's cappuccino?"

"No," I say. "Absolutely not. He said ten, but then he changed it to ten thirty. I'm positive about this."

"There's no need to be defensive," he says soothingly.

What the fuck? I'm not being defensive, I'm being accurate. In my own defense. Aren't I?

"Listen, Jess, I don't want you to get off on the wrong foot. My suggestion is that you build an extra few minutes into your commute time so this doesn't happen again."

"Okay. Uh, thanks for the heads-up."

"No problem," Steve says. "I'm sure we'll talk soon."

"Great," I say, but he's already terminated the connection.

I wheel in on my bike at 10:25. I'm still not sure if that's five minutes early or twenty-five minutes late, but I dump the bike in the courtyard like it's on fire and paw frantically through my road-ravaged hair as I burst through the front door.

"Hello?" I call out softly.

Zelda leaps from the sofa and gallops over to greet me, burying her nose in my crotch.

"In here," Tyler calls from the kitchen, where I find him pacing and smoking in what looks like acute agitation. "I'm so glad you're here! The espresso machine isn't working. Again. I hate this thing. Can you run to Starbucks before we get into our day? Double cappuccino, extra dry."

"Absolutely." I'm hyperaware that I'm possibly late, but I can't say anything, so my voice sounds all fake and tinny in my ears. "Do you want me to take my bike? I can probably get there and back in about twenty minutes."

"Oh God, no," Tyler says. "I can't get through the next four minutes without caffeine, let alone twenty. Take the Bronco."

Nine

I'm riding down Lincoln Boulevard on the morning of my second day for Tyler when my phone rings, an 818 number I'd normally let go to voice mail, but I *am* a celebrity personal assistant now, after all. I mean, what if it's something important?

I stop at the corner and slip in my ear buds, balancing my foot against the curb. "This is Jess," I say, pressing my mouth to the mic as a Humvee guns through the yellow light.

"Hi, Jess, it's Steve Collier."

"Oh, hey," I say. Shit. Tyler's business manager. I immediately get a flutter in my chest like I've done something wrong, which, hello? I've been on the job for exactly one golden day.

"So, you had your first day yesterday," he says. "How was it?"

"Oh my God, are you kidding? It was great."

"Good, good," he says, and I can hear the buzz of an office behind him, people talking, computer keys clacking. "Tyler thought you were great, really top-notch, but there's the little problem with your tardiness."

The flutter in my chest migrates south into my stomach. "I'm sorry, my what?"

"Tyler told me he asked for you at ten, and you were almost half an hour late."

couple weeks, even when I had her drink and pastry waiting by the time she got to the counter.

Finally, I asked how long she'd lived in the area, and she said she got emancipated at fourteen and moved into the one-bedroom apartment next to the Date Palm and had lived there ever since, with about as much forward momentum as a car on blocks.

"Jesus, really?" I said.

"I know," Scout said, like she was used to answering the question. "Crazy, right?"

"No, you don't get it. I'm blown away because it's so familiar."

And on that foundation, our friendship was built.

Scout and I mostly hang out when Megan's out of town. Which is weird, because Scout's best friend is an actress too. The difference is that Scout's best friend is bona fide famous. She's Eva Carlton, who spent her formative years playing the slutty sister on a sitcom, then moved to one of the big five soap operas—and finally hit the big-time on a high school show where every actor was gorgeous and pushing thirty.

You'd think that Scout and I would bond over it, but instead it creates a weird distance between us. Maybe it's that neither of us is good at girl stuff, or maybe it's that Scout's celebrity friendship is bigger than my celebrity friendship. It's a very L.A. question: can a girl who hangs with a solid B-lister be friends with a girl whose closest friend is clinging to the D-list?

She swears I grabbed her arm in an aggro Freddy Krueger slasher grip, but we agree on what happened next, which is that she startled like a gazelle on the African veldt and sloshed a good sixteen ounces of hot, black coffee—with two shots of Italian roast espresso—all over her tattooed arms and white tank top.

And here's my favorite part. She dropped her purse, still without making eye contact with me, and carefully set her phone and the bag with her scone on top of it. She sluiced coffee from her forearms and wrung a thin stream from the lower part of her shirt. She took off her black-framed glasses and wiped them on a clean spot on her shirt.

The whole thing took maybe ten seconds, but it was very effective: *You will wait while I deal with your mess.*

Finally, she looked at me with her crazy-beautiful pale blue eyes and said the most ridiculous, clichéd, L.A. thing that you'd think nobody could ever be cheesy enough to say aloud.

"Don't you know who I am?"

(For the record, she says that I said, "Who do you think you are?" but she lies.)

"Yeah, you're the girl who just tried to ditch out on paying for breakfast. Can I get an autograph?"

Scout flicked her hair over her inked shoulder. "You must be new."

It turned out she lived in an apartment that was practically connected to the Date Palm, and she was such a regular that Pete let her run a tab. Which was lovely, except the Date Palm has a strict "no credit" policy and she's one of a handful of exceptions, which no one had bothered to mention to me.

She grudgingly accepted the replacement shirts I handed over in a beribboned gift bag two days later, then ignored me for the next

46

met her on my first day at the Date Palm counter, and we almost got into a fistfight.

I'd only been behind the counter for ten minutes when she came striding in with her tattoo-sleeved arms and her ironic red pigtails and her size-14 skinny jeans that are so body conscious they're a thrown-down gauntlet challenging you for even looking. Her whole persona screams, *Go ahead, say something about my body.* People either love Scout or hate her. She's like cilantro or Chris Brown. For the record, I love cilantro.

She was wearing a skintight white wife-beater over a purple lace bra that day, and she'd twisted an old-school white bandana into an ad hoc headband that was part Bettie Page rockabilly chick and part Aunt Jemima. She had big black platen headphones clamped on her ears, and I could hear something feedback-filled and angry leaking out into the space between us, maybe an old Tool song. She was tapping on her phone and didn't even look up at me when I said hi.

"Double red-eye, no room, maple scone," she said, and turned her back to lean her ample ass against the counter, like *We're done here, right?*

I looked at the leaping koi and exotic mermaid decorating the backs of her arms and thought, *Huh, that's kind of a bold attitude to take with the person who's about to handle your food.*

When I set everything on the counter, Scout grabbed her order and headed for the open front door without another word, trailing a guitar solo and the scent of gardenias.

"Hey," I yelled after her. "Hey, that's $11.75."

I ran from behind the counter, hobbled by the apron, and caught up with her at the edge of the patio. I reached for her elbow to get her attention, because she still had her music blasting and she wasn't acknowledging my presence.

to pay for transportation to the venue. It's a harsh gig. Not many girls could hack it.

"I'm getting too old for this shit," she says in lieu of a greeting when I answer.

"Where are you?" I say.

"You don't want to know. A random Motel 6 in Texas. How's your job? Today was your first day, right?"

"Dude, it was like the best blind date ever. He has a Weimaraner named Zelda and Dupioni silk drapes in his living room that cost more than the house I grew up in."

"Dude," she says, mocking me.

"Today? I drove around in his Carrera and picked up fabric swatches for the sofa he wants to buy."

"Swatches?" Scout says.

"Yeah."

"Well, good. Maybe he has a straight brother."

"I think he's straight."

"Yeah, the hot guy with a Weimaraner?" she says. "What did you say his curtains are?"

"Dupioni silk."

"Single straight guys don't have curtains, let alone doopy-whatever."

"What do you think, they tape cardboard over their windows?"

"What windows?" she asks.

"You are hanging around with the wrong single straight—"

There's a huge crash, followed by the unmistakable sound of puking. Which sort of proves my point.

"Shit, I have to go," Scout says. "We'll hang out when I get back."

"Sounds good," I say. "I'm around."

I cut the connection with a smile on my face. Fucking Scout. I

Eight

Tyler is a dream boss. We ate burgers, took the dog for a walk, looked at Kilim fabric swatches from George Smith for the new sofa Tyler wants. It was kind of a magical day.

When I pull up at the door to my apartment, I lock my bike and dash into the One Life to buy real food to cook myself a proper dinner, something I haven't been motivated to do for weeks. I buy a bunch of organic dinosaur kale, a perfectly ripe avocado, a can of Italian white beans, a shallot, and a handful of roasted pepitas. It's like I can't commit to feeding myself more than one meal, but it's definitely a start. I even dash across the street to the liquor store and pick up a twenty-dollar bottle of white Burgundy. I mean, why shouldn't I treat myself like a grown-up? I'm feeling pretty sassy, I have to say.

As I'm hauling my bike and my groceries off the antiquated elevator, my phone rings, lighting my screen with a picture of my friend Scout and me in a thrift store in Echo Park. I'm holding a shirt up across my chest that reads I'M WITH STUPID, the arrow pointing toward her, and we're both laughing. For the record, Scout is way less stupid than I am.

Scout works as a tour manager for a couple metal bands. Not A-list, like Motörhead or Metallica. I'm talking about bands on a level where they sometimes turn down shows because they can't afford

He grimaces. "That's my agent. I have to take this."

"Of course," I say. "What do you want on your burger?"

"They know me," he says. "Just make sure you talk to Kyle. There's a credit card in the silver box on the ottoman. I always tip thirty percent."

"Perfect," I say. All this, and a big tipper.

I peek into the cupboards—Baccarat rocks glasses, Arte Italica white porcelain coffee mugs with pewter bases, simple Tiffany flatware—then hurriedly arrange myself in what I hope is a casual pose against the perfectly worn limestone countertop as he returns, having an animated phone conversation with a shrill voice on the other end that buzzes in the cozy kitchen.

"Cassidy, you're overreacting. I was just . . ." He looks over at me and shrugs apologetically. "You know what? Jess is here. Let me call you back in two minutes." He disconnects the call from the button on the Bluetooth in his ear and turns to me. "Sorry, that was my manager."

And I have a weird feeling like maybe he doesn't realize that Cassidy and I already spoke. There's a weird thing that happens in Hollywood sometimes where the talent gets protected by layers of agents and managers and assistants, and I'm not sure where I fall in this structure right now, so I'm just going to keep my mouth uncharacteristically shut.

"Listen," he says, before I have time to second-guess myself. "Why don't you run up and get us lunch at 17th Street Café and I'll be done by the time you get back?"

"Sure," I say. "But, uh, I'm on my bike."

"Right, your bike." He scratches the back of his neck. "Well, it's as good a time as any for you to get familiar with the cars. Do you drive stick?"

"Of course," I say. "Since I was sixteen."

"Great," he says. "Take the Carrera. The keys are on the hook by the door."

His phone bleats the opening bars of Wagner's "Ride of the Valkyries."

I jot notes in a notebook with a leather spine and a brown Kraft paper cover, and I'm inordinately pleased when I catch Tyler eyeing it approvingly because, seriously, his taste is beyond impeccable.

His cell phone rings nonstop, and after the first couple callers, he tosses it into the silverware drawer in the kitchen.

The kitchen is more amazing than my wettest kitchen dreams. A six-burner Viking range, a double-door SubZero, an oversize Bosch dishwasher—the works. This whole job thing is so fairy-tale ridiculous that I'm starting to panic. Fortunately, there's a La Marzocco GS/3—a seven-thousand-dollar espresso machine, all stainless steel and dry steam and manual preinfusion—just waiting there for a chance to show Tyler how awesome I am.

Except he won't let me fire it up.

"There's something weird with it," he tells me. "I think we need to send it back."

Which sucks. But I just smile and say, "Do you cook?"

"Not really," Tyler says. "Do you?"

"I love cooking," I say. "What do you like to eat?"

"I'm easy about food these days. I've been living on croissants from Starbucks and burgers and steak sandwiches from 17th Street Café."

"Really?" I say. "You don't strike me as a burger guy."

"I'm totally a burger guy. As a matter of fact, I'd like to be a burger guy right now. Why don't we take a run up there? I'll take you to lunch."

"That sounds fantastic," I say.

Free lunch, cute new boss. Better than Maui.

"Let me throw on a clean shirt," he says, retrieving his phone from the drawer and disappearing into his bedroom.

"Throw your shit anywhere," he says, gesturing vaguely with his lit cigarette.

People smoke in L.A. It trickles down from the celebrities, who smoke so they can fit into their size-00 jeans, and to create a filter between themselves and the rest of the world. It's every actor's dilemma—pay attention to me but don't look at me.

I stow my backpack on the paisley-covered window seat in the sunroom, hesitating for a moment because the fabric is lush and spotless, unlike any of my belongings, which have been exposed to four miles of beach salt and road dirt as I pedaled over on my bike.

Every surface in the house is polished and sparkling: the bird's-eye maple Biedermeier dining table, the Louis XV rolltop desk in the sunroom with its gilt-edged green leather inlay; even the wrought iron of the antique campaign chairs on the deck gleams with a burnished sheen and the striped fabric cushions look crisp and clean, which strikes me as a little odd because it's been raining for three days and this is the first sunny day we've had all week. Yet everything feels comfortable and lived in, like a page from a Ralph Lauren catalogue or *Elle Décor*, not stuffy and formal like *Architectural Digest*. I've never seen anything quite like it, and I'm instantly house-smitten.

"I just want to get you used to the lay of the land. You know, *mi casa es su casa* and all that."

"Great," I say, because "I do" would be too forward at this juncture.

Tyler moves through the house as I trail behind him, pointing out things that slipped through the cracks after Kenner's departure. The French doors to the deck are swollen from the uncharacteristically damp weather and need to be planed. The climbing roses have a white fungus that the plant guys need to look at.

I'm not exactly a morning person, but what am I supposed to say? "Right. Good!"

"Let me get to the point. Tyler took quite a liking to you, and he'd like to offer you a month's trial to see if the two of you are a good fit."

"That sounds like a smart way to move forward," I say, thinking, *I'm working for an Oscar winner whose manager vets his new hires. Suck it, gluten-free croissants!*

"He'll work out the schedule with you," Cassidy continues. "He just finished a film and he's taking a break for a few weeks."

"That's fine, um, sure, that's good," I say.

"I'm going to give you the number for Tyler's business manager. He's expecting your call. One month. Twenty dollars an hour. I'm sure we'll be talking soon."

She severs the connection while I'm still thanking her. And holy shit, I have a big-girl job. At least for a month. We'll deal with the fact that Kenner told me he made twenty-five an hour after they've fallen in love with me.

My first day working for Tyler is like a "meet-cute" montage in a romantic comedy. First of all, it turns out he doesn't want me until the luxuriously sensible hour of 10:30 A.M.

"I'm not a morning person," he said on the phone the night before. *Hallelujah.* "Come around ten. No, make it ten thirty. Let's not be too ambitious."

Sounds good to me. I'm not sure what Kenner's problem was, because Tyler is a dreamboat, sweet and casual, adorably rumpled when he greets me at the front door in what looks like the same jeans from the other day and a tattered, vintage Led Zeppelin T-shirt.

Seven

My phone rings the next morning at the ungodly hour of 8:05. The caller ID reads UNKNOWN but I'm pretty sure that my job offer from Tyler is imminent, so I shake my head like a cartoon dog and grab it on the fourth ring.

"Hello?" I croak.

"Jess Dunne? Please hold for Cassidy Shaylan." The phone clicks into a near-silent hiss that gives me a second to guzzle a mouthful of water from the bottle on my bedside table, then the disembodied voice clicks back. "I have Jess Dunne for you, Ms. Shaylan."

A voice booms through my earpiece like the landing of *Air Force One* on a deserted tarmac. "Jennifer? It's Cassidy Shaylan, Tyler Montaigne's manager."

She pauses, and while instinct tells me I should fill the space with my adoration, I was asleep until about forty-five seconds ago, and I'm still kind of astonished that it's not Tyler himself on the phone. Maybe I've underestimated his celebrity value.

"Hi," I say. Slick.

"Am I disturbing you?"

"No, no, of course not," I say, and it sounds like I'm gargling marbles.

"Good," she says. "I've been up since five, which is what Tyler will expect if you're going to be his new assistant."

wine from the Bota box on the counter and Google Tyler for hours. It's almost like meditating.

The Oscar, the Grammy, and the Emmy just scratch the surface. I listen to his stuff, and I'm a little blown away. And a little excited. Maybe this is it. I mean, nobody dreams of being the assistant, the gofer, the lackey, but maybe basking in a reflected glow isn't just the best I can do, maybe it's exactly what I need.

When Megan comes home, I spring from my room to tell her the good news. Got a job, he even offered an advance. I don't mention anything about Donna.

"Boof," she says, nonplussed by my enthusiasm, "it's not a deal until the check clears."

"I don't know, it seems like a thing."

"You didn't close the deal with him directly?"

"Well, he has to run it up the flagpole with his people."

"Ugh," Megan says.

"Don't shit in my cornflakes. I'm optimistic about it."

"Oh, honey, that is such a rookie mistake," she says with a flash of concern in her eyes and a furrow in her smooth yet un-Botoxed brow.

Then she takes me to dinner to celebrate, because we're out of champagne.

acai on my oatmeal, acai in my sunflower-sprout salads. I feel better already.

Then she says, "Is there a health-food store near you?"

Which is like asking if you can get saltwater taffy on the Atlantic City boardwalk. There's the granolafied hippie fest of the One Life, practically in the lobby of my building, and a giant Whole Foods on Lincoln and Rose. There's the indie Rainbow Acres near Venice Circle, and there's Rawvolution right up Main, which isn't a health-food store per se, but they'd have me hooked up to an acai berry IV if I walked in with a handful of twenties and the wrong kind of pallor. And that's just within walking distance.

There's a thrust and parry to my exchanges with my mother that's as nuanced as a fencing exhibition. No blood is drawn, it's just a show of skill designed to throw the other party off guard. I had a boyfriend once—well, not really a boyfriend, because he had an actual girlfriend who he took on dates and everything—who was on the high school fencing team. He loved to pepper conversations with fencing terms. He was all *en garde* and *riposte* and *pas de touché*, which, by the way, is different from *touché*. It's what the aggressor says when they've struck a glancing blow, to graciously acknowledge that the hit should not be counted.

Pas de touché is not a concept my mother would understand.

"Where are you staying?" I say, then mentally kick myself for even going there.

"I haven't gotten that far, snickerdoodle," she says. "I'll call you tomorrow. Big kiss."

Then she's just gone and I'm holding the dead phone in my hand.

After my *derobement* from my mother—that's when you avoid your opponent's attempt to trap your blade—I pour myself a mug of

Six

I binge-read six gossip websites, then break down and call Donna. Not knowing if she's coming or not is almost worse than finding out she definitely is.

"Sugar beet!" she says when she answers the phone. "I'm in the middle of packing."

"You're really coming?"

"Well, of course I'm coming, lamb chop. Didn't you get my texts?"

"I did," I say. And I let it lie there like a coiled snake.

Apropos of nothing, she says, "Oh, I've been meaning to tell you. I've been putting acai in my smoothies lately and I lost five pounds without even trying."

Which obviously means that I need a shit ton of acai berries and should immediately find someone who can supply me in bulk. One of my mother's major beefs with me is that I don't present myself the way she'd like. Whenever I see her, she invariably greets me with a comment about my appearance. Layers of sugar over ground glass:

You changed your hair. It's . . . different.

Wow, that's quite a dress you're wearing.

Are you taking something for your skin?

I don't know. Maybe acai berries are the answer. Acai smoothies,

over the treetops and looks a little shifty. Here it comes. He wonders if I'd mind dressing like Betty Boop and calling him "Herr Doktor."

He says, "Uh, Jess?"

"Yeah?" I ask.

"Sometimes, um, when I hire a new person?"

You want to see how they look in a ball gag?

"Yeah?" I say.

He takes a breath. "They're in a bit of money trouble. So if you need an advance against wages, now's the time to say so."

I take a deep, hopefully inaudible breath and force myself to exhale noiselessly. "Nope. I mean, I'm not here under the auspices of altruism or anything, but I'm solid."

"Great," he says with an even-toothed, glowing smile I wouldn't even question for its pearly authenticity if I hadn't spied the overflowing ashtray on his ottoman.

"Unfortunately," he continues, "I have a whole committee for this shit, but I really dig you. Let me make some calls and I'll definitely be in touch. I mean, soon."

"Perfect," I say, and I rub the dog's soft, inquisitive snout as I shoulder my bag and head for the door.

ers and Humvees zooming past my elbow. I wait in the street for a minute to compose myself, straddling my bike and breathing in the salt air and eucalyptus, then smooth down my cargo pants and the Petit Bateau T-shirt I bought on credit at Planet Blue yesterday. First impressions are important.

And Tyler is definitely making a good first impression on me. The outside of the house is very beachy chic. The paint on the eaves of the unassuming cottage peels in a fetching fashion and climbing roses bloom in hand-painted Italian pots, each one lined with checkerboard-patterned moss in shades of vibrant green. I park my bike in the open carport beside a shiny black Carrera and another sleek-looking car— a vintage Mercedes, I think—sheathed in a green canvas cover.

Tyler answers the door wearing perfectly rumpled Levi's and unlaced Timberland boots. He's on the short side, maybe five-foot-nine, but he's smooth-skinned and lean, long muscles evident under a fitted white thermal that looks soft and perfectly worn in. His sleek blue Weimaraner snuffles a greeting, then reclaims her position on the leather sofa. There's a full ashtray on top of the art books piled on an oversize zebra-skin ottoman.

The whole vibe is exquisite. And Tyler's not bad to look at either.

We sit on his deck and talk about the job in an offhand kind of way. He sounds like a perfectly normal guy who just needs a hand during a busy period, and I sound like a perfectly normal girl who just moved back to her hometown after a divorce. Just a shitload of normal all the way around.

He doesn't mention his Oscar. I don't mention that I searched online and saw that he won two Grammys, too, and an Emmy for Outstanding Musical Composition for a Series. He's laid-back and confident and too good to be true.

I'm not surprised when, at the end of the interview, he gazes out

Five

When I get home from my yogurt run the next day, there's a missed call from Kenner. I stand there for a long moment, my quart of nonfat salted caramel melting, and curse myself for leaving my phone behind during my four-hundred-yard dash across the street. It's always the way, right? You light a cigarette and the bus comes. But before I can call him back, my phone beeps with a voice-mail message.

"Jess, hey, it's Kenner. Uh, from the Date Palm. So I talked to my boss's manager. Well, you know, my ex-boss." He laughs, a nervous squawk that sounds like a jungle bird. "He wants to meet you. I . . . It's a little weird, because he told me to just have you come to the house. His name is Tyler Montaigne and he lives in Santa Monica Canyon. Can you go there tomorrow at ten A.M. sharp?" He gives me the address. "You can't miss it. There's a nine-foot hedgerow surrounding it and a Brian Murphy glass arch by the front gate . . . Ooh, which reminds me: Tyler absolutely hates it, so don't mention it."

I wait all of eleven seconds before I text him back. Thank you thank you. I owe you. Big. Xoxo.

I arrive for the interview on my beater Trek hybrid bike, huffing and puffing up the hill from the Pacific Coast Highway, with Range Rov-

She's the most well-balanced actress I've ever met, which explains why, when she comes in my room the next day and tells me that the pilot is on hold, I'm the only one who freaks out.

"Fuck, seriously?" I can't keep the creeping note of panic out of my voice. "What happened? Don't you have a contract? Fuck!"

"Boof, it's not a big deal."

"It's Maui!"

"Do you even like Maui?" She has a point. Even though I grew up in L.A., I'm not built for the heat. My pale skin reddens and freckles without ever approaching a tan, and humidity makes my hair look fungal.

"I like that it's not *here*," I say, thinking about Donna's texts. "Just tell me one thing."

"What's that?"

"Who the fuck is Gary Scott Thompson?"

She laughs, which makes me happy, and I tell myself that this isn't the end of the world. Who wants to spend six weeks in Hawaii? Not me. Sunburn city.

I finally break down and call Kenner. I mean, maybe the composer's not someone you'd have heard of unless you're a studio musician, but surely he's a big-enough name that I can let my unfortunate denouement at the Date Palm fade like the end credits after a straight-to-cable movie. The anticlimactic result is that I get his voice mail and leave a babbling message that rivals Jon Favreau's excruciating scene in *Swingers* when he has an entire relationship arc on the machine of a girl he met in a bar. Like most things, it's much funnier when it's happening on the big screen and not in your bedroom.

"You mean, like, *girlfriend* girlfriend? You boof girls?"

Megan grabbed my hand and led me away toward her Jeep, which was idling at the curb. "Thanks for watching *Jade Wolf*."

It was a weird L.A. bonding moment, and we've called each other Boof ever since.

"There's only a bottle of Krug in here," I yell after rummaging through the fridge.

I peer around the corner, where I can just glimpse Megan's face hanging upside down from the side of my bed.

"Then we better use the good glasses," she says, blowing one smoke ring through another, like it's no big deal that we're cracking a two-hundred-dollar bottle of champagne at three in the afternoon.

The truth is, Megan doesn't get recognized that often when we're out in L.A. Despite working steadily, she's not even C-list famous. She was a theater major at UCLA when she was a teenager and she studied at the Marcel Marceau Mime School in Paris one summer. She said it was all "now you're in a box," "now you're climbing out of a well," while the teachers told her in French that she had to stop eating cheese or she'd get even fatter than a size 2.

She came home determined to change her major to something practical when she got cast from a student showcase in a gross-out torture horror film. She never looked back. She still talks wistfully about wanting to do theater, but she's a Hollywood workhorse. She auditions constantly, and when the jobs come in she takes them and when they don't she taps into savings.

She just shrugged when *Jade Wolf* only ran in the United States for twenty episodes, which shafted her out of syndication money. She shops at vintage stores and Target, not Fred Segal and Planet Blue, and she still drives the Jeep she paid cash for after her first big payday.

"Gary Scott Thompson," she says, and unleashes her smile.

I'm not entirely clear who Gary Scott Thompson is, but her enthusiasm is infectious. And this would solve all my problems.

"Gary Scott fucking Thompson!" I say. "I'm in! Is it time for bubbles?"

Megan always keeps a couple bottles of good champagne in the fridge. It's her philosophy that we should always be able to celebrate good news at a moment's notice. I tend more toward the notion that we should always be able to drown our sorrows, which kind of illuminates the basic—and major—difference between us.

"Boof, please," she says. "That's not even a real question."

I should explain the Boof thing. We picked it up six years ago, when a drunk guy in an unfortunate mesh shirt sidled up outside the restaurant—the now defunct Guys and Dolls—where Megan and I were waiting for her car from valet. We barely knew each other then. I'd been dating Robbie—my ex-husband—for a few months, and she'd just started dating his business partner, a shady guy who wouldn't last long in any of our lives. The boys had gone to the SXSW music festival and we were making the best of being left behind. We were both a little tipsy, not so much from the bottle of wine we'd shared but from our mutual delight that we were getting along so well.

"You're the girl from *Jade Wolf*!" the guy said, fumbling with his iPhone for the inevitable picture request.

Megan gave him a hundred-watt fan smile. "You must be one of the three people in the US who watched it."

"Areyoukiddingme?" He threw an arm around her shoulders, then peered at me. "Are you somebody too?"

"This is Jess," Megan said, slipping gracefully from his sweaty clutch after he'd clicked the picture. "She's my girlfriend."

from Pete at the Date Palm. Maybe I should feel guilty, but honestly, I was doing his ironic hipster ass a favor.

I'm this close to mentioning that if I don't pay off Donna—which is what I'm convinced all those texts are about—she'll slither onto our couch and poison our lives. But I can't. What if Megan offers to front the money? I don't mind mooching a little, but the whole actress-as-friend thing is tricky. There's such a fine line between friend and entourage.

"You're so dramatic," Megan says. "We're young, white, and living the Hollywood dream."

"That's you, Boof. I'm feeling more fat, jobless, and broke right now, frankly."

Megan exhales a stream of smoke. "I hated that Date Palm job for you. You need to cook, not cashier."

"Now I'm not doing either," I say. Cooking is another one of those jobs where looks don't matter—in any other city on the planet. But here, even a scullery job at a hip restaurant feels like going on a casting call for a commercial. They want head shots. Seriously, head shots.

"Well, I want to care about your crappy job loss, but it's a big win for me because I just booked a Gary Scott Thompson pilot."

I look at her blankly.

"I'm shooting in Maui for six weeks," she explains. "I want you to come with."

"As what?" I scoff, as if I'm not already throwing sunscreen into a suitcase.

Megan kicks her bare feet into the air. "Whatever. Are you hearing me? *Maui.*"

"I don't know . . ."

"I bet I can get you paid."

"Really?"

cheaper roommate. She could afford better—hell, she could treat herself like a celebrity instead of an actress and blow through her savings in a year. But she would never. That's her greatest fear: waking up one day with no work, no money, and no prospects.

My greatest fear is that she'll wake up one day and realize that she can do better than a shitty apartment in a shitty neighborhood with a shitty roommate. Or at the very least, that she can live in a building with a working elevator.

"Are you here, Boof?" Megan drops what sounds like a steamer trunk on the wood floor in the living room.

"In my room," I call out, which should give you some idea of the acoustics in our rent-controlled sliver of the L.A. dream.

A moment later, she flops beside me on the unmade bed and kicks her slip-on Keds onto the floor. "What is going on in here? It smells like ass, and you're sitting in the dark."

"That's not ass," I tell her. "That's dried tropical-fruit yogurt."

"Classy," she says, yanking on the blinds to let the afternoon summer sun flood in.

My room doesn't look that bad. Well, sure, there's the mound of yogurt containers and a couple piles of dirty laundry, but nothing to expose the horrible facts that I quit my job, my mother is threatening to descend on us like a plague of crazy, and I'm the biggest twenty-nine-year-old loser west of the 405.

"I quit my job," I say. "And I am the biggest loser west of the 405." No point in avoiding the obvious.

Megan plucks an American Spirit from the pack on the table. Her hazel eyes are sparkling like it's the best news she's heard all week.

"I need fire," she says.

I toss her the pink My Little Pony disposable Bic that I swiped

with Stokke and Bugaboo strollers pushed by underpaid Filipina nannies while the slim-again mothers sift through lingerie at Only Hearts or grab a Pilates mat class at YogaWorks.

Then there's where we live, Baja Santa Monica, on the cusp of Venice. Sure, we've got an Urth Caffe and some celebrities tucked into the walk-streets by the beach, but Baja Santa Monica is low-key, and our rent-controlled apartment would make a Montana Avenue mommy wrinkle her sculpted nose in disdain. There are drunk sorority girls puking and shrieking in the alley outside O'Brien's Pub every Friday and Saturday night, and a contingent of moderately aggressive homeless people form a gauntlet between our building and the Coffee Bean & Tea Leaf a block down.

But there are definite pluses, such as rent control, which means we pay only $612 each for our minuscule two-bedroom/one-bath apartment, a price seriously unheard-of in this or any other livable part of the city. And we're three blocks off the beach, so when the rest of the city is sweltering during our long, subtropical summers, we've got a morning marine layer that lets the beach kittens add a layer of Planet Blue cashmere over their James Perse sundresses.

Megan scored the apartment from the makeup artist on her last movie, who took a job doing fetish porn in Japan. Megan paid her five grand in cash to walk away. Technically the lease is still in her name, and we send our checks to a PO box every month, plus an extra two hundred bucks cash, which Megan always pays. It's the vig. So far, we haven't gotten an eviction notice, but I squint at the front door every time I come home. Megan says we have nothing to worry about, but do we really think that a fetish porn star would hesitate to screw us?

Megan chooses to live modestly, in a cheap apartment with a

"Prada guy will never hire me."

He looked at his shoes and sighed. "They're Rick Owens. And seriously, you'd be perfect."

"Why's that?" I asked.

"Because you have the skin of a rhinoceros and the soul of a rose."

I stared in astonishment.

"Stella Adler," he explained.

Believe me, I knew the provenance of the quote. Donna said it every time I came in crying from the playground. "You're better than those assholes," she'd say of whichever girl had hurt my feelings with some imperceptible slight. "You have the skin of a rhinoceros and the soul of a rose." For the longest time, I thought she'd made it up. Turned out it's a pretentious trope from the Actors Studio. I wasn't really surprised. Also? I have the least rhinoceros-y skin on the planet. I guess she meant it in an aspirational way.

Kenner had slipped the napkin into my hand with an agonizing pity smile. "Seriously. Call me. He won an Oscar!"

An Oscar is major, even if you're not into that kind of thing. Although, of course, everyone's into exactly that kind of thing. Which is why I'm in my room eyeing the napkin with Kenner's number when I hear a key scrape in the door.

A spark of hope ignites in my chest. Megan's home. I hear her swearing under her breath and jiggling our sticky lock.

If you're feeling generous, you could call our apartment bohemian. It's on the fourth floor of an old five-story Masonic lodge in Baja Santa Monica. Santa Monica is divided into two areas. First there's the flats, or what we jokingly call Norte, where the real-estate price tags start in the multimillions and Montana Avenue teems

And by "must see you," she means *must see my money*. Also, for what it's worth, I'm patently aware that there is no Emily. There's never an Emily. You know how little kids create imaginary playmates and then blame broken cookie jars and dead goldfish on them? Well, Donna never outgrew that phase. She's a master at diverting uncomfortable truths or unpopular opinions to the mouths of her nonexistent friends. ("I was talking to my friend Cecelia, and she noticed you're looking a little chubby, hon," or, "I would love to come to your spelling bee, but I have to go to court with my friend Rachel that day.") It's one of the many forms of Kabuki theater I grew up with—smooth, bland masks that kept us from having to have real conversations. At this point, it's just par for the course.

The third text says, I'm planning the L.A. trip now. Hope the old clunker can make it over the Grapevine. xoxo

I start sweating damp, sticky circles under my arms. Is she really coming? Where's she going to stay? Not here. She's probably lying about that, too. She's probably just threatening to visit so I'll send her money. Gaaah.

I scrape out the dregs of a quart of strawberry frozen yogurt like maybe there's a golden ticket at the bottom, then set the empty on my cluttered nightstand. If Megan doesn't come home soon, I'm going to weigh three hundred pounds. Maybe I can join the circus. Better than living with Donna.

My only other option is calling Kenner. He scrawled his number on a Date Palm napkin after my unfortunate instant resignation with Pete.

"Call me in a couple of days," he'd said while I'd fought back tears and tugged at my bike lock. "I'll talk to my old boss."

nods and grunts when I order, then bags my quarts of chocolate malt and old-fashioned vanilla—and, occasionally, a quart of tropical fruit that tastes like ipecac syrup, because I tell myself it has more Vitamin C. I'm invisible to him, which is fine with me. The last thing I want is to be seen.

Megan's been in San Diego for a week, shooting episodes of a new network show featuring impossibly hot lady cops who keep finding themselves in investigations involving lingerie or swimsuits. If she were here, she'd bring a salad bowl full of popcorn into my bed and tell me everything is going to be all right with the sort of sincerity only a working actress can muster.

A working actress is an anomaly in L.A. Everyone is some kind of model-actress-whatever, but when you drill down, waitress-barista–sex worker turns out to be more accurate. Not Megan. She's gorgeous, but not in a starlet way. She's a brunette, first of all, and she's curvy like a pinup model, not wafer-thin with pneumatic tits and lips, which is de rigueur in L.A. She's kind of a tomboy Dita Von Teese, if that oxymoron makes any sense. Her looks can skew toward either blueblood or girl-next-door, and once she has a few drinks in her, she becomes a bawdy, size-2 truck driver—yeah, that's curvy in Los Angeles—so of course I fell in love with her the moment I met her.

And after I read my mother's latest texts, I need her. But I can't call when she's on an audition. She'll turn off her phone while she's actually in the room, but I don't want to break her concentration if she's still sitting in some endless holding pen full of the pneumatically-titted.

Donna's texts are a cavalcade of bad news.

The first one says, SweetP? RU there?

The second one says, Emily's not in good shape. I'm agonized. Really must see you.

"What? Why?"

"There was a thing with a line cook a few years ago where he sabotaged the dry goods with bug larvae."

"Gross," I said. "I would never."

"God, I know that, Jess. But it was, like, rule number one in my management training."

"So, I'm just cut, then?"

"I can pay you out a few vacation days," he said. "But yeah, basically. You know it's not personal, right?"

I craned my head around the empty office. "Kind of feels like it, since we're the only two people in here." The truth is, I wasn't even thinking about the money, not thinking about rent or even Donna's potential visit. As I cleared out my locker and tossed my polyester apron into the dirty-linen bin, all I was thinking about was Kenner's mystery celebrity.

Sometimes you have to close one door before another opens.

Slam.

The thing is, I'm not very good at unemployment. At this point, I've been in bed for three days, surfing Facebook and Twitter and watching reruns of *Keeping Up with the Kardashians* and *House Hunters International*, in addition to my steady gossip-blog diet. Once in a while, under the cover of darkness, I skulk across the street to get frozen yogurt, dressed in a pair of stretched-out gray sweatpants and the Sex Pistols T-shirt I've been sleeping in. And I haven't heard a peep out of Kenner. I have his number, but it feels too desperate to call.

Pretty much the only contact I have with the outside world is the guy behind the frozen-yogurt counter. He never says a word, just

Four

In hindsight, maybe I should've waited to hear about Kenner's mysterious composer before I gave Pete notice. I suck at the long game—I'm more of an instant-gratification kind of girl—but I couldn't help myself.

The truth is I played it way cooler with Kenner than I felt. I wasn't totally honest about my gossip-blog consumption either. I'm not proud of the fact that I'm beyond obsessed, but the blogs are only the tip of the iceberg. I also watch *E! News* and *Access Hollywood*, devour *E! True Hollywood* specials, *Extra*, *The Insider*, you name it. I even pick the longest lines at the grocery store so I can page through *Star* magazine and *OK!* and *In Touch* weekly, although I balk at purchasing them, because that would cross a line.

With the shiny lure of celebrity dangling in front of me, I leaped into the fucking abyss.

"It's time for me to pursue other options," I said to Pete when I went back in. "I can give you as much time as you need. Two weeks? Three?"

Pete frowned. "I can't, Jess. The policy is to immediately cut anyone who gives notice."

"I'm not supposed to talk about it."

"Uh-huh," I say, because that's how these conversations always have to start, all *Oh, no, I couldn't possibly*. "Give me a hint."

Kenner sighs, but his eyes are shining with the desire to let it rip. "Well, he's an Oscar-winning film composer."

"Yeah, no clue," I say. "Um, Trent Reznor? Danny Elfman?"

"Not even close. This guy isn't a rock star who dabbled, he's the real deal."

"Yeah?" I say. "Is he still looking for someone to replace you?"

"Huh," Kenner says, and I can see the wheels turning as he considers the possibilities. "You know, you might be a good fit for him."

"How was the money?"

"Twenty-five an hour, plus, you know—" Kenner waggles a shoe in my direction. "Extras."

"Those shoes were an *extra*? And you left there to come here? For fuck's sake, why?"

"You're on call 24/7," he says. "My boyfriend isn't a fan of the two A.M. phone calls."

"Well, lucky me—I don't have a boyfriend."

"It definitely takes a certain personality."

"Abrasive and moody?" I ask. "Sign me up."

"Neurotic and smart," he says, then blushes a little bit at his own honesty. "I'll call and see if he'll interview you."

"Really? Now?" I say. Inside I'm dancing the Charleston.

"It's the least I can do since I'm snaking your day shifts. It may take a minute. He's not good at answering his phone."

"Then I will rock at this job," I say. "Answering phones is one of my special gifts."

The truth is, I don't have any special gifts. But I'm not an idiot.

thin transfers from a pad by the steering wheel and pressed them into my hand.

"I got home eventually," I tell Kenner, then offer him the pack of American Spirits.

"Thanks, no." He looks faintly embarrassed. "I don't smoke."

"You're too young," I say. "You haven't developed lungs yet."

He gives that the feeble half smile it deserves. "Well, Pete asked me to check on you. I can tell him whatever you want."

"Maybe you can tell him I quit," I hear myself say.

"What? No—really?"

"I don't know. It's time for me to move on anyway."

Kenner bounces the heel of his ridiculously expensive shoe against the ground like a bashful little kid on the playground. "Move on to what?"

"No clue," I say. "My skill set is limited."

"Oh, I doubt that."

"I'm divorced, twenty-nine, with a head full of celebrity trivia. I'm thinking sign twirler. I can get a little sun, do some cardio."

Kenner laughs. "You're a pop-culture junkie? I'm *obsessed*. What blogs do you read?"

"*Deadline*," I say. "*Radar, Page Six, TMZ.*"

"Are you kidding? I live for that stuff, even though three-quarters of it is bullshit."

He sounds like he's speaking from experience, so I give him a look.

"My job before this," he explains. "It was for a celebrity, oddly enough."

"Really? Who?"

smoke in my direction, and careening out the driveway onto Verdugo. "You're twenty pounds fatter and not half as cute as the other girls, and you have to sell it with your personality or you're fucked."

I felt the familiar swell of tears rising in my throat and I turned to look out the window so she wouldn't see.

"Don't you have anything to say for yourself?" she said.

I took a breath. "I don't want to do any more auditions."

She swerved the car to the curb, jamming the gearshift into park. "Get out, you little ingrate," she said, her voice low and even.

I crossed my arms over my chest and tucked my chin. She leaned across me and shoved the passenger door open with a flourish.

"Seriously, get the fuck out," she said. "If you're too good to go on an audition then you're too good to ride home with me."

"I don't even know where we are."

"When I was your age, I was driving a car," she said, and I remember thinking, even then, *Jesus, she's so full of shit.*

"You'll figure it out," she said.

I picked up my book bag and stepped onto the curb. She threw the car into gear and drove off with the door still gaping like a startled mouth.

And it's not like she was watching from around the corner, trying to teach me a lesson. She was gone. My best guess is that she ended up at the dive bar on Olive where old actors sing karaoke and get shit-faced, but I couldn't have told you that back then.

When a skinny lady with a mustache sat down beside me, I acted as though I knew what I was doing, studying the numbers on the metal bus sign like I was picking the optimal route.

Eventually, a bus pulled to the curb and I didn't even stammer when I asked the driver how I could get to Fourteenth and Idaho in Santa Monica. He rattled off a couple changes and tore two tissue-

Donna was usually pretty pragmatic about it. She'd cross the ad off her list and hype me up about the next audition, or else she'd drop me at Gloria's, and months would go by before she'd show up and we'd do it all over again.

On that day in Burbank, I don't know what happened. Maybe it was the other mothers and daughters in the holding area, blond and well dressed and patrician. We sat on the folding metal chairs in the waiting room and I watched my mother's eyes flick from one blonde to the next, finally landing on my mouse-brown head with disappointment that shaded into disgust.

When I got into the room, they didn't even let me read. A woman with a shiny black bob wanted to know what kind of products I used on my hair.

I giggled nervously and said I couldn't remember.

She asked me to smile "really, really big, so I can see those toofers," and I could feel the streaky heat of embarrassment prickle up my chest and into my face.

She flipped my picture facedown onto a stack of paper. "Thank you, sweetheart," she said, then flicked her glance toward my mother. "We'll be in touch."

Mom thanked her for seeing me in a voice that sounded like cherry syrup, overly colorful and cloyingly sweet.

She waited until we got to the parking lot before she let me have it.

"I don't know why I even bother with you." She dug in her fake Chanel handbag for a crumpled pack of Benson & Hedges. "You're a fucking ventriloquist's doll, and I am sick and tired of shoving my hand up your ass to make you talk."

"I didn't even get to read," I said.

"Because you looked like shit," she said, exhaling a plume of

mother was seven, she got a part on a nighttime drama for a season. She replaced another kid who got ugly over summer hiatus. It shaped the rest of her life. And mine, I might add."

Kenner smiles, but his expression is weird and sad, not amused. "At least you have a mom to fight with."

"Well, be careful what you wish for. The grass is always greener on the other side of Sunset Boulevard."

Kenner wrinkles his nose. "Is that how the saying goes?"

"It is in my world. When I was ten, I bobbled an audition and my mother was so pissed that she left me at a bus stop in Burbank."

"No way."

"With three dollars in my pocket and only a vague idea of how to get home." I inhale a lungful of smoke. "Though in her defense, I was well versed in the Santa Monica Big Blue Bus system."

Actually, we only went to Burbank when she lost a job or broke up with a boyfriend. She'd get a wild hair to make me over in her image, which was a stone impossibility. I inherited exactly none of her acting ability and I've always been shy around new people. Donna didn't care. She'd swoop me up from Gloria's house or pull me out of class with a dog-eared copy of *Backstage* magazine and a determined gleam in her eye. We'd chug up over the 405 and down the 101 in her shitty, clanking Toyota and she'd coach me like a pageant mom on *Toddlers & Tiaras*. It never helped.

I choked every time the red light started blinking and the casting agents—an endless parade of too-thin women wearing pencil skirts and matte red lipstick—cued my first line. I'd stammer and sweat until they told me they'd heard enough.

"We'll be in touch," they said, and never were.

Three

I'm sitting on the gum-speckled curb, finishing my cigarette, when Kenner sidles up. He hovers awkwardly for a moment, then lowers himself into a praying mantis–like crouch.

"Pete's asking if you're coming back in," he says. "Jayne bailed five minutes ago and I'm all alone."

"Yeah," I say, blowing a scrim of smoke between us. "As fast as my stubby little legs can carry me."

Kenner looks at me blankly.

"It's a joke," I say.

"That doesn't even make sense," he says. "You're totally hot."

"Don't patronize me."

"You know," Kenner says, tentatively. "If I did something to piss you off, I want to make it right."

Kryptonite, I'm telling you. I'm such an asshole. "It's not you. I'm having a thing with my mom, and I'm bringing it along with me like a backpack."

"I heard . . ." He pauses. "She teaches acting in Reno?"

How the fuck does Kenner know that?

"Yeah, to talentless child actors who are never going to get one single job, like, ever." And by some horrifying trick of fate or low self-esteem I start confiding in *Kenner*, of all people. "When my

their hard-earned dollars to have my mother—a genuine child star!—teach their kids how to smile on cue and hork up a convincing sob.

"Teaching acting in L.A. is a whole different thing," I tell her. "You know that. Plus, let's not pretend you'd have anything left over after you paid for a hotel."

"Your roommate told me your door is always open. Megan's such a nice girl. And so pretty. You can tell she takes care of herself."

Okay, first of all? Donna's never met Megan, my best friend and roommate. Megan politely accepted Donna's friend request on Facebook, and now my mother acts like Megan's the daughter she always wanted and never had.

"Listen, Mom," I say, skittering my eyes around the near-empty dining room. "We're getting slammed in here. It's the dinner rush. I'm sorry. I can't help you."

"Oh, sweet pea, just think about it."

"Mom, there's nothing to think about. I don't have the money."

"We'll think of something. You're my peanut-butter princess."

I hang up without saying good-bye. It's funny how three words can catapult me straight back into childhood. "Peanut-butter princess" is what Donna called me when I was four or five, before the whole *you're-going-to-be-a-star* thing started, in that brief window when I still loved her fiercely and with abandon.

between my ear and shoulder, and tell Donna yet again that there's no money left from my windfall inheritance.

"Don't be silly," she says. "It's not imaginary. You were her beneficiary and—"

"So it *is* about money. I knew it."

"I'm not calling about money," she says. "Well, not entirely."

Jesus Christ. Donna is the queen of oblique conversation. But short of hanging up the phone, there's really no way to rush her to a conclusion.

"Go on," I say.

"It's just . . ." Her voice falters for a second before she continues, and it's so perfectly timed that I want to applaud her performance. "The doctors aren't sure what's going to happen to Emily and she's not talking to her son and she's miserable about it."

"Sounds rough," I say flatly. "So what do you need from me?"

"I can tell this isn't a good time, honey pie. I want to talk to you, maybe come see you in person, you know."

I *don't* know, actually. Donna hasn't shown any interest in seeing me for about fifteen years, and our relationship works best with five hundred miles between us. "What do you mean, come see me?"

"I've got enough to come for a visit." Her voice turns conspiratorial, like she's letting me in on a delicious secret. "But it might leave me a little short somewhere else."

"So you want to come for a bonding visit, but you want me to fund it?"

"It's okay, peanut," she says. "I'm sure I can pick up some freelance work in L.A."

Donna teaches acting to children at Lights, Camera, Action! in Reno. It's a good living. All those cocktail waitresses line up to spend

Gloria mostly raised me, which was a benefit for all of us. Donna was a product of the '70s, and there's a reason they called that era the "me generation." She was hypnotically glamorous and predictably unstable, and sometimes it was just better for her to go off and do her own thing when the mood struck.

Gloria bought me breakfast cereal and shiny plastic headbands; Donna occasionally showed up with a bedraggled stuffed animal one of her dates had won at a carnival somewhere. Gloria watched from the window every morning as I waited at the curb for the bus, waving vigorously until we turned the corner and she disappeared from sight; Donna, on one of the only occasions when she drove me to school, made me take off my underwear in the car because she said it gave me a visible panty line. I got sent home from school after I forgot and did a backflip dismount off the jungle gym on the playground.

Gloria attended a couple PTA meetings every year; Donna was a school-year no-show, although once she picked me up from school on a spring afternoon wearing a bikini, which caused a gossipy clusterfuck with the other mothers that haunted me through middle school.

Gloria made sure I had dinner with at least one vegetable on the table. Donna took me along on dates to dive bars, where my entire meal consisted of a highball glass full of maraschino cherries.

When Gloria died, I was the beneficiary of her insurance policy, which my mother will never, ever let me forget. She's asked for that money a hundred times in the past decade, for a down payment on a condo, to invest in "biotech," to buy an Arthur Murray franchise. After expenses and taxes, I walked away with fourteen grand. I've told her a dozen times that it's gone, but she refuses to believe me.

I turn away from Pete and Kenner's curiosity, tucking the phone

"Well, I'm having a bit of a crisis, and I could use a tiny bit of help."

"I figured," I say. "How much?"

"Oh, sparkle, no. This is important."

"Don't bullshit me, Donna."

"You're so cynical," she says, and I can tell she's irked; no big surprise. Donna does not like to be called on her shit. "Maybe it's something *really* important, sugarplum."

"So let's hear it."

"Well, you remember my friend Emily, don't you?" She pauses for my assent, which I don't offer, because I have no idea who she's talking about. "She just had a big health scare and she hasn't been herself at all, poor thing. I mean, she can't work, she can't drive herself to doctor appointments, nothing. I've basically been taking care of her twenty-four hours a day for the past four months."

"Why are you telling me this?" I say.

I can feel Pete and Kenner listening without even looking in their direction, and the hair on the back of my neck is waving like cilia. I'm sure I sound like the worst daughter in the world, but I've spoken to Donna maybe three times in the past five years, and every single time it's been about money. "Let me guess. In taking care of your friend in her time of need, you've fallen a bit behind on your own obligations and you were thinking that maybe I could dip into the imaginary money from Gloria."

The money from Gloria is such a fucking thing. Gloria was my mother's mother—my grandmother, though I was never allowed to use that word. The gospel according to my mother is that Gloria beat the shit out of her when she was a little girl, but my memories of Gloria are of a more benign kind of crazy, like having me erase her crossword puzzles so she could do them a second time.

"*Not here,*" I whisper.

"She's right here," Pete says, and he tosses the receiver onto the counter between us, like a rapper dropping the mic.

I must look stricken because his face morphs from mild managerial disapproval—no personal calls at work—into genuine concern. "*What the fuck?*" he mouths, eyebrows raised. "*Are you okay?*" He's probably wondering why an old lady like me doesn't want to talk to an older lady like my mother. Isn't that what old ladies do all day, talk on the phone and watch soap operas?

I wave him off with an attempt at a smile. It's ridiculous for me to not be fine. I can't be not fine. I'm totally fine. The receiver sits there for what feels like a long time. I wait for it to explode, or start leaking green slime, or turn into a snake and slither off the counter.

Eventually I pick it up. What else am I going to do? "Hello?"

"Well, there you are, cupcake," my mother says, sparkly and brittle as a drugstore Christmas ornament. "I've been looking all over for you."

My mother never calls me by name. It's all *sweet pea* and *cupcake* and *lamb chop*—a whole arsenal of diminutive food names that she's used in rotation for as long as I can remember.

I duck my head into the receiver like I'm trying to use it as camouflage. "Hi, Donna," I say. "What do you want?"

"I'm just calling to check up on you, sugar pop. How's it going down there in Tinseltown?"

I snort a half laugh. "Seriously, Mom, how did you even get this number?"

"You gave it to me, honey pie."

That's a total lie, but there's no point in going there. "Whatever. What do you need?" I guarantee that she is not calling me at the Date Palm at 5:00 P.M. on a Tuesday to *check up on me.*

Two

When I get back to the dining room, Pete's on the landline, which only happens when someone places a to-go order or checks our hours. He's smiling, and when he catches my eye I brace myself for another assault of kindness. Then he says the words that are so much worse than *You're fired* or even *I hope we can still be friends.*

"It's your mother," he says, proffering the receiver in my general direction.

A fizzle of adrenaline blooms at the back of my head, snaking up my scalp and down into my arms.

"*Seriously?*" I mouth, and Pete nods and looks at me quizzically, turning one palm up, and shrugging his shoulder, like *What's the problem?*

I swear to God, my mother has a sixth sense about when I'm feeling vulnerable. It's no coincidence that she's calling right now, this minute, as opposed to twenty minutes ago when I was just garden-variety irritated. It's like she can smell my fear pheromones all the way in Reno.

I give Pete the "shut it down" gesture, flapping my hand in a sawing motion across my throat.

"Christ, Jess." He cups his hand over the receiver. "C'mon, it's your mom."

heartfelt, which is unfortunate, because *nice* is my kryptonite. "I can't give you those shifts. I'm sorry, I just can't."

"Yeah, okay," I say. "I get it."

Pete gives me a look of gentle empathy, so I sidle into the bathroom before I well up or, worse, bust out the full ugly cry. Once I start the ugly cry, it's pointless trying to hold it back.

"Wait a second," I say. "Did you work lunch today?"

Kenner looks stricken. "I, um . . . Yes?"

"Since when?"

"Since Pete, uh, hired me for then?"

Holy shit. *Kenner* is getting the day shifts? I shoot a side-eye in Jayne's direction and she shrugs innocently, but I know she's got details.

Pete picks that moment to roll in. He sees Jayne and me gnarled in a counter knot, and says, "Two horses walk into a bar, and the bartender says, 'Why the long faces?'"

He's big on bad jokes, which might have something to do with the fact that he's twenty-three and perpetually stoned.

"Dude," I say, "are you giving Kenner day shifts?"

"Well, nothing's decided for sure," he says, and his eyes flick toward the door.

"Really, Pete?" I can't keep the hurt from my voice, and I take a deep breath before continuing. "We talked about giving me days. Or putting me in the kitchen. You know that's where I'll kick ass."

"We don't need another cook, Jess." Pete rubs his temples and sighs. "I'm not trying to be a dick, but, c'mon. Kenner fits the demographic around here. You're . . . well, you know how it is."

Yeah, I know how it is. I was born and raised here. Beauty talks, average walks. I'm a solid size eight—sometimes a ten—with plain brown eyes and plain brown hair that I've been dyeing auburn since my late teens, with the exception of that one unfortunate flirtation with platinum blond, which ended in a pixie cut and tears.

Pete looks at me imploringly. "Jess, you're awesome, but you are kind of . . . aging out of the barista scene."

I fucking knew it.

"Please don't make this into a thing." He sounds earnest and

"Those are some impressive kicks," I say. "Are they Prada?"

"Rick Owens," he says in a weird monotone. "They were a gift from my last boss."

"Wow, generous boss."

"Hazard pay," Kenner says.

"What'd you do?"

"I was his personal assistant."

"Oh, yeah? What's that like?"

"Hazard pay," he repeats, then turns to wipe down the already clean counter.

"How'd you do?" I ask Jayne, nodding toward the stack of bills.

"Not bad." She folds the cash into two unequal piles. "We were slammed until three."

I look around at the empty restaurant. "Must be nice."

The day shift at the Date Palm is the cash cow, but Jayne gets first pick of the schedule, so I'm always the weekday closer. The differences are staggering. She stacks twenties while I'm happy to get an occasional five. Which sucks, because I'm trying to scrape up some savings. I don't even know why at this point—maybe I just need one stable element in my otherwise unbalanced life. It's clear that my ship of youthful exuberance has left the dock. Don't get me wrong—in almost any other town I'd be considered viable. Here? They're about to set me adrift on an ice floe.

Jayne tucks the smaller wad of cash into the pocket of Kenner's fancy jeans. "Here, luv," she says. "You killed it today."

Kenner throws his arms around her. "Oh my God, thank you so much. You're the best."

Hold up. I'm barely covering rent and Jayne's tipping the new guy out on his first day? And also, *what*? Did Kenner work the day shift before I got here?

strain to hear the word "coconut," but I've already hit my limit on groundless irritation for the day.

"Seven seventy-five," I say, and his flat-ironed hair waves in a single sheet as he nods his assent.

I fill a white paper cup halfway from the steaming glass carafe of black chai tea waiting on the warmer, then dump a few inches of organic coconut milk into a steel pitcher and foam it up on the espresso machine. When I push the cup across the counter, he peers at me with one kohl-rimmed eye.

"Did you steam the milk with the same wand you use for dairy?" he says.

"Of course not. We only use that one for almond and soy. And the occasional coconut, obviously." I wave my hand toward the other side of the behemoth machine. "Dairy happens over there."

He flips a quarter into my empty tip jar, and shuffles away.

"You're definitely going to hell," Jayne says, laughing.

"I don't get it," Kenner says.

"That steamer hasn't worked since I've been here," Jayne says.

I bring Kenner to the kitchen to watch the line cook whip up a batch of famous secret-recipe Date Palm granola. If you ask me, it's nothing to get excited about. I make a granola of my own with dried cherries and pumpkin seeds that blows it out of the water. The Date Palm version is eight dollars a bowl and has more saturated fat than a rib eye, but the tourists line up to buy souvenir bags of it for twenty-two bucks a pop.

When we return to the front, Jayne has emptied her tip jar onto the freshly wiped counter, stacking the bills in neat rows. I'm no fashion expert, but that's when I notice that Kenner's wearing a pair of leather sneakers that cost more than my car. Oh, wait, make that more than my *repossessed* car.

of warm gluten-free croissants and start shoving them into the display case. Who the fuck eats a gluten-free croissant? People who live in zip codes that start with a 9-0, that's who.

"A lot of celebrities have houses in this neighborhood, right?" Kenner continues. "Fiona Apple, have you ever seen her? I mean, I wish I lived closer, but I love driving here from the Valley. Once you get over the Sepulveda Pass, there's a change in the air. I swear the temperature drops ten degrees and the people are just so interesting. I heard Julia Roberts has a place down the street. Does she ever come in? Oh my God, I don't know what I'd do if she ever came in. I guess I'd—"

"Kenner," I say, whirling around and wiping my coconut-oil-slicked hands on my apron. "You need a star map from the twenty-first century."

Kenner looks hurt and toys with a pocket on his Nigel Cabourn jeans, which, hello? If he can afford six-hundred-dollar jeans, what's he doing at the Date Palm?

Truth? It's the invocation of Julia Roberts that pushes me over the edge. I mean, I'm a huge fan of abject starfuckery, but can't he find a timelier object of infatuation? Shouldn't he be making references to hip, obscure microcelebrities? It feels like he's reaching into the oldies bin for a star I've actually heard of.

"Sorry," I say, grudgingly. "I know I've only been here three minutes, but I'm already having a day."

"No problem," Kenner says, but his body language says otherwise.

As Kenner sulks, I help a pseudo-Goth kid hidden beneath a scrim of dyed-black hair, who whispers his order for a decaf coconut-milk chai latte.

"How much is that?" he mumbles, not making eye contact.

I consider charging him an extra dollar because he made me

"Seriously, Jess," he says without cracking a smile. "I need you back there. The new hire's standing around with his head up his ass. Go tell him what to do."

I stare at Pete. So much for flirting. Also, what new hire? There's no room on the schedule for another counterperson. In fact, I've been looking to pick up a couple extra shifts, but Pete's been stone-walling, and I'm increasingly paranoid. "Wait, you hired someone new?" I say. "Are you still going to put me on mornings?"

Pete eyes the still-smoldering cigarette butt. "We can talk about this later, Jess, okay? Just get in there."

I push through the warped wooden door and into the near-empty dining room. This is so not how I envisioned myself on the cusp of my thirties. Recently divorced, back in L.A., starting over. This isn't even square one, it's square negative two.

From behind the counter, Jayne chirps, "Hello, luv," as I stow my purse.

She sounds chipper, but I know she's pissed I'm late. She cloaks her bad attitude behind her Manchester accent, wide hazel eyes, and masses of pre-Raphaelite hair.

"Hi," I say. "Sorry."

She shrugs. "This is Kenner."

I shoot a sidelong glance at the new guy: young, sleekly androg-ynous, and twitchy in a not-entirely-unappealing way. Could be worse. But *Kenner*? What kind of a name is Kenner?

I give him a facsimile of a smile as I tie my green polyester apron around my waist, which he takes as an invitation to start talking.

"Jayne's told me all about you," Kenner says enthusiastically. "I'm so excited you're going to be training me. Don't you love working at the beach?"

I can feel a twisted smirk replacing my faux smile, so I grab a pan

One

A few hours before I quit my job, I'm stuck at the light on Rose and Pacific, watching a string of kids wearing T-shirts emblazoned with the name of their preschool—"Blackberry Atelier"—as they cross the dirty asphalt. Harried teachers urge them onward while supermodel-beautiful moms in Fred Segal sweatpants bring up the rear, tapping urgently on their cell phones.

Another perfect day in Venice, California.

I'm stuck on my bike, even though the only people in Los Angeles who ride bikes to work are fourteen-year-olds and people convicted of multiple DUIs. And me. I'm not a drunk or a kid—or even an eco-warrior—I just have no other way to get around.

When I pull up at the Date Palm ten minutes later, Pete—the baby-faced twenty-three-year-old manager—is outside smoking a cigarette.

"You're late," he says, flicking his cigarette toward the sand-filled ring surrounding the public trash can.

"There was a toddler pileup on Pacific," I say. "It was a bloodbath."

I give him a nudge with my shoulder as I pass. There's a mild flirty thing we do, even though I'm six decades older than he is—okay, six years, but that's a lifetime in L.A.—and if I can get him laughing, he'll forget that my shift started five minutes ago.

Oh!
You Pretty
Things

For Chris, of course, for all the yeses.

DUTTON
— est. 1852 —

Published by the Penguin Group
Penguin Group (USA) LLC
375 Hudson Street
New York, New York 10014

USA | Canada | UK | Ireland | Australia | New Zealand | India | South Africa | China
penguin.com
A Penguin Random House Company

LIBRARY OF CONGRESS CATALOGING-IN-PUBLICATION DATA
Mahin, Shanna.
 Oh! You pretty things / Shanna Mahin.
 pages cm
 ISBN 978-0-525-95504-7 (hardcover)
 I. Title.
 PS3613.A3493335O38 2015
 813'.6—dc23
 2014028686

Printed in the United States of America
10 9 8 7 6 5 4 3 2 1

Set in Warnock Pro
Designed by Alissa Rose Theodor

WITHDRAWAL

Oh!
You Pretty
Things

SHANNA MAHIN

DUTTON
— est. 1852 —

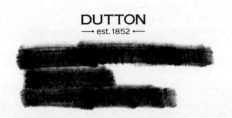

Oh!
You Pretty
Things